WORTHINGTON
WHITTREDGE

WORTHINGTON
WHITTREDGE

Anthony F. Janson

The right of the
University of Cambridge
to print and publish
all kinds of books
was granted by law
in 1534.
The University has printed
and published continuously
since 1584.

CAMBRIDGE UNIVERSITY PRESS

Cambridge • New York • Port Chester • Melbourne • Sydney

Published by the Press Syndicate of the University of Cambridge
The Pitt Building, Trumpington Street, Cambridge CB2 1RP
40 West 20th Street, New York, NY 10011, USA
10 Stamford Road, Oakleigh, Melbourne 3166, Australia

First published 1989

Printed in the United States of America

Library of Congress Cataloging-in-Publication Data

Janson, Anthony F.

Worthington Whittredge / Anthony F. Janson.

p. cm. – (Cambridge monographs on American artists)

Bibliography: p.

Includes index.

ISBN 0-521-32432-7

1. Whittredge, Worthington, 1820–1910 – Criticism and
interpretation. 2. Hudson River school of landscape painting.
I. Title. II. Series.

ND237.W624J36 1989

759.13 – dc20

89–15778
CIP

British Library Cataloguing in Publication Data

Janson, Anthony F.

Worthington Whittredge. – (Cambridge monographs on
American artists)

1. American paintings. Whittredge, Worthington
I. Title

759.13

ISBN 0-521-32432-7 hard covers

Contents

Illustrations

Black and White Figures

Editor's Preface

THE CAMBRIDGE MONOGRAPHS ON AMERICAN ARTISTS series aims to present the most complete and recent research on individual American artists whose importance and place in our history of art now call for reassessment and reevaluation. Resisting the temptation to provide easy digests of the available resources on well-known and often overly documented giants, we have sought out those scholars whose research focuses on the works of important artists who have not yet received the critical attention they deserve.

In *Worthington Whittredge* Anthony Janson presents us with a careful study of a long-admired American landscapist, but one who has all too often fallen between the categories provided by those scholars most influential in determining a chronology and typology for American nineteenth-century landscape painting. The painter's training and career are freshly examined, his art is placed within the context of his time, and our understanding and appreciation of his work are enriched by our exposure to the rich selection of his seldom-reproduced paintings.

Dr. Janson not only makes a compelling case for the importance of Whittredge as an important figure in nineteenth-century American landscape painting, but also helps us to challenge and rethink the received assumptions about that particular form of our artistic heritage.

Preface

DESPITE ITS MODEST SIZE, the present monograph on Worthington Whittredge represents more than sixteen years of work, which has often been interrupted by research in other areas. I came to American art belatedly, after devoting much of my graduate studies to Dutch Baroque painting. The Hudson River school provided a natural bridge from my first love, Dutch landscape painting. I chose Whittredge as the topic of my doctoral thesis because his gentle expressiveness reminded me of Salomon van Ruysdael's. The invitation to write this book has provided a welcome opportunity to redress the errors of my dissertation by presenting the more mature view of the artist that I began to develop in my articles about him. I have no illusions that this account is definitive. There is plenty of room for more work and other points of view.

My goal has been to tell Whittredge's story as simply and clearly as possible. I have tried to resist the temptation felt by every author to justify his studies by exaggerating the importance of his subject. This is especially difficult when the object of his study elicits the kind of ardent support that Whittredge inspires in his most passionate admirers. A more restrained view is nevertheless in keeping with the innate modesty of the artist himself.

Whittredge, it must be said, was not one of the pioneering spirits who defined the Hudson River school. He does not rank in importance with the likes of Thomas Cole and Asher B. Durand in the preceding generation, or Frederic Church, Albert Bierstadt, John Kensett, and Sanford Gifford among his own. Much of the reason lies in Whittredge's personality. He did not possess the temperament needed for such a role. Nor did he have the requisite talent. All of those artists were gifted with greater technical ability. He consciously eschewed the virtuoso displays favored by the Churches and Bierstadts. Although it is true that most of his acknowledged masterpieces are large paintings, he was most comfortable working on a small scale of

around 14 × 22 inches, a common format among the Hudson River school that was appropriate to his abilities and outlook. What Whittredge lacks in heroic stature he more than makes up for in charm. Qualitatively, his paintings are gems of their kind, which require no more apology than a Schubert song does for not being a Beethoven symphony.

Whittredge's position was also partly a function of historical circumstance. Few artists from the Midwest other than George Caleb Bingham played seminal roles in American painting before the Centennial. Whittredge was born and trained in Ohio, where he assimilated the Hudson River style and its ethos very much at second hand. When he left Cincinnati, where he spent most of his early career, it was to go to Europe. By the time he returned to the United States a decade later, he had missed his chance to help shape American landscape at a critical juncture in its history, but instead was obliged to follow in the footsteps of those who had determined its course. Because his development was slower, he came into his own only in the 1870s, when he emerged as the leading representative of the Hudson River school and acquired a new prominence in the nation's artistic affairs.

Whittredge's work has a diversity and freshness unique among second-generation Hudson River painters. It repays repeated viewing with enhanced pleasure, and I have never tired of his landscapes. After defining their mature styles, even its leaders had a hard time avoiding the repetitiousness that characterizes much of Hudson River painting. Not so with Whittredge. Throughout his career, he tried to assimilate the changing art of his time. Indeed, he acted as a sensitive barometer of American landscape painting between 1840 and 1900. For that reason, he is a most rewarding artist to study. Moreover, his long stay in Europe and struggle to become again an American artist provide an exceptionally interesting comparison between the landscape traditions on both sides of the Atlantic.

I have analyzed Whittredge's sources in detail, not to reduce him to a mere follower – he had too much individuality for that – but to place him in his proper context. This is especially necessary with an artist who was so receptive to new ideas and styles. Historical discussions have been integrated into the main body of text as much as possible. However, I decided to treat the early Hudson River and Cincinnati landscape schools in a separate chapter, which includes additional background material as well. This strategy was dictated by the fact that this book must also function as an exhibition catalogue. Chapter 1 is intended to introduce the interested lay reader to the American Romantic landscape tradition and Cincinnati's special position in it. To scholars, much of this terrain will seem all too familiar; they may happily skip most of it if they prefer.

Because the purpose of this book is to tell Whittredge's story, I have not attempted to address every issue of interest. I am acutely aware that I have dealt with the Hudson River school in rather general terms. No movement is monolithic, of course. It is nevertheless convenient to maintain this fiction

in order to set Whittredge into sharper relief. Moreover, the artist himself saw his fellow painters as being united into a distinctly American school by the concerns they had in common, which overrode the very real differences in temperament and outlook that existed between them. Finally, there is still a great deal that we do not know about his relations with other Hudson River painters. He is mentioned only occasionally in the diaries and correspondence of his closest friends, including Jervis McEntee, whose lengthy diaries shed relatively little light on Whittredge. The rest of the documentary record is even sketchier. It consists for the most part of a family tree and exhibition records.

The primary source remains Whittredge's remarkable autobiography. It is well known from the edited version published in 1942 by the late John Baur, one of the first great students of American art, and reprinted some 25 years later by DaCapo Press. The transcription is reliable except for several dates, which are probably due to typographical errors. Baur, however, excluded a certain amount of valuable material. The largest portion is a fascinating account of the cultural life of Düsseldorf, which was presumably omitted to conserve space, but numerous other details were excised as well. I have incorporated most of the deleted information, which is designated in the text and footnotes by the clear but repetitious term "original manuscript."

The autobiography is almost as notable for what it leaves out as for what it includes. The absence of information about Whittredge's early years is understandable, as the manuscript was written when the artist was around ninety years old. However, the pattern of omissions also reveals personal biases, which are sometimes of a patently self-serving nature. For example, he goes to great lengths to assert his independence and avoids any reference that might suggest a debt to other artists. Nonetheless, the artist's personality shines through, with all its generosity, good humor, and honesty intact. Reading the original manuscript at the Archives of American Art is a special experience.

My views about Whittredge and American painting generally fall well within the norm for the field, but they are inevitably colored by my perspective on European art. Although I have avoided invidious comparisons, an admittedly European bias can be discerned in Chapter 1, which may prove controversial. It has also affected my treatment of other issues such as luminism, always a subject of debate, with which not everyone will agree. Sometimes there are legitimate differences of opinion. For example, some scholars consider Whittredge's trips to the West as having had a greater impact on his work than I do. I regard them as having consolidated his vision of America and confirmed his style, but beyond providing a new kind of subject matter, they did not mark a dramatic change in his art, which I believe would have continued in the same direction anyway. This is not to forestall criticism, only to acknowledge that sometimes one must agree to disagree.

Happily, scholarship is never an entirely solitary pursuit, and I am indebted to the kindness of many people who shared information and ideas with me. Chief among them are William Gerdts and Abigail Booth Gerdts, Annette Blaugrund, Brucia Witthoft, Bruce Webber, Jean Pablo, Nancy R. Horlacher, and Mary Nason. I am particularly grateful to Lawrence Fleischman and Frederick Bernaski of Kennedy Galleries, Stuart P. Feld and M. P. Naud of Hirschl and Adler Gallery, and Ira Spanierman and David Henry for supplying numerous photographs and helping me obtain reproduction permission from owners. I received constant encouragement from Robert Aaronson and Arthur Lesser, who shared their boundless enthusiasm for Whittredge and the pleasure of their company on many occasions. My research was funded in part by generous grants from the Andrew W. Mellon Foundation and the Newington-Cropsey Foundation as part of its ongoing educational program. Finally, I cannot fail to mention the singular generosity of the late Edward Dwight, who organized the first serious exhibition of Whittredge's paintings. By making available his photographic and research files, he saved me a year's work. As repayment for his kindness, he asked only that I freely share my research with other people, a charge I have tried my best to live up to. He was a model of unfailing integrity, decency, and courage who will never be forgotten by those of us privileged to have known him.

Cincinnati and the American Landscape Tradition

THE RISE OF AMERICAN LANDSCAPE PAINTING

THE FIRST AMERICAN LANDSCAPES were topographical records made by artists who accompanied early explorers on their trips into the wilderness.[1] Although most are of essentially documentary value, some have real artistic worth. Paintings such as Gerard van Edema's *Fishing Station on Placentia Bay* (late 1600s, Royal Ontario Museum, Toronto) are also of considerable historical interest in anticipating the settler scenes of Thomas Cole and his followers. The Romantic artists certainly took their cue in part from landscapes by the military artists Hervey Smyth and Thomas Pownall, whose views of America were engraved respectively in 1760 and 1761 by the great English picturesque artist Paul Sandby.[2] The literary counterpart of these explorers was William Bartram. His account, published in 1791, of a visit to the New World two decades earlier influenced Wordsworth and Coleridge, the poets whose *Lyrical Ballads* (1798) played such a seminal role in shaping American attitudes toward nature.[3]

Intervening between this topographical mode and Romanticism was the picturesque, which dominated American landscape between 1790 and 1825. It was the direct outgrowth of the picturesque tradition in England, where it emerged as a distinct approach to landscape theory with the publication in 1780 of William Gilpin's *A Guide to the Lakes, in Cumberland, Westmorland, and Lancashire*.[4] Gilpin codified earlier thinking by defining the picturesque largely in terms of Salvator Rosa's paintings and by using the term almost interchangeably with the sublime and the romantic.[5] As the title of his book suggests, this pictorial mode of seeing was also stimulated in part by the actual scenery of northern England.[6] In his *Essay on the Picturesque* (1794), Uvedale Price attempted to define the picturesque with greater precision by locating it between the beautiful and the sublime, which was concerned with man's

awe of grandiose nature, thereby enlarging its scope as well.[7] He further insisted on a greater fidelity to nature than Gilpin. By 1800, the picturesque had become semantically and stylistically separate from the sublime, which was equated with the romantic.

The theorists were simply following the practices of English artists, who created the picturesque style between 1750 and 1800 by uniting elements from previously disparate tendencies: the romantic imagery of Salvator Rosa, the rustic scenes of the Northern Baroque, the topographical approach of Canaletto, and the pastoral mode of Claude Lorrain. The resulting eclectic style, epitomized by the landscapes of Philip de Loutherbourg, may be regarded as a prelude to Romanticism proper, which subsumed and altered it into new landscape forms.[8] The picturesque underwent little development after 1800, but its refined formulas continued to be widely practiced in England for another quarter-century in topographical landscapes, especially prints.

The picturesque was imported into the United States by a succession of British immigrant artists: William Winstanley, William Russell Birch, Joshua Shaw, and Guy Wall. It was brought back as well by American artists returning from England, most notably William Trumbull, whose *View of West Mountain near Hartford* (1791, Yale University Art Gallery, New Haven) is among the earliest monuments in native American landscape painting. English prints further helped to transmit the style to this country. It is hardly surprising that the picturesque held such authority. American taste continued to be set largely by English standards long after the Revolution.

During the Federalist period, America preferred to see itself as the embodiment of the pastoral ideal, demonstrating the advance of civilization in peace and prosperity. The picturesque provided a tame vehicle for transcribing genteel views of country estates modeled on English examples. Judged by Gilpin's and Price's standards, the wilderness held little pictorial interest. To Americans, moreover, the environment was something to be controlled, if it could not be conquered outright. The taming of the surrounding wilderness eventually allowed them to see nature as the escape from civilization that had motivated European landscape painters from the beginning. During the early decades of the century men of wealth assembled collections of English and Old Master paintings, including landscapes, which they made increasingly available for viewing in exhibitions and in private.[9] After 1810, the attitude of American artists toward landscape began to change as well. It was stimulated in part by the appearance in 1811 of a new edition of Archibald Alison's *Essay on the Nature and Principles of Taste*, originally published in London in 1790. Stirred by the grandeur of unspoiled nature, the viewer was inspired to sublime emotions that were morally uplifting. Through a chain of associations, this exalted spirituality led in turn to a nearly mystical communion with the deity and the contemplation of His universal order. The descriptions of God's

blessings on America that accompany Joshua Shaw's print series *Picturesque Views of American Scenery* (1820) attest to the influence of Alison's association psychology on American artists.[10]

THE CULT OF NATURE

As in England, the contribution of the poets proved essential to shaping Romantic ideas about landscape. During the first three-quarters of the century, western thought was pervaded by pantheism: the belief that God is present in his work, from the smallest blade of grass to the sweeping movement of the cosmos. This is an old heresy that had been successfully refuted many times by Christian theologians. Typically enough for Romanticism, pantheism was less a coherent doctrine than an emotional attitude.[11] In other words, it was essentially a heightened state of mind affected by poets from Wordsworth on.

The cult of nature virtually amounted to a national religion in the United States during the second and third quarters of the nineteenth century.[12] Based as it was on a loose set of feelings, pantheism cut across doctrinal boundaries. The cult of nature managed a paradoxical coexistence with seemingly incompatible sects in a land where freedom of religion spawned innumerable churches over the slightest theological disagreements. In general, the sharp controversies over Christian dogma that raged throughout the era had little discernible impact on the arts.[13] There were only minor differences in the attitude toward nature between the poets William Cullen Bryant, a Unitarian, and Ralph Waldo Emerson, a Transcendentalist who rejected the Enlightenment rationality of Unitarianism for an ecstatic communion with God through nature.[14] More important than theological considerations was the source they shared in William Wordsworth.

Bryant elevated the wilderness to a symbol of the nation itself.[15] Nature, he tacitly assumed, determined America's character and, with it, its destiny. In the great cycle of history, the United States was seen as the natural successor to the Old World, which was thought to be on the decline. The cult of nature validated the rising civilization of the new country being carved out of the wilderness. This national myth lent a distinctive flavor to American landscape painting before the Centennial because of the strong influence Bryant exercised on the Hudson River painters.[16] By 1825, he was calling on artists to depict the wilderness as the most conspicuous feature of the New World. Landscape painting thus became a vehicle for expressing the myth of America as Nature's Nation, to borrow Perry Miller's felicitous phrase.[17] Since God and His eternal laws could be seen written everywhere in the American landscape, the painter assumed the role of the poet as a teacher of moral truth by revealing the immanently divine in nature.

The Rise of the Hudson River School

The first critical thinking about landscape took place in 1815 in Philadelphia, the leading art center in the United States before 1825.[18] It was there that Thomas Doughty and Thomas Cole, the fathers of the Hudson River school, began their careers. The two artists possessed very different manners and temperaments. Cole, it might be said, was the more sublime painter, Doughty the more picturesque. They nevertheless shared closely related visions of the United States and were equally responsible for turning the picturesque into a distinctly Romantic expression in the mid–1820s. Between them, they determined the course of American landscape painting through midcentury.

Thomas Doughty started painting around 1816.[19] Although he absorbed a variety of influences, his greatest debt remained to the picturesque. Doughty's acknowledged masterpiece, *In Nature's Wonderland* (1855, Detroit Institute of Arts) differs only in its nostalgic reverie from *High Tor, Matlock* (H.G. Balfour, England) painted almost a hundred years earlier by the English artist Alexander Cozens.[20] Doughty, however, has elevated the crag from a merely picturesque feature to a national symbol by treating it as nature's counterpart to the antique ruin in the Claudian *Classical Landscape with Temple* (Pennsylvania Academy of the Fine Arts, Philadelphia), which he had executed a year earlier. The painting embodies William Cullen Bryant's concept, announced in the third of a series of lectures delivered in 1825 at the National Academy of Design, that it is nature rather than the past that provides America with its traditions.

Trained as an engraver, Thomas Cole came with his family from England in 1818, settling briefly in Philadelphia before moving to Steubenville, Ohio, where Cole's father opened a wallhanging business.[21] In Ohio Cole learned the rudiments of painting from the itinerant artist John Stein, who also showed him prints after Salvator Rosa that affected him deeply. Upon returning to Philadelphia in 1823, he saw paintings attributed to Rosa, though they were probably copies.[22] Like Doughty's, his early landscapes were no doubt indebted to the English picturesque as well. Cole's achievement cannot, however, be explained simply in terms of such sources. It was his genius to invent from them the means of expressing visually the elemental power of the country's primitive landscape.

Cole's earliest surviving painting, *Landscape with Figures and a Mill* (Minneapolis Institute of Arts), painted in 1825 before he left Philadelphia, still relies on picturesque formulas. There is an astonishing transformation of style in *Landscape with Dead Trees* (Allen Art Museum, Oberlin College), executed later that year after he followed his family to New York. The evidence indicates that it was the experience gained that summer on a sketching tour up the Hudson River which suddenly transformed him into an artist of greatness.[23] *Landscape with Dead Trees* is one of the landscapes by Cole that were discovered in a shop window by John Trumbull, who immediately recognized their originality and

4

acquired one for himself. He brought them to the attention of Asher B. Durand and William Dunlap, who records that Trumbull declared, "This youth has done what I have all my life attempted in vain."[24] This should not be dismissed simply as the sort of artistic mythmaking familiar since Vasari. Trumbull's enthusiasm contains an implicit acknowledgement that Cole had formulated a specifically native landscape style of the kind he himself had sought earlier and that in the process the young artist had discovered a landscape equivalent to Trumbull's history paintings as an American art form.

Cole proved to be the right man at the right time. His move to New York coincided with the opening of the National Academy of Design, and he was quickly accepted into the leading artistic and intellectual circles there. Because he was so keenly attuned to the morality and nature concepts of the day, he was able to create the artistic counterpart to the literary rhetoric of William Cullen Bryant. Indeed, Cole's success is partly attributable to the fact that, since an early age, he himself had written high-minded poetry regularly, if badly, along the same lines as Bryant's.

Cole and Doughty attracted extraordinary support. The first quarter of the nineteenth century had witnessed the first great amassing of wealth through commerce that was a necessary prelude to a capitalist industrial society – and to patronage. The Hudson River school rode the tidal wave of cultural nationalism fostered by the Jacksonian era. Collectors who had concentrated on buying dubious Old Master paintings now turned to supporting native artists who could articulate their vision of the United States. American Romantic art can be understood in one sense as justifying the economic, political, and social order that emerged under Jacksonian democracy. It is little wonder that artists, patrons, and intellectuals came to share a common point of view for perhaps the only time in our nation's history. What is so striking about American Romantic painters between 1825 and 1875 is that, as a whole, they were remarkably normal men. Never before or since has such a group of establishment types ruled the national art scene. To be sure, they were not without their quirks. Furthermore, there were lively disagreements over particulars between artists and their patrons, from whom they wrested control of the art societies and academies only with the greatest difficulty. Such skirmishes, however, did not prevent collectors from encouraging painters and sculptors in most major cities. The rise of art unions in the 1840s provided a welcome source of income for artists, who often found commissions in short supply. The art unions can be regarded as a unique experiment in cultural democracy by distributing art to the people for the price of a cheap lottery ticket.

CINCINNATI, THE ATHENS OF THE
AMERICAN WEST

An important chapter in the history of cultural democracy was written in Cincinnati, where Worthington Whittredge got his start as an artist. There

were good reasons for this achievement. Established in 1788, only two years after the end of the American Revolution, the Queen City – as Cincinnati liked to call itself – underwent a prodigious growth in size, population, trade, and manufacturing as the result of its favorable location on the Ohio River. Within only two decades it became a bustling city, and by midcentury it supported well over 100,000 residents.[25] The facts, although impressive in themselves, inform us that some of the necessary conditions existed to support the arts, but they do not as such explain the growth of Cincinnati as a leading cultural center.

More important perhaps than sheer growth was the role Cincinnati played in the American imagination. Poised on the brink of the frontier, the Queen City was seen almost from the beginning as a noble experiment that would give rise to a new kind of culture based on popular democracy. The Ohio River was the principal route for not only carrying new settlers and trade goods, but also transmitting the American ethos. Cincinnati acted as the main point for diffusing this outlook throughout the Ohio Valley and beyond to the Midwest as a whole. No tour of the New World was complete without a trip to the new metropolis. What astonished European visitors was that Cincinnati accomplished so much in so little time. Though lacking the established heritage of Boston, the city soon acquired most of the amenities of a civilized society. Cincinnati was very conscious of its cultural leadership and had ambitions of becoming the "Athens of the West." More than a matter of civic vanity, this dream was the direct outgrowth of the American vision and the nation's sense of place in history.

Cincinnati was nevertheless a set of contradictions that meant all things to all people. Frances Trollope's experience must be interpreted in this light.[26] She came impoverished to the New World to make her fortune and ended up in Cincinnati, which she had been told was a flourishing city. In 1828, she built an emporium, called the Bazaar, where she sold European novelties as objets d'art to wealthy rubes. Unfortunately for her, the hicks in Cincinnati were too smart to be taken in by her trinkets, and her "museum," as she sometimes called it, closed after two years. Unable to forgive the city for her failure, she returned to England to write *Domestic Manners of the Americans*, a vitriolic account of the United States based almost entirely on her escapades in Cincinnati. The book created a sensation upon its publication in 1832. With the aid of uproarious lithographs by her companion, the young French artist Auguste Hervieu, she vented her resentment by castigating American gaucherie. Mrs. Trollope found in manners the trappings of the established European order, with its class distinctions. For her, democracy was anathema, although she rarely attacked it directly. The book, although greeted with mirth by the Cincinnatians, served to remind them of their provincialism. Once saddled with this burden, the city had a hard time living down the charge, despite its accomplishments. A curious combination of genuine pride and

inferiority complex continued to mark Cincinnati culture throughout the remainder of the nineteenth century.

Mrs. Trollope arrived in Cincinnati the year the first attempt was made to establish an art academy, which closed in short order. Had she stayed another ten years, she would have witnessed the birth of Cincinnati art, for it took that long to develop the city's institutional, cultural, and spiritual foundations. The fact that the population of Cincinnati was heavily German is significant. In the late-eighteenth and early-nineteenth centuries, museums and academies based on the French example opened in Dresden, Munich, Düsseldorf, and Karlsruhe – all of which became important centers of landscape painting that were to attract Cincinnati artists. The initial effort to establish an academy in Cincinnati was not only as American as apple pie, it was as German as bratwurst. Coming only three years after the National Academy of Design opened in New York, it was a symbol of the city's desire to support the arts. The Cincinnati Academy of Fine Arts finally opened in 1839, after a second failure the year before. In contrast to the National Academy of Design and the Pennsylvania Academy of the Fine Arts, the Cincinnati Academy was not an association of artists.[27] And unlike its French and German counterparts, the Cincinnati Academy lacked training facilities.[28] Most artists therefore remained largely self-taught. Their formal instruction consisted generally of a few lessons from an established professional, who was himself likely to be untutored.[29] Prints, paintings, and an occasional instruction manual imported from England were the chief sources of knowledge for the nation's provincial artists.[30]

The Academy of Fine Arts served to promote the rapid growth of painting in Cincinnati. Enhancing the status of artists by its very existence, it held exhibitions in which painters and sculptors could display and sell their work. The academy's inaugural exhibition catalogue of 1839 listed only nine Cincinnati artists, but two years later the roster had risen to 20. The number of works shown increased commensurately. Local fairs provided additional opportunities for exhibitions, as did the Society for the Preservation of Useful Knowledge and the Ohio Mechanics Institute, which opened in 1837 in Mrs. Trollope's former bazaar. Such exhibitions also allowed Cincinnati artists to view the work of their colleagues from other cities around the Midwest, such as Dayton and Louisville, and sometimes the East Coast as well.

An important role was played in the development of Cincinnati art by the patron Nicholas Longworth. During the 1830s, he supported the Cincinnati sculptors Hiram Powers and Shobal Clevenger.[31] In a lengthy reminiscence about Longworth,[32] Whittredge writes that the collector owned many works, including Benjamin West's *Hamlet and Ophelia* and a painting by the Rembrandt school. At Whittredge's request, Longworth donated $100 for local artists to buy plaster casts to study from. As the circle of collectors gradually widened, artists like the well-known animal painter Henry Beard were at-

tracted to the booming city during the late 1830s and early 1840s. In spite of these promising conditions, most Cincinnati artists toiled in poverty and, with rarely enough commissions and sales to go around, they often moved on after only a few years. Contemporary writers complained that the Queen City did not fully appreciate or support its artists. However, no other city in the Midwest, not even Saint Louis, came close to duplicating Cincinnati's achievement.

During the second quarter of the century, Cincinnati had a thriving cultural life dominated by a community of transplanted New Englanders. They included an active body of Transcendentalists and a rival group of Presbyterians under the leadership of the Reverend Lyman Beecher, president of the Lane Theological Seminary. Although the New Englanders were generally isolated from the rest of Cincinnati society, they helped to make the Queen City a hotbed of social and religious reform. Published there from 1835 through 1841 with only a brief interruption, *The Western Messenger* conveyed the latest ideas from the East to the Midwest. Although it acted as an organ of Transcendentalist thought, *The Western Messenger* was by no means restricted to theology. In addition to publishing the work of local writers, it regularly included discussions of literature. The January 1836 issue featured an essay on the poetry of Wordsworth and Bryant by the Reverend J.H. Perkins. "Correspondence between Man's Moral Nature and the Material Universe," signed C. A. B. and published in the following issue, reflects essentially the same mode of thought found in Bryant, particularly in its apparent debt to the association psychology of Archibald Alison.

THE EARLY CINCINNATI LANDSCAPE SCHOOL

The Cincinnati landscape tradition is among the richest in American nineteenth-century art.[33] It includes some of the leading painters in American art between 1840 and 1900: Worthington Whittredge, William Sonntag, Robert Duncanson, Alexander Wyant, Frank Duveneck, and John Twachtman. It is a remarkable fact that this midwestern city succeeded Philadelphia as the second most important center of landscape painting in America. During the second half of the century, Cincinnati ranked behind only New York, which became the art capital of the United States in 1825. The exact origins of the Cincinnati school are still unclear, however. The early works of its leaders have largely disappeared, and paintings by its lesser members remain all too rare. The documentary evidence is equally fragmentary. With such large gaps in our knowledge, it is possible to provide only a general account of the rise of Cincinnati landscape painting.

The dean of the city's landscape painting was Godfrey Frankenstein, a founder and first president of the Cincinnati Academy. Frankenstein's family had moved from Darmstadt, Germany in 1831.[34] He started out in Cincinnati as a sign painter a year later but soon opened his own studio. His earliest

dated picture, *Mill Creek near Springfield* (1845, Cincinnati Historical Society), shows him to have been a skilled, self-taught painter. In 1849, he moved to Springfield, where he devoted himself for the next decade to painting a famous moving panorama of Niagara Falls. He continued to repeat this subject with little variation for the rest of his career, so that the Cincinnati Art Museum's *American Falls from Goat Island* (1871) shows little stylistic evolution from a canvas of 1848 now in a private collection.

Because their works from the 1830s have disappeared, Frankenstein's impact on Whittredge is impossible to gauge, though it becomes evident later on. Nor is it possible to measure the impact of other landscapists Whittredge might have imitated, whose activity is recorded in Cincinnati exhibition records. Most intriguing of all is Benjamin McConkey, an elusive figure with whom Whittredge formed a close friendship.[35] In 1847, McConkey wrote a letter (Archives of American Art, Washington, D.C.) to Thomas Cole enthusiastically surveying the local landscape school. He reserved the greatest praise for William Sonntag, who was Whittredge's closest rival.[36] Born in 1822 in East Liberty, Pennsylvania, near Pittsburgh, Sonntag came with his family to Cincinnati at the age of seven. His talent manifested itself early, but his father, a wealthy merchant, only reluctantly permitted him to become an artist. Sonntag studied with Godfrey Frankenstein in 1841–2 while supporting himself as a clerk and continuing to live at home. After his father moved to Philadelphia, he did artistic odd jobs over the next several years, painting sets for local theaters and panoramas for the Western Museum in Cincinnati.[37] Like Whittredge, Sonntag began his career as a landscapist in earnest only in 1845, when he first began exhibiting regularly at shows around town.

Sonntag adopted Cole's manner in his first known work, *Catskill Landscape* (private collection), which bears the date 1846 on the front and the inscription New York October 1847 on the back. The canvas documents Sonntag's first trip east, undertaken, it is tempting to believe, at McConkey's suggestion to meet Cole. *Catskill Landscape* is patterned in a general way after Cole's paintings like *Tornado* (1833, Corcoran Gallery of Art, Washington, D.C.). It has a bold composition and attempt at bravura, revealing a dramatic temperament but an undisciplined approach. The painting is probably misnamed. It most likely shows the region of Hawk's Nest, one of Sonntag's favorite sketching sites. He camped there for up to three months at a time and is known to have painted entire canvases outdoors.[38] *Mountain View* (fig. 8), which shares the epic spirit of Cole's *Schroon Mountain* (Cleveland Museum of Art), may be such a work, for it has the rapid freedom of a painting from nature. If so, the artist must have worked quickly to finish such a large picture on the spot.

Sonntag began to attract considerable attention. In 1847, the art unions started carrying his work regularly. Around that time he executed a series of four canvases titled The Progress of Civilization, suggested to the artist by the Reverend E. L. Magoon and presumably inspired by Cole's series *The Course of Empire* (1833–6, New York Historical Society), which had been dis-

seminated in prints. Sonntag had already done a large work depicting Long-
fellow's "Evangeline" and a painting based on Shelley's "Alastor." In 1850,
he painted a huge panorama of Milton's *Paradise Lost* for P. T. Barnum, which
was shown around the country to great acclaim. With his scenographic back-
ground, Sonntag was ideally suited to painting large allegorical scenes, which
he continued to execute into the early 1850s.

Sonntag was widely regarded as the best artist in Cincinnati by writers of
the period. In 1853, he went to Europe for further study, mainly in Florence,
which he was to visit often. Upon his return a year later, Sonntag enjoyed
almost immediate success in New York, and his trips to Cincinnati became
increasingly rare. He seemed poised on the brink of greatness and his style
was set – perhaps too set, for he never fulfilled his promise. Already in 1854,
Robert Duncanson, who accompanied Sonntag and his wife to Europe, com-
plained that Sonntag was painting the same pictures as three years earlier.[39]
Although Sonntag's style underwent some changes in New York, Duncanson's
criticism proved all too prophetic. After Sonntag's death in 1900, J. W. Pat-
tison condemned his work on the grounds that "he painted the same motif
so many times that the subject matter became reduced to a mere convention-
alism" and that "he wrote down a few hundred trees on a mountain faster
than a typewriter can spell words."[40]

Duncanson himself is important as one of America's first black artists of
stature.[41] Born in New York in 1821 of a Scottish father and Negro mother,
he moved to Cincinnati during the early 1840s after spending much of his
youth in Canada. He began exhibiting landscapes and portraits in 1842 and
later turned his hand to still lifes as well. After 1845, he was also active
periodically in Detroit, where he met with considerable success.

Duncanson's earliest-known works are the famous decorations done in
1848–50 for the entrance to the Nicholas Longworth house, now the Taft
Museum. Although the precise sources remain to be discovered, the Rococo
decorative borders and broadly colored forms leave little doubt that, rather
than being simply Ohio Valley scenes, they must be adaptations from the kind
of wood block wallpaper produced in France and England from the late
eighteenth century on and then in this country. Duncanson used a different
source for *View of Cincinnati from Covington* (c. 1851, Cincinnati Art Museum).
During the early 1850s, he was a partner in a Cincinnati daguerreotype studio
and was associated with another black daguerreotypist, J. P. Ball, who com-
missioned finished paintings from photographs. The same view of Cincinnati
is shown in an engraving reproduced in the June 1848 issue of *Graham's
Magazine* from a daguerreotype that Duncanson must also have used.[42] At
the same time, the handling of forms and treatment of light show a debt to
Whittredge (see page 27).

Duncanson defined his mature vision in *Blue Hole, Flood Waters, Little Miami
River* (1851, Cincinnati Art Museum), which is one of the masterpieces of
Cincinnati landscape painting. It is painted in a Colean style derived from

William Sonntag, marking the beginning of the association between the two artists that culminated in their tour of Europe. The trip had very different consequences for each painter. Whereas Sonntag settled in New York, Duncanson returned to Cincinnati and developed into a much more imaginative landscapist. After 1862, he spent much of his time in Europe and Canada to escape the effects of the Civil War and Reconstruction. The artist also continued to work in Detroit, where he died in 1872 after suffering from mental illness.

This survey, though brief, should help to correct a common misconception. Because its best landscapists left Cincinnati to attain success elsewhere, it is easy to conclude that the city was too provincial to have the resources necessary for sustaining a major school. However, that judgment fails to explain why such a supposedly inhospitable artistic environment fostered so many significant painters in the first place. Scholars with an East Coast bias have sometimes been tempted to cast the Midwest as a villain in the artist's struggle to achieve success. It is a convenient fiction which forgets that not every important artist has needed to live in a leading center under the protection of a great patron to launch his career. Seen in its proper perspective, the Cincinnati accomplishment was truly remarkable.

2

Whittredge in Cincinnati

APPRENTICESHIP AND EARLY CAREER

OUR ARTIST WAS BORN Thomas Worthington Whitridge on May 22, 1820 on the marginal grazing farm near Springfield, Ohio, where his family had settled five years earlier. He adopted the name Worthington Whittredge by which he is customarily known only in 1860, after returning from his European sojourn. From a genealogy published in 1894 by his relative George Worthington of Cleveland, we know a good deal about the family's lineage.[1] His parents were Joseph Whitridge, a sea captain from Rochestor, Massachusetts, whose family settled in Ipswich in 1635[2], and Olive Worthington, a descendent of Nicholas Worthington who came to New England in 1649, probably from Lancashire, England.[3] Both brought with them children from their previous marriages which, as often happened, had ended in the deaths of their spouses. The merger resulted instantly in a large family. His offspring were Mary, Abigail, and Joseph, whereas she had two daughters, Mary and Olive. They produced three sons: William, who was born in 1815 and died at the age of ten; Thomas, who died in 1842 at the age of twenty-nine; and our artist who was given the same first name but later dropped it in favor of his middle name.

Whittredge was "a born trapper" who acquired an early love of nature that never left him.[4] Like most rural youths of the period, he had little formal education and was denied the opportunity by his father to attend high school in Springfield: "Two or three 'quarters' as they were called, is all the time I ever had to learn anything more than I was taught at home."[5] As the youngest son, Whittredge was expected to remain on the farm and care for his elderly parents. Tales of New England, however, instilled in him a restless desire to escape the confines of the farm.[6] When "an unmarried brother" (undoubtedly Thomas) returned home, he "seized the opportunity to announce I was going away."[7]

Whittredge left at the age of seventeen, full of "youth's vague and usual longing ... to see something of the world."[8] He also had "a longing, I know not from where it sprang, to be an artist."[9] He may have seen the painter's

12

life as his passport to travel and adventure. Nothing we know of his childhood suggests he would otherwise have chosen this profession. His family lacked artistic background.[10] Indeed, "the very word 'artist' was anathema" to his father.[11] "My ardent love of nature which dominated my whole being from my earliest recollections is the only thing I can look to as finally leading me to the study of art. I look in vain for anything I ever did when I was a child which showed in the slightest that I had any talent for drawing or coloring or possessed any of those qualities so necessary to make a painter."[12] Despite his early love of nature, he seems to have had no innate urge to take up pencil or brush. He relates that his drawings were primitive compared to those by a much more talented schoolmate.[13]

It is likely that Whittredge's desire to become an artist was fired by his brother-in-law, Almon Baldwin. A native of Connecticut, Baldwin married Whittredge's sister Abigail in 1827 in Clark County. Two years later they moved to Cincinnati, where he became an artistic jack-of-all-trades.[14] He began as a house and sign painter but by 1838 had turned to portrait and landscape painting as well. He also became an etcher and later served as curator of the Cincinnati Art-Union.[15]

Whittredge went to Cincinnati in 1837 and apprenticed himself to Baldwin. His autobiography includes a rare description, related with considerable gusto, of the process by which many a frontier Raphael rose from the ranks of the artisans to become a professional artist:

> Now since I had promised my father that I should learn a trade I thought that nothing could be more suitable than for me to learn the painting trade. Of course there is a gulf of many thousand miles between a housepainter and a painter of pictures, but somehow the gulf did not seem so wide to me at that time. I was told that I must begin at the bottom and I did.[16]

The narrative continues with an amusing account of how he literally worked his way up, beginning with the baseboards of a new house. The work did not suit him, and he soon became homesick:

> But there was the sign painting still to learn; this, I thought, might be a more congenial occupation. It was. After I had obtained a minimal proficiency in forming letters I was put on a ladder 30 feet high to paint "Porkhouse" on the side of a wall. This employment was soon dropped; I was getting to be an artist. I had painted a boot and shoe sign and had received great applause for my work.[17]

The autobiography provides no information about Whittredge's subsequent training, local contacts, or early influences. The silence must be considered

deliberate, as he continually asserts his independence from other artists throughout the manuscript.

It is not known how long Whittredge's apprenticeship with Baldwin lasted. The Cincinnati city directory listed Whittredge for the first time in 1838 as a portrait painter, but he may have remained under his brother-in-law's general care until 1841, when he turned twenty-one years old. Whittredge soon took up landscapes, because "my love of outdoor life and the impressions of nature I had received in my boyhood were too strong to keep me shut up indoors all my days."[18] He began exhibiting them in 1839, when three untitled landscapes were for sale at the first exhibition held by the Cincinnati Academy of Fine Arts. A year later he was listed in the city directory as a "landscape painter, corner of Court and Main Streets," but during the election campaign was occupied chiefly with painting Tyler's image on every available surface.[19] In 1841, Whittredge sent seven landscapes to the Cincinnati Academy's second exhibition. Two of the paintings were owned by O. Hollowell, the proprietor of the studio building in which Whittredge and several Cincinnati painters maintained their quarters. The remaining canvases were in the possession of Baldwin, who was a tenant at the same address. If, as seems likely, Whittredge's apprenticeship was over by this time, then Baldwin either continued to act as his agent, or they entered into a loose partnership to share their resources. Other artists seem to have made such arrangements in Cincinnati during the 1840s when they lacked enough work to support themselves. The landscape painter William Sonntag, for example, shared a studio and collaborated with the portraitist George White, who added the figures to his pictures.[20]

The Academy's transcripts for 1841 record Whittredge's seven pictures as copies. It is apparent that Whittredge can have learned no more than the barest rudiments of his craft from Baldwin. The rest he had to pick up through trial-and-error experimentation and imitation of other artists. *The Shantee* was done from an engraving, the kind of source often used by fledgling provincial artists. That Whittredge turned to prints is hardly surprising in light of Baldwin's activity as an etcher. In fact, Baldwin himself seems to have relied on them in his own work: The earliest of the rare paintings known to be by Baldwin's hand (184[?], John Martin, Cincinnati), is a fantasy landscape that was probably derived from an English print, though the houses match local ones in description.[21]

Like other Cincinnati artists, Whittredge showed his work in every available forum. He exhibited "at agricultural shows, charity fairs and the like, as best I could, until I obtained a little local reputation."[22] In 1842, he sent a half-dozen landscapes to an exhibition sponsored by the Society for the Preservation of Useful Knowledge. This time, only two of the paintings were listed as copies: *The Conflagration* and *Inundation*. That the other four were apparently original subjects indicates a growing mastery of and commitment to landscape. He also exhibited at least one group portrait and no doubt continued to depend on portrait commissions for his livelihood.

In the summer of 1842, Whittredge set himself up in an abortive partnership in a daguerreotype studio in Indianapolis. This venture must have been very brief, as no record of it remains. In January of 1843, he advertised himself instead as a portrait painter in a local newspaper. What appears to be his only documented commission has turned up in an Indiana private collection (fig. 1) An account in the *Indiana Daily State Sentinel* on December 31, 1842, of a visit to Whittredge's studio mentions an unfinished painting of General Tilghman Howard that "promises to be excellent."[23] The Indiana portrait, inscribed with the general's name on the back, accords in appearance

FIGURE 1. Attributed to Worthington Whittredge. *General Tilghman Howard,* c. 1842–3, oil on canvas, 27¼ × 22⅛, F. G. Summit, Bloomington, Ind.

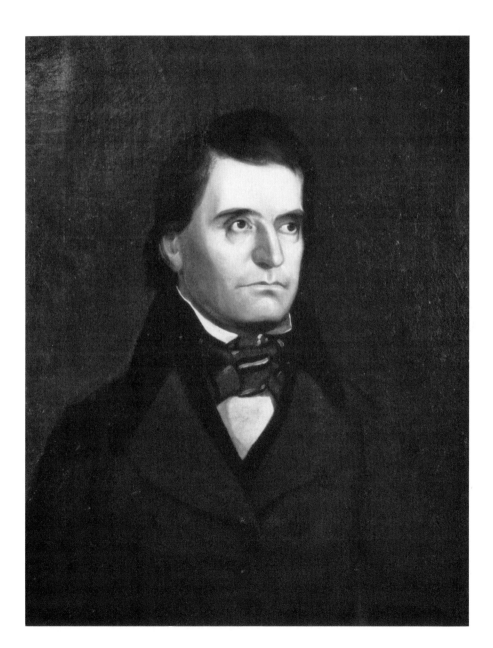

with a man of his age at the time. It is a fine example of Ohio Valley portraiture, which has a distinctive regional flavor; though unsigned, there is no reason to doubt that it is by Whittredge, as the style is certainly not that of Jacob Cox, the only other Indianapolis artist, who spent that winter in Cincinnati.

Things went so badly for Whittredge that he had to be rescued from destitution and illness by the Reverend Henry Ward Beecher, with whom he lived "just for one year." The autobiography provides an enlightening account of how *Uncle Tom's Cabin* began as a round-robin story in letters between members of the family. He added, "All the art of this wonderful story, however, is Mrs. Stowe's. No other member of the family could have written it."[24] Whittredge painted portraits of the entire family except for Edward, who was away at boarding school, but none have turned up.[25]

The artist later wrote, "I had known old Dr. Lyman Beecher of Cincinnati all my life, and all his family, and his son Henry Ward came to Indianapolis when I was there and began his preaching, and soon converted everybody in the town, myself among the number."[26] Of his conversion to Congregationalism by Beecher, the autobiography adds: "I have ever since been a believer in the doctrines of the presbyterian faith. His church however then as later was not strictly presbyterian."[27] It is fair to say that Beecher did not exercise any direct influence on the specific content or form of Whittredge's landscapes. There are very few references to nature in Beecher's writings before he left Indianapolis to become pastor of Plymouth Church in Brooklyn in 1847, and these hardly differ in outlook from William Cullen Bryant's. Only after visiting the galleries in Europe did Beecher come to appreciate landscape as a means of conveying religious sentiment and in the 1870s became an enthusiastic supporter of George Inness's spiritualist paintings.

After leaving Indianapolis, Whittredge returned home to finish recuperating from his illness. While there he painted a portrait of his father that removed any objections to the painting trade. Upon his recovery he went back to Cincinnati, where he painted *Happy as a King* (fig. 2). Inscribed Cincinnati 1843, it is his earliest signed work. The picture is not listed in the exhibition records for that year, probably because it was bought by Charles G. Swain of Dayton, or perhaps he simply returned too late to have it included in any shows. The picture is typical of American genre paintings from the 1840s and 1850s showing children at play, such as William Sidney Mount's *The Novice* (1847, Suffolk Museum and Carriage House, Stony Brook, New York). This theme originated in eighteenth-century England, where it was developed further by Victorian painters. It became especially popular in the United States as a metaphor of the young and vigorous nation, and Whittredge has given it a characteristically rambunctious expression. The style, however, is curiously old-fashioned. It is reminiscent of Alvan Fisher's genre scenes from the second decade of the century. This is the first sign of an influence

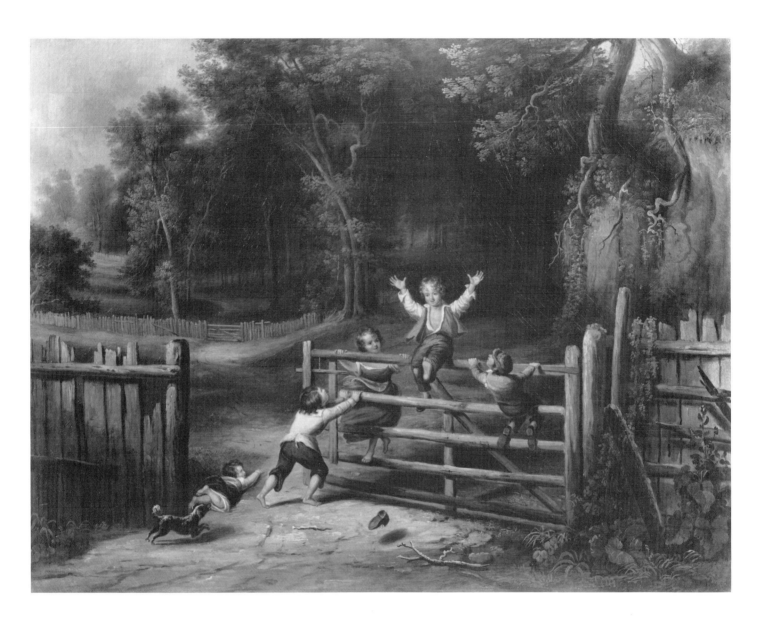

FIGURE 2. Worthington Whittredge. *Happy as a King*, 1843, oil on canvas, 36 × 48, Hirschl and Adler Galleries, New York.

from the Philadelphia school that was to continue in Whittredge's work through the mid–1840s.

In 1844, Whittredge joined forces with B. W. Jenks, an itinerant portrait painter from Kentucky who was active in Cincinnati at the time.[28] Their partnership was patterned along the lines of the successful Waldo and Jewett firm in New York.[29] Whittredge and Jenks left Cincinnati in early summer for Charleston, in what is now West Virginia, where they hoped to obtain commissions for portraits at lucrative prices. Armed with letters of introduction from Cincinnati patrons, they soon found work. The partnership, however, literally dissolved in Jenks's alcoholism. He eventually agreed to quit the

studio and left the city. Whittredge remained in Charleston to complete his orders but fled when he became enamored of a married woman whose portrait he was painting.[30]

The vicissitudes of Whittredge's early career are a sign of Cincinnati's fledgling status as an art center in the early 1840s. However, the general situation improved rapidly by the middle of the decade and with it his fortunes. It is certainly no coincidence that in 1845 he began to emerge as an identifiable artist whose development can be traced in detail through a succession of paintings. Beginning that year, moreover, his activity is documented by an extensive exhibition record. Whittredge now devoted himself entirely to landscapes and started to make a name for himself. In 1846, his *View on the Kanawha, Morning* (now lost) was exhibited at the National Academy of Design in New York, the country's premier art institution, and earned a complimentary letter from its president, Asher B. Durand.[31] At the same time, Whittredge began to acquire a circle of patrons who supported and collected his paintings. The Western Art-Union, which opened in 1847, provided a new outlet for his work. Like the American Art-Union in New York, it distributed works of art by lottery to its subscribers, who paid only a few dollars for their membership. By offering the chance to own a painting at little cost, the art unions tapped the nation's hunger for images of all kinds.[32]

FIRST LANDSCAPES

Scene near Hawk's Nest (fig. 3) is probably identical to number eighteen in the Cincinnati Firemen's Fair exhibition held in June 1845. Signed and dated May of that year, it is, with *View in West Virginia* (fig. 4), Whittredge's first surviving landscape. He had been a practicing artist for seven years, and its poor condition notwithstanding, the painting reveals the competent craftsmanship of an experienced professional. The only weakness lies in the flat modeling of the ledge to the right of the path, which reads mainly as a surface effect. *Scene near Hawk's Nest* captures the rugged terrain and somber atmosphere that characterizes the region around Gauley Bridge, West Virginia. The monumental composition and expressive color convey a strong feeling for the picturesque aspects of the American wilderness.

Like most provincial American landscapists, Whittredge imitated the Hudson River school. Literally thousands of paintings in the manner of Cole and Doughty, ranging from crude pastiches to charmingly eclectic originals, survive by minor masters doomed to eternal anonymity. Although Cincinnati would soon develop a true regional style, in 1845 it was still dependent on the East Coast for its artistic models. The somber color and forbidding atmosphere in *Scene near West Virginia* betrays the influence of Thomas Doughty. There is not a single botanical form or geological feature that cannot be found in his landscapes. In fact, the quotations seem so direct that one suspects Whittredge virtually copied a lost painting by the Hudson River artist.[33]

View in West Virginia (fig. 4) was also completed in May 1845. A dark, silvery light establishes an elegaic mood in the broad, serene landscape. The small figures contemplate the idyll with hushed reverence for the vastness and benevolence of nature. The view suggests another setting near Hawk's Nest, but the scenery has been manipulated beyond recognition to fit established prototypes. Although it is different in expression from *Scene near Hawk's Nest*, the painting adheres so closely to Doughty's landscapes from the late 1820s that Whittredge may well have been imitating another picture by him.[34]

View in West Virginia shows the hand of an artist who is as yet incapable

FIGURE 3. Worthington Whittredge. *Scene near Hawk's Nest*, 1845, oil on canvas, 22 × 17¼, Cincinnati Art Museum. Appropriation.

of transcribing nature. At this stage of his career, Whittredge's artistic vision was restricted to a formulaic approach, and he was unable to depict many of the scenes he observed or express the feelings they inspired in him. The artist faced a handicap common among provincial landscape painters. His initial development was limited by his exposure to at best a handful of works by the Hudson River school, which were collected and exhibited in Cincinnati only on a small scale into the mid–1840s. The Philadelphians Doughty and Fisher were represented in the collections of Reuben R. Springer and Charles Stetson. As of 1845, Whittredge evidently had seen none of Thomas Cole's work. Just how he came to know it remains uncertain. There is no documentary

FIGURE 4. Worthington Whittredge. *View in West Virginia*, 1845, oil on canvas, 17½ × 22½, formerly Dr. W. P. Barnes, Cincinnati.

20

evidence that Cole's paintings made their way to Cincinnati before 1847, when four of them were distributed by the Western Art-Union lottery. Also in that year, the duplicate set of *The Voyage of Life* (National Gallery of Art, Washington, D.C.) entered the Cincinnati collection of George Schoenberger. The fact is, however, that both Whittredge and William Sonntag had already undergone virtually simultaneous conversions to Cole's idiom in 1846. This suggests that the intermediary may have been Benjamin McConkey. A native of Maryland, he moved to Cincinnati as a young man in the early 1840s. Whittredge states that McConkey was "my pupil until he went to study with Thomas Cole at Catskill with whom Frederic E. Church was then studying" around 1845.[35] According to Groce and Wallace, he "began sending pictures east for exhibition in 1846, many of them views in New Hampshire and New York."[36] His work is virtually unknown so that it is impossible to assess his role in Cincinnati art.

Cole's landscape style came as a revelation to Whittredge. With its powerful conception and assured technique, *View from Hawk's Nest* (fig. 5), dated 1846, reveals an astonishing transformation in style under Cole's liberating influence. From paintings like Cole's study for *Catskill Mountain House* (1844, Hirschl and Adler Galleries, New York; the finished picture is in the Brooklyn Museum), Whittredge acquired a new understanding of how to compose mountains in simple masses and how to transcribe the changing skies overhead. The rich palette and painterly brushwork establish an ominous mood that contrasts sharply with the muted expression in *View in West Virginia*. *View from Hawk's Nest* is based on a study (fig. 6), which it follows closely in every respect. The finished picture retains the vigorous execution adopted from Cole, lending it an immediacy entirely new to Whittredge's work. The principal departure from the sketch lies in the addition of the hunter and his dog, who play an active role in establishing the viewer's visual and emotional relationship to the landscape.

ARTISTIC MATURITY

Whittredge had now worked in the styles of America's two leading landscape painters. The artist understood instinctively that Cole and Doughty were not so dissimilar as they first appeared, and he sought to discover the common ground between them. In *View of Hawk's Nest* (fig. 7), dated 1847, he incorporated the lessons of his exemplars by combining the best features of his previous work. The result was a masterpiece. Whittredge synthesized the composition from *View from Hawk's Nest* and *View in West Virginia*. The color and mood were likewise adapted from those earlier pictures. Perhaps the most compelling feature is the superbly observed sky, which fully conveys the turbulent atmosphere around Hawk's Nest. The painting achieves a nearly perfect wedding of the sublime statements of Cole and the picturesque scenes of Doughty by integrating a wealth of carefully observed details within the

monumental composition. The landscape captures a sense of endless space while remaining supremely poetic in its response to nature.

This expressive harmony embodies the Transcendentalist unity of the finite and the infinite to convey a cosmic vision. The painting is suffused with a grandiloquence that adheres closely to the sublime imagery in "The Kanawha." Written at Hawk's Nest by one "L.R.," this poem in doggerel verse, excerpted below, appeared in *The Western Messenger* in October 1835:

> Nature in her wildest mood,
> 'Mid her grandest solitude:
> Here the earth-cloud lowly creeping
> There along the summit sleeping:
> All is fresh, sublime, and wild,
> As when first by nature piled,

FIGURE 5. Worthington Whittredge. *View from Hawk's Nest*, 1846, oil on canvas, 17 × 24, formerly Bernard Danenberg Gallery, New York.

FIGURE 6. Worthington Whittredge. *Study for View from Hawk's Nest*, 1846, oil on cardboard, 9½ × 11¾, present whereabouts unknown.

'Ere the white-man wandered here,
Or the red-man chased the deer –
Roaming amid scenes like these,
Not the eye alone rejoices,
E'en the stilly hour of even
Seems all eloquent with soul,
Earth communing full with heaven,
Blending in one glorious whole;
Darkly all of earth concealing,
Brightly all of Heaven revealing.[37]

Although light acts as a means of religious revelation to the viewer, man has no place in the brooding landscape. Instead, Whittredge has included the two deer as symbols of primal life and of the emotion he discovered in nature.

View of Hawk's Nest is one of the great American landscapes of the mid-century. The size and quality attest to Whittredge's intention of painting a major work. The artist may well have been spurred to create a large display piece by the emergence of William Sonntag as an important landcape painter. Sonntag's *Mountain View* (fig. 8), datable to the later 1840s, is roughly contemporary with Whittredge's *View of Hawk's Nest*.[38] The paintings have much in common, suggesting that the two artists looked closely at each other's work.

23

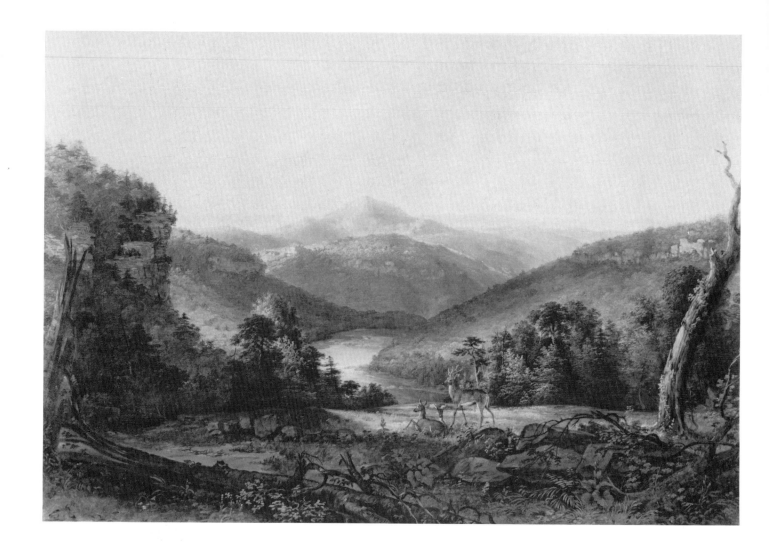

View of Hawk's Nest may be the better picture, but Sonntag clearly provided Whittredge with stiff competition.

The artist repeated the deer in *View of Cincinnati* (fig. 9). The painting must therefore date from 1847, not 1845, as is sometimes thought, which is implausible on stylistic grounds alone.[39] This delightful scene, unique in American art, shows a deer preserve owned by George Schoenberger that is known today as Belleview Park. It may well have been inspired by a print or painting from England, where deer parks were common. The picture shares the subject and sun-filled ambience of *View of Dalkeith Park* (Duke of Buccleuch and Queensbury, Bowhill) by George Barret, for example. *View of Cincinnati* is based on an oil sketch (fig. 10) from nature (Shelburne Museum, Vermont), which the artist did little more than enlarge. The small canvas is inscribed, The City of Cincinnati from Mr. George Schoenbinger's [sic] Deer/park painted on the ground in 1840 [sic]/by W. Whittredge N.A./(July 24, 1905).

FIGURE 7. Worthington Whittredge. *View of Hawk's Nest*, 1847, on canvas, 26 × 38¼, present whereabouts unknown.

24

George Schoenberger was the collector who acquired the second set of Cole's *Course of Empire* in 1847, the year *View of Cincinnati* was probably executed. The sketch, then, documents the kinds of contacts that existed between Cincinnati artists and patrons. Whittredge certainly knew Schoenberger, and it is tempting to conjecture that the painting might even have been done for him.

View of Cincinnati is not the first cityscape by Whittredge. It was preceded by *View from Dayton Cemetery* (fig. 11), which can be dated a year or so earlier on the basis of the style and the handwriting on the back.[40] It was probably done around the same time as another view of the city (Dayton Public Library) by Almon Baldwin, though they are very different from each other. The two canvases seem to have been occasioned by visits to relatives in Dayton, where the name Baldwin is recorded on tombstones as early as 1836.[41] They are so accurate that various features can still be identified. This kind of panoramic view descends from the English topographical tradition. Indeed, an etching that was perhaps done slightly later by Baldwin suggests that imported prints served as the models for both artists. The foreground of *View from Dayton Cemetery* forces nature to conform to the timeworn pictorial conventions found in English landscapes. Otherwise, the scene must derive from a detailed sketch.

FIGURE 8. William Sonntag, *Mountain View*, c. 1845–8, oil on canvas, 38¾ × 46, present whereabouts unknown. Photo courtesy of Hirschl and Adler Galleries, New York.

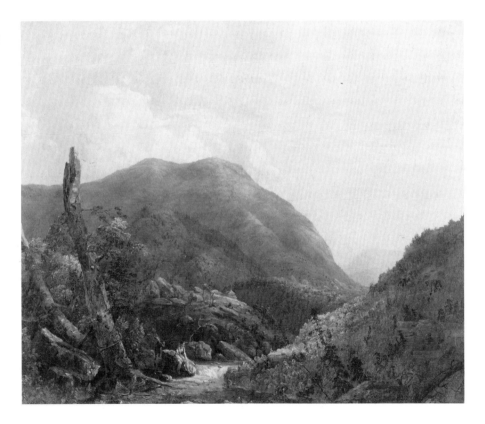

FIGURE 9. Worthington
Whittredge. *View of
Cincinnati*, c. 1847, oil on
canvas, 28⅛ × 40¼,
Worcester Art Museum,
Worcester, Mass.

FIGURE 10. Worthington
Whittredge. *Sketch for View of
Cincinnati*, c. 1847, oil on
canvas, 10½ × 14,
Shelburne Museum,
Shelburne, Vt.

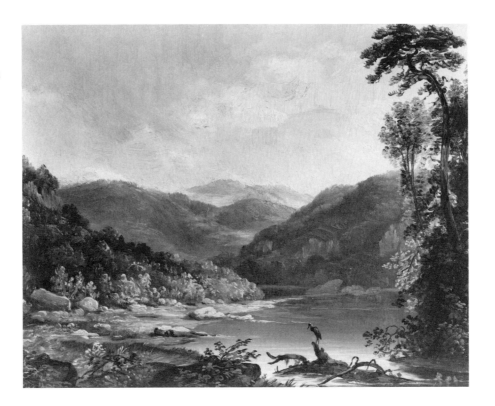

FIGURE 13. Worthington Whittredge. *Kentucky River near Dick River*, c. 1847, oil on board, 8⅝ × 11, present whereabouts unknown. Photo courtesy of Frank S. Schwarz and Son, Philadelphia.

paintings were exhibited or collected in Cincinnati. It is entirely possible that the two artists met during a sketching trip along the Kanawha River.

Whittredge's autobiography provides an account of painting from nature. He writes that he packed a knapsack with his "sketch box, a block of small canvases, a dozen bladders of colors [and] a folding campstool" for an excursion to Hanley's Landing, Kentucky,[43] which was undertaken in 1847, the year he exhibited a Kentucky landscape at the Western Art-Union.[44] A small study of *Kentucky River near Dick River*[45] (fig. 13, Frank S. Schwarz, and son, Philadelphia) is probably a product of that trip. The rapid execution and fluid paint make it likely that this small panel is a sketch from nature. Here the brushwork is close to Godfrey Frankenstein's of the later 1840s, though the painting otherwise differs but little in style from *Study for View from Hawk's Nest*. A related panel, *View of a River* (fig. 14), dated 1847, may well show another view in Kentucky rather than the Ohio River, contrary to its present title. In this case, there can be little question that it was done from nature. The fact that the painting is dark in coloration does not argue against this virtual certainty, as it is a feature shared by *Study for View from Hawk's Nest* and *Kentucky River near Dick River*. The sketch is of great importance for directly anticipating the essential features of *The Crow's Nest* (fig. 15), painted in 1848.

It is unclear whether *The Crow's Nest* shows a view on the Kanawha near

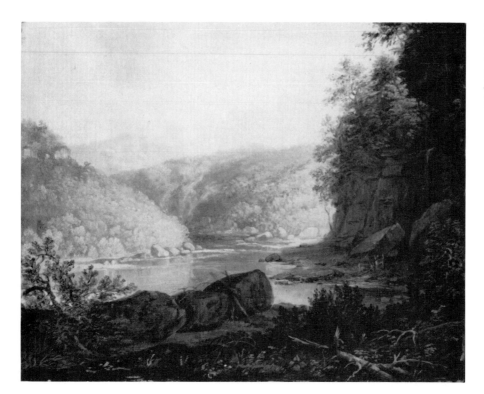

FIGURE 14. Worthington Whittredge. *View of a River*, 1847, oil on board, 10 × 12, private collection. Photo courtesy of Christie's, New York.

the Hawk's Nest or one in Kentucky. The site has thus far eluded identification. There is no place in the Ohio Valley by that name, nor is one listed in any of the geographical surveys of the period. The painting may have received its title in modern times from a popular spot in the Catskills.

The Crow's Nest represents the culmination of Whittredge's development in Cincinnati. The painting combines the expansiveness of *View of Hawk's Nest* with the naturalism of *View of Cincinnati*. The monumental composition suggests the influence of Cole's White Mountain scenes like *Crawford's Notch* (1839, National Gallery of Art, Washington, D.C.), but despite the fact that the scene has been manipulated for artistic effect, especially in the foreground, the apprehension of light creates the impression that the picture is an accurate transcription of nature. Through subtle variations in color and texture along the distant hills, the painting achieves a plein air realism that becomes the cornerstone of Whittredge's work throughout most of his career. At the same time, the response to light achieves a new lyricism. The landscape conveys a poetic sentiment that is now an end in itself, without reference to the Transcendentalist idea that had motivated *View of Hawk's Nest*.

Although he was still moved by the sublime, the artist's more intimate relationship with nature signifies a major change in his attitude toward the American ethos as well. The unusually active figures in *The Crow's Nest* reflect

the contemporary genre paintings by Charles Deas and William Ranney of frontiersmen in true landscapes. The assertion of man's presence in the hospitable setting portrays the United States as a benevolent Eden in which settlers assume their rightful place. Rather than being dwarfed by a vast and often hostile continent, these hardy pioneers live in an ideal state of harmony with nature, symbolized by the clear daylight.

DEPARTURE

With a growing regional and national reputation, the artist could look forward to a promising career. Yet in 1849, he suddenly decided to go to Europe and

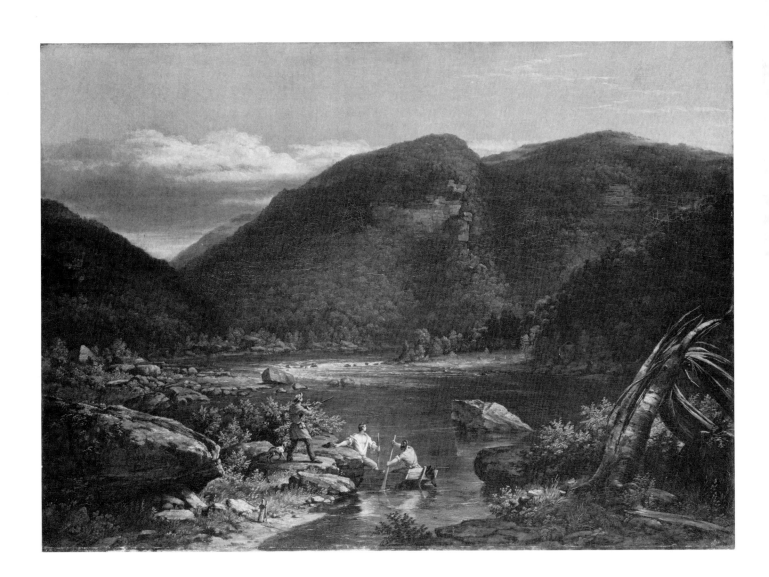

FIGURE 15. Worthington Whittredge. *The Crow's Nest*, 1848, oil on canvas, 39¾ × 56, Detroit Institute of Arts.

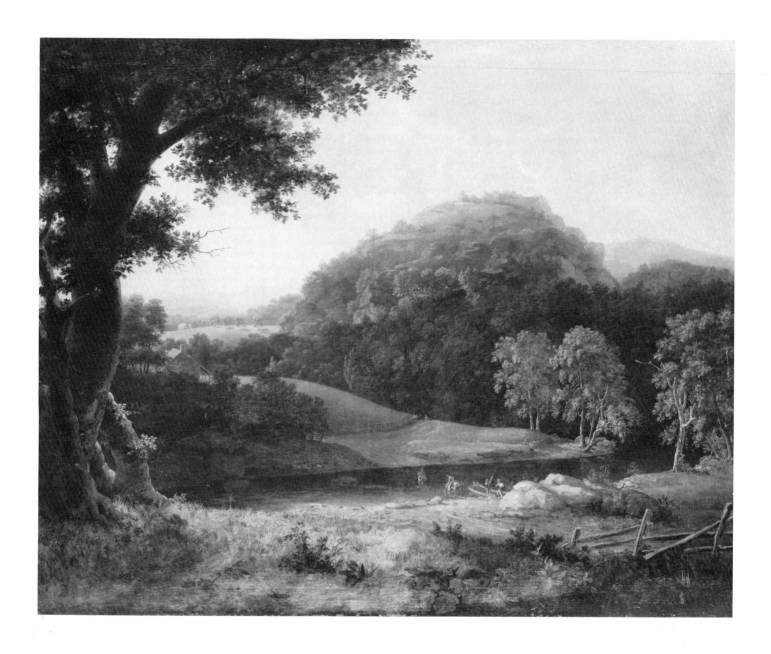

improve his training. Whittredge was one of the few established American painters of his time to go abroad with the avowed purpose of studying under another artist. There is some evidence that the decision came in response to a fallow period he underwent around this time. *View on the Juniata* (fig. 16), which is a smaller version of a picture distributed that year by the American Art-Union,[46] shows a slackening of inspiration. Perhaps he felt he was losing ground to William Sonntag. More likely, however, Whittredge realized that Cincinnati afforded him only limited possibilities for further development. He was faced with the choice of remaining there and stagnating or striking

FIGURE 16. Worthington Whittredge. *View on the Juniata*, c. 1849, oil on canvas, 40 × 52, private collection.

32

out boldly in a new direction. Having had little chance to pursue his education as a boy, he could not easily resist the urge to advance his skills. Nor had his youthful wanderlust left him. Like many other Americans of the time, he was subject to fits of restlessness. This impetuous desire for adventure had motivated his escape from the confinement of the family farm for the artist's life in Cincinnati, and the prospect of travel no doubt heightened the attraction of Europe.[47]

It mattered little that he was already a mature painter. The lack of instructional facilities in the United States before 1865 forced even experienced artists to visit Europe, if only to put a finishing touch to their work. History painters from Benjamin West onward felt the need for further education most acutely, since their formal training was generally limited to drawing from casts after antique statues, whereas life classes were unavailable. Landscape painters began to travel to Europe soon after the rise of the Hudson River school. The first to go was Thomas Cole, whose trip in 1829 gave rise to Bryant's famous admonition "To Cole, the Painter, Departing for Europe" to "keep that earlier, wilder image bright." Cole faced Europe with trepidation but was profoundly affected by the experience. His example opened a veritable flood gate. Thomas Doughty went to London in 1837.[48] Three years later Asher B. Durand departed for England and the Continent in the company of his fellow engravers John Kensett, John Casilear, and Thomas Rossiter, all of whom became important landscape painters.[49] Most of their contemporaries among the Hudson River school managed to spend at least a few months, sometimes even years, across the Atlantic.

Like Durand and most other American artists going abroad, Whittredge financed his travels through commissions, as patrons rarely gave outright grants:

> Mr. Longworth never gave me any money to go abroad. I never asked him for any. Mr. Longworth's son, Mr. Joseph Longworth, gave me several orders for pictures when I decided to go to Europe, which together with many others from friends secured work for me all the time I expected to be away. But perhaps the most signal instance of confidence came from Mr. W. W. Scarborough, whom I scarcely knew at the time. He called one morning and said he had heard that I was going abroad, and asked me if a letter of credit for $1,000 would be of service to me. I might get sick or otherwise disabled, and he would give me such a letter that I might use or not, as occasion required. Of course I accepted his kind offer and for ten years I sent him all my pictures to distribute to my patrons or sell to others, and we kept an open account.[50]

His survival assured by an adequate supply of orders, Whittredge left Cincinnati for New York on May 11, 1849. There he boarded a ship for London on May 24, 1849.[51]

3

European Sojourn

BRUSSELS AND PARIS

IN HIS ORIGINAL MANUSCRIPT, Whittredge states, "I went to Europe with a friend, a young man of fortune, who had been my pupil until he went to study with Thomas Cole at Catskill." He can be identified securely as Benjamin McConkey, who is known to have been in Düsseldorf later at the same time as Whittredge. Whittredge writes of him: "He was in his better moods of singular fascination for me. I had been so much with him, knew him so well and had enjoyed his friendship so long that I loved him as I have seldom loved any man." He adds, "My friend and I did not cross the ocean together. We were to meet in Paris on the arrival of the ship I was to sail on and even this meeting was delayed."[1]

Whittredge arrived in London aboard the packet ship *Northumberland* in late June 1849, after a voyage of thirty-five days, half of them spent in the middle of the Atlantic in a "dead calm."[2] Among the other eleven cabin passengers was the family of Thomas G. Clemsen, the American *chargé d'affaires* in Belgium, who introduced him to "all the artists of note in Brussels and Antwerp."[3] "Not very well satisfied with anything I saw in Belgium," Whittredge spent several weeks during the summer sketching along the Rhine between Bonn and Bingen. The original manuscript describes this trip in great detail. His European sketchbook contains numerous drawings labeled with the names of the places he saw, which can be related easily to the narrative. He then returned for another visit with the Clemsens in Belgium. "I had a delightful two months with them and then went to Paris where I met my friend and took a studio with him" in early September.[4]

Whittredge began to look for a teacher almost immediately; however, as he later wrote, "I found no landscape painter in Paris that I cared to go with."[5] He had come to Europe with "all the prejudices common to our artists concerning foreign tuition of any kind." He further admitted: "I cannot say that I had any great desire to take lessons of anyone. Up to that time my education in art had been just no education at all."[6] Despite being largely self-taught, he was an experienced professional who had acquired a distinct artistic personality, which made it difficult for him to accept someone else as a mentor.

Whittredge's introduction to French landscape painting was disappointing:

> I went to Barbizon, where I heard several young landscape
> painters had congregated to set up a sort of school by them-
> selves. Diaz was the only one I remember as being there at the
> time. They were represented as being very poor, but genuine
> "Kickers" against all pre-existing art. It was said that Diaz
> would paint a picture a day for a good dinner if anybody would
> offer it to him. I liked the spirit of these young men but I did
> not think much of the pictures. I think better of them now.[7]

Whittredge's ignorance of European tradition was an insurmountable obstacle
to understanding French art. Although he could admire the Barbizon attitude
toward nature, Théodore Rousseau's vision of nature was far more subjective
than his own, whereas the classical landscape practiced by Corot was alien to
his American sensibility.[8] The antiurban, antiindustrial outlook that helped
to vault the Barbizon painters to prominence during the revolution of 1848
must have been largely incomprehensible to a painter newly arrived from the
Midwest, if he was aware of it at all.[9] Unable to speak French, he was isolated
from the continuing turmoil by the narrow circle in which he moved: "My
friend with whom I had expected to share a studio in Paris, introduced me
into a society of fast extravagant people. I was totally unprepared to mingle
in any such company. I had come abroad with little money, but if I had had
ever so much, I would have felt that such company was not the best for me
as a student."[10]

Actually, Whittredge was surprisingly well off. From an analysis of his
European account book, it emerges that, in addition to the letter of credit for
$1,000 from Scarborough, he left Cincinnati with approximately $2,025 in
commissions, of which $450 worth were not recorded among the payments
received and were presumably not fulfilled. Four others were left open, three
of which were evidently never completed. In Düsseldorf he received $2,800
more in commissions, of which $400 seem not to have been paid. He sent
$500 worth of paintings to Cincinnati for sale, and earned another $600 from
various commissions and sales in Düsseldorf. Given the exchange rates and
cost of living, the artist had more than enough to live comfortably, even in
France which was appreciably more expensive than Germany.

DÜSSELDORF

In early October 1849, after only one month, Whittredge "finally resolved to
leave Paris and seek some less gay society. I believed that Düsseldorf was such
a place."[11] At first McConkey "stormed at my proposition," but decided to
join him "at the last minute."[12] Emmanuel Gottlieb Leutze, Whittredge wrote,

was "the magnet which drew me thither."[13] Leutze, a native of Germany who grew up in Philadelphia, had enjoyed a meteoric rise. *The Return of Columbus in Chains from Cadiz* (1842, Frances K. Talbot, Philadelphia), part of a trilogy about the explorer's life painted soon after Leutze's arrival in Düsseldorf, was awarded a silver medal in Brussels before being distributed as part of the Apollo art lottery in New York, where it was reviewed enthusiastically. The American Art-Union's subscribers later received engravings of this and *Raleigh Parting from His Wife* (present whereabouts unknown). The expatriate was accorded wide newspaper coverage in the United States, for example, a report in November 1846, that he had amassed $30,000 in American commissions.[14] Even before he left for Europe, Whittredge could hardly have failed to learn of Leutze's popularity or the sensation created by the Düsseldorf Gallery in New York upon its opening in 1849.[15] He undoubtedly heard further reports about the Düsseldorf Academy during his trip up the Rhine and again after his arrival in Paris, where German art had been exhibited regularly since 1820.[16]

During the 1840s and 1850s, Düsseldorf was the leading art center in Germany. Its eminence rested on the history paintings of the Academy's director, Wilhelm von Schadow, and his students Carl Friedrich Lessing, Ferdinand Hildebrandt, and Rudolf Hübner, but all genres prospered under Schadow's benevolent regime. Landscape in particular flourished after the formation in 1827 of the Association for Landscape Composition by Lessing and his pupil Wilhelm Schirmer, who became the leading landscape painters in Düsseldorf along with Andreas Achenbach.[17] Schadow cultivated a tolerant atmosphere that quickly resolved disputes between opposing factions and established one of the most liberal curricula in Europe.[18] The situation was ideal for a painter seeking further training without losing his independence:

> I found the professors of the Academy in Düsseldorf among the most liberal-minded artists I have ever met, extolling English, French, Belgian, Norwegian and Russian art. The Düsseldorf School therefore was not alone the teachings of a few professors in the Academy but of the whole mass collected at that once famous rendezvous, and America had Leutze there, the most talked-about artist of them all in 1850.[19]

Leutze, a liberal reformer, acted as the benefactor of American painters in Düsseldorf.[20] Under his protection, they enjoyed special privileges, circumventing the Academy's usual admission requirements and rarely enrolling formally in its classes. Whittredge was immediately taken under Leutze's wing and posed, as did many others, for *George Washington Crossing the Delaware*.[21] Later, in April of 1853, he rented a studio from Leutze for the low sum of fifty thaler per year. Although allowing that "a great deal of his work is carelessness beyond excuse," Whittredge praised Leutze as "one of only two

36

artists I have ever met who seemed to me endowed with the god-like gift of genius."[22]

Whittredge began to search once more for a teacher. In the hope of receiving lessons from Andreas Achenbach, he persuaded the artist's wife to rent out a small storage room in their attic, but rarely saw him:

> I am mentioned sometimes in the catalogues of exhibitions as the pupil of Andreas Achenbach. This would be true if I could say that he ever gave me a regular lesson or in fact any lessons at all. He hated, with a hatred amounting to disgust, to see artists imitating his pictures, and he had no sympathy whatsoever for the usual French atelier where numbers of students were doing nothing more than imitating the techniques of their masters. His talk sometimes took a serious turn, but this was generally at the "Mahlkasten" (Paint Box)....I could have learned just as much about painting if I had never met him anywhere else but at this club during the whole year I was with him.[23]

To demonstrate his independence, Whittredge recounts finishing a now lost canvas of the Siebengebirge in Achenbach's garret without any assistance from him, then boasts that the picture was hailed by Achenbach and the other painters in Düsseldorf as a highly original work of art.[24]

Even without the benefit of formal instruction from Achenbach, Whittredge's conversion to the Düsseldorf style was rapid and complete. *Fight below the Battlements* (*The Castle of Drachenfels*) (fig. 17), signed and dated 1849, is so Germanic that it hardly seems the work of a newly arrived American. The skirmish of knights in the brooding landscape exemplifies the dark Romanticism of Lessing and his followers.[25] Only in such details as the foreground foliage does one recognize the hand that had executed *View on the Juniata* (fig. 16) earlier that year.

Whittredge soon assimilated Achenbach's style as well. He made at least two copies after the German's paintings, which he sent to W. W. Scarborough in Cincinnati "to retain for me."[26] His own composition *View of Drachenfels from Rolandseck* (formerly Victor Spark, New York), which was executed in Achenbach's house in 1850, shows the influence of the artist's Norwegian landscapes.[27] The painting is probably related to a work that Whittredge sent to the American Art-Union in September 1850.

The same shipment included *Scene on the Marsh – Night* (fig. 18), which is recorded in his account book as "Moonlight from a sketch of the Marsh in Belgium." He writes, "I went to Robbe for a month or two into a waste part of Belgium to sketch after having copied a few of his studies."[28] The landscape modestly announces the initial appearance of Barbizon influences in Whittredge's paintings. The subject and composition reflect the school's impact on

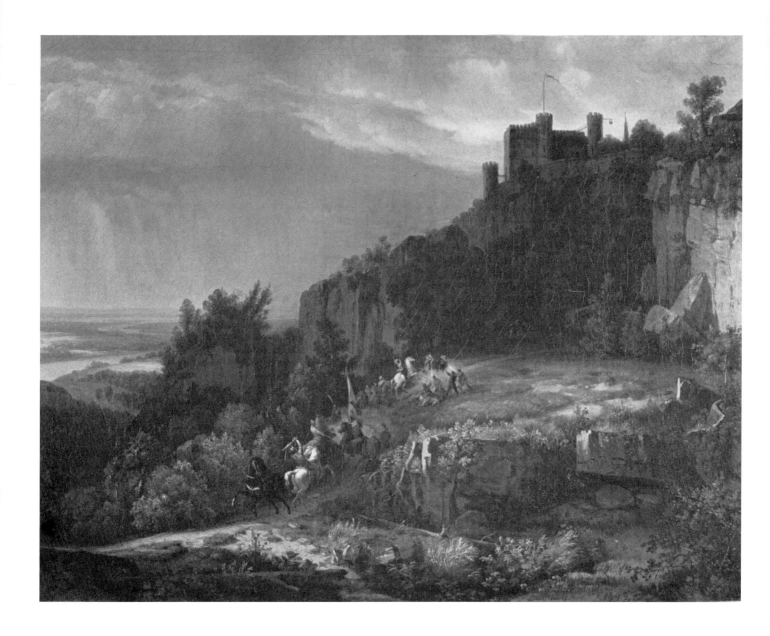

Belgian art in the late 1840s, though the execution itself is typical of Düsseldorf painters.[29]

After he left Achenbach's house, Whittredge joined the circle of Carl Friedrich Lessing. Lessing was a favorite of American artists in Düsseldorf because of his close friendship with Emmanuel Leutze, who acknowledged him as his model, though not as a teacher.[30] Whittredge first became "intimate" with the Lessings through his activity as a "picture buyer" for Cincinnati patrons.[31] This was a small sideline for Whittredge, done primarily as a service for his Cincinnati clients, mainly Nicholas Longworth. His account shows only twelve transactions, mostly for works by Lessing, as well as a couple of paintings

FIGURE 17. Worthington Whittredge. *Fight below the Battlements* (*The Castle of Drachenfels*), 1849, oil on canvas, 25 × 33¼, Kresge Art Museum, University of Michigan, East Lansing. Gift of the Class of 1927, Friends of Kresge, Kresge Art Gallery Fund, MSU Fund, and Chamber Music Fund.

FIGURE 18. Worthington
Whittredge. *Scene on the
Marsh – Night*, 1851, oil on
canvas, 14⅜ × 18½, private
collection.

FIGURE 19. Worthington
Whittredge. *From the Harz
Mountains*, 1852, oil on
canvas, 25 × 33, Fine Arts
Museums of San Francisco.

FIGURE 20. Worthington Whittredge. *Summer Pastorale (View of Kallenfels)*, 1853, oil on canvas, 38¾ × 32⅜, Indianapolis Museum of Art.

by Andreas Achenbach. Whittredge's commission appears to have averaged 10 percent, so that he probably earned only about $325 to $350 as an agent.

It was through Lessing that he also became immersed in the cultural life of the city, which is the subject of a lengthy account omitted in John Baur's edition of the autobiography. For example, he was acquainted with all the poets and musicians in Düsseldorf, particularly Robert and Clara Schumann whom he got to know "very well." Because of his love of music, he even studied the violin but gave it up due to lack of talent. Equally important was the inspiration provided by literature and poetry.[32]

Whittredge records a trip with Lessing to Hannover, which included an excursion to the nearby Harz Mountains.[33] The journey must have taken place in August and September of 1852, the dates on a series of drawings by Lessing (Cincinnati Art Museum) which correspond in subject and style to Whittredge's. Except for the addition of a group of riders, *From the Harz Mountains* (fig. 19) duplicates a drawing evidently showing a view near Regenstein (formerly E. P. Richardson, Philadelphia), but the perception of daylight in the delicately shaded sketch is altered to a more Romantic atmosphere using Lessing's dark palette.[34] The canvas may be considered Whittredge's first important essay in the mainstream of Düsseldorf landscape painting, notwithstanding his earlier attempt at Lessing's style in *The Castle of Drachenfels* (fig. 17).

From the Harz Mountains is probably the earliest of an important group of three paintings recorded in Whittredge's account book on April 21, 1853. The others are *Summer Pastorale* (fig. 20) and *Landscape in the Harz Mountains* (fig. 21). The chronology of these canvases is problematic. They are signed and dated 1854, but all of them must have been executed between October 1852 and April 1853. The entry for *Summer Pastorale* is clearly inscribed 1853; however, the last digit in the entries for *From the Harz Mountains* and *Landscape in the Harz Mountains* was later altered by the artist to read 1852. To confuse matters further, the date for the entry concerning the duplicate version of *Landscape in the Harz Mountains* in the Detroit Institute of Arts (fig. 22) was also changed, first from 1853 to 1852 and then to 1854. However, these four entries follow two others from February 14, 1853 and another of April 18, 1853, and precede three more from October 6, 1854. There is no reason, then, to doubt the veracity of the original date 1853. Moreover, Whittredge postdated two of the paintings, not to mention several others, probably to make them look like recent works to clients. *Summer Pastorale* was commissioned by E. J. Mathews of Cincinnati on May 8, 1853, more than two weeks after the date of the journal entry, while the Detroit replica of *Landscape in the Harz Mountains* went to James L. Claghorn in Philadelphia to complete a commission received from T. B. Read of Cincinnati on September 20, 1853. From the contradictions between the dates, it becomes apparent that Whittredge had both pictures at hand and changed the entries in his log after using them to fill these orders.

41

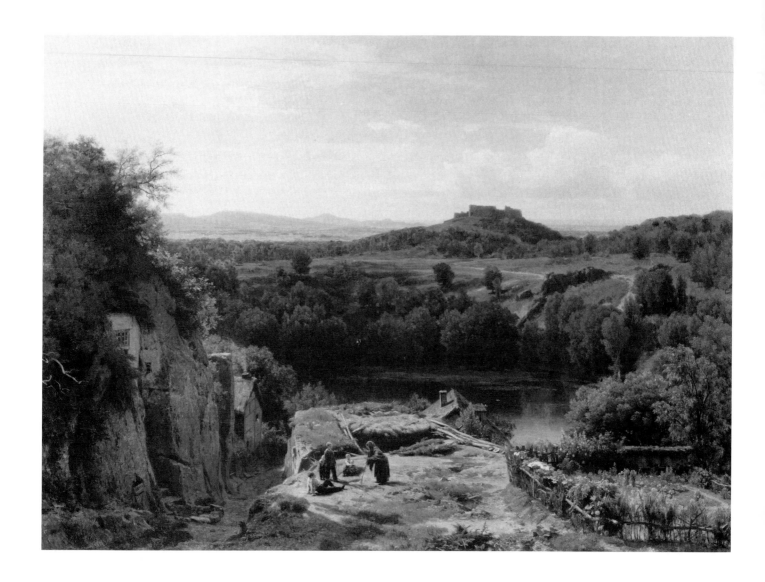

According to Whittredge's entry of April 21, 1853, *Summer Pastorale* (fig. 20) was painted "from a study taken on the River Nahe, 'Callenfels.'" A comparison with a later oil of the same site (fig. 29) shows that this large, ambitious canvas actually consists of two motifs joined by the line of trees. The Düsseldorf school would often freely combine separate studies into elaborate compositions like this. The entry for *Landscape in the Harz Mountains* (fig. 21), the final painting Whittredge recorded on April 21, 1853, bears the notation, Composition from studies made in the Harz Mountains, Motive near Langenfeld. As the description indicates, this canvas, too, is an amalgam of different subjects. A small oil sketch (fig. 23) of just the castle suggests that Whittredge began to explore ideas for *Landscape in the Harz Mountains* soon after he returned from his expedition with Lessing in September 1852. Like *Summer Pastorale*, the painting integrates two distinct views into one scene by

FIGURE 21. Worthington Whittredge. *Landscape in the Harz Mountains*, 1853, oil on canvas, 46¼ × 63⅛, High Museum of Art, Atlanta.

adding a stand of trees along the river and emphasizing the play of linear patterns such as the winding road in the middle distance. The picture also includes a view of a rural garden, a motif he explored around the same time in an impressionistic sketch of *A Bit of Garden by a Westphalian Cottage* (fig. 24).

 Summer Pastorale and *Landscape in the Harz Mountains* reveal a major change in style under the impact of Johann Schirmer. The lower half of *Summer Pastorale* is similar in technique and composition to Schirmer's *Landscape near Bonn* (Kunsthalle, Karlsruhe), for example. Both artists lead the eye along a serpentine path replete with an abundance of details, while adding crisp highlights on the water and foliage to suggest the play of sunlight. Whittredge's change in allegiance was inevitable. Although Lessing had created what became the Düsseldorf landscape style during the 1820s, while still Schadow's student in Berlin, he devoted most of his art to scenes of Protestant

FIGURE 22. Worthington Whittredge. *Landscape in the Harz Mountains*, 1853, oil on canvas, 26¾ × 35⅜, Detroit Institute of Arts.

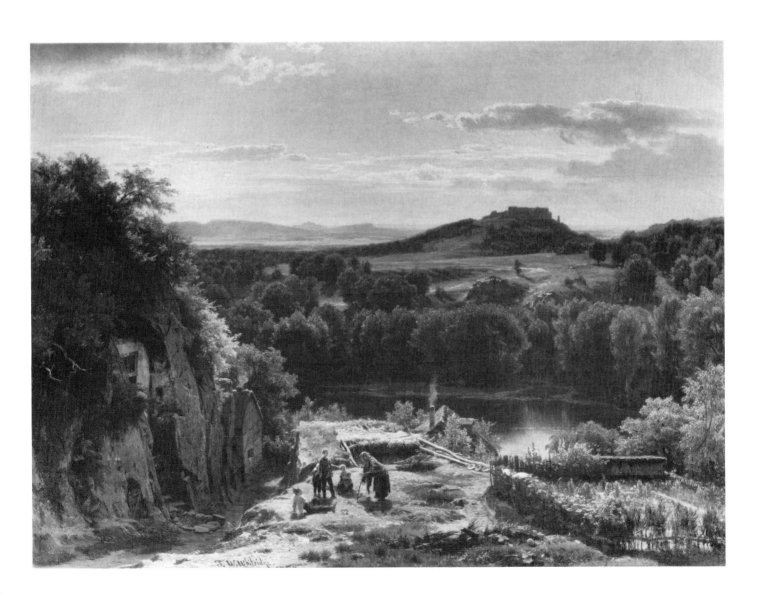

FIGURE 23. Worthington Whittredge. *Castle in the Harz Mountains*, c. 1852, oil on paper, 10 × 11¾, Kennedy Galleries, New York.

history, for which he was famous.[35] Like Andreas Achenbach, moreover, he disliked teaching, so that it was his protégé Schirmer who became the head of the Düsseldorf landscape painters.[36] Virtually every aspiring landscapist passed through or was affiliated, however loosely, with Schirmer's studio, contributing to and expanding on the school's style.[37] This communal manner was so well-defined that Whittredge did not actually have to study with Schirmer to feel his pervasive influence, one which is never acknowledged in his autobiography but which dominates his work throughout the rest of his stay in Germany.

On April 18, 1853, a few days before he registered this trio of pictures, Whittredge entered *Landscape with Boy and Cows* (fig. 25) into his account book. The painting follows the general composition found in Jules Dupré's *Landscape with River* (Louvre, Paris) of about the same time. *The Mill* (fig. 26), completed a few months earlier, similarly adheres to Constant Troyon's river views. The source of these Barbizon influences is not immediately clear. Whittredge mentions that "while in Düsseldorf, I went frequently to the Hague, Dresden, Berlin and Antwerp with an occasional short visit in Paris to see the pictures, but for the most part I kept my studio in the old town."[38] There is no documentation that he went to France in 1852 – but such an excursion cannot be ruled out. In the first place, his passport is not necessarily complete. More-

over, Düsseldorf landscape painters visited Paris regularly after Andreas Achenbach, Eduard Pose, and Henrich Funk attended the exhibition of their work at the Salon of 1838.[39] However, Whittredge's statement implies, and the evidence provided by his paintings consistently suggests, that his knowledge of Barbizon was acquired largely, if not entirely, at second hand in Düsseldorf rather than through direct exposure to the school. Thus, it appears, the style he had originally disdained proved more palatable in tempered form away from Paris. Content as he generally was to remain within the boundaries of the Schirmer school, Whittredge absorbed Barbizon art only selectively. The smooth execution and pale tonality in *The Mill* are consistent with Eduard Pose's landscape, *View of the Siebengebirge from Godesberg* (Wallraf-Richartz Museum, Cologne), which observes Düsseldorf conventions within what is otherwise a Barbizon composition.

Landscape with Boy and Cows and *The Mill* participate in the Barbizon tendencies that affected Düsseldorf art during the early 1850s. At that time, Johann Schirmer began to translate Jules Dupré's manner into a German idiom.[40] Whittredge's fellow students, such as Ludwig Becker, soon took up Barbizon motifs as well, but except in some of their paintings from nature,

FIGURE 24. Worthington Whittredge. *A Bit of Garden by a Westphalian Cottage*, c. 1852, oil on canvas, 13⅜ × 12⅝, private collection.

they did not adopt a French style.[41] Düsseldorf naturalism was based on constant sketching outdoors. Schirmer first painted studies from nature with Carl Friedrich Lessing during the 1820s and continued the practice throughout his career.[42] However, sketches in Düsseldorf were treated for the most part simply as useful records or compositional aids. Only rarely were they valued for their intrinsic qualities, and not until the final quarter of the century did they assume the status of independent paintings under the influence of Impressionism.[43] The exceptions are generally small, carefully painted outdoor studies. Düsseldorf landscape painters would also occasionally execute small studio works that mediate between the sketch and finished landscapes. They were otherwise unwilling to relinquish their dark tonalism for plein air

FIGURE 25. Worthington Whittredge. *Landscape with Boy and Cows*, 1852, oil on canvas, 40½ × 52½, Cincinnati Art Museum. Gift of Mrs. Maria Longworth Storer and Margaret Rives Nichols, Marquise de Chambrun.

colorism or an essential integrity of form for more spontaneous notation. Like other German artists, they remained committed to large studio landscapes, which liberally reinterpret nature for artistic effect while observing meticulous realism of detail.[44]

A group of interrelated works by Whittredge illustrated the Düsseldorf approach. Oaks were popular throughout German Romantic art but nowhere more than in Düsseldorf. They are a common feature of landscapes by Lessing and Schirmer, who made the intensive study of their massive, gnarled forms an almost mandatory part of his students' training. Whittredge mentions going to see the famous oaks at Dessau.[45] The artist returned from the journey, which his passport shows took place in 1855, with a large drawing of the trees that is in the collection of the Century Association.[46] His impressive rendering of an oak (fig. 27), which is similar to one by Schirmer of around the same time or a little earlier (Kunsthalle, Karlsruhe), was undoubtedly executed soon after the trip. The experience of painting this study in turn provided the foundation for perhaps the most ambitious work undertaken by Whittredge

FIGURE 26. Worthington Whittredge. *The Mill*, 1852, oil on canvas, 25 × 52, Cincinnati Art Museum. Bequest of Reuben Springer.

FIGURE 27. Worthington
Whittredge. *The Oak*, 1855, oil
on canvas, 27½ × 19½, pres-
ent whereabouts unknown.
Photo courtesy of Kennedy
Galleries, New York.

while he was in Düsseldorf: *Landscape near Minden* (plate I), showing a view
in the Weser mountains, which was completed by April 1855. The canvas
shows the impress of Schirmer's forest views based on those by the Dutch
Baroque painter Jacob van Ruysdael. In bog scenes such as *Lower German
Landscape* (1847, Museum der bildenden Künste, Leipzig), Schirmer sought

FIGURE 28. Worthington Whittredge. *Outskirts of the Forest*, 1855, 25½ × 35½, M. and M. Karolik Collection, Museum of Fine Arts, Boston.

to express the hidden meaning of life which he, like other German Romantics from Caspar David Friedrich on, believed to be revealed by nature.[47] With its mammoth forms and powerful composition, Whittredge's painting rivals Schirmer's in grandeur. *Outskirts of the Forest* (fig. 28), dating from the fall of 1855, depicts the same scene as *Landscape near Minden*; yet the two pictures are so different that one would hardly suspect they are based on the same drawing (formerly Hirschl and Adler Galleries, New York). *Outskirts of the Forest* sacrifices the monumentality of *Landscape near Minden* for a picturesque intimacy by cropping the composition and using delicate, pastelike colors to convey the sunlit ambience evoked by the drawing.

Pilgrims at a Shrine (Henry Radel, Newport, Ky.) inscribed Düsseldorf 1856, can be identified with *Pilgrims of St. Roche* (*Rhine Landscape with a Large Number of Figures*), mentioned in Whittredge's autobiography among the major

49

works he painted in Germany.[48] With its highly finished surface, the picture conforms to the potboilers of roadside shrines that were popular throughout Europe in the nineteenth century. This kind of scene originated as a souvenir of the Campagna, where such shrines were abundant. The landscape provides the first sign of the growing interest in Italy that led the artist to move to Rome in the summer of 1856, soon after he finished painting it.[49]

The circumstances surrounding Whittredge's decision to leave Düsseldorf were much the same as when he left Cincinnati seven years earlier:

> From boyhood I had heard of Rome, so I began to plan how I could get there, for my resources were small. I confess I had some misgivings as to whether a visit to Rome would after all be much benefit to such an unclassically educated boy as I was. I understood Rome to be a place for *polish* entirely, which included the idea of something in a state ready to be polished and which could be benefited by rubbing up.[50]

At thirty-six Whittredge had lost none of his desire for travel and adventure. There is also some evidence that he was once again motivated by artistic restlessness. In March 1856 he visited the Nahe River by himself, then returned in June accompanied by many of the American painters in Düsseldorf.[51] *View of Kallenfels* (fig. 29), dated July 1856, which repeats the background from *Summer Pastorale* (fig. 20) of three years earlier, is symptomatic of the kind of stagnation that had afflicted Whittredge in *View on the Juniata* (fig. 16) shortly before he left Cincinnati in the spring of 1849.

Whittredge's decision may have also come in response to the artistic decline of Düsseldorf. He had arrived there at its cultural zenith; however, between 1853 and 1859, the city lost most of its leading painters. Johann Hasenclever died in 1853. A year later Johann Hildebrandt resigned from the Academy because of mental illness. The most serious loss also came in 1854, when Schirmer left to become director of the newly opened Karlsruhe art school, where Lessing joined him in 1858. Leutze returned to the United States in 1859, the year Schadow retired as director of the Academy. By the end of the decade, with its reputation under increasing attack, Düsseldorf lost its preeminence to the Munich school, led by Karl von Piloty.[52]

SWITZERLAND

Whittredge spent late July through early September sketching in Switzerland in the company of John Irving, Emmanuel Leutze, and William Stanley Haseltine. He states that he first saw the Alps on his way to Rome, when the party arrived at Lake Lucerne.[53] This is confirmed by his passport, which is stamped for Switzerland only in 1856 and 1857. At Lake Lucerne they were joined by Albert Bierstadt, who had departed several weeks earlier. The sketches Whit-

tredge painted during that summer often bring Barbizon sketches to mind. On his tour up the Rhine he made a quick oil sketch in Assmannshausen (private collection) that is reminiscent of Corot, whereas *An August Morning* (private collection), painted a little later in Switzerland, recalls Troyon in color and technique.[54]

It is noteworthy that an interest in the French sketch aesthetic should first manifest itself in the oil sketches Whittredge painted on his way to Italy, as it was there that German painters primarily absorbed this legacy. The leading center of exchange between French and German artists was Rome, but Naples played an important role as well through the Scuola di Posilippo, founded in 1812 by Antonio Sminck van Pitloo upon completing his studies with Jean-Victoire Bertin, who was Corot's teacher as well.[55] Johann Georg von Dillis painted a series of small canvases in Rome during 1817 and 1818 that show

FIGURE 29. Worthington Whittredge. *View of Kallenfels*, 1856, oil on canvas, 30½ × 27, Cincinnati Art Museum. Gift of Mary Hanna.

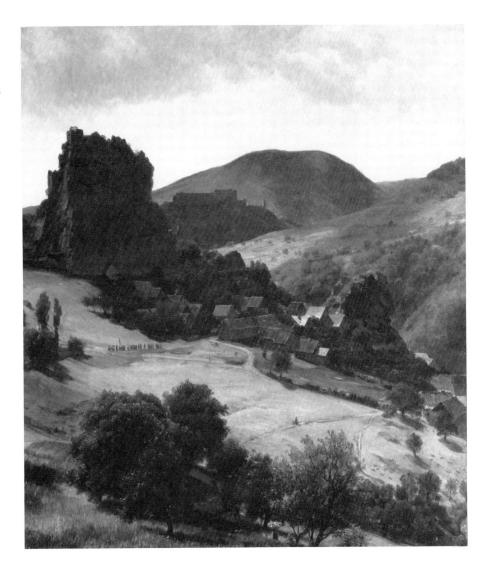

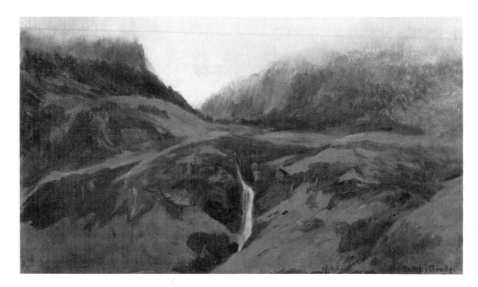

FIGURE 30. Worthington Whittredge. *The Distant Falls at Meyringen*, 1856, oil on paper mounted on canvas, 7¼ × 12¼, Kennedy Galleries, New York.

the direct influence of Italian sketches by Pierre-Henri de Valenciennes and his followers. After visiting Italy in 1820–1, Johann Christian Dahl began to do cloud studies (Kunsthalle, Hamburg) similar to Valenciennes's (Louvre, Paris). The landscapes Karl Blechen executed in Rome in 1828–9 also show a clear debt to French landscape painters, as do Friedrich Wassmann's Tyrolean scenes of the 1830s (Kunsthalle, Hamburg). Johann Schirmer was principally responsible for establishing the French sketching technique in Düsseldorf. During his two years in Rome, he painted a sketch of a villa (Wallraf-Richartz Museum, Cologne) that was strongly affected by Corot and continued to use a modified French approach following his return from Italy.

Whittredge probably derived this Germanic version of the French sketching technique in part from the studies Andreas Achenbach painted in Italy between 1843 and 1845.[56] *The Distant Fall at Meyringen* (fig. 30) is similar in execution, for example, to Achenbach's *Mount Vesuvius* (Kunstmuseum, Düsseldorf), which falls within the same Franco-Italian tradition as Corot's sketch of the Bay of Naples (Louvre, Paris).[57] *In the Village of Brunnen* (New York State Museum, Albany), on the other hand, is closer to the *View of Roofs and Garden* (c. 1828, Nationalgalerie, Berlin) painted by Karl Blechen from his studio window. There is some evidence to suggest that Whittredge assimilated Blechen's sketching style, if only indirectly, through such early sketches by Schirmer as *Alpine Landscape* (Kunstmuseum, Düsseldorf). The influence of Schirmer and his circle is felt more specifically in a small study of Lake Lucerne at Minthal (fig. 31), where Whittredge also made a drawing of three boats (M. and M. Karolik Collection, Museum of Fine Arts, Boston), which documents his presence there on August 9. The harmony of greys creates an atmospheric veil across the landscape, whose spacious composition belies its modest size. *Along the Brook* (fig. 32) is one of Whittredge's happiest produc-

FIGURE 31. Worthington
Whittredge. *Minthal*, 1856,
oil on board, 12½ × 15½,
Taggart and Jorgensen
Gallery, Washington, D.C.

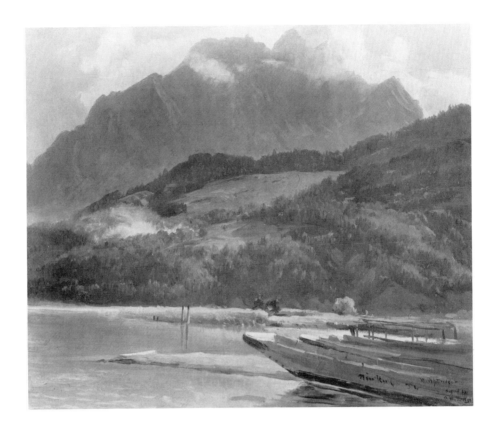

FIGURE 32. Worthington
Whittredge. *Along the Brook*,
1856, oil on board, 5½ ×
15¹/₁₆, Gerald Peters
Gallery, Santa Fe.

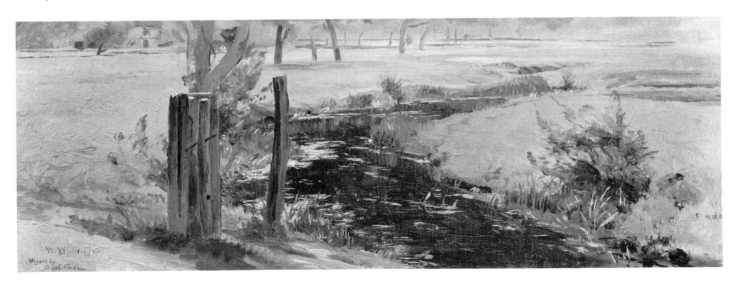

tions. Its joyful color and sparkling light seem to express his optimism about his prospects in Rome. This ranks among the most advanced oil sketches by any Düsseldorf artist at that time. Ludwig Becker and Julius Rollmann adopted a comparable pleinairism only after 1860; and such direct color and fluid brushwork did not become common until Eugene Dücker and Ernest te Peerdt a generation later.

ITALY

Whittredge spent the early part of September along the lakes of northern Italy with Haseltine and Bierstadt.[58] Haseltine then returned to spend the winter in Düsseldorf, while Whittredge and Bierstadt continued on to Florence, where they temporarily parted company.[59] Whittredge's buoyancy soon changed to dismay:

> I was at last in Florence, the cradle of the Renaissance. I wandered and wandered about the galleries for several weeks, generally alone, and often in a most despondent state of mind. For the first time in my life I realized that the great works of art which had stirred the world and set the mighty chorus of praise ringing down the ages were not landscapes. The atmosphere of Florence was mild, milder than I had been accustomed to, and this may have had something to do with my depressed state. It was constantly recurring to me that I was "but a landscape painter" and landscape painting seemed, in my low condition, to cut but an insignificant figure among the great works of art which had been produced in this world. I began to think of starting for Rome. I had made just no acquaintances in all Florence. I had been listless and completely out of sorts. The most intimate acquaintances I had were two vagrant dogs.[60]

Whittredge was suffering in part from a common form of depression in Florence that is sometimes known as Stendhal's Syndrome, after the author who first described it during his visit there in 1817. However, his distress upon confronting the Renaissance was shared by many other American landscape painters, unlike history painters for whom the study of Italian art was an indispensable part of their education. As he was leaving for Europe in 1829, Cole wrote that his anticipations were "not at all pleasing, for I am going to study the great works of art. I feel like one who is going to his first battle and knows neither his strength nor his weakness."[61] Before the works of Raphael, Cole felt a sense of meanness as a landscape painter. He also harbored ambitions as a history painter, having already executed a series inspired by James Fenimore Cooper's *The Last of the Mohicans*. After his return from Europe he responded to the challenge of the Renaissance by painting

increasingly elaborate allegorical landscapes in the mold of J. M. W. Turner and John Martin, culminating in *The Voyage of Life* (1846, Munson-Williams-Proctor Institute, Utica, N.Y.)[62] Asher B. Durand experienced an even more acute crisis in Italy. He felt "bewildered, wretched, and desolate" and was afraid he would fail "to keep sufficient self-possession through all the sudden transitions and excitements."[63] Sanford Gifford and John Kensett, on the other hand, seem to have experienced few, if any, problems.

ROME

Whittredge set out for Rome by coach. Among the passengers was a young Englishman, "the life of the party from start," who, he later learned, was Frederick Leighton: "He was a slender youth with beautiful features and long flowing locks of light hair which in his many spirited movements blew about his face and shoulders, reminding one of a . . . girl."[64] Once in the Holy City Whittredge fell into a state of lassitude that rendered him insensate to the great art around him.

> I soon arranged myself in Rome and endeavored to become calm. Nevertheless more discouraged than tired (tiresome it is to look at pictures), I often came away from the Vatican and other galleries, which were filled with the works of the Old Masters, with a kind of indifference which I am afraid did not speak well for me as a student. I did not, however, give up the study of their works, for, after all, a landscape painter may derive as much benefit from studying the works of a figure painter as the works of a mere painter of landscape. The whole matter is one touching only our taste, and that certainly can be improved by the study of all great historical performances.[65]

Thus shielded from his malaise, Whittredge resumed painting. The landscapes he executed in the winter of 1856 have all the liveliness of his sketches from that summer. The delightfully airy study of *The Cypresses in the Villa d'Este, Tivoli* (fig. 33) from 1856 falls into a well-established tradition. Few German landscape painters in the nineteenth century passed through Rome without immortalizing this favorite site. Whittredge's canvas closely follows one from 1840 by Johann Schirmer (Kunstmuseum, Düsseldorf), which preserves the luminosity found in Johann Adam Klein's well-known drawing of twenty years earlier (Hessisches Landesmuseum, Darmstadt). Whittredge, coincidentally, painted his study in the same year as Anselm Feuerbach's darkly expressive watercolor (Staatsgalerie, Stuttgart).

The Foot of the Matterhorn (fig. 34) was most likely done not long after *The Cypresses in the Villa d'Este.* Whittredge had sketched the Matterhorn in early September 1856, when his party settled in nearby Meyringen.[66] This is the only known vertical mountain landscape by Whittredge, who admitted to being

unsuited temperamentally to treating the sublime. The painting was no doubt inspired by the presence of Albert Bierstadt, whose early works it resembles in execution. Whittredge has depicted the scene as literally as possible to mitigate its terror, in contrast to the young J. M. W. Turner, who could not resist heightening the awesome power of *The Falls at Reichenbach* (Cecil Higgins Art Gallery, Bedford, England).

The relationship between Whittredge and Bierstadt was very close at the

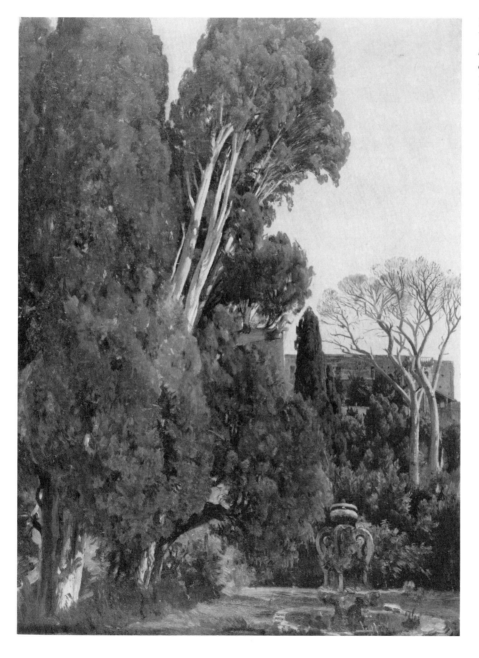

FIGURE 33. Worthington Whittredge. *The Cypresses in the Villa d'Este, Tivoli*, 1856, oil on canvas, 23¼ × 16, Princeton University Art Museum.

time. Whittredge's autobiography states that Bierstadt called himself his student while they were in Düsseldorf out of gratitude for his early assistance.[67] They were constant companions with Sanford Gifford throughout their stay in Rome. However, a rift seems to have developed between them at a much later date. Whittredge fails to mention that Bierstadt was among the group that visited Bingen in June 1856 and accompanied him through Switzerland and Italy later that summer.[68] And in recounting his brush with death in early 1857, Whittredge substituted Bierstadt with Frederic Edwin Church, whom he cannot possibly have known at the time. "It was in Rome that I was smitten

FIGURE 34. Worthington Whittredge. *The Foot of the Matterhorn*, c. 1857, oil on canvas, 24¾ × 19⅝, National Academy of Design, New York.

with 'Roman fever.' I grew worse daily and my dear friends Gifford and Church [sic] gave up all hope of saving my life." He continued that, while his companions were playing cards and waiting for him to die, his fever broke and he asked to be dealt in. The anecdote ends with characteristic good humor: "To make a long story short, I cleaned them out, every penny, and arose the next morning perfectly well."[69]

Gifford and Bierstadt toured Naples and Capri before leaving separately for the United States in August 1857.[70] After sketching in and around Rome, Whittredge joined Haseltine at Brunnen on Lake Lucerne in late July.[71] They returned to Rome together in mid-September after stopping at Lake Maggiore, where Whittredge completed a highly finished drawing of the *Isola dei Pescatori* (M. and M. Karolik Collection, Museum of Fine Arts, Boston) in a

FIGURE 35. Worthington Whittredge. *Lake Lucerne*, 1857, oil on canvas, 23 × 31, private collection.

characteristic Düsseldorf style. Only a handful of major landscapes were to issue from the summer of sketching. A pair of scenes near Lake Lucerne, one of which (fig. 35) survives, were ordered in Rome by Tobias Wagner of Philadelphia for the sum of $200 and completed over the winter of 1857. The recently discovered *View near Brunnen on Lake Lucerne* (plate II), dated 1857, can be identified with a picture listed among Whittredge's completed commissions in June 1857 as "Subject from Brunnen. About 4 by 5 feet. To Mr. W. W. Beecher. Sent in March 1858 to the Philadelphia Academy and sold to Mr. Sam B. Faler for $350. Rome."[72] The background shows the same view as his later painting of *The Bay of Uri, Lake Lucerne* (plate III), but the foreground is entirely different. Like his major Düsseldorf pictures, *View near Brunnen on Lake Lucerne* combines two different subjects into a single composition by adding a stand of trees along the mountains and using the winding river to lead the eye into the middle distance. The canvas ranks with *The Wetterhorn* from the following year (fig. 43) as the undisputed masterpiece among the artist's Swiss scenes. Few large pictures by him are of such high quality. Unlike most of his other alpine landscapes, there is not a single weak passage. The viewer's interest is captivated by the crisply defined details distributed across the entire surface. Whittredge was always interested in local color, but in only a couple of other paintings does he include so many figures. Most remarkable is the sense of outdoor light, which retains an aura of fresh

FIGURE 36. Worthington Whittredge. *Sketch of Lake Lucerne*, 1856, oil on paper, 13 × 16, private collection.

observation otherwise never found in his Swiss landscapes. At least one of his canvases sent to Tobias Wagner (fig. 35), for example, is based on an oil sketch from nature (fig. 36) but the academic finish negates any sense of pleinairism.

The Wagner paintings are the last commissions noted in the artist's European account book. There is no record that Whittredge shipped other paintings to William Scarborough in Cincinnati until just before his departure from Italy a year and a half later. Our knowledge of his financial status in Rome is confined, however, to his account with Parkenham, Hooker & Co., which amounted to about $900 all told, of which a little over $200 was transferred as soon as he moved to Rome; the rest was added in a series of small transactions mostly under $50.[73] Although he presumably had adequate funds to survive in Italy, where food and housing were cheap, it is clear that Whittredge was no longer able to rely on Cincinnati patronage and was forced to turn to the open market in Rome.

> Of course, the artists residing in this far-off region looked upon winter as the time when they were most likely to sell their works or to get orders from the art-interested strangers visiting Rome at that season. The sculptors were much less fidgety about selling their work than the painters were. They often had large orders on hand and could easily afford to keep cool. But the painters who had come to Rome, expecting to find sale for their works there, often manifested considerable uneasiness. The necessity of selling our work made us bestir ourselves in society, and in making the acquaintance of all the strangers we could, who had come to town.[74]

In order to compete successfully Whittredge was compelled to paint standard academic landscapes for American tourists as souvenirs of their European

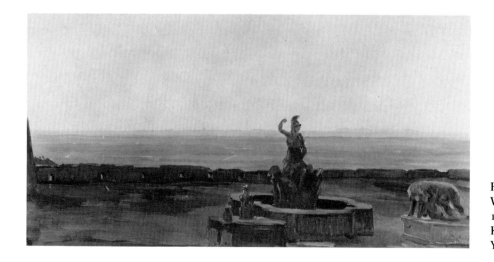

FIGURE 37. Worthington Whittredge. *Fountain in Italy*, 1858, oil on paper, 7 × 14, Kennedy Galleries, New York.

FIGURE 38. Worthington
Whittredge. *Villa d'Este*,
1858, oil on canvas, , 10¾ ×
13¾, Springfield Art Center,
Springfield, Ohio.

travels. He made his living primarily from Swiss scenes that conform to the
formulas established by François Diday and his student Alexandre Calame,
whom Whittredge met in late August 1856.[75] Whittredge had little difficulty
adapting to the Swiss style, which enjoyed considerable favor in Düsseldorf.
In fact, Johann Schirmer and Calame seem to have influenced each other
around 1840.[76] Whittredge's Lucerne landscapes are the kind of scenery paint-
ing that was widely practiced by both schools.

 ˙Whittredge's Italian scenes are altogether different in character. *Roman
Campagna* (plate IV), dating from 1857, was reportedly given to the Cincinnati

FIGURE 39. Worthington
Whittredge. *Benedictine
Monastery at Subiaco*, 1862 oil
on paper, 6¼ × 14¾,
present whereabouts
unknown. Photo courtesy of
Kennedy Galleries, New
York.

FIGURE 40. Worthington
Whittredge. *Market near
Subiaco*, 1862, oil on canvas,
8½ × 19, present
whereabouts unknown.

FIGURE 41. Worthington
Whittredge. *Landscape in
Northern Italy*, 1858, oil on
canvas, 33½ × 54, Butler
Institute of American Art,
Youngstown, Ohio.

FIGURE 42. Worthington Whittredge. *Aqueducts of the Campagna*, 1859, oil on canvas, 33 × 53¾, Cincinnati Art Museum. Gift of Caroline Hooper.

collector and painter Thomas Buchanan Read near the beginning of his long residency in Rome and may have been painted expressly for him.[77] The picture is of great importance for understanding Whittredge's subsequent development: The flat composition with a view of mountains in the distance not only lays the stylistic foundation for his landscapes of the following year, but directly anticipates his first major opus as a Hudson River artist and even certain aspects of his western paintings.

Whittredge spent the summer of 1858 in the mountains to the south and east of Rome:

> The beautiful lake of Albano I sketched and tried to make a picture of. The Sabine mountains claimed me in the summer because they were higher and cooler. Subiaco was generally my goal. There was a small town higher up on the mountains, Olevano, which, ever since the first landscape painter set foot in the Sabines, had been trodden over until a new proselyte of the brush could find his way to the most picturesque places without a guide. I . . . left the mountains in October and returned to Rome.[78]

63

FIGURE 43. Worthington Whittredge. *The Wetterhorn*, 1858, oil on canvas, 39½ × 54, Newark Museum. Gift of Mr. and Mrs. William Katzenbach, 1965.

He probably began the season at Tivoli, where he painted two oil sketches in the Franco-Italian manner. *Fountain in Italy* (fig. 37), apparently showing a view of the Campagna from Hadrian's Villa at dusk,[79] has the serenity of *Rome at Evening* (Louvre, Paris) by Pierre-Henri de Valenciennes, whereas *Villa d'Este* (fig. 38) maintains the simplicity found in the Frenchman's sketches. In late June 1858, he executed a careful drawing of Olevano (Saint Louis Art Museum) in the style of the Nazarenes.[80] And at Subiaco, he painted a quick sketch of the Benedictine monastery (fig. 39) and one of the market (formerly William Katzenbach), from which he later painted a finished canvas (fig. 40)[81]

Five months of continuous sketching resulted in only a few landscapes by the artist's hand. *Lake Albano*, mentioned in his autobiography and exhibited at the National Academy of Design in 1861, is now lost.[82] The so-called *Landscape near Rome* (fig. 41), dated 1858, which also exists in a slightly smaller

replica, is probably mistitled, as it seems to show a view of the alps in northern Italy rather than any of the lakes around Rome. Stylistically the canvas proceeds from *Roman Campagna*, as does *Aqueducts of the the Campagna* (fig. 42), painted in 1859, which the artist rightly considered to be one of his most important works.[83] The aqueducts were a standard subject for artists working for the tourist trade in Rome. Thomas Cole, Sanford Gifford, and John Tilton among other Americans painted nearly identical views.[84] Whittredge based his canvas on a small oil sketch from nature (formerly Hirschl and Adler Galleries, New York). Like Cole, he bathed the scene in a nostalgic twilight

FIGURE 44. Johann Schirmer. *The Wetterhorn*, 1837–8, oil on canvas, 95¼ × 78⅜, Kunstmuseum, Düsseldorf.

glow, which is intended to elicit the philosophical associations surrounding these picturesque relics:

> The plain is a great historical palimpsest, from which the towns and cities of a subdued race have been expunged, in order to make room for the proud structures of a conquering people, which, now, in their ruins, are no more than monuments of a lost power and memorials of faded glory.[85]

Paintings like *Aqueducts of the the Campagna* did not meet with the same demand as Swiss scenes, which continued to be Whittredge's staple product. He may have painted as many as seven landscapes of Lake Lucerne in 1858–9, of which three survive. The labored execution and indifferent color in *The Bay of Uri, Lake Lucerne* (plate III) and *Lake of the Four Cantons* (formerly Ira Spanierman Gallery, New York), both dated 1859, display an art-by-the-yard attitude which can be explained largely by Whittredge's antipathy toward alpine landscapes.

> My thoughts ran more upon simple scenes and simple subjects, or it may be I never got into the way of measuring all grandeur in a perpendicular line, though I frequently returned to the quaint village of Brunnen which is one of the most picturesque and charming spots on the lake.[86]

Whittredge's aversion to vertical space is epitomized by *The Wetterhorn* (fig. 43), his most successful alpine landscape. In a typical rendering of this view, Johann Schirmer's *The Wetterhorn* (fig. 44) adopted an upright format to emphasize the towering height of the mountain and depicted the scene at night to increase the sense of drama. Whittredge, by way of contrast, has chosen a much closer vantage point toward the center of Schirmer's landscape, and composed the scene horizontally in two simple, opposing masses, which offset the mountain looming in the distance. The picture is filled with sunlight and includes an artist calmly sketching away as a companion lies idly on the grass nearby, unconcerned by the broken trees that testify to nature's destructive power.

In 1859, Whittredge began to turn away from this academic style. Two freely executed sketches from that spring, *Sheep Cote on Lake Albano* (fig. 45) and *A Shepherd's Hut – Campagna* (fig. 46), have pastel hues never before employed by him. The same light palette and broad modeling lend an air of spontaneity to *The Amphitheater at Tusculum* (fig. 47), which is rare among his European landscapes in retaining the plein air color and directness of a painting from nature.[87] Although it is probably based on a drawing done more than a year and a half before in September 1857, the luminous colors and unaffected naturalism place *Morning on Lake Maggiore* (fig. 48) among the

FIGURE 45. Worthington Whittredge. *Sheep Cote on Lake Albano*, 1859, oil on canvas, 11½ × 14¾, Kennedy Galleries, New York.

FIGURE 46. Worthington Whittredge. *A Shepherd's Hut – Campagna*, 1859, oil on canvas, 11½ × 15, private collection.

masterpieces of Whittredge's European sojourn.[88] The painting is comparable to the atmospheric watercolors of the Tegernesse by the Munich artist Wilhelm von Kobell, one of the early pioneers of naturalism in Germany, who was strongly affected by French art during his several stays in Paris and Rome.

Before he could pursue the implications of this new style any further, Whittredge suddenly decided to return to the United States. His motive was simple enough:

> Much that we diligently pursue in this life is finally abandoned
> for no other reason than the lapse of time. I had now been
> nearly ten years in Europe and began to long for my homeland.
> I accordingly resolved . . . to go home. I was not long in packing
> up my studio and leaving Rome.[89]

In the haste to arrange his departure, this usually careful bookkeeper failed to draw up an inventory of two final shipments of paintings, which must have included much of his work from 1858–9.[90] His passport was

FIGURE 47. Worthington Whittredge. *The Amphitheater at Tusculum*, 1859, oil on canvas, 24 × 40, National Museum of American Art, Washington, D.C.

68

FIGURE 48. Worthington Whittredge. *Morning on Lake Maggiore*, 1859, oil on canvas, 30 × 50, Cleveland Trust Co.

stamped on July 20, 1859, by the American and French consuls in Rome, then again in Paris on August 1. Whittredge sailed from Le Havre shortly afterward on the *Vanderbilt* and arrived in New York eleven days later.[91]

4

The Development of a Hudson River Painter, 1860–1868

NEW YORK AND THE HUDSON RIVER SCHOOL

AFTER LANDING IN NEW YORK in August 1859, Whittredge "took one day to visit the Historical Society"

> where I knew were treasured among other valuable things, Cole's "Voyage of Life"/"Course of Empire,'" and Durand's "Thanatopsis." I may have been a little nervous, I cannot say, but when I looked at Durand's truly American landscape, so delicate and refined, such a faithful if in some parts sombre delineation of our own hills and valleys, I confess that tears came to my eyes. I viewed with no less interest the more masterly *Course of Empire* of Cole and endeavored to contrast it with the work of ancient and modern landscape painters while the memory of their work was fresh in my mind, and the conclusion that I reached was that few masters of any age had surpassed him in rugged brush work. But he leaned so strongly to allegory, especially in the works before me, and had presented so few objects distinctive of American landscape that his pictures made less impression upon me than the work of Durand. I was not then familiar with the many other noble landscapes inspired by our own scenery which Cole had left behind.[2]

Although it captures the flavor of the artist's response, the passage is wrong in its particulars, having been written more than forty years later. There is no evidence that Durand's *Thanatopsis* (Metropolitan Museum of Art, New York), then in the New York collection of Frank Moore, was on display at the Historical Society. Moreover, this large allegorical landscape, inspired by William Cullen Bryant's poem of the same title, hardly accords with the el-

oquent naturalism in Whittredge's description. He was unsure whether he saw Cole's *Voyage of Life* (Munson-Williams-Proctor Institute, Utica, N.Y.) or *The Course of Empire* at the Historical Society and claims not to have known the painter's more naturalistic landscapes. It was, in fact, *The Course of Empire*, which is still owned by the New York Historical Society, that was on view. And, as we have seen, Whittredge had not only been influenced by Cole's work, but had also known *The Voyage of Life* as early as 1847, when the duplicate version now in the National Gallery of Art, Washington, D.C., entered the Cincinnati collection of George K. Schoenberger.[3]

The artist spent a month painting "a few sketches in Newport, a very few, occupying my time chiefly in looking at the sky and endeavoring to find out what was the matter with it. But I was just in from Italy." He then went to Cincinnati, where he "stayed with Mr. Joseph Longworth in his country home until after Christmas." Despite "no end to the flattering arguments urged to induce me to stay in 'the town of my birth,' as they were pleased to term it, I returned to New York and began at once to fit up my studio," which had already been rented in the recently completed Tenth Street building.[4] Having worked successfully in Düsseldorf and Rome, the artist felt confident of his prospects in the nation's art capital. He considered his large New York studio not only suitable working quarters but also an appropriate symbol of his professional stature.[5]

After settling in New York in January 1860, Whittredge found himself with insufficient time to prepare a major painting for the annual spring exhibition at the National Academy of Design.[6] Instead, he "filched from a box of pictures on the way to Cincinnati"[7] *Aqueducts of the Campagna* (fig. 42) and two lost canvases, *Twilight – Lake Lucerne* and *Duck Shooting – Lake Lucerne*.[8] *The Amphitheater at Tusculum* (fig. 47) was evidently added from a final crate he had shipped just before leaving Italy.[9] The paintings were well received, and the artist was elected an associate member of the Academy in 1860. Although this success was "a great encouragement," the difference in style and topography between American and European landscapes plunged him into a severe artistic crisis as noted in his autobiography:

> It was the most crucial period of my life. It was impossible for me to shut out from my eyes the works of the great landscape painters which I had so recently seen in Europe, while I knew well enough that if I was to succeed, I must produce something new which might claim to be inspired by home surroundings. I was in despair. Sure, however, that if I turned to nature I should find a friend, I seized my sketch box and went to the first available outdoor place I could find. I hid myself for months in the Catskills. But how different was the scene before me from anything I had been looking at for many years! The forest was a mass of decaying logs and tangled brush wood, no peasants to pick up every vestige of fallen sticks to burn in

their miserable huts, no well-ordered forest, nothing but the
primitive woods with their solemn silence reigning everywhere.

Toward the end of the original manuscript, Whittredge mentions his crisis
again:

> It was extremely difficult to adapt myself to the new situation.
> I wanted to use the knowledge I had obtained abroad in such
> a way that my work would reflect myself and my love of our
> own scenery. This was not to be done in a day, and I struggled
> on through years, and have not yet abandoned the struggle to
> produce something which had some individuality in them.[10]

He continues:

> I think I can say that I was not the first or by any means the
> only painter of our country who has returned after a long visit
> abroad and not encountered the same difficulties in tackling
> home subjects. Very few independent minds have ever come
> back home and not been embarrassed with this same problem.
> And it is to be hoped that none will ever return without being
> bothered in the same way.[11]

Whittredge added the standard caveat about foreign study:

> It was then, is now, and probably always will be a question
> whether our students going abroad to study art, are likely to
> make better artists than if they stayed at home. Frankly, I doubt
> the desirability of long foreign study. A flying visit across the
> water is not objectionable but rather to be commended. But
> to go abroad and to become so fascinated with the art life in
> Paris and other great centers as to take up permanent abode
> there is not everywhere believed to be the best thing for an
> American artist.[12]

During Whittredge's decade abroad, a new generation of Hudson River
school painters had arisen with a different style and outlook from Cole's and
Doughty's that he had absorbed in Cincinnati. Although Cole continued to
act as an important influence for another ten years after his death in 1848, his
close friend Asher B. Durand led the school away from the Romantic style
practiced by the first generation of Hudson River artists. Durand stood in
much the same relation to Cole as Thoreau did to Emerson. Durand assumed
leadership of the Hudson River school in the early 1850s, when Thoreau was
writing *Walden*. More than any other artist, he translated into visual terms
the relationship between fact and "truth" that Thoreau tried to convey in his
writings. Both record not merely the details of carefully observed nature, but

also the quality of the experience itself, through the binding medium of passion recalled later in more tranquil moments.[13] Cole had been a leader in the growing naturalism of the 1840s, but except in his smaller canvases, he often altered fact for the sake of truth perceived through the filter of time and imagination.[14] Durand, in his *Letters on Landscape Painting* (1855), insisted on total fidelity to nature without sacrificing sentiment.[15] In his hands, landscape became an expression of intensely personal religious understanding, rather than the sweeping revelations of Cole and his friend the Rev. Louis Noble. In adopting his general style, few of Durand's followers attained his spiritual depth or intellectual purity. By the early 1850s, the philosophy of Wordsworth and Emerson had become so widely accepted[16] that the attitude toward nature of most Hudson River painters was that form of generalized deism which Max Friedländer has called emotional pantheism.[17]

Whittredge was confronted by the unprecedented variety of style and subject that characterized American landscape painting after 1850. While Durand was seeking out the deepest recesses of the Catskills, John Kensett roamed its rivers and lakes.[18] Kensett also turned his attention to the New England coast, which he painted with the clarity and intensity of marine paintings by the luminist Fitz Hugh Lane. Lane's fellow Luminist Martin Johnson Heade imbued the New Jersey marshes with the aura of mystery, at once ominous and lyrical, that haunts his landscapes of Nicaragua and Florida.[19] Heade was drawn to the tropics by his friend Frederic Edwin Church, Cole's student. In primordial scenes of South America that were inspired not by William Cullen Bryant's poetry, but by Baron von Humboldt's *Cosmos*, Church articulated anew the belief in the nation's Manifest Destiny blessed by God.[20] Albert Bierstadt in turn traced the course of empire in its westward movement.[21] Despite this rich diversity, all of these artists practiced a meticulous realism of particulars, if not of conception, thanks in large measure to the pervasive influence of *Modern Painters* by John Ruskin, who advocated thoroughgoing naturalism.[22]

FIRST HUDSON RIVER PAINTINGS

The first canvases Whittredge painted after his return from Europe attest to the difficulties he faced adapting to the American landscape. *Study of West Point* (fig. 49), painted from nature around August 1860,[23] masters neither the terrain of the Hudson River nor the style of its painters. The unruly woods, with its profuse detail, presses uncomfortably against the observer and impedes his view of the river, while the unfamiliar light is translated into a pallid yellow-green tonality.[24] It must have been with considerable relief that Whittredge emerged from the primitive forest onto the vista in *Catskill Lake* (fig. 50), dated 1861. The composition, bathed in twilight, is a standard one for the Hudson River school. Like other landscapes by Whittredge from this period, the painting transposes the somber Romanticism of the Düsseldorf

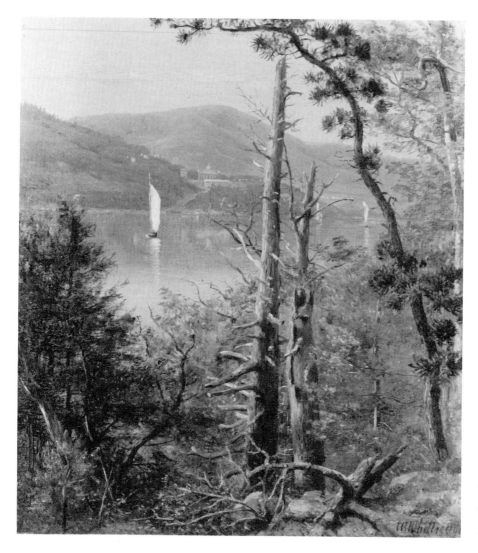

FIGURE 49. Worthington
Whittredge. *Study of West
Point*, 1860, oil on canvas,
12 × 11, present
whereabouts unknown.

school onto an American setting, demonstrating how hard "it was . . . for me
to shut out from my eyes the works of the great landscape painters which I
had so recently seen in Europe."[25]

Aesthetically and iconographically *Landscape with Hay Wain* (fig. 51) con-
stitutes the first major step in Whittredge's development as a member of the
Hudson River school. Probably finished in late 1861, the painting succeeds
in presenting "something new which might claim to be inspired by my home
surroundings." Yet as Henry Tuckerman noted in 1867, "It has been justly
said of Whittredge that his landscapes often 'give the aspect of foreigns scenes,
treated with remarkable fidelity, and with a degree of repose in harmony with
the sentiment of the country portrayed.'"[26] The canvas proceeds directly from
scenes Whittredge had painted in Rome. *Landscape with Hay Wain* essentially
translates the subject and composition from *Roman Campagna* (plate IV) into

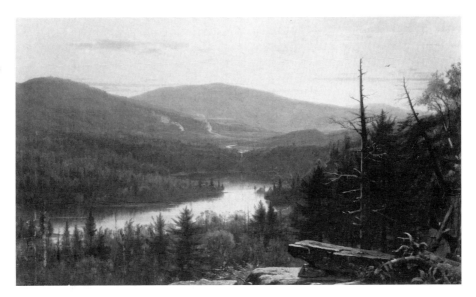

an American setting, adding features from *Morning on Lake Maggiore* (fig. 48)
and the tinted atmosphere of *The Amphitheater at Tusculum* (fig. 47).[27] Despite
the apparent manipulation of topography and light, the landscape conveys a
convincing impression of the Hudson Valley and may well incorporate ob-
servations made in an oil sketch around the same time as *Study of West Point.*

Landscape with Hay Wain is a self-consciously national landscape. The farm-
ers serve as a convention to establish the setting as the United States by adding
a note of regional picturesqueness, much as blacks and Indians do in genre
painting.[28] The land's bounty they are gathering stands in telling contrast to
the more modest harvest being reaped by the peasants in *Roman Campagna.*
In his effort to create a distinctly native work, Whittredge has introduced the
Stars and Stripes to the left of the cabins. The flag helps to identify the scene
specifically as the United States. It also serves to elevate the farmers to emblems
of the American pastoral ideal who live with beneficent nature in a state of
harmony, symbolized by the mellow sunset.[29]

Whittredge was formally instated as a full member of the National Acad-
emy of Design in 1862, though he may actually have been elected the previous
year, as indicated in his autobiography.[30] In addition to being an honor that
he treasured, election to the Academy was virtually a prerequisite of success.
The painters were the social lions of New York, and the humorous, cosmo-
politan Whittredge fitted easily into the circle of artists and businessmen
around the Academy. For him, these years were the high tide of American
landscape painting.

> [The Civil War] had disturbed many things, but strange to say,
> it had less effect upon art than upon many things with more

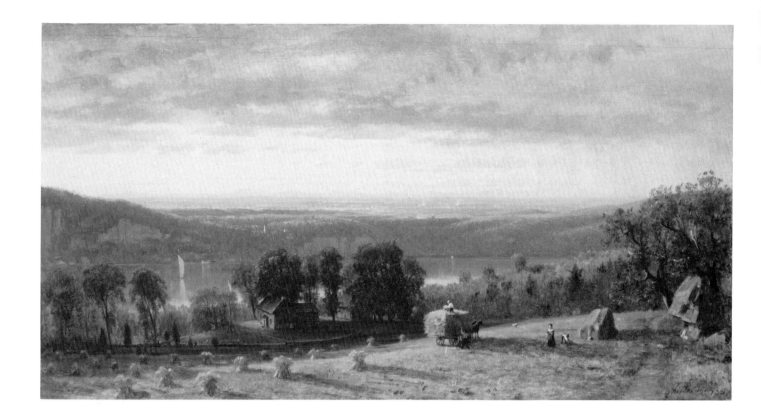

stable foundations. The Academy at 23rd Street and 4th Avenue was built chiefly during the war and it was during the war and a little later that the very popular artists' receptions were held there, for which it was often difficult to get a ticket, so many fine people were desirous of attending them. They were the great occasions for the artists to show their works and meet nearly all the lovers of art in the city. The painters sold their pictures readily and native art flourished more conspicuously than now.[31]

FIGURE 51. Worthington Whittredge. *Landscape with Hay Wain*, 1861, oil on canvas, 15⅞ × 30⅞, Cleveland Museum of Art.

Whittredge himself tried unsuccessfully to enlist in the Union Army in Baltimore and spent the war as a member of one of the sewing circles that were popular among genteel society in New York City.[32] His statement to the contrary, the war did have a serious impact on the New York art world. Along with several other artists, Whittredge was invited to join the Century Association after his election to the Academy, in part because the club was having trouble maintaining its membership.[33] Founded in 1846 by one hundred artists and writers, the Century, which still thrives, proved vital to Whittredge's career:

> [It] introduced me into the company of a rare set of gentlemen.
> The Club being composed of artists, literary men and amateur
> lovers of art and literature, the atmosphere of the place has

always been congenial to me. Among so large a body of representative men, an artist can associate with much benefit to himself, and apart from all its social pleasures I feel that my connection with the club has been of great advantage to me in my profession.[34]

Besides giving him entry to a wider circle of patrons, the club brought Whittredge into close contact with a group of intellectuals. Although this self-educated man never developed into a profound or original thinker, he had been drawn to similar circles in Cincinnati and Düsseldorf.[35] It was at the Century that Whittredge absorbed much of the philosophy which informs his autobiography. Much as it had earlier in his career, the rhetoric of the times was to play a formative role in his development as a Hudson River artist.

GENRE PAINTINGS

A deeper involvement with Romantic literature and art soon manifests itself in a group of some ten indoor genre scenes begun by Whittredge in 1862. *A Home on the Hudson* (plate V), the earliest of the series, shows a young woman arranging a bouquet of flowers in the simply appointed parlor of what is said to be the Louisa Nevins residence in Riverside, N.Y. *A Window, House on the Hudson River* (fig. 52) of 1863 probably shows the sitting room in the same house, as the view of the Hudson River is nearly identical. The light streaming in through the open bay window bathes the black nurse playing with an infant in an evocative atmosphere. The elegant interior, with its refined treatment, brings to mind the sumptuous settings in Eastman Johnson's portraits.[36]

Interior of the Bedroom of Thomas Whitridge (fig. 53) heightens the distinction between outdoor light and indoor atmosphere that is consistently maintained in these paintings. It provides a rare glimpse of his personal world by showing the home of his uncle in Tiverton, R.I., near Newport, where Whittredge began in the early 1860s to spend some of his summers. (For more on Whittredge at Newport, see Chapter 6.) In contrast to a painting of *Thomas Whitridge Reading* (private collection), the room is seemingly empty. Our presence is nevertheless strongly implied, as it is in Adolph Menzel's painting *The Balcony* (1845, Nationalgalerie, Berlin), which it recalls. The resemblance may not be entirely coincidental: Menzel was a well-known figure in Germany when Whittredge was in Düsseldorf.

The idyllic, if somewhat melancholic attitude toward nature conveyed by *Retrospection* (fig. 54) establishes that Whittredge must have been familiar with both the artistic and the literary traditions of the open window theme. In this widespread Romantic subject,

> The window is like a threshold and at the same time a barrier.
> Through it, nature, the world, the active life beckon, but the

77

[figure] remains imprisoned, not unpleasantly, in domestic snugness. It contrasts with what A. W. Schlegel called "the poetry of possession" – the intimate interior – with the "poetry of desire", the tempting spaces outside. This juxtaposition... adds a peculiar tension to the sense of distance, more poignant than could be achieved in pure landscape. The contrast be-

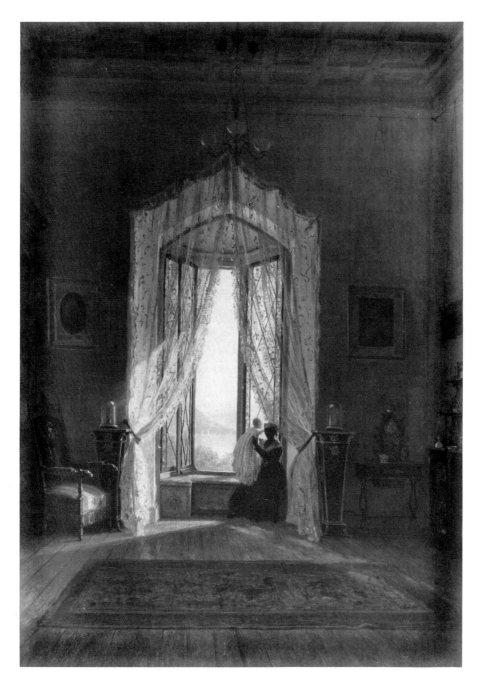

FIGURE 52. Worthington Whittredge. *A Window, House on the Hudson River*, 1863, oil on canvas, 27 × 19½, New York Historical Society.

tween the interior space and the space outside need not be literally represented to achieve this [poetic] effect. Some of these paintings merely hint at it.[37]

The old man staring wistfully out of the window conforms to a general type of contemplative figure that recurs in the sentimental Victorian genre paint-

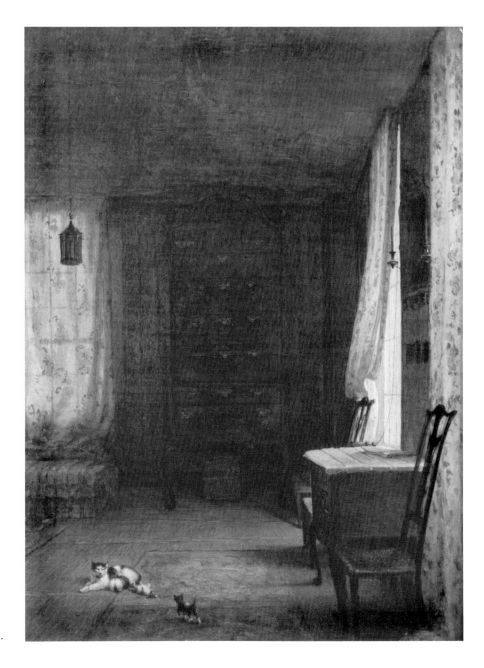

FIGURE 53. Worthington Whittredge. *Interior of the Bedroom of Thomas Whitridge*, c. 1863, oil on canvas, 24½ × 18½, Munson-Williams-Proctor Institute, Utica, N.Y.

ings of Eastman Johnson after 1860. Whittredge and Johnson had met in Leutze's Düsseldorf studio and formed a fast friendship that continued in New York, where the two artists frequently socialized together.[38] In the mid–1860s, they collaborated on several genre scenes, two of which, *Sunday Morning* (fig. 55) and *Springtime*: *Man Seated by a Hearth* (Yale University Art Gallery, New Haven), survive.[39] In the ascetic interior, an old woman is lost in meditation while her husband reads the bible by what is perhaps the light of religious revelation. Were it not inscribed W. Whittredge/figures by Johnson one would hardly guess that the painting involves two hands, let alone Whittredge's. The introspective mood and dry execution are more characteristic of Johnson's New England subjects. Thematically and visually the painting

FIGURE 54. Worthington Whittredge. *Retrospection*, 1864, oil on canvas, 22⅛ × 18⅛, Baltimore Museum of Art (on loan from Peabody Institute, Baltimore).

conforms to the peasant interiors popular in German nineteenth-century art
that provided the models for both artists.[40]

FIRST FOREST INTERIORS

The "primitive woods with their solemn silence reigning everywhere" left
Whittredge ill at ease, and although his sketchbook (Archives of American
Art, Washington, D.C.) contains several woods scenes from around 1860–1,
he did not attempt a painting of the deep wilderness until a year later, when
he had become acclimated to the American landscape and accepted the Hud-
son River school's philosophy of nature. His forest interiors rely on the ex-
ample of Asher B. Durand, who pioneered the genre. The germ of
Whittredge's conception begins to emerge in *The Glen* (fig. 56), which borrows
from Durand the asymmetrical view down the stream surmounted by an
arching canopy of twisted boughs. *The Pool* (fig. 57), completed later in 1862,
is a more accomplished and individual work.[41] The serenity of the woods has
stilled his earlier disquiet, and there is a new gravity that looks forward to his
mature work.

Whittredge's first great forest interior is *The Old Hunting Ground* (fig. 58).
After being exhibited at the National Academy in 1864, the painting was
acquired by James Pinchot and was included among the works assembled by
Samuel P. Avery for the Paris Exposition of 1867. Whittredge undoubtedly
came to know Pinchot, an important art collector, through Sanford Gifford,

FIGURE 56. Worthington
Whittredge. *The Glen*, 1862,
oil on canvas, 24¼ × 20¼,
formerly Douglas Collins,
North Falmouth, Mass.

who maintained a lively correspondence with him.[42] An etching was made of
the painting by H. C. Eno, who was related to Pinchot's wife, Mary Eno.

The Old Hunting Ground was quickly recognized as a major work. Henry
Tuckerman wrote:

> [Whittredge's] "Old Hunting Ground" has been well called an
> idyl, telling its story in the deserted, broken canoe, the shallow
> bit of water wherein a deer stoops to drink, and the melancholy
> silvery birches that bend under the weight of years, and lean
> towards each other as though breathing of the light of other

days ere the red man sought other grounds, and left them to
sough and sigh in solitude.[43]

The contribution of literature is central to the meaning of *The Old Hunting Ground*. The painting is a complex realization of William Cullen Bryant's poetry. The hoary, "forlorn trees [leaning] toward each other like the vaulted nave of a cathedral"[44] reflect Bryant's belief, expressed in "A

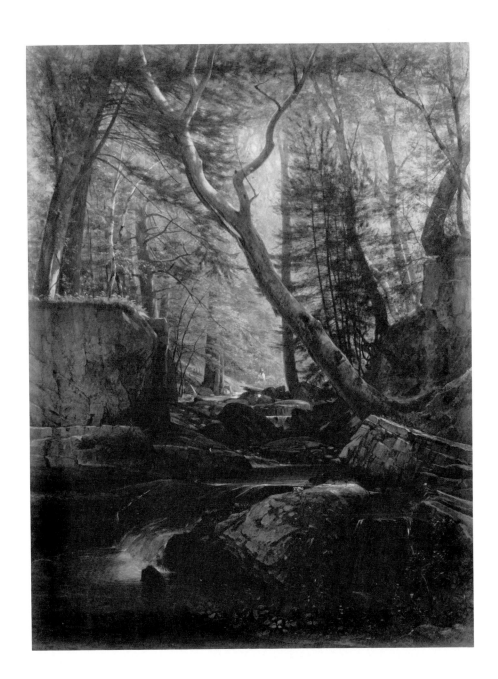

FIGURE 57. Worthington Whittredge. *The Pool*, 1862, oil on canvas, 54 × 41, owned by a private club.

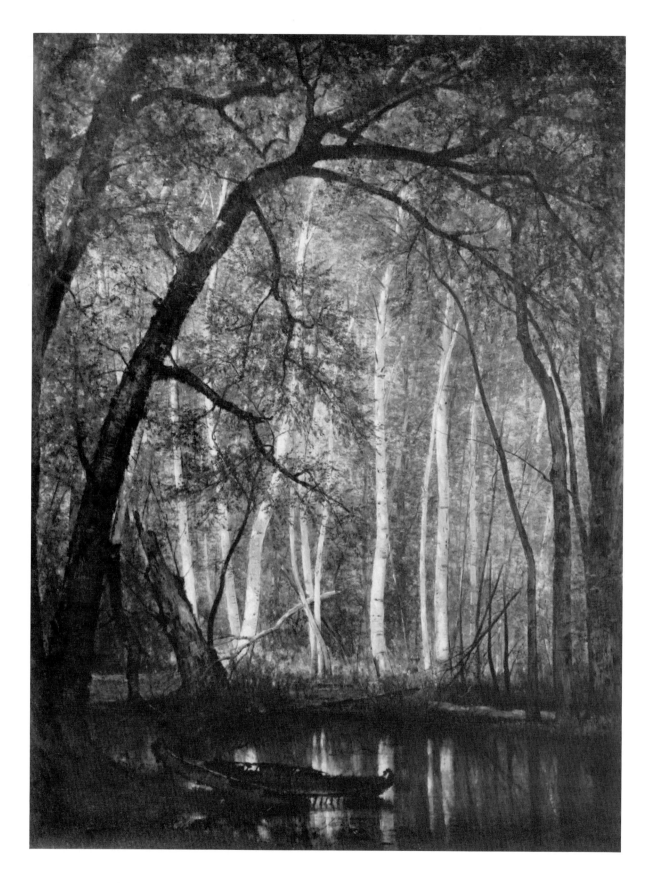

84

Forest Hymn," that "the groves were God's first temples," created as a "fit shrine for humble worshipper to hold Communion with his maker." The decaying canoe symbolizes a tragic vision of life closely related to the storm-tossed boat theme.[45] It inspires a nostalgic sentiment similar to that in Bryant's "A Walk at Sunset":

> For ages, on the silent forest here,
> Thy beams did fall before the red man came
> To dwell beneath them; in their shade the deer
> Fed, and feared not the arrow's deadly aim.
> The warrior generations came and passed,
> And glory was laid up for many an age to last.[46]

Whittredge was galvanized by the poetry of Bryant, whom he came to know well through the Century.[47]

> Bryant's poems had always affected me deeply. Many of them breathed a spirit of our forests, lakes and rivers so peculiar to their primitive lonesomeness that they struck a note in my breast scarcely touched by any other of our poets. There is no doubt that his poems had considerable influence in shaping the work of the landscape painters of the period.[48]

Whittredge used the Romantic naturalism of Durand's forest scenes to penetrate the spirit of Bryant's poetry. The painting has the grandeur of Durand's *In the Woods* (fig. 59) which, like his "Letters on Landscape Painting" published in *The Crayon* in 1855, owe a great deal to the poet.[49] The style, however, is Whittredge's own. A visual and expressive unity is created by the use of a painterly brushwork to suggest the dense foliage and a subdued palette to evoke the reverential mood.

The Old Hunting Ground fully absorbs the attitude of the Hudson River school toward nature by accepting her as a teacher of moral truths to be transmitted by the artist.[50] Yet as in Bryant's poetry, philosophy serves Whittredge primarily as the framework for expressing a personal experience which was the source of inspiration in the first place and which could therefore exist as an independent statement. In two later versions of the painting (Yale University Art Gallery, New Haven; Melville A. Kitchin, New York), Whittredge omitted the canoe and arching canopy, eliminating the overt symbolism while communicating the same elegiac mood. These are admittedly less effective than *The Old Hunting Ground*, however, for such devices heighten the viewer's reaction to landscape through a series of romantic associations.

FIGURE 58. Worthington Whittredge. *The Old Hunting Ground*, 1864, oil on canvas, 36 × 27, Reynolda House, Winston-Salem, N.C.

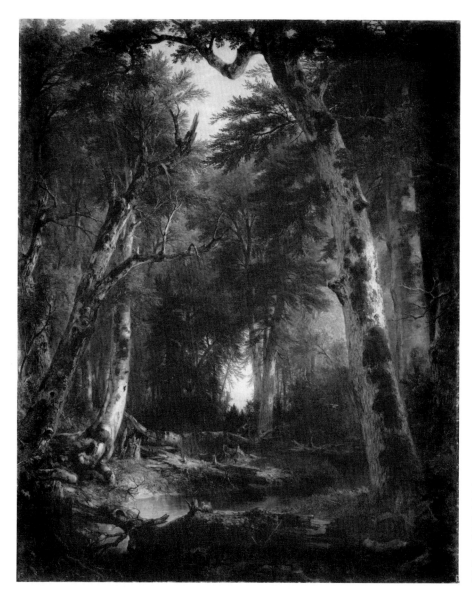

FIGURE 59. Asher B.
Durand. *In the Woods*, 1855,
oil on canvas, 60¾ × 48⅝,
Metropolitan Museum of
Art, New York. Gift in
memory of Jonathan Sturges
by his children, 1895.

SANFORD GIFFORD

With Asher B. Durand, Sanford Gifford was the central figure in Whittredge's
evolution as a Hudson River artist. The lifelong friendship between Gifford
and Whittredge began during the eight months they spent in Rome with
Albert Bierstadt in 1856–7. They maintained studios in the Tenth Street
building and moved in a tightly knit social circle that included Bierstadt,
Church, and Jervis McEntee.[51] Whittredge eulogized the dead artist at a mem-
orial meeting held by the Century Association in 1880 and included a warm
reminiscence in his autobiography.[52]

86

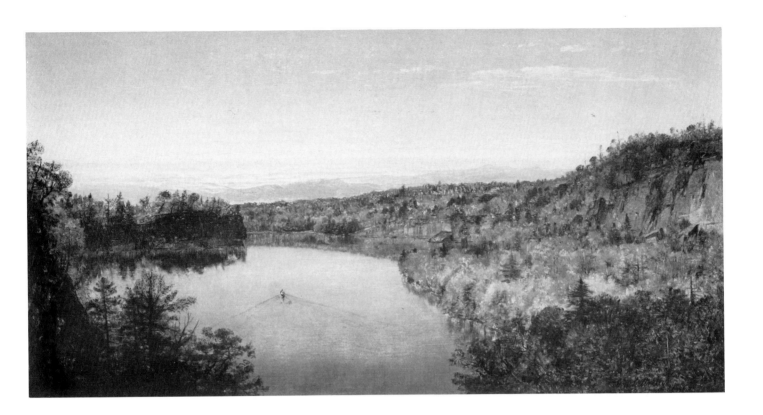

FIGURE 60. Worthington Whittredge. *On the Shawungunk*, 1863, oil on canvas, 12⅞ × 24¾, Indianapolis Museum of Art.

Using a glowing palette derived from Gifford, Whittredge was able for the first time to depict the fiery colors unique to the American autumn in *On the Shawungunk* (fig. 60) of 1863. *Rocks and Pines* (fig. 61) is similar to a study of Kauterskill Clove (fig. 62) by Gifford.[53] It is tempting to think that Whittredge's canvas represents another view of the clove, but the site may lie instead along the Shawungunk, where he painted a related oil sketch with his fellow Cincinnatian Alexander Wyant in 1864. With its plein air freshness, *Rocks and Pines* avoids the dry naturalism that sometimes afflicted the Hudson River school. Whittredge observed:

> The study of nature proved to be too strong meat for all the babes to digest. They never got beyond a literal transcript. Ruskin, in his "Modern Painters" just out then and in every painter's hand, had told these tyros nothing could be too literal in the way of studies, and the consequence was that many of them made carefully painted studies of the most commonplace subjects without the slightest choice or *invention* and exhibited them as pictures. It did not require a very shrewd critic to overhaul such work as this.[54]

87

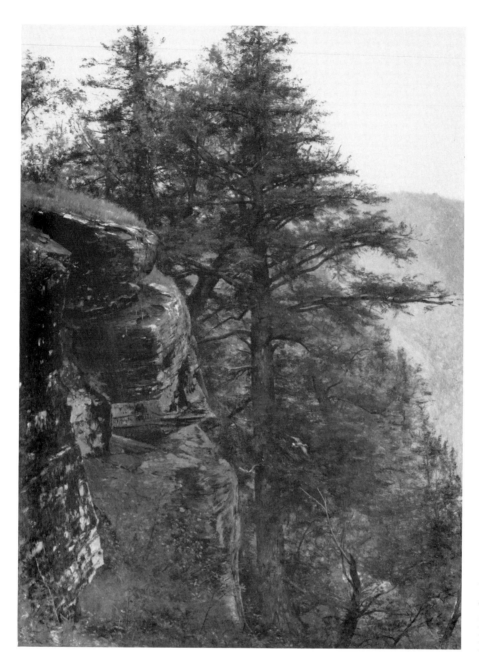

FIGURE 61. Worthington
Whittredge. *Rocks and Pines*,
c. 1863–4, oil on canvas,
29 × 22, Vassar College Art
Museum, Poughkeepsie,
N.Y.

Whittredge's initial difficulties upon returning from Europe had been
principally conceptual rather than executive. Gifford's example served to
demonstrate how Whittredge could adapt the lessons learned in Europe to
painting American scenery. Whittredge's growth can be seen in *Autumn
Landscape* (fig. 63). The painting has a coherent organization which allowed
him to paint each detail with a new clarity and precision, in contrast to the
clutter of *West Point* (fig. 49). Like his other studies of this period, *Autumn*

88

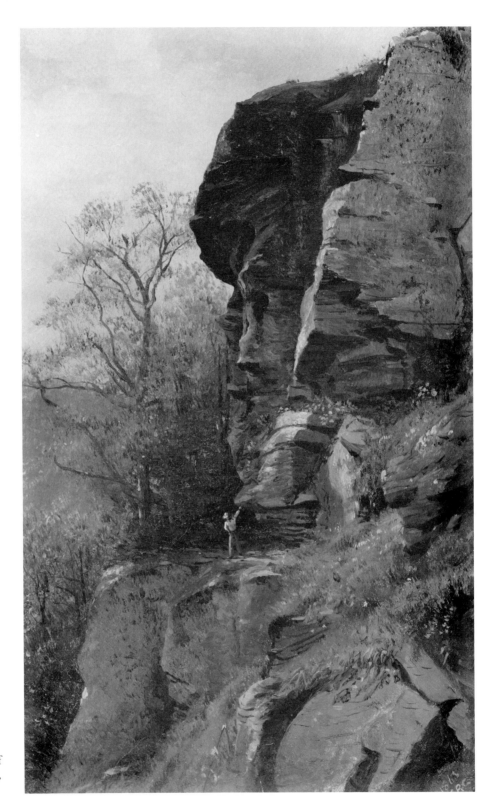

FIGURE 62. Sanford
Gifford. *Sketch of Cliffs in
Kauterskill Clove*, mid-1860s
oil on canvas, 18¼ × 11½,
present whereabouts
unknown. Photo courtesy of
Hirschl and Adler Galleries,
New York.

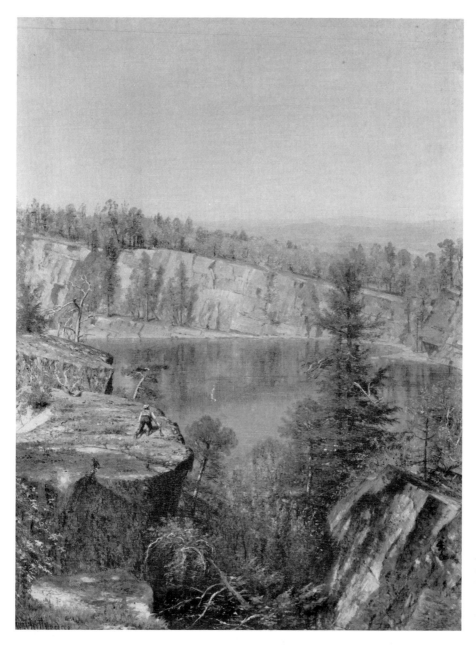

FIGURE 63. Worthington
Whittredge. *Autumn
Landscape*, c. 1863–5, oil on
canvas, 24¼ × 18¼, present
whereabouts unknown.
Photo courtesy of Hirschl
and Adler Galleries, New
York.

Landscape is still based firmly on his European experience. The composi-
tion recalls *The Foot of the Matterhorn* (fig. 34); yet it also harks back to the
much earlier *View from Hawk's Nest* (fig. 5). Henry Tuckerman noted this
confluence of American and European traits in a picture similar to *Autumn
Landscape*:

> There is sometimes not only a feeling *for* but *in* his color, which
> betokens no uncommon intimacy with the picturesque and
> poetical side of nature. In a little autumn scene, the deep

crimson of a creeper, a dreamy level, the true rendering of the trunk and branches of a tree, the clear, dark, calm lake, the many-tinted woods, and the manner in which the pervading light reveals and modifies all these, show that Whittredge unites to the American fidelity to nature in feeling, much of the practical skill derived from foreign study.[55]

FIGURE 64. Worthington Whittredge. *View of Kauterskill Falls*, c. 1864–5, oil on canvas, 22 × 32, private collection.

Around 1864–5 Whittredge painted two superb landscapes of Kauterskill Clove (fig. 64, plate VI). The site can be identified from a drawing from 1861 in one of his sketchbooks,[56] and from Sanford Gifford's paintings of the falls, where he spent many of his summers in a small boarding house in Palenville at the foot of a nearby Mountain Top.[57] In fact, it is possible that the two artists were working side by side. Certainly Whittredge took his stylistic lead from Gifford in both pictures. The smaller of the two pictures has the atmo-

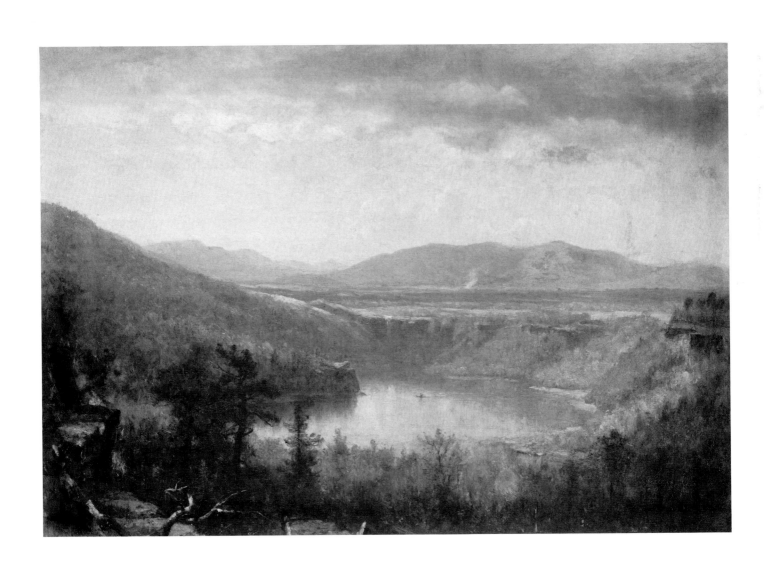

spheric qualities of Gifford's painting of Kauterskill Clove from 1862 (Metropolitan Museum of Art, New York), whereas the other has the hot pink colors that Gifford sometimes affected.

There is an additional significance to these landscapes beyond their artistic worth and that is Whittredge's experience of the place itself: Kauterskill Falls, dimly visible in the far distance, had been one of the most hallowed spots in the Catskills ever since James Fenimore Cooper celebrated them in his 1823 novel *The Pioneers*. It was, however, Thomas Cole who established the falls as a mecca for artists after his first trip to the Catskills in 1825. He was so closely identified with them that they provided the setting for Asher B. Durand's famous painting of Cole and the poet William Cullen Bryant, *Kindred Spirits* (New York Public Library). By the time Whittredge saw the clove, the Catskill Mountain House, which opened in 1824, had become an elegant resort, and the entire area was being deforested and quarried at a rapid rate.[58] This pilgrimage was nevertheless an essential part of his artistic repatriation, for it was one that every Hudson River painter had to make. Kauterskill occupied such an important position in the American ethos of nature that Whittredge's paintings mark his full assimilation into the native school.

In 1865, Whittredge painted the masterpiece of his career, *Twilight on the Shawungunk* (fig. 65). This great landscape, showing a view of the Wallkill Valley, was probably worked up as a showpiece expressly for that year's annual spring exhibition at the National Academy of Design,[59] which was held in conjunction with the opening of its new building on upper Fifth Avenue.[60] The canvas was bought by the collector and dealer Samuel P. Avery, who sold it two years later to W. B. Smith of Philadelphia. After being exhibited at the Centennial Exposition in Philadelphia, it dropped from sight for more than a century. Like *The Old Hunting Ground* (fig. 58), *Twilight on the Shawungunk* was recognized by Henry Tuckerman as "a memorable work . . . remarkable for its vivid and true effect of light – the deep yet clear amber gleam of the horizon in contrast with the wild and shadowy hills."[61] Beyond its size, which makes this one of the artist's largest productions, the canvas is unprecedented in Whittredge's oeuvre for consciously rivaling the machines of Frederic Edwin Church and Albert Bierstadt. These two artists were widely esteemed, by Tuckerman among others, as the greatest living landscape painters in the United States. Although they were among Whittredge's closest friends at the time, he rarely emulated them. Here, however, the high vantage point is adopted from Bierstadt's western scenes, such as *Wind River Country* (1860, formerly Kennedy Galleries, New York). *Twilight on the Shawungunk* has a nationalist rhetoric implicit in the brilliant sunset – a device taken from Church's paintings, notably *Twilight in the Wilderness* (Cleveland Museum of Art), which created a sensation upon being exhibited in 1860 and spawned a host of imitations.[62] *Twilight on the Shawungunk* owes something to Sanford

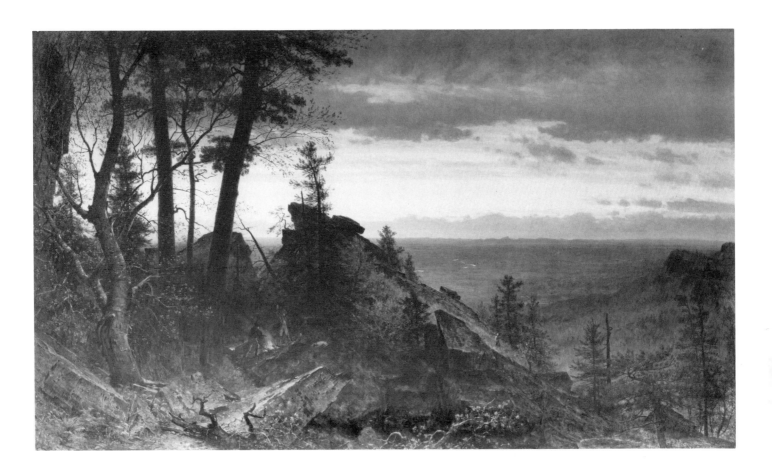

Gifford as well. The landscape has the twilight atmosphere often found in
Gifford's paintings of the 1860s.

The personal and artistic relationship between the two men was especially
intimate at this stage of their careers. It is interesting to note that Gifford,
too, executed a lost painting of *Twilight on the Shawungunk*, which was sold to
the Artists' Fund Society in 1877 but may have been executed much earlier.
In October 1866, Whittredge painted a small oil sketch from nature of Hunter
Mountain (Dee Wigmore Fine Arts, New York) that is nearly identical in view
to Gifford's *Twilight on Hunter Mountain* (Terra Museum of Art, Chicago). We
can be certain that Whittredge knew Gifford's painting. Gifford began work-
ing on the canvas in the autumn of 1865 and completed it in the following
year, when it was purchased by his close friend James Pinchot, who also owned
Whittredge's *The Old Hunting Ground*.[63]

Twilight on the Shawungunk anticipates Whittredge's western landscapes so
directly that two closely related canvases (figs. 66 and 67) executed around
this time have been mistaken for scenes in Colorado. *Mohawk*, wrongly titled
Indian Encampment in the Rockies, is based on a drawing in one of the artist's

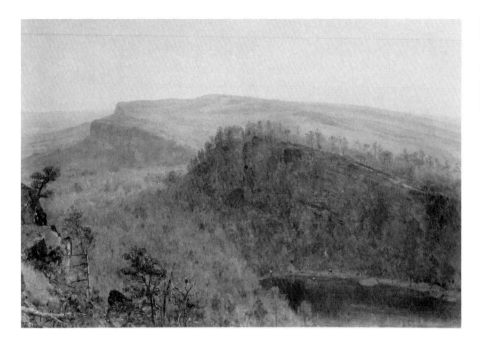

FIGURE 66. Worthington Whittredge. *Mohawk*, c. 1865, oil on canvas, 15 × 23, present whereabouts unknown. Photo courtesy of Kennedy Galleries, New York.

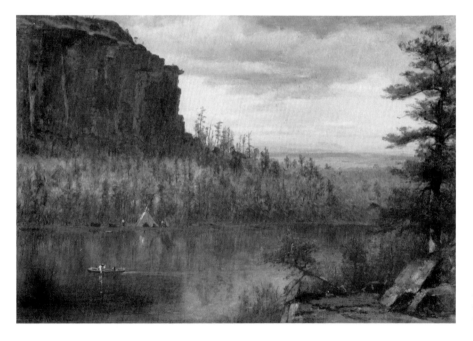

FIGURE 67. Worthington Whittredge. *Fishing in the Mohawk*, c. 1865, oil on canvas, 16 × 22½, present whereabouts unknown.

sketchbooks (Archives of American Art, Washington, D.C.) clearly identifying the locale in upper New York State. *Fishing in the Mohawk*, misnamed *Landscape near Fort Collins*, depicts a view of the same site just to the right. The error is further explained by the presence of tepees similar in kind to those found on the Great Plains, although these are sportsmen, not Indians.

LUMINISM

Whittredge's *Second Beach, Newport* (fig. 68), dated 1865, bears an equally close relation to the oil sketches Gifford painted that summer at nearby Cape Ann.[64] The scene features a landmark known as Bishop Berkeley's Seat and is perhaps related to a lost painting by that title which was one of Whittredge's best known works.[65] The rock is named for the famous cleric who landed in Newport in 1728 with the intention of founding a seminary in Bermuda and left four years later when a parliamentary grant failed to materialize. The painting conveys much the same sensibility as Bryant's "A Walk at Sunset":

> Yet, loveliest are thy setting smiles, and fair,
> Fairest of all that earth beholds, the hues,
> That live among the clouds, and flush the air,
> Lingering and deepening at the hour of dews.
> Then softest gales are breathed, and softest heard
> The plaining voices of streams, and pensive note of bird.

FIGURE 68. Worthington Whittredge. *Second Beach, Newport*, 1865, oil on canvas, 18 × 30, private collection.

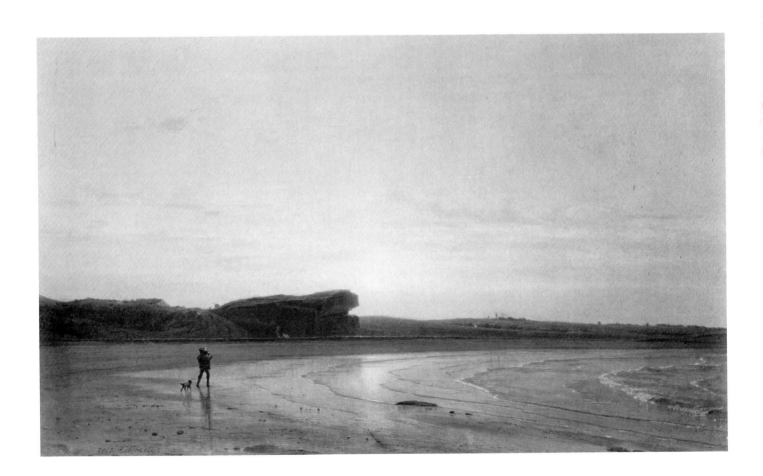

For Whittredge as for Bryant, twilight is the occasion for the reverence expressed in another line of the poem: "Give me one lonely hour to hymn the setting day." The expansive mood associates the landscape with the cosmos. The hushed awe of the clam digger walking along the sunset shore with his dog bespeaks a nearly mystical harmony with the universe.

Although there is no proof that they worked together in the summer of 1865, it was undoubtedly Gifford who led Whittredge to the luminism in *Second Beach*. Gifford frequently employed a glowing palette with exquisite refinement to veil the scene in a poetic mood that is the real subject of the landscape. American luminism was characterized by a finely nuanced treatment of light and atmosphere. According to John Baur, who defined the movement,

> Technically, [the luminists] were extreme realists, relying on infinitely subtle variations of tone and color to capture the magical effects. Spiritually they were the lyrical poets of the American countryside and the most sensitive and feeling and in the profound identification of the artist with what he portrayed. [The luminists], living at a time when pantheism was a genuine force, found in nature a presence and a spirit. Like Emerson, they became before her "a transparent eyeball," losing themselves completely in her moods. Their art is rapt, lyrical, filled with a sense of awe.[66]

Baur states that luminism arose spontaneously as a peculiarly native American tradition and implies that it presented an alternative to the Hudson River school. To Flexner, on the other hand, luminism was simply one aspect of normal Hudson River practice.[67] Novak argued further that luminist tendencies can be traced from the colonial period into the twentieth century and therefore constitute the underlying American tradition in painting, cutting across school lines.[68] Most recently, a team of leading scholars, writing in the catalogue of the mammoth exhibition held at the National Gallery of Art in 1980, surveyed the subject from a variety of viewpoints without reaching a consensus.[69]

Luminism was, in reality, a provincial style of marine painting imported by Thomas Birch, Joshua Shaw, and above all, Robert Salmon to the United States from Britain, where it continued to be practiced through midcentury by minor artists like Henry Pether and John Ward.[70] Using a self-effacing technique to render details of form and nuances of light, native marine painters such as Fitz Hugh Lane, Salmon's protégé whom Novak has called the paradigm of luminism, translated this English style into a cosmic vision closely related to the Transcendentalist theology of Ralph Waldo Emerson in which light acts as a spiritual messenger.[71] In a more general sense, luminism was a common vehicle of expression in European Romantic landscape painting stemming from the Claudian tradition. Luminist tendencies can be found in

the work of J. M. W. Turner and his follower Joseph Linnell in England; Caspar David Friedrich and Karl Blechen in Germany; and Théodore Gudin and Jean-Louis Coignet in France; not to mention a long list of Scandanavian and Russian painters who practiced the style concurrently with the Americans.[72]

Luminism was neither a spontaneous native tradition nor was it ever the leading tendency in American art. On the contrary, it was confined almost entirely to marine painting until the mid–1850s, when the Hudson River school began to expand its subject matter to include a detailed investigation of the interaction between light, water, and atmosphere. During the following decade, Hudson River artists found in luminism consonant means to express the awe they felt before nature's sublime poetry. Yet as Stebbins has rightly emphasized, luminism remained a minority style even among the artists with whom it has been identified most closely, Fitz High Lane and Martin Johnson Heade, let alone John Kensett and Sanford Gifford, its chief representatives among the Hudson River school.[73] By the time Whittredge painted *Second Beach* in 1865, however, luminism had become an integral part of the Hudson River aesthetic.

The religious connotations carried by luminist pictures were rarely as specific as has sometimes been claimed.[74] Despite theoretical differences in their outlooks, most American landscapists shared essentially the same spirituality, which they felt free to express in any appropriate visual terminology available to them, including luminism when it suited their purposes.[75] The Romantics sought to reveal the immanent divine in nature and to imbue their paintings with a personal sentiment, which is often one of vague longing. *Second Beach* possesses a timeless sense of mystical communion unburdened by the conscious symbolism of water as the mirror of God or of light as the instrument of revelation. Because it was a general style, luminism could also exist independently of content. In *Clam Diggers* (fig. 69), of a year or so later, luminism is completely divorced from all religious associations and is used solely to present an accurate transcription of the atmosphere along the New England coast on a brisk day. The staffage immediately announces the difference in intent between the two paintings: The trudging figures in *Clam Diggers* communicate none of the rapture of the lone man with his dog in *Second Beach*.

BARBIZON PAINTING

Because Newport was the artist's ancestral home, James Flexner remarks that "it was [therefore] not a brooding patrician but the log-cabin-born Ohioan who first painted the eastern seaboard as long inhabited. To Whittredge, one hundred and fifty years seemed a very long time."[76] To suggest a personal nostalgia, he employed a luminist sunset in *Farm near Newport* (c. 1866–1867, fig. 70), while adopting a Barbizon composition that associates New England

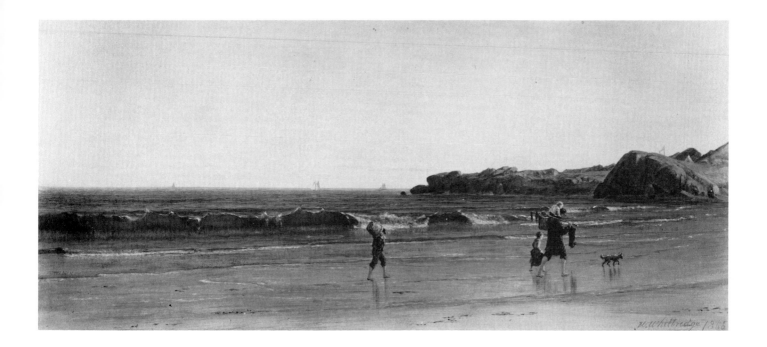

FIGURE 69. Worthington
Whittredge. *The Clam
Diggers*, 1866, oil on canvas,
10⅝ × 24¼, private
collection.

with the Old World. There is further evidence of the artist's renewed contact
with Barbizon landscapes. In 1864, he had included his name among the
backers of Samuel Avery for a sale of French art. That same year Whittredge
painted *Duck Pond* (fig. 71), which imposes Gifford's autumnal foliage onto a
composition reminiscent of Jules Dupré's paintings, for example *La Vanne*
(Louvre, Paris).[77]

As the dominant landscape school in America, Hudson River painting
found strength in diversity and selectively integrated aspects of seemingly
incompatible styles into its unifying vision. A decade later, when the fortunes
of the two schools were reversed, Whittredge would find it difficult to achieve
a comparable synthesis of elements from Barbizon and Hudson River paint-
ing. In the mid–1860s, though, he perceived no such incongruity. At the time,
Barbizon was an important factor only in Boston, where William Morris Hunt
extolled the work of Millet and Rousseau, and the dealer Seth Vose found a
ready market for Corot's landscapes.[78]

Even George Inness, the leading Barbizon painter in America, was still
working in an idiom that was largely grounded in the Hudson River school.
Although he certainly did not comprehend its radical implications, Whittredge
discovered in Inness's art solutions to the problem of how to depict the in-
teraction of light and atmosphere with water that paralleled his own luminist
investigation in *The Clam Diggers*.[79] *New England Coast Scene* of c. 1866–7 (fig.
72) shares optical and expressive qualities with Inness's *Clearing Up* (1860,
George Walter Vincent Smith Art Museum, Springfield, Mass.). The painting
marks the end of Whittredge's brief experiment with luminism, which he

98

abandoned altogether in 1867 as part of a larger change in style and outlook following his first trip out West (see Chapter 5).

STILL-LIFE PAINTING

On October 16, 1867 at the age of forty-seven, Whittredge married Euphemia Foote of Geneva, New York, who was his junior by seventeen years.[80] It may have been around the time of their honeymoon that he took a brief respite from landscape and painted *Apples* (fig. 73). He also executed *Autumn Guild* (formerly Douglas Collins, North Falmouth, Mass.) around the same time. American landscape specialists began painting still lifes as early as the 1820s. They rarely did more than a handful of them, and except for Martin Johnson Heade's flower pieces, most are simple fruit arrangements painted between roughly 1855 and 1870.[81] The affinity of landscapists for still life as a related

FIGURE 70. Worthington Whittredge. *Farm near Newport*, c. 1866–7, oil on canvas, 18 × 27½, present whereabouts unknown. Photo courtesy of Kennedy Galleries, New York.

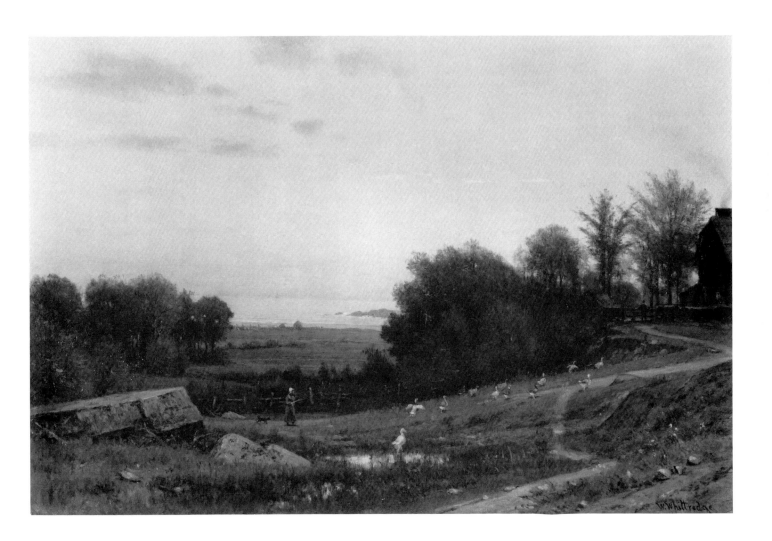

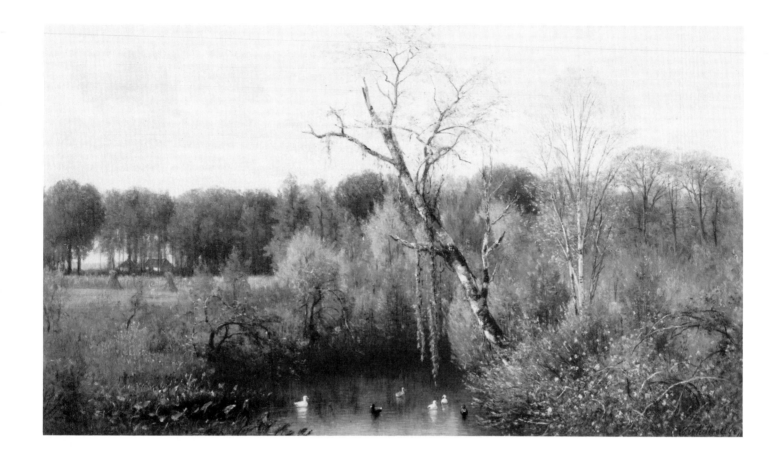

investigation of nature is peculiar to the nineteenth century. To them, still life was a diversion undertaken with an obvious relish that was hardly shared by portraitists, to whom such accessories were perhaps too familiar to be engaging. Although distinguished by their freer execution, the fruit pieces by these landscape painters are closely related to the American tradition of intensely observed still lifes stemming from the Peales. They have the charming appeal of works by Robert Spear Dunning and the Fall River school of still-life painting and share a Chardinesque concern for light and texture. Whittredge's picture is similar in style to *Green Apple* (1865, private collection) by his fellow Hudson River artist Jasper Cropsey, but is exceptional in showing the fruit still on the tree.[82] Bough paintings form a rare subcategory in American art distinct from trompe l'oeil still lifes.[83] Inspired by the writings of John Ruskin, most are nature sketches, but Whittredge's canvases, like some of Joseph Decker's, are clearly studio products.[84]

LATER FOREST SCENES

Whittredge's forest interiors underwent a metamorphosis toward a greater naturalism after the Civil War, beginning with *Pine Cone Gatherers* (1866, fig.

FIGURE 71. Worthington Whittredge. *Duck Pond*, 1864, oil on canvas, 18 × 30, present whereabouts unknown. Photo courtesy of Kennedy Galleries, New York.

74). If the space established by the cadence of the trees is not altogether convincing, the painting remains a faithful rendering of how diffused sunlight picks out the color and texture of the woods as it filters through the canopy to the undergrowth below. The landscape is based on an oil sketch (Dr. Olive C. Smith, Baltimore) that gives the appearance of having been done outdoors. The final painting introduces subtle adjustments in the composition and alters details of appearance to heighten the pictorial effect but otherwise follows the study closely.

Pine Trees, Minerva (c. 1866–8, fig. 75) was probably derived from a detailed oil or pencil sketch from nature as well.[85] The canvas is unusual in America, where landscapists seldom painted studies of trees, although they drew them regularly. Durand, however, observed the practice, and in his *Letters on Landscape Painting* gave a prescription that was followed by most Hudson River artists: "If your subject is a tree, observe particularly wherein it differs from those of other species; in the first place, the termination of its

FIGURE 72. Worthington Whittredge. *New England Coast Scene*, c. 1866–7, oil on canvas, 15 × 22, present whereabouts unknown.

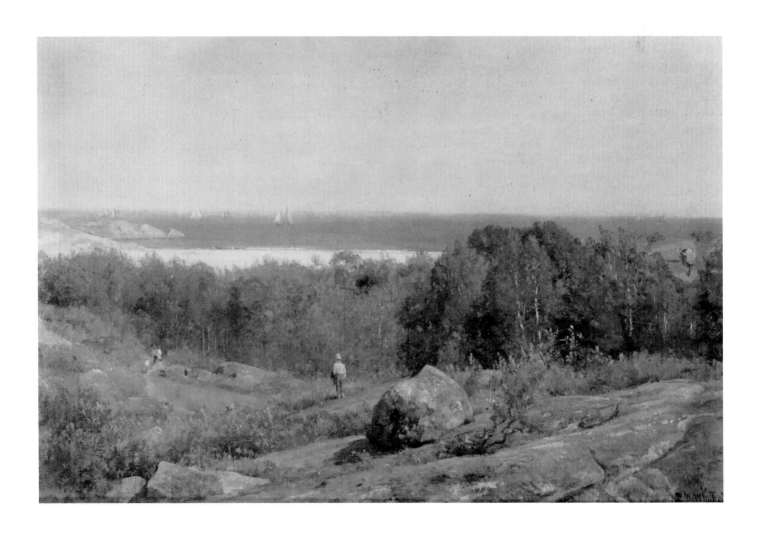

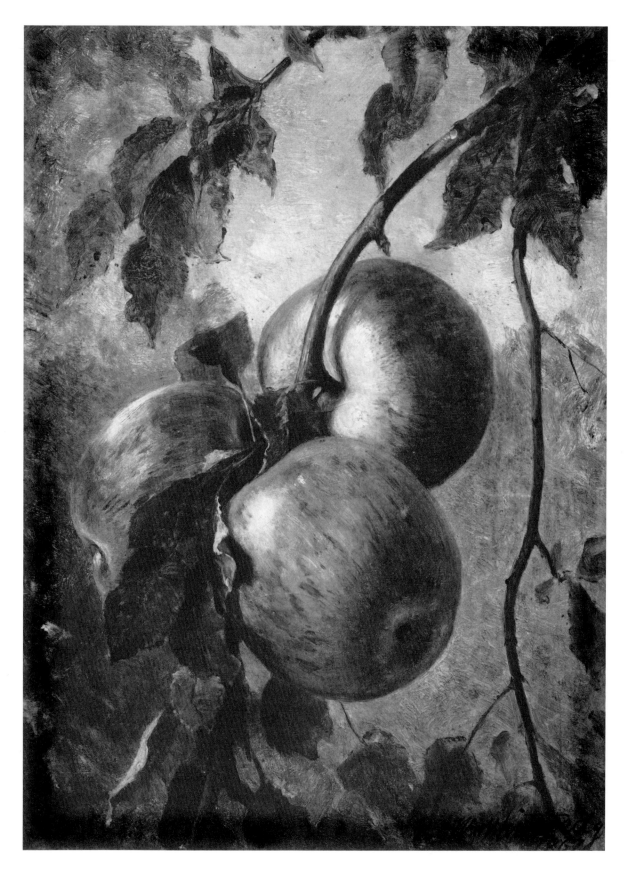

foliage, best seen when relieved against the sky, whether pointed or rounded, drooping or springing upward. Next mark the character of its trunk and branches, the manner in which the latter shoot off from the parent stem, their direction, curves and angles."[86] Although it departs from this formula, *Pine Trees* unites Durand's probing spirit with skills gained in Düsseldorf, where, as we have seen, Whittredge had painted a study of an oak. The strongly vertical composition endows the picture with the monumentality of

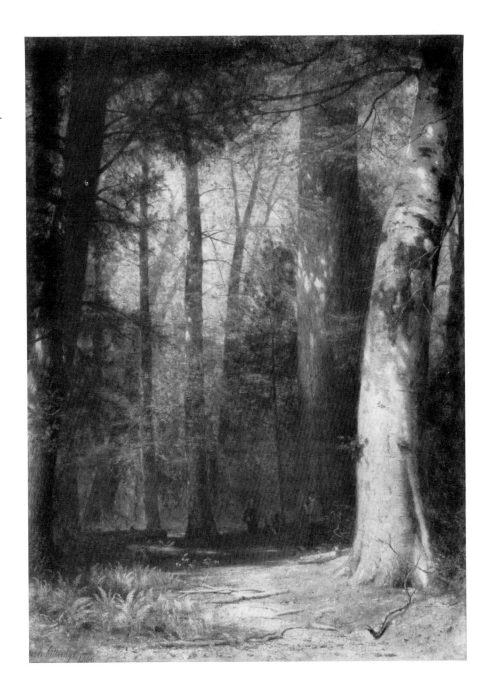

FIGURE 75. Worthington
Whittredge. *Pine Trees,
Minerva*, c. 1866–8, oil on
canvas, 36 × 14, Kennedy
Galleries, New York.

Summit, Sierra Nevada, California (early 1870s, present whereabouts unknown) by Whittredge's "student" Albert Bierstadt, whereas the treatment retains the intimacy distinctive to the Hudson River school.

View in the Ashocan Forest of 1868 (fig. 76) represents the culmination of the Romantic phase of Whittredge's forest scenes. This dignified landscape is infused with a poetic sentiment bespeaking an exaltation before nature that transcends the symbolism in *The Old Hunting Ground* (fig. 58). Like Durand's *In the Woods* (Metropolitan Museum of Art, New York), the painting communicates Bryant's mystical sense of nature as the instrument of individual understanding and spiritual salvation. At the same time, the exquisite refinement of light and wealth of details growing out of Whittredge's renewed investigation of nature express a tender lyricism.

A group of woods scenes painted immediately afterward reveals a markedly different attitude toward nature from the elevated feeling of *View in the Ashocan Forest*. The more open scene in *Boys Fishing in a Pasture Stream* (fig. 77), also painted in 1868, lends the picture a new note of wistful charm. It is typical of genre paintings from Williams Sidney Mount to Winslow Homer showing innocent youth in idyllic settings. Pictures like this of children beside a stream enjoyed a certain vogue after 1865.[87] Their gentle nostalgia, however, reflects more than the American idealization of childhood. As in Alexander Wyant's *Day Dreams, Mohawk Valley* (JoAnn and Julian Ganz Collection, Los Angeles), which incorporates the popular motif of the train in the wilderness to denote the progress of civilization, these landscapes poignantly convey America's loss of nature by equating her with the transient joys of youth.[88] Like Huck Finn, the lads in Whittredge's canvas seem to hark back to a bygone era when the United States was a more pastoral nation that had not yet given itself over to "progress."[89] The identification of the wilderness with virtue in America posed a dichotomy between nature and civilization.[90] In a larger sense, then, such landscapes also reflect the altered perception of America in the wake of the Civil War. They partake of the growing pessimism that undermined the earlier faith in the nation's destiny.

Fishing (fig. 78) completes the change in Whittredge's outlook. The artist now enters the wilderness as an urban man, not to seek spiritual solace or to worship God, but to escape civilization.[92] The woods in *Fishing* becomes a friendly retreat for the occasional outdoorsman, who delights in nature but no longer identifies with her. The canvas treats nature not as the spiritual healer in Bryant's "Inscription to the Entrance of a Wood," but as a place for refreshment in "The Fountain":

> Since then, what steps have trod thy border! Here
> On thy green bank, the woodman of the swamp
> Has laid his axe, the reaper of the hill
> His sickle, as they stopped to taste thy stream.
> The sportsman, tired with wandering in the still

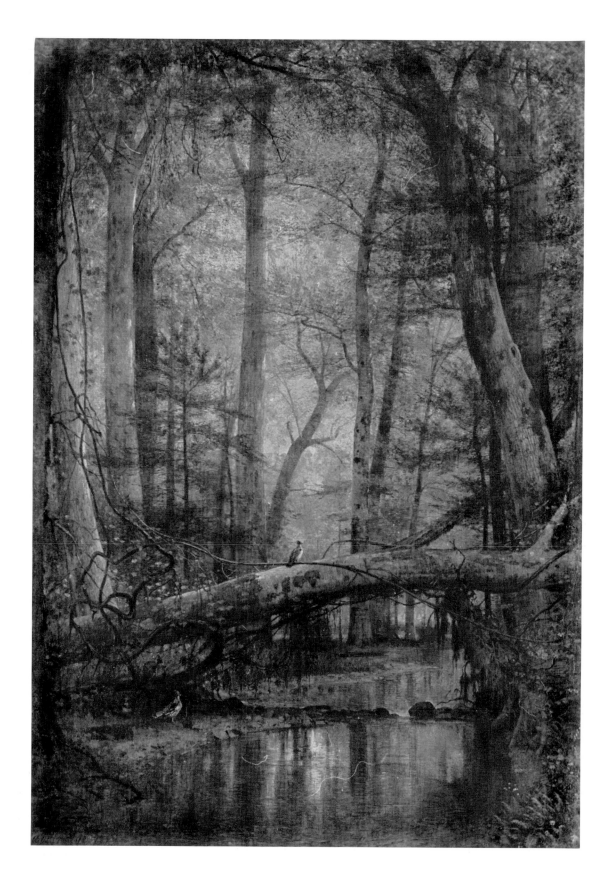

106

FIGURE 76. Worthington
Whittredge. *View in the
Ashocan Forest*, 1868, oil on
canvas, 57½ × 40¾,
Chrysler Museum of Art,
Norfolk, Va.

September noon, has bathed his heated brow
In thy cool current. Shouting boys, let loose
For a wild holiday, have quaintly shaped
Into a cup the folded linden-leaf.

Fishing shares a sense of foreboding with another passage from the same
poem:

Is there no other change for thee, that lurks
Among the future ages? Will not man
Seek out strange arts to wither and deform
The pleasant landscape which thou makest green?
Or shall the veins that feed thy constant stream
Be choked in middle earth, and flow no more

FIGURE 77. Worthington
Whittredge. *Boys Fishing in a
Pasture Stream*, 1868, oil on
canvas, 19½ × 31, private
collection.

The underlying message of Whittredge's paintings from the late 1860s is
that man can no longer abandon himself to nature; rather, it is nature that

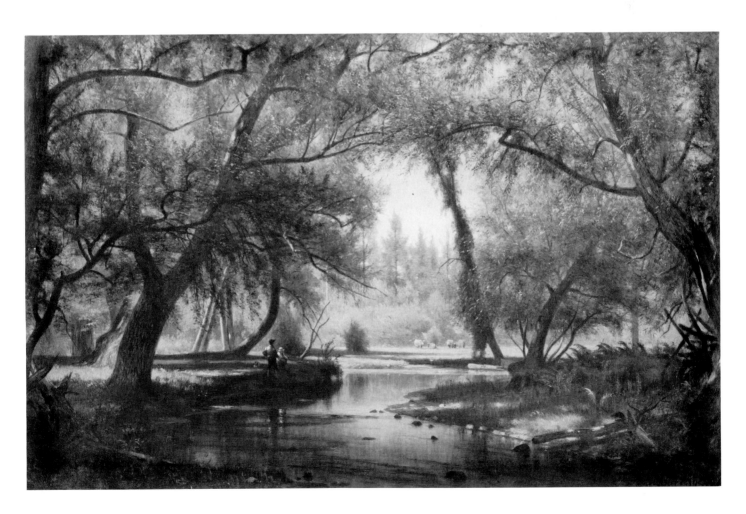

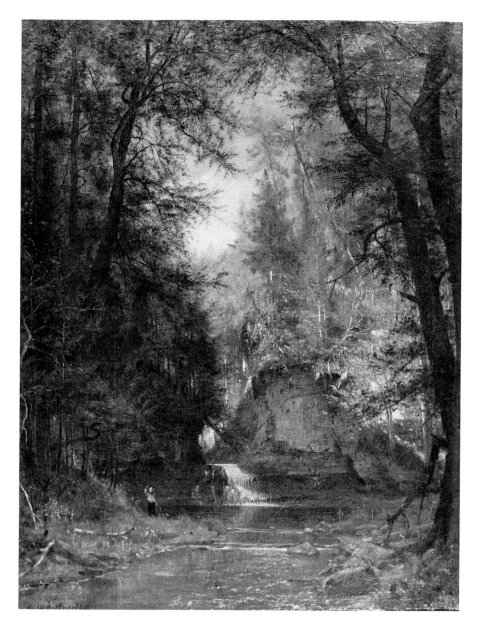

FIGURE 78. Worthington Whittredge. *Fishing*, 1868–70, oil on canvas, 21 × 17, the Reading Public Museum and Art Gallery, Pa.

will inevitably be lost to man. This shift in attitude is accompanied by one of style. *Fishing* is reminiscent of *Bash Bish Falls* (1855, National Academy of Design, New York)[93] by John Kensett, who replaced Durand as the main influence on Whittredge's forest scenes in the late 1860s and early 1870s. The bridge in *Bash Bish Falls* implies man's intrusion on nature,[94] a theme which is hardly, if ever, found in Durand's forest interiors but which distinguishes Whittredge's woods scenes of the period. Kensett's impact on Whittredge is felt most fully in *The Trout Pool* (fig. 79) of 1870.[95] The canvas follows a type

FIGURE 79. Worthington Whittredge. *The Trout Pool*, 1870, oil on canvas, 36 × 27⅛, Metropolitan Museum, New York.

108

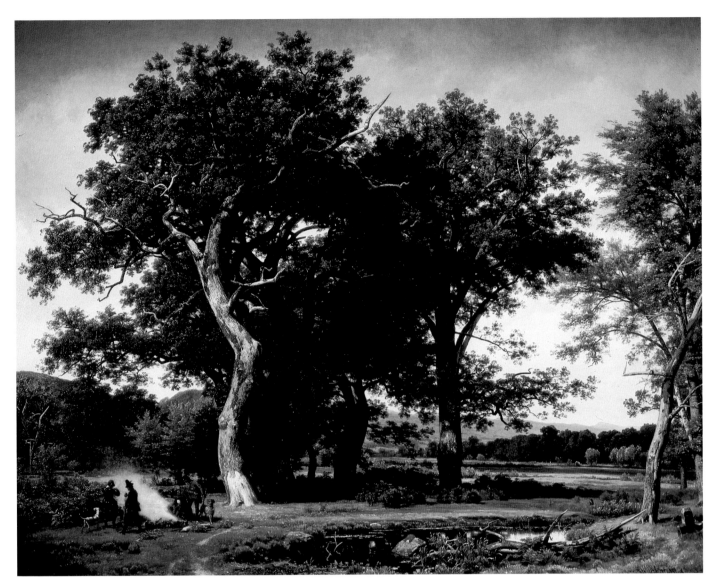

PLATE I. Worthington
Whittredge. *Landscape near
Minden*, 1855, oil on canvas,
52½ × 66¼, Shearson-
Lehman Collection, New
York.

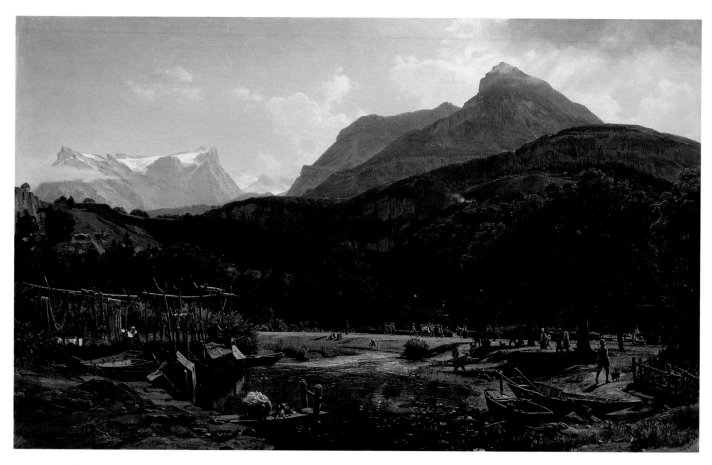

PLATE II. Worthington Whittredge. *View near Lake Lucerne*, 1857, oil on canvas, 33 × 53¼, Brooklyn Museum of Art, New York.

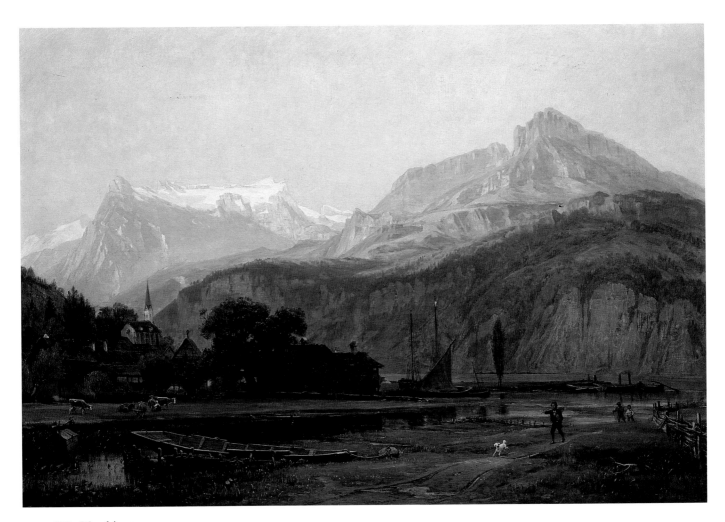

PLATE III. Worthington
Whittredge. *The Bay of Uri,
Lake Lucerne,* 1859, oil on
canvas, 14 × 24, private
collection.

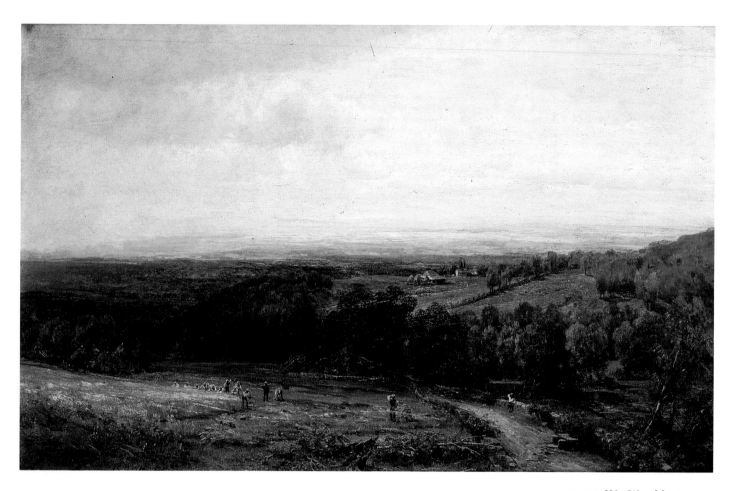

PLATE IV. Worthington Whittredge. *Roman Campagna*, 1857, oil on canvas, 24 × 39, photograph courtesy Sotheby's, Inc., New York.

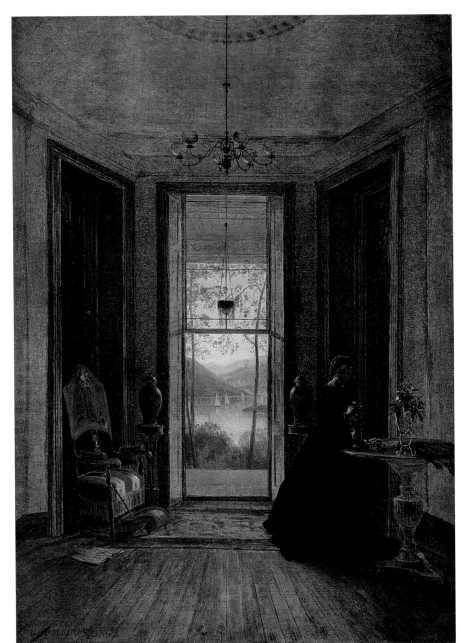

PLATE V. Worthington
Whittredge. *A Home on the
Hudson*, 1862, oil on canvas,
26⅞ × 19⅛, Jeffrey W.
Cooley, Simsbury,
Connecticut.

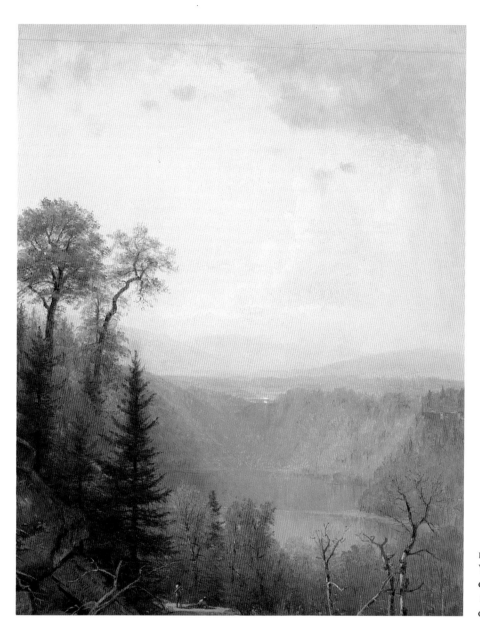

PLATE VI. Worthington
Whittredge. *Kauterskill Clove*,
c. 1864–5, oil on canvas,
19½ × 15½, private
collection.

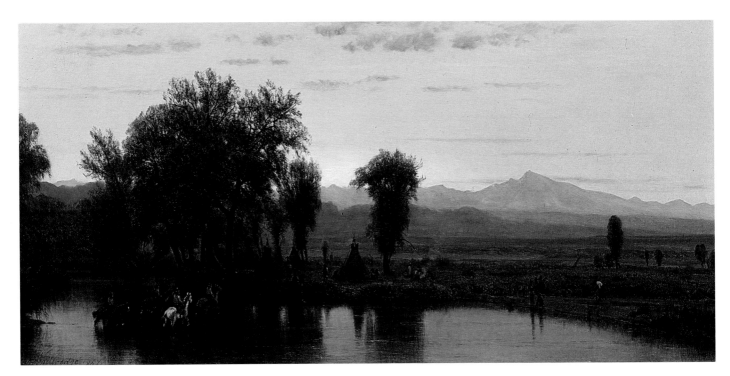

PLATE VII. Worthington
Whittredge. *Indians Crossing
the Platte River*, 1867, oil on
canvas, 11 × 22, private
collection.

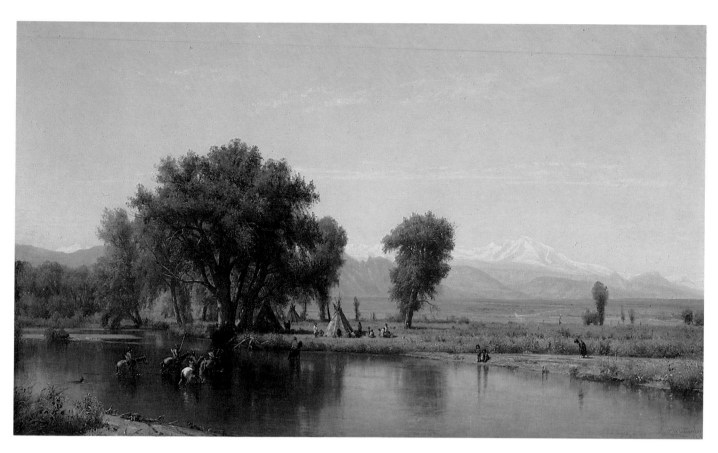

PLATE VIII. Worthington Whittredge. *Crossing the Ford (The Plains at the Base of the Rocky Mountains)*, 1867–70, oil on canvas, 40 × 68, Century Association, New York.

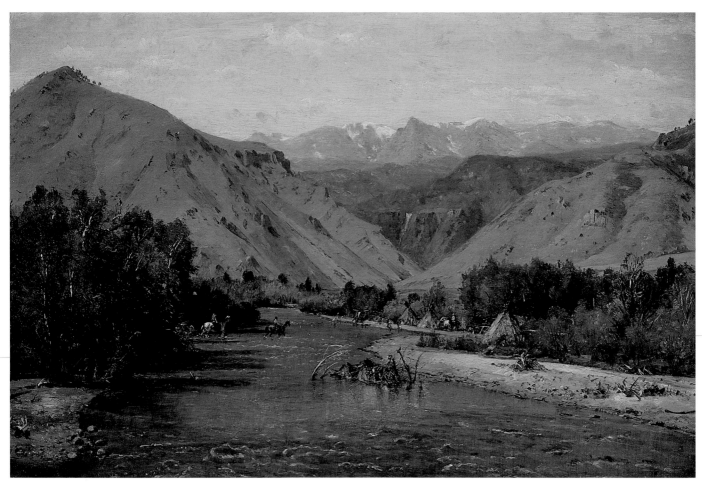

PLATE IX. Worthington
Whittredge. *Indian Encamp-
ment on the Platte (II)*, c.
1870–2, oil on canvas,
14½ × 22, Mongerson-
Wunderlich, Inc., Chicago.

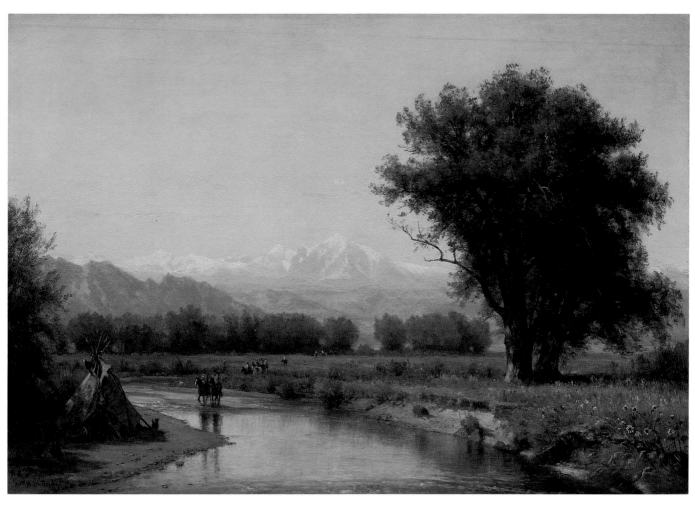

PLATE X. Worthington
Whittredge. *Indian Encamp-
ment on the Platte River (III)*,
c. 1872, oil on canvas, 22 ×
32, private collection, photo-
graph courtesy Spanierman
Gallery, New York.

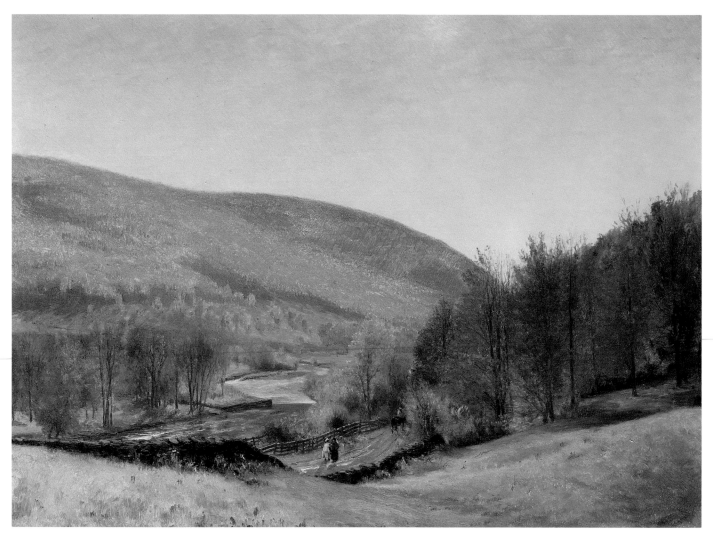

PLATE XI. Worthington
Whittredge. *Autumn Land-
scape*, c. 1874–6, oil on can-
vas, 16 × 22, private
collection.

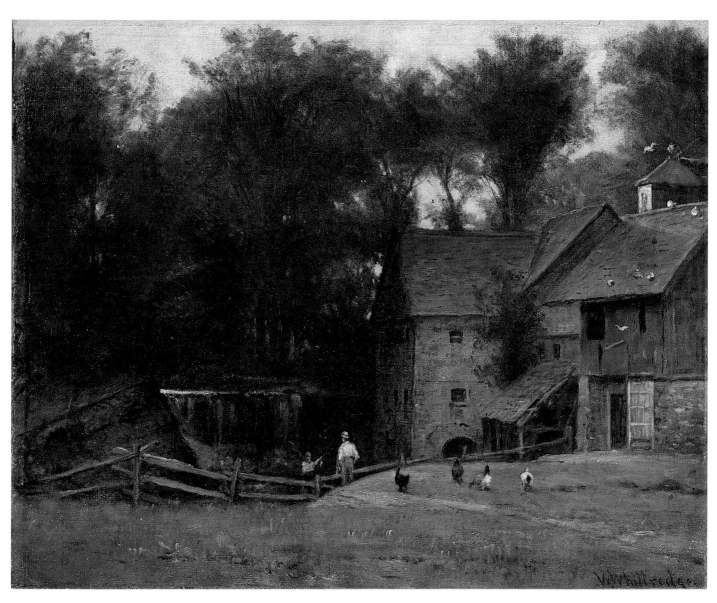

PLATE XII. Worthington
Whittredge. *The Mill, Sims-
bury, Conn.*, c. 1875, oil on
canvas, 13½ × 17¼, present
whereabouts unkown.

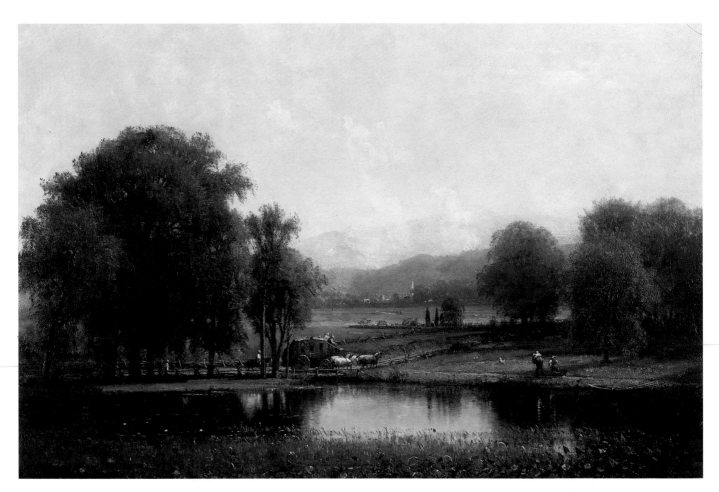

PLATE XIII. Worthington
Whittredge. *The Morning
Stage*, 1875, oil on canvas,
24 × 36, Arthur Lesser,
New York.

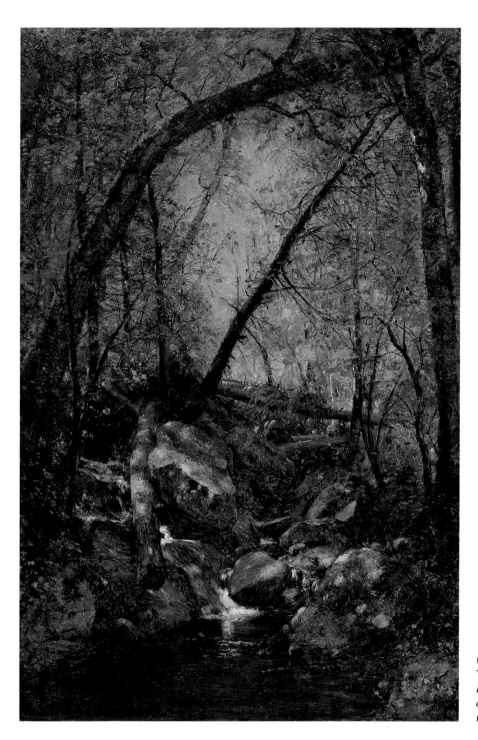

PLATE XIV. Worthington
Whittredge. *Sunshine on the
Brook*, early 1870s, oil on
canvas, 23 × 15¼, Spanier-
man Gallery, New York.

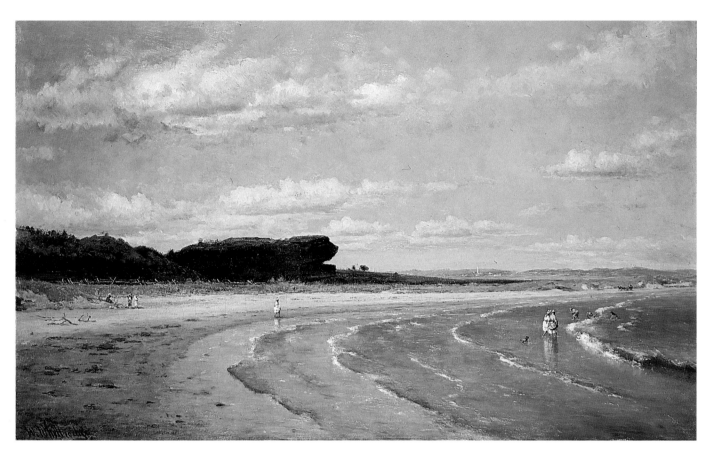

PLATE XV. Worthington
Whittredge. *Second Beach*, c.
1880–1, oil on canvas, 30⅛
× 50⅛, private collection.

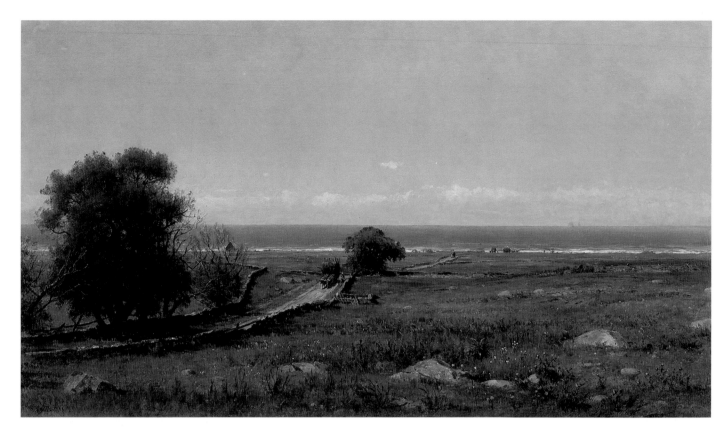

PLATE XVI. Worthington Whittredge. *The Old Road to the Sea*, 1884, oil on canvas, 31 × 51, private collection, photograph courtesy Spanierman Gallery, New York.

Frederick G. "Jerry" Sain

Frederick G. "Jerry" Sain died May 15, 1996, at his son's home near Sandpoint, Idaho.

Born October 11, 1926, in Salt Lake City, Utah, to Henry and Margaret Thomas Sain. He attended Salt Lake City schools, graduating from East High School.

During World War II, he served in the Philippines and Japan in the U.S. Army. He received a BFA in 1950 and MFA in 1953 from the University of Utah.

He was married to Mary Lou Harper from 1948 until 1974, and to Diana Anderson from 1976 to 1986.

Jerry worked for the telephone company for 32 years, starting as an artist for Mountain Bell yellow pages in Salt Lake City. In 1957 he became the art director of the Albuquerque, New Mexico, division. He was transferred to Denver, Colorado, in 1962 as Regional Art Director for U.S. West and later became the Director of Marketing for U.S. West. He resided in Denver after his retirement in 1987 until shortly before his death.

He is survived by two children from his first marriage, Leslie Ann (Jeff) Lasher of Everett, Wash., and Thomas M. (Becky) Sain of Sandpoint, Idaho; two children from his second marriage, Lindsay M. and Jessica L. Sain of Denver, Colo.; three grandchildren, Michael and Elisha Lasher and Erin Sain; three brothers and a sister, Eugene H. Sain of Salt Lake City, Myrtle Bowen of West Valley City, Richard J. Sain of Omaha, Nebraska, and Howard C. Sain of Centerville.

A private family memorial was held in Sandpoint and as he had requested, his ashes will be kept at the family mountain cabin.

T 5/26 N 5/26

of composition found in paintings by Kensett, including one of the same title from a year later (formerly Abbott Academy, Andover, Mass.). This is not the rapturous hymn of *View in the Ashocan Forest*, but a civilized vision of hospitable nature presented with meticulous realism; nor does the painting attain the same lyrical harmony, despite its serenity. We experience a rush of pleasure on approaching the enchanting scene, with its dazzling sunlight and cool, moss-green shade. *The Trout Pool*, Whittredge seems to say, is paradise regained, not on God's terms but man's.

5

Western Landscapes

Western landscapes occupy an unusually prominent place in the oeuvre of Worthington Whittredge for a self-proclaimed member of the Hudson River school. Executed over an eleven-year span, they chart the artist's progress at the height of his career, when he was considered among America's premier landscape painters. Their legacy consists of over forty oil sketches and studio paintings. The largest ones include four masterpieces that share in the grandeur of canvases by Albert Bierstadt and the Rocky Mountain school, but differ in character by otherwise adhering to the Hudson River aesthetic.

First Tour of the West: 1866

Whittredge's autobiography includes a lengthy and vivid description of his first visit to the West, which made a profound impression on him. The beginning of the narrative has given rise to some confusion about the date of the trip. He writes, "At the close of the Civil War, I was invited by General [John] Pope to accompany him on a tour of inspection throughout the department of the Missouri."[1] The original manuscript continues, "We left Fort Leavenworth on the first of June 1866, thirty days after Lee's surrender,"[2] which actually occurred on April 9, 1865. Because of a typographical error, Baur's edition gives the dates as June 1865 to September 1866. As Moure has demonstrated, however, letters published in congressional documents place General Pope at his headquarters in Saint Louis through the summer of 1865 and prove that the inspection tour took place in 1866.[3] The later date is confirmed by a description of the artist in Henry Tuckerman's *American Artist Life*, published in 1867, from a correspondent who met him in Colorado the year before.[4]

The expedition left Fort Leavenworth, Kansas, in early June for Fort Kearney, Nebraska. From there it probably traveled the Oregon Trail and then followed the South Platte River into Colorado before heading west, apparently from Fort Morgan to Fort Collins on the Cache la Poudre River. After a layover of several days in Denver, at that time hardly more than a

large mining town, the company made its way past the Garden of the Gods along the eastern base of the Rocky Mountains, crossing them near the Spanish Peaks and picking up the main trail to Santa Fe. It was at Santa Fe that Whittredge met Kit Carson, whom he describes at length in his autobiography. Pope's forces continued on to Albuquerque, where they remained long enough for Whittredge to take a week's excursion through the Tuerto Mountains with two officers in search of some overdue gold prospectors. During a second visit to Santa Fe in late July the artist sketched negotiations with the Ute chief Kaniatchie and painted a view of the town (fig. 80). At Fort Union, New Mexico, Pope filed a lengthy report to General Sherman in Washington and conducted an inspection of the post while his men refitted their equipment. On the final leg of the return journey, they took the Old Santa Fe and Cimarron trails across the arid Llano Estaccado to Fort Riley, Kansas, and disbanded. Whittredge then caught the nearby Southern Pacific Railroad back to New York via Saint Louis in mid-August.

The expedition with General Pope had a profound effect on the artist. Although he had grown up on what was then the frontier, participation in the great national adventure of opening the West consolidated his vision of the United States. Whittredge's autobiography, written nearly forty years later, recalls details and events of the journey with an astonishing vividness that expresses the wonder of discovery. The western land also stirred the painter's imagination:

> I had never seen the plains or anything like them. They impressed me deeply. I cared more for them than for the mountains, and very few of my Western pictures have been produced from sketches made in the mountains, but rather from those

FIGURE 80. Worthington Whittredge. *Santa Fe*, 1866, oil on canvas, 8⅛ × 23⅛, Yale University Art Gallery, New Haven. Gift from the estate of William W. Farnam, B.A. 1866, M.A. 1869, to the Peabody Museum of Natural History.

112

made on the plains with mountains in the distance. Often on reaching an elevation, we had a remarkable view of the great plains. Due to the curvature of the earth, no definite horizon was visible, the whole line melting away, even in that clear atmosphere, into mere air. I had never seen any effect like it. . . . Nothing could be more like an Arcadian landscape than was here presented to our view.[5]

Undertaken at the height of his involvement with the Hudson River school, the summer of intense sketching out west in 1866 served as an important catalyst in the formation of Whittredge's mature style, which relied on the faithful rendering of light and color for much of its effectiveness. Because of his essentially pastoral vision, he preferred to depict the plains, and the western oil sketches dating from 1866 deal almost exclusively with them and similar terrain rather than with mountains. Most were painted on easily portable half-sheets of paper roughly 10 x 23 inches in size, a format ideal for capturing the horizontal sweep of the seemingly endless plains. They were generally executed after one o'clock in the afternoon, when the caravan would stop for the day.[6] *Encampment on the Plains* (fig. 81) shows just such a layover. This sunlit study is very similar to some of Albert Bierstadt's early western sketches, suggesting that Whittredge looked at his colleague's work to get an advance look at the West and how to paint it. If so, he gained little from the exposure, since his work is otherwise very different in character. Although some are comparatively brief notations, *Graves of Travelers, Fort Kearney* (fig. 82) and *Long's Peak* (fig. 83) are typical of Whittredge's sketches in their careful attention to detail and fresh observation of light. The blue and green colors capture the melting visual effect in his description. At the same time, they evince the artist's deep sense of identification with nature.

Once back in New York, Whittredge began translating his studies into

FIGURE 81. Worthington Whittredge. *Encampment on the Plains*, c. 1866, oil on paper mounted on board, 7½ × 23, Gene Autry Museum, Los Angeles.

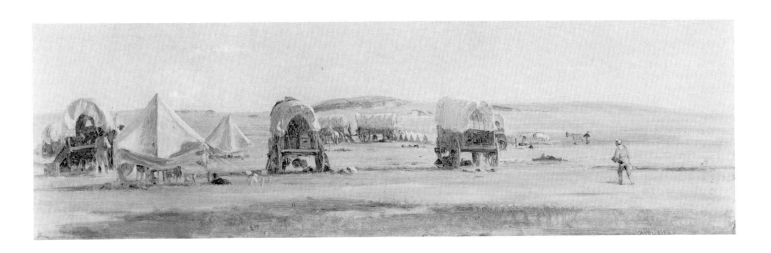

canvases, which differ little at first from the sketches themselves. *The Lonely Graves* (George Walter Vincent Smith Art Museum, Springfield, Mass.), for example, is a slightly narrower and taller version of *Graves of Travelers, Fort Kearney*, except for the addition of clouds gathering at dusk to heighten the mood of the melancholy scene. He soon began to manipulate light and topography more freely. *Indian Camp on the Platte* (fig. 84) must closely follow a lost sketch, but when the artist returned to the subject in *Twilight on the Plains* (fig. 85) he not only imposed a sunset atmosphere, but also reworked the foreground, enlarging the sweep of the river, while making several adjustments in the background.

Whittredge's twilight western landscapes culminate in *Indians Crossing the*

FIGURE 82. Worthington Whittredge. *Graves of Travelers, Fort Kearney*, 1866, oil on paper mounted on canvas, 8 × 22¾, Cleveland Museum of Art.

FIGURE 83. Worthington Whittredge. *Long's Peak,* c. 1866, oil on paper, mounted, 8¼ × 21¾, Joslyn Art Museum, Omaha.

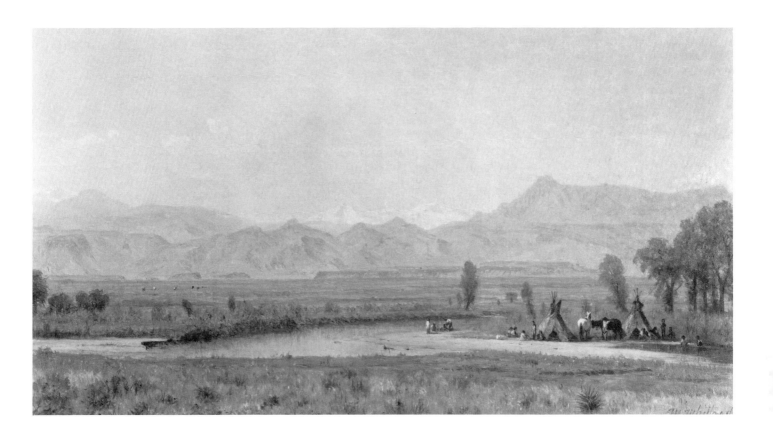

FIGURE 84. Worthington
Whittredge. *Indian Camp on
the Platte*, c. 1866, oil on
canvas, 8⅞ × 16⅞, present
whereabouts unknown.
Photo courtesy of Kennedy
Galleries, New York.

Platte River, dated 1867 (plate VII). It is derived from an oil sketch from
nature (fig. 86) inscribed Long's Peak from Denver/W. Whittredge June 27
1866. The sketch, on loan to the Buffalo Bill Historical Center since 1984, is
the most detailed and beautiful of Whittredge's known studies from his first
trip west. Intervening between the sketch and painting is a series of small oil
studies that explore the rich pictorial possibilities inherent to the subject,
although the final results follow the main outlines of the original composition.

 The picture has a complex symbolic content derived from the poetry of
William Cullen Bryant. As in "A Walk at Sunset" by Bryant, which had acted
as a source of inspiration for Whittredge's forest scenes, the evanescent light
in *Indians Crossing the Platte River* becomes a simile of the red man's disap-
pearance by eliciting a nostalgic reverie imbued with tragic overtones:

> So, with the glories of the dying day,
> Its thousand trembling lights and changing hues,
> The memory of the brave who passed away
> Tenderly mingled...
> The warrior generations came and passed,
> And glory was laid down for many an age to last.

115

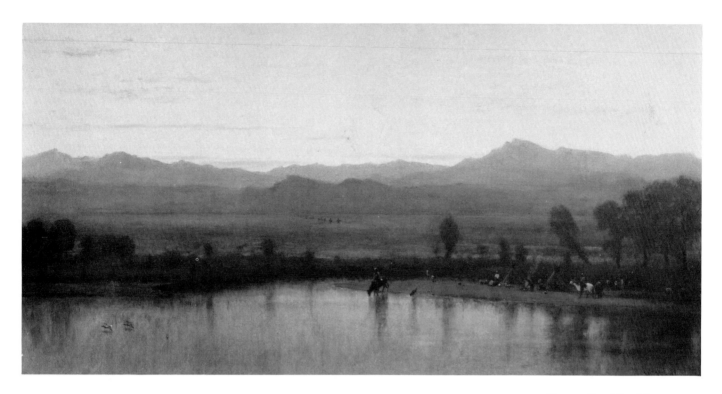

FIGURE 85. Worthington
Whittredge. *Twilight on the
Plains*, c. 1867, oil on canvas,
14½ × 29, present
whereabouts unknown.

Now they are gone, gone as thy setting blaze
 Goes down the West, while night is pressing on,
And with them the old tales of better days,
 And trophies of remembered power, are gone.

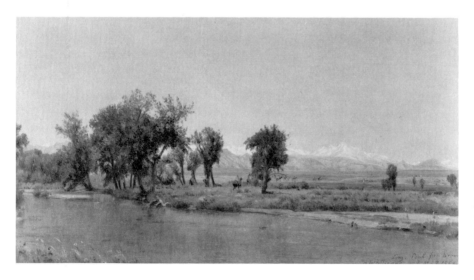

FIGURE 86. Worthington
Whittredge. *Long's Peak from
Denver*, 1866, oil on canvas,
12¾ × 23¼, Anonymous
loan to the Buffalo Bill
Historical Center, Cody,
Wyo.

Whittredge's painting also incorporates the Indians' plight in "The Prairies" by Bryant as a warning to America about the transience of civilization and the implicit danger of progress at the expense of nature:

> The Prairies. I behold them for the first,
> And my heart swells, while the dilated sight
> Takes in the encircling vastness.
> Man hath no power in all this glorious work:
> A race, that long has passed away,
> Built them; a disciplined and populous race
> Heaped, with long toil, the earth, while yet the Greek
> Was hewing the Pentelicus to forms
> Of symmetry. . . . The red man came –
> The roaming hunter tribes, warlike and fierce,
> And the mound-builders vanished from the earth.
> Thus change the forms of being. Thus arise
> Races of living things, glorious in strength,
> And perish, as the quickening breath of God
> Fills them, or is withdrawn. There man, too,
> Has left the blooming wilds he ranged so long,
> And, nearer to the Rocky Mountains, sought
> A wilder hunting ground.

Visually and iconographically, *Indians Crossing the Platte River* is an American counterpart to Whittredge's *Aqueducts of the Campagna* (fig. 42) from 1859. The meaning is not as immediately apparent as in the Italian landscape, which, as noted previously, is a complex allegory exemplifying George Hillard's comment that the Roman plain "is a great historical palimpsest, from which the towns and cities of a subdued race have been expunged, in order to make room for the proud structures of a conquering people, which now, in their ruins, are no more than monuments of lost power and memorials of faded glory."[7] The reason is that Bryant's poetry provides no more than a loose philosophical framework for the imagery in the western painting. Through a visual analogy with *Aqueducts of the Campagna*, the glimmering light in *Indians Crossing the Platte River* communicates the artist's rapt appreciation of the plains that "nothing could be more like an American landscape." The red men identify the scene, however, as a specifically American paradise. Although he shared General Pope's distrust of Indians as dangerous savages,[8] Whittredge depicts them as living in an ideal state of nature similar to that enjoyed by the pioneers in his early landscape *The Crow's Nest* (fig. 15). Their harmony with the universe is signified by the sunset in the broad panorama. The elegiac mood established by the evening glow further acts to suggest the artist's underlying sympathy with a vanishing way of life.

To express this vision Whittredge turned to luminism, heightening the effects observed in *Aqueducts of the Campagna*. In *Indians Crossing the Platte River*

Whittredge adopted the refined brushwork and tinctured light of Sanford Gifford's *Twilight on Hunter Mountain* (Terra Museum of Art, Chicago), transforming light and atmosphere into palpable entities but without imposing a veil between the subject and viewer. The harmonious crimsons and purples evoke the sense of tenderness mingled with mystery shared by Gifford's work.[9]

Soon after finishing *Indians Crossing the Platte River*, Whittredge began *Crossing the Ford* (plate VIII), which repeats the composition but adheres more faithfully to the oil sketch from nature. The large canvas represents a major departure in style and outlook from his previous work. The artist rejects luminism and its philosophical associations in favor of a more direct approach. He has applied a lighter palette using a painterly brushwork to create the impression of spontaneous plein air naturalism devoid of all symbolic references. The freely rendered atmosphere lacks the visionary precision that characterizes Whittredge's luminist landscapes. In its attempt to capture fleeting light effects, *Crossing the Ford* remains faithful to an actual experience instead of to an artistic idea. The lyric sentiment imparted by the delicate tonality seems to emanate from nature itself rather than being imposed artificially from literature.

The changes introduced in *Crossing the Ford* are related to the broad changes that took place in the United States after 1865. Although the picture appears to be more optimistic than *Indians Crossing the Platte River*, there is a considerable difference in attitude. America was still recovering from the Civil War, while being transformed rapidly by the Industrial Revolution. The fratricide left deep emotional scars that altered the nation's mental fabric, while the precarious balance between nature and progress shifted once and for all in favor of civilization. "The Civil War," Henry James wrote in 1879, "marks an era in the history of the American mind. It introduced into the national consciousness a certain sense of proportion and relation of the world being a more complicated place than it had hitherto seemed, the future more treacherous, success more difficult."[10] Thus the artist was no longer able to resort to patriotic allegory. He was left instead with his primary reaction to landscape, for the Romantic conception of nature had hardly been questioned yet. If Nature was no longer seen to reflect God and His moral laws directly, it nevertheless continued to be a teacher – only its lessons were now more personal.

Whittredge could therefore act as more than a faceless recorder of visual perceptions. Like many other Romantic landscapists, he elevated his intimate love of nature to a universal statement by painting *Crossing the Ford* on a monumental scale. Here it is size rather than colored light that acts as an index to the pantheistic feeling inspired in him by God's sublime creation. The enlargement of the scene relies on skills Whittredge had gained in Europe during the 1850s. In the left portion of the canvas he follows compositional solutions found in *Landscape near Minden* of 1855 (plate I). Although adhering to principles learned from the Schirmer school in Düsseldorf, he reveals the inner poetry of nature by allowing it to speak for itself as directly as possible.

This synthesis of European and American experience in a large painting produces a new fullness of expression that marks a turning point in Whittredge's career.

Because of its size, *Crossing the Platte* necessarily competes with the epic western scenes of Albert Bierstadt, but it does so on essentially different terms. Absent are the dramatic forms and light favored by the Rocky Mountain painters. Instead, the quiet side of nature is depicted with a sympathetic understanding characteristic of Hudson River artists. Whittredge himself underscored the difference between the two schools:

> Great railroads were opened through the most magnificent *scenery* the world ever saw, and the brush of the landscape painter was needed immediately. Bierstadt...answered the need. For more homely scenery this need was answered by a group of artists known as the Hudson River School – all of whom I knew, and one of whom I was.[11]

SECOND VISIT TO COLORADO: 1870

Crossing the Ford bears the dates 1868 and 1870. According to the contemporary critic Henry Tuckerman, the painting was finished in 1867.[12] Whittredge certainly considered the picture complete upon exhibiting it the following year at the National Academy of Design as *The Plains at the Base of the Rocky Mountains*. Yet the canvas remained in his studio because he was dissatisfied with the trees. It was for this reason that he decided to return to Colorado in the summer of 1870:

> I went twice to the Rocky Mountains after my first visit, these last times by railroad. The first of these later visits was undertaken because I had gotten into some trouble with one of my pictures. On my first visit to Denver I had made a sketch from near our camping ground, from which I had begun a large picture. The trees did not suit me. I remembered a group of trees I had seen on the Cache la Poudre River, fifty miles from Denver, which I thought would suit my picture better. I undertook the journey to make sketches of them. They were finally introduced into the picture, much to its improvement.[13]

The artist's quest for the right trees was perhaps inspired by an incident he witnessed in Rome during 1859: Lord Frederic Leighton went to the Isle of Capri in search of a specific lemon tree for one of his paintings and returned a month later with detailed drawing in hand.[14]

The repainting in *Crossing the Ford* appears indeed to be confined largely to the major stand of trees, which are more powerful than the slender forms

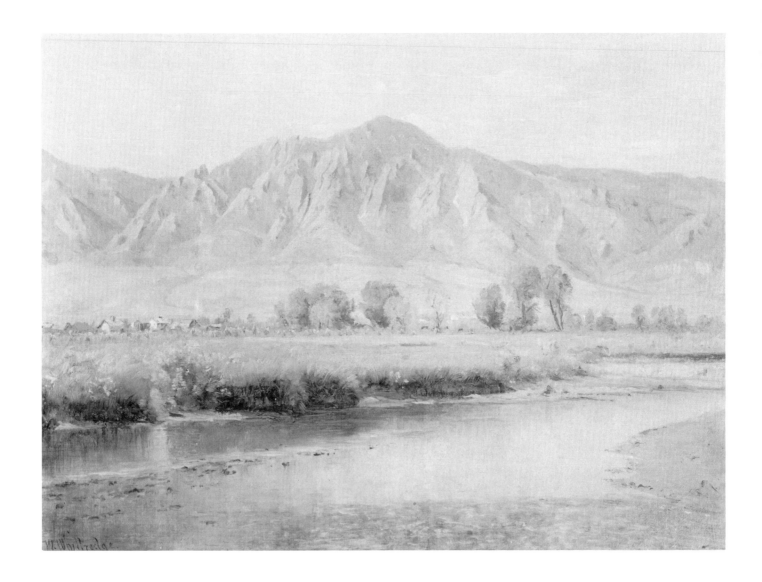

in *Indians Crossing the Platte River*. The execution is uneven, however, as is the finish of the surface, suggesting that Whittredge may have reworked other parts of the landscape as well. Finally, in 1871, the canvas was presented by a group of thirty-eight subscribers to the Century Association. The club regularly purchased works from its more prominent members. In 1867, the year Whittredge began *Crossing the Ford*, John Kensett received the princely sum of $5,000 for *Mount Chocorua*, which remains his largest landscape. It is fitting that the two paintings now flank a fireplace at the Century, for they have strong affinities. James Flexner observes that *Crossing the Ford*

> had resemblances to Kensett's more panoramic Eastern views:
> the distant mountains served as walls to close the picture in,

FIGURE 87. Worthington Whittredge. *Valmont Valley*, c. 1870, oil on canvas, 11¾ × 15¾, private collection.

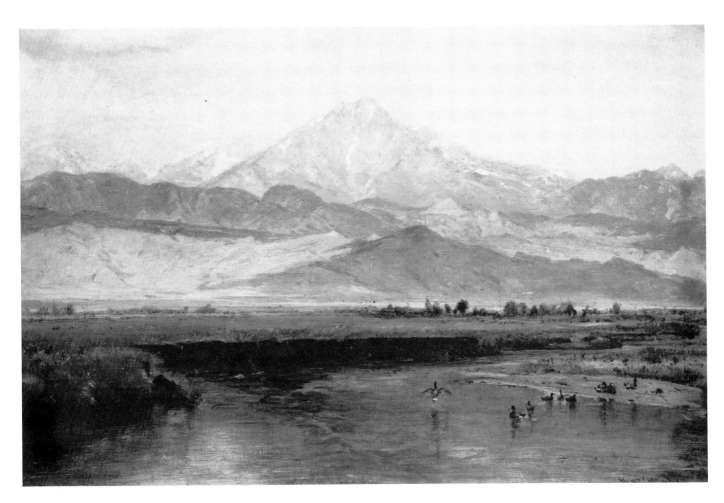

FIGURE 88. Worthington
Whittredge. *Long's Peak (II)*,
c. 1870, oil on canvas, 14½
× 22, M. and M. Karolik
Collection, Museum of Fine
Arts, Boston.

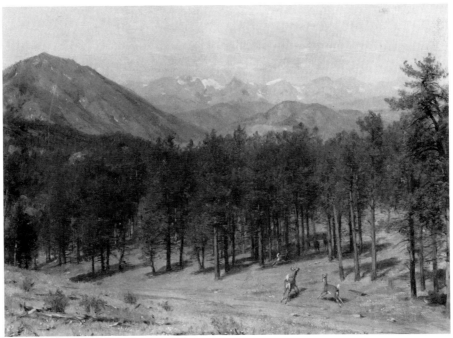

FIGURE 89. Worthington
Whittredge. *In the Rocky
Mountains*, c. 1870, oil on
canvas, 14⅜ × 20, the
Harmsen Collection,
Tucson.

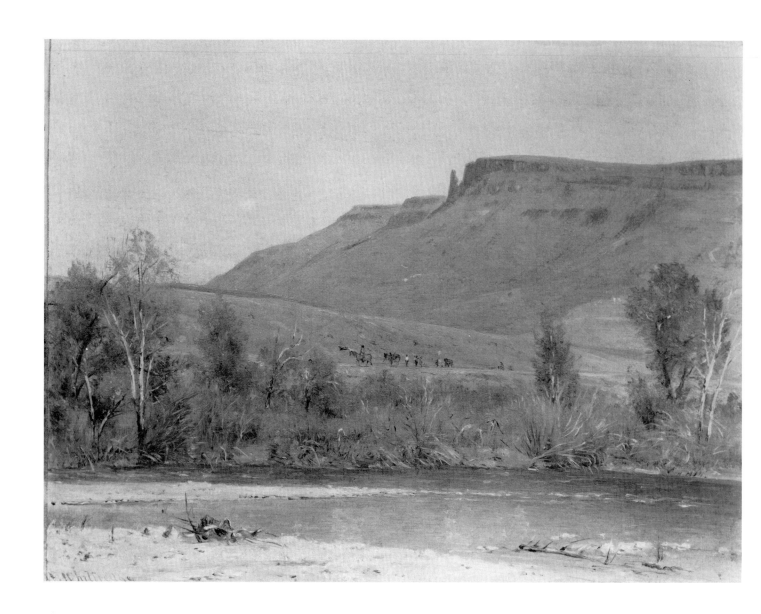

and despite the greater depth Whittredge painted, he also, by emphasizing horizontals and lengthening his composition in relation to height, indicated that space continued laterally. In marked contrast to Bierstadt's busy, melodramatic generalizations, Whittredge's picture breathed the hushed calm of Kensett's best work, and was minutely faithful to local details of atmosphere and topography. In this Kensettian manner Whittredge assimilated European skills. Keeping to a minimum his formerly bruising pinks, he achieved lyrical color brighter because of a less religious adherence to the Hudson River spatial progression of black and white values.[15]

FIGURE 90. Worthington Whittredge. *Mesas at Golden, Colorado*, c. 1870, oil on panel, 11½ × 15, National Cowboy Hall of Fame, Omaha.

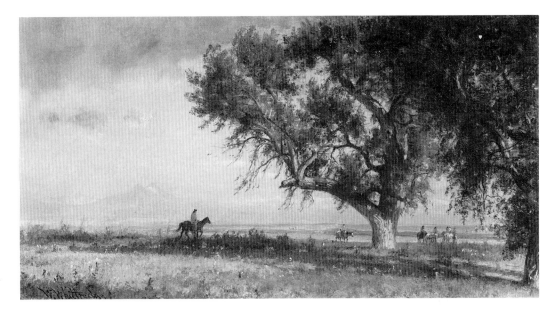

FIGURE 91. Worthington
Whittredge. *Along the Platte
River*, c. 1871, oil on canvas,
9¼ × 18, Hirschl and Adler
Galleries, New York.

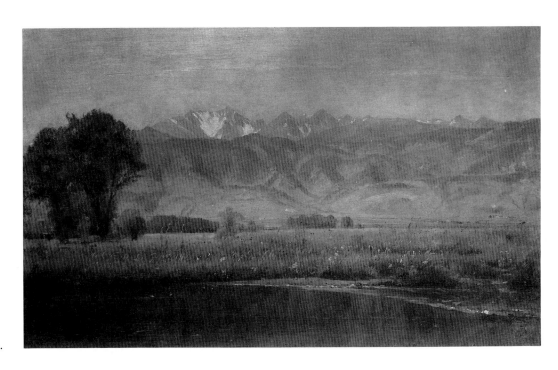

FIGURE 92. Worthington
Whittredge. *The Foothills*, c.
1870–2, oil on paper, 11¾
× 19¾, Denver Art Museum.

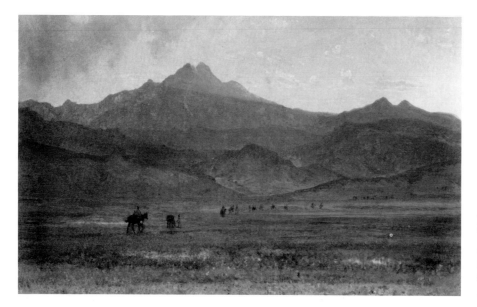

FIGURE 93. Worthington Whittredge. *Long's Peak – Sunset*, c. 1872–4, oil on canvas, 14 × 21½, Amon Carter Museum of Western Art, Fort Worth.

It is appropriate that Whittredge was accompanied on his second visit to Colorado by the two artists who had affected him most: Sanford Gifford, who had never been west before, and John Kensett, who had traveled only as far as the Missouri River. The autobiography provides very little further information about the journey. It is likely, however, that the three painters arrived in Colorado in early July 1870. After spending perhaps a week or so in the vicinity of Denver, they headed slowly north through the Valmont Valley and Greeley to the Cache la Poudre River, where Whittredge sketched the trees for his picture. The group entered Wyoming by early August, when Gifford

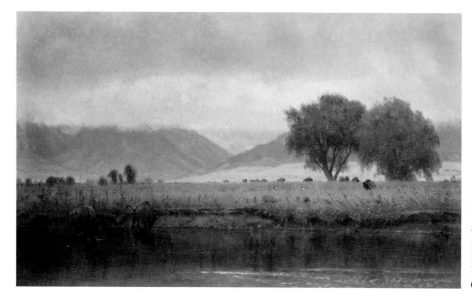

FIGURE 94. Worthington Whittredge. *Buffalo on the Platte River*, c. 1874–6, oil on panel, 13½ × 22½, Archer M. Huntington Art Gallery, University of Texas, Austin. Gift of C. R. Smith.

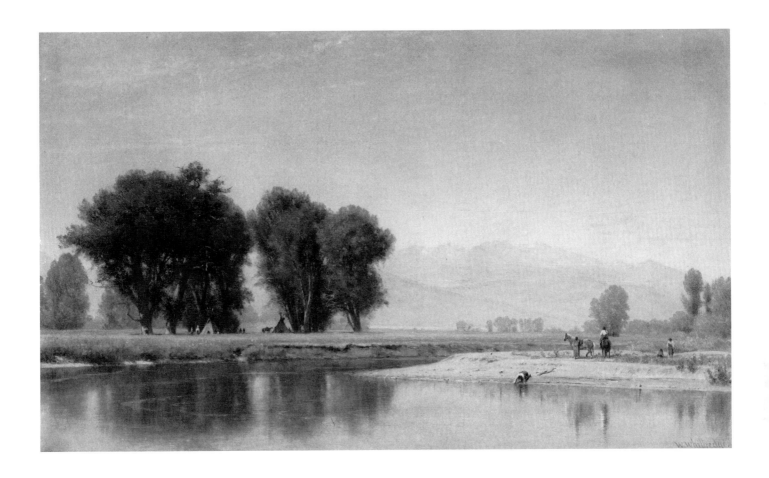

FIGURE 95. Worthington
Whittredge. *On the Plains*,
1872, oil on canvas, 30 ×
50, St. Johnsbury
Atheneum, St. Johnsbury,
Vt.

left to join the F. V. Hayden survey of the territory. Whittredge and Kensett
passed the rest of the summer in the Rockies west and northwest of Denver
before returning to New York, probably in late September.[16]

The sketches Whittredge painted in Colorado in 1870 are very different
from his earlier studies of the plains. In many respects they continue the
tendencies seen in *Crossing the Ford*. The delicate rust and grey tints of *Valmont
Valley* (fig. 87) and *Long's Peak (II)* (fig. 88) are effectively atmospheric. This
heightened sensitivity to nuances of light may be attributed in part to the
artist's companions: Some of his oil sketches bear similarities to the few known
paintings from that summer by Gifford and Kensett. *In the Rocky Mountains*
(fig. 89) resembles *Summit near Idaho City* (private collection) by Kensett,
whereas *Mesas at Golden, Colorado* (fig. 90) is related in style to Gifford's *Valley
of the Chug Water, Wyoming Territory* (Amon Carter Museum, Fort Worth). The
second tour of the west thus proved of major importance in his career by
reconfirming his pleinairism. His landscapes of the next six years are re-
markable for their ability to capture even the most transient effects of light
and mood.

FINAL EXCURSION: 1871

No such significance can be attached to the artist's third and final visit west in 1871. Mentioned in passing in his autobiography, it was very brief and resulted in so little work that its existence has been questioned.[17] According to the diary of James D. Smillie, who accompanied Whittredge on the train,[18] they left New York with Smillie's brother, George, on June 2 and arrived in Denver on the ninth, after stopping over in Seymour, Indiana, on the fifth and transferring to the Denver Pacific Railroad at Kansas City on the seventh. From the account it is unlikely that Whittredge joined the Smillies on the tenth for an excursion to Idaho. A week later the brothers continued on to California, where they spent the next two months. The only surviving works by Whittredge from this trip are a drawing inscribed Platte River June 23rd/ 1871 (M. and M. Karolik Collection, Museum of Fine Arts, Boston) and a

FIGURE 96. Worthington Whittredge. *Crossing the Platte River*, c. 1872–4, oil on canvas, 40 × 60½, the White House, Washington, D.C.

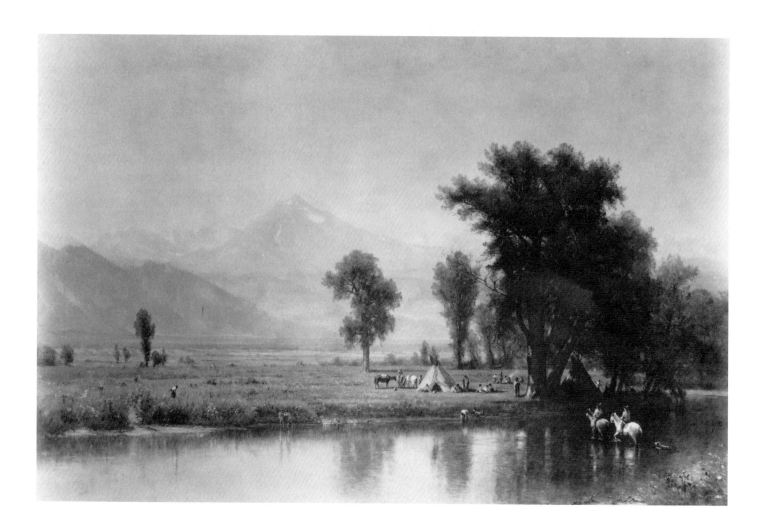

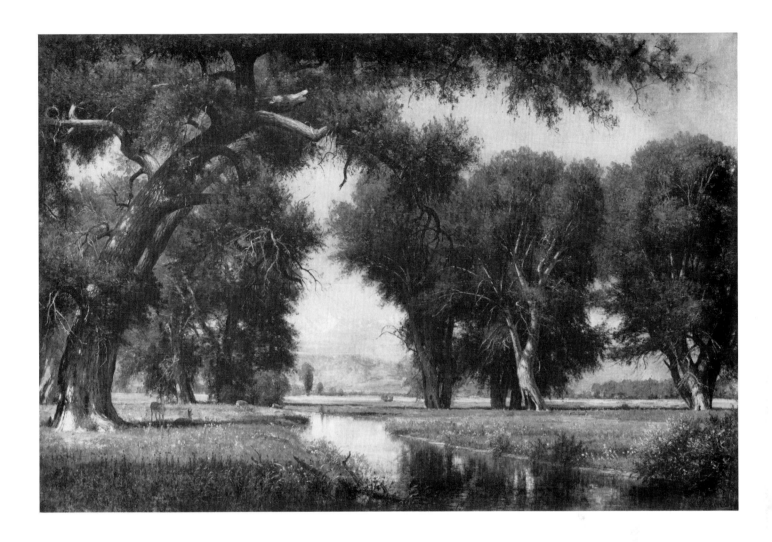

FIGURE 97. Worthington Whittredge. *On the Cache La Poudre River*, 1876, oil on canvas, 40¼ × 60⅜, Amon Carter Museum of Western Art, Fort Worth.

small painting of an Indian on horseback (fig. 91) which is so closely related in style that it was probably done at virtually the same time.

From 1870 to 1876 Whittredge was at the peak of his powers, and western scenes assume an important position among his landscapes. The majority are comparable in size and character with the oil sketches of 1870. *The Foothills* of 1870–2 (fig. 92), for example, maintains the same airy naturalism as *Valmont Valley*. The picture is distinguishable as a studio work only by the firmer structure and more detailed brushwork. The best of these canvases, such as *Indian Encampment on the Platte (II)* (plate IX) have an irresistible appeal. Over time, western landscapes like *Long's Peak – Sunset* of c. 1872–4 (fig. 93) and *Buffalo on the Platte River* from around 1874–6 (fig. 94) exhibit the growing refinement that can be observed in Whittredge's work as a whole.[19]

There are several large paintings of Colorado as well, which must be regarded as Whittredge's major works from this period. *On the Plains* of 1872

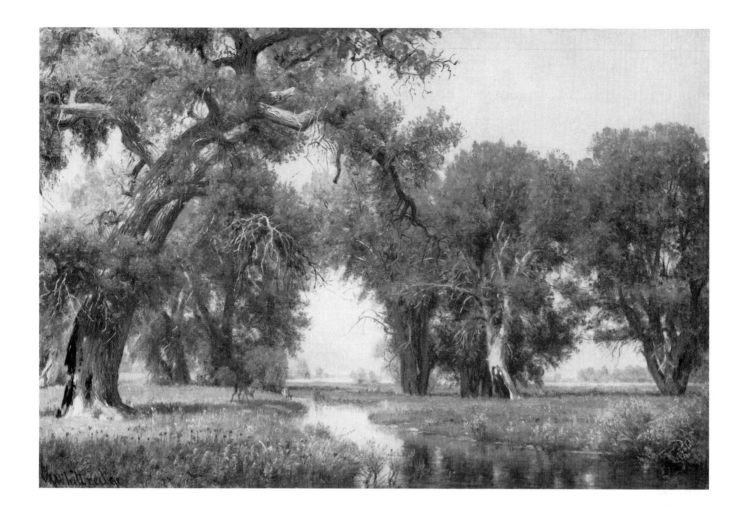

(fig. 95) is essentially a variation on *Crossing the Ford*. Although at first glance the landscape seems to depict another location altogether, the artist simply reworked the trees and treated the bank to the lower right as a separate piece of land jutting out into the river. He also eliminated the group of riders and substituted new figures along the shore. The picture exists in a smaller version (formerly Coe-Kerr Galleries, New York) that must be slightly later in date. The only difference between them is that Whittredge has restored some of the original staffage from *Crossing the Ford*. *On the Plains* is subtler in its observation of atmospheric effects but otherwise remains consistent in style with the Century painting.

Crossing the Platte River from around 1872–4 (fig. 96) takes much greater liberties with the scene by reversing the composition and substantially re-arranging the topography. In particular, the mountains have been enlarged, so that they appear much closer. The main pair of trees were taken from a smaller painting, *Indian Encampment on the Platte River (III)* (plate X), showing a completely different site. *Crossing the Platte River* is superior in execution to

FIGURE 98. Worthington Whittredge. *On the Cache La Poudre River*, 1868, oil on canvas, 15⅛ × 22¾, San Francisco Museum of Art.

Crossing the Ford, and the coloration with its pink hues, is quite daring for this artist. However, the landscape as a whole, albeit more imposing, is less well integrated.

On the Cache La Poudre River (fig. 97) is unquestionably the masterpiece among Whittredge's western landscapes.[20] This painting from 1876 repeats a much smaller one from eight years earlier (fig. 98), inscribed with the title on the back. Although they are of equal aesthetic merit, the increase in scale is appropriate to the monumental composition and enhances the picture. *On the Cache La Poudre River* and *Crossing the Ford* present the two sides of Colorado, which replaced Newport and upstate New York as Whittredge's favorite subjects prior to the Centennial. The artist shifts from the unrelieved glare of the open plains to a shaded grove. The towering view of trees in a glade returns to the prototype of *Landscape near Minden*, but the sunny tonality lends the picture the immediacy of *Outskirts of the Forest*. The flickering brushwork has a suppleness that transcribes the play of light and Whittredge's delight in the refreshing verdancy with consummate skill. As much as the attention to local detail and atmosphere, the artist's poetic response to the setting convinces us of his fidelity to specific nature.

It is ironic that Whittredge's finest statement should also mark the end of his activity as a western landscape painter. *On the Cache La Poudre River* is the last of the Colorado pictures. Shortly after he painted the great canvas, he began to undergo a profound crisis that changed the course of his art, in which western scenes no longer had a place. Whittredge did not return west until 1893, when he accompanied Frederic Edwin Church on a tour of Mexico, and then he chose not landscapes but town views as his main subject matter.

6

Climax and Crisis

THE YEARS 1872–6 MARK THE HIGH POINT of Whittredge's career. At this time he reached the peak of his powers. In the middle years of the decade, he also attained a new prominence in the artistic affairs of the nation. It was nonetheless a difficult period that in the end left him deeply troubled and the Hudson River school in disarray.

Whittredge's work during this brief span achieved a consistent excellence that places him among the great painters of the American landscape school. More than at any other time in his life, it is marked by the diversity that he noted proudly in his autobiography:

> The subjects of my pictures have been extremely varied. I have tried anything and everything which has struck me as interesting, until I am hardly known as the painter of any particular class of landscapes. Coast scenes, brook scenes, scenes on the plains, interiors of old New England houses, moonlight, firelight and every picturesque feature that presented itself I have tried in some way to present.[1]

For the most part, however, Whittredge returned to his favorite haunts, although he would sometimes wander quite far afield. As in the mature landscapes of the Stour Valley by John Constable, it is the intimate knowledge of favorite places and their rich associations that provided the basis for the sentiment which informs Whittredge's paintings of the 1870s.[2] His landscapes integrate a wide range of artistic and personal experience. Like Constable, Whittredge expresses a strong sense of place through the faithful record of details and atmospheric light. At the same time, both artists often monumentalize their intimate love of nature and use traditional compositional devices to rearrange its appearance for the sake of effect. The combination of intimate naturalism and high art leavened with deep conviction makes Whittredge's landscapes the most important body of work by any member of the Hudson River school in the 1870s.

The Leader of the Hudson River School

During the early years of the decade, the artist was preoccupied with the western experience, but in 1872 he once again began to devote himself to traditional Hudson River subjects. It was at this time that he assumed effective artistic leadership of the school upon the death of John Kensett. It is a measure of Whittredge's standing in the art world that he served as a pallbearer at Kensett's funeral.[3] Yet because of his ingrained modesty, he never gained wide recognition for his contribution. The essential qualities of his style are demonstrated by a group of landscapes along the Delaware River, which lies southwest of the Catskills, just beyond the Shawungunk River. The master-piece among these paintings is *Scene on the Upper Delaware, State of New York* of c. 1872–5 (fig. 99), formerly owned by the Santa Barbara Museum of Art. There are two main variants of this autumnal scene, which also exist in other replicas: *Autumn Landscape* (plate XI), which is nearly identical to *Scene on the Upper Delaware, State of New York* but includes more of the vista and changes the staffage, and *Along the Upper Delaware* (fig. 100), a vertical composition that shows slightly less along the wings of the landscape. The differences in the background suggest that the mountains were rearranged for the sake of pictorial effect in *Scene on the Upper Delaware*, in which the more balanced composition enhances the picture. Here, too, the inspiration is purer. In it, the intuitive apprehension of light receives its most radiant expression of all Whittredge's paintings. He uses a myriad of small, pointed brushstrokes to suggest forms through the sparkling play of colored light across the landscape, which achieves an extraordinary range of visual effects surpassing anything he had painted before. Light becomes the expression of an immediate, yet profoundly lyrical response to a visual impression. The serene naturalism evinces an unusual receptiveness to nature, which the artist allows to speak directly through his innately poetic sensibility.

Whittredge's point of departure was the late work of John Kensett.[4] At a time when other Hudson River painters were relying increasingly on stale realism and repetitious formulas, he alone seems to have realized that, in pastoral landscapes like *The Farm in Autumn* (1871, Mr. and Mrs. Hamilton Hadley) Kensett had begun to treat colored light as the visual and expressive equivalent of things themselves. Kensett's investigation parallels his clinically precise analysis of light and radical abstraction of form in *Eaton's Neck* (1872, Metropolitan Museum of Art, New York). American landscape painters typically maintained color as a property of objects distinct from light, except in the luminist paintings of Sanford Gifford, where they sometimes merge to form a single entity. Whittredge was able to appreciate Kensett's and Gifford's experiments because of his exposure to Barbizon painting: For a comparable approach to light one must turn to the art of Corot and Daubigny.[5]

Two ingratiating bucolic scenes, *The Meadow* (formerly Kennedy Galleries, New York) and *Near Gray Court Junction* (George D. Hart, San Francisco)

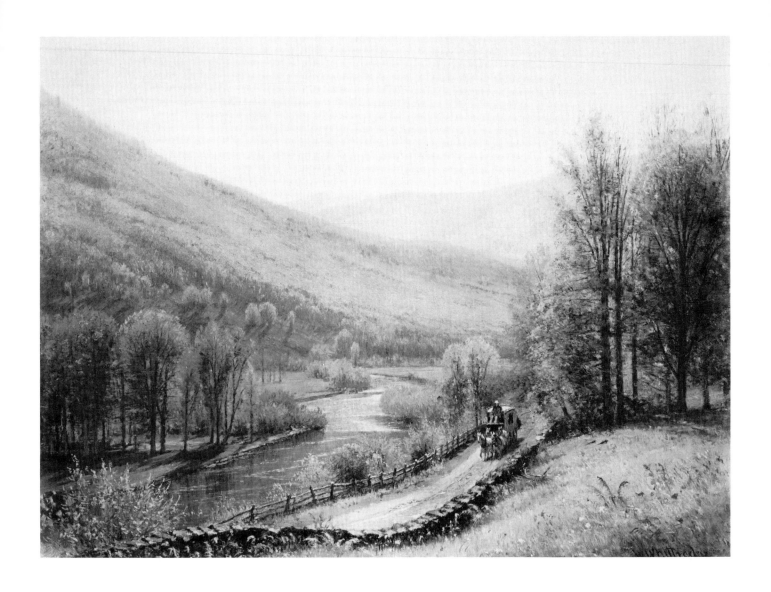

further share in the deceptive simplicity of Kensett's unpretentious studies. They are closely related to *Autumn on the Hudson* (fig. 101) and to two small scenes around Bernardsville, N.J., once owned by Mr. and Mrs. John L. Winston. Such paintings testify to the important contribution of the English school to American landscape painting at midcentury. In composition and execution they reflect the work of Turner's disciple John Linnell and his followers in the 1850s, when Kensett and Jasper Cropsey paid extended visits to England and when the writings of John Ruskin began to enjoy widespread influence on both sides of the Atlantic.[6]

Around 1875, Whittredge painted an enchanting view of *The Mill, Simsbury, Conn.* (plate XII). He was presumably drawn there by continuing ties to the family of Mary Eno, the wife of James Pinchot. Like many members of

FIGURE 99. Worthington Whittredge. *Scene on the Upper Delaware, State of New York*, c. 1872–5, oil on canvas, 17 × 23, private collection.

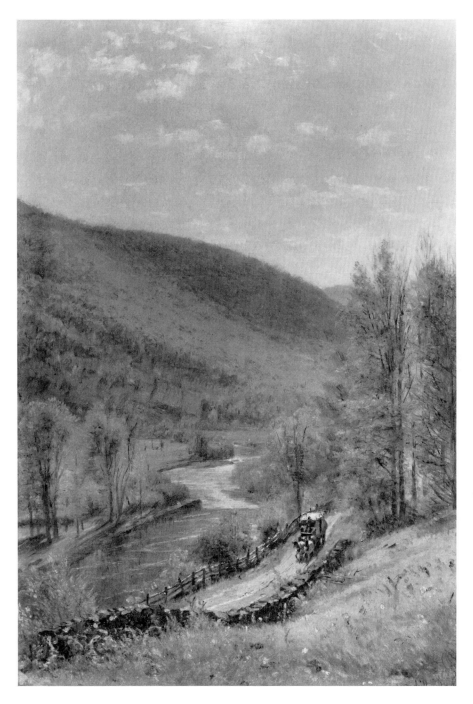

the Hudson River school, he kept up a lively correspondence with Pinchot
and often visited him in Milford, Pa.[7] Because H. C. Eno had etched *The Old
Hunting Ground* in Pinchot's collection, there is every reason to believe that
Whittredge maintained his connections to the Enos as well.[8] The artist bathes

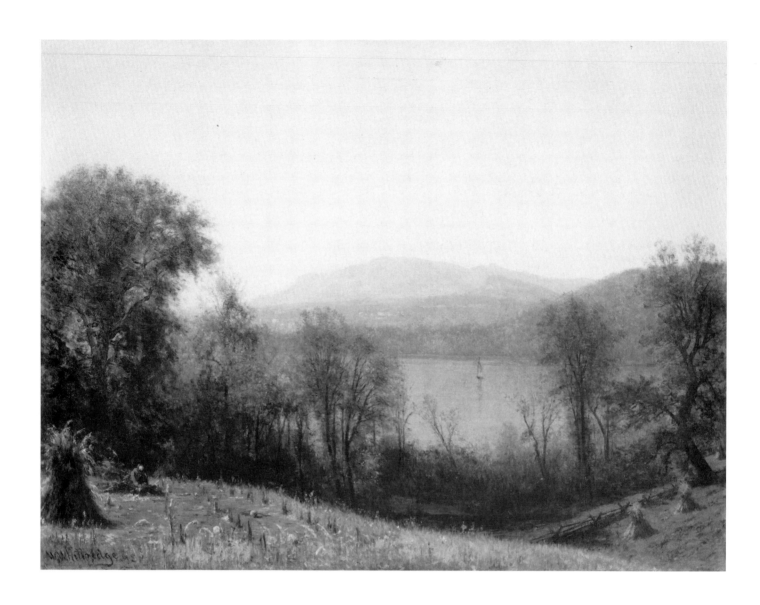

The Mill in an air of nostalgia, evoked by the ramshackle structure and cool, moss-green and brown hues.

The Morning Stage (plate XIII), exhibited at the National Academy of Design in 1875, probably shows a scene in western New York along the main coach route between the Erie Canal and Auburn in the central part of the state. The scene represents a dying way of life, for by the Centennial the railroad had largely supplanted the stage in the region. The composition itself is retrospective, harking back as it does to Asher B. Durand's pastoral landscapes like Sunday Morning (1860, the New Britain Museum of American Art, Connecticut). Indeed, the picture has a distinctive iconography. As in Durand's painting, Whittredge has included a church steeple as a reminder of the piety in that bygone, simpler era. In the middle distance, just beyond the

FIGURE 101. Worthington Whittredge. *Autumn on the Hudson*, c. 1875, oil on canvas, 19½ × 26½, private collection. Photo courtesy of Kennedy Galleries, New York.

road, is a small cemetery of the sort that can still be found throughout rural America. Barely discernible are a funerary chapel and obelisk or spire rising above the stone wall. The juxtaposition of the burial ground immediately above and to the right of the coach is intriguing. At the very least, this device reinforces the self-conscious nostalgia by adding a wistful note. But it also suggests that the stage coach may be taken as a broader symbol of life's journey, comparable to the storm-tossed ship as a metaphor for the voyage of life. As we have seen, Romantic themes in this vein occasionally provided the focus for Whittredge's art. There may be a personal meaning as well. Arthur Lesser has argued in an unpublished article that the motif of the father carrying his child piggyback may be associated with the artist's sorrow over the death of his first child, Jeannie, in 1873 and joy about the births of his daughters Euphemia and Olive in 1874 and 1875. (Another girl, Mary, was born 1879.)[9]

Two years later, Whittredge executed one of his most unusual works, *Geneva House* (fig. 102). It depicts the home of his father-in-law, Samuel A. Foote, who had served on the Supreme Court of New York State. The judge is seen reading a book on the porch, while Whittredge's young daughters are playing below.[10] Architectural scenes of this sort were not uncommon at the time in European illustrations showing people wearing the latest fashions, but they do not seem to otherwise occur in American art until late Victorian times.[11]

The broad range of Whittredge's art is further seen in the casual studies he occasionally painted for his own pleasure to supplement his landscapes. *The Interior of the De Wolfe House* (fig. 103) shows a famous Newport mansion that was destroyed by fire early in this century.[12] *The Artist's Fishing Gear* (fig. 104) resulted when, "according to family legend, [he] went fishing one day but had to return home because of a rainstorm. Unable to put his fishing gear to use, he laid it on a table, then made this painting."[13] Executed with particular concern for texture in dark, rich colors, this simple arrangement has the economy and intensity that distinguish much of American nineteenth-century still-life painting.

NEWPORT

In 1872, the artist resumed spending part of his summers in New England. He states that Cape Ann had many attractions for him and that he also made many sketches of Gloucester.[14] But for the most part he stayed at Newport, which for him meant the entire area. The city itself is located at the southern tip of an island in Narragansett Bay and is separated from the mainland to the east by the Seconnet River. He seems never to have painted Newport proper. The only scenes he did of the island itself are near Middleton. These center on Bishop Berkeley's house, "Whitehall," and the rock where he used to meditate, known as "Bishop Berkeley's Seat," at Second Beach.[15] The much

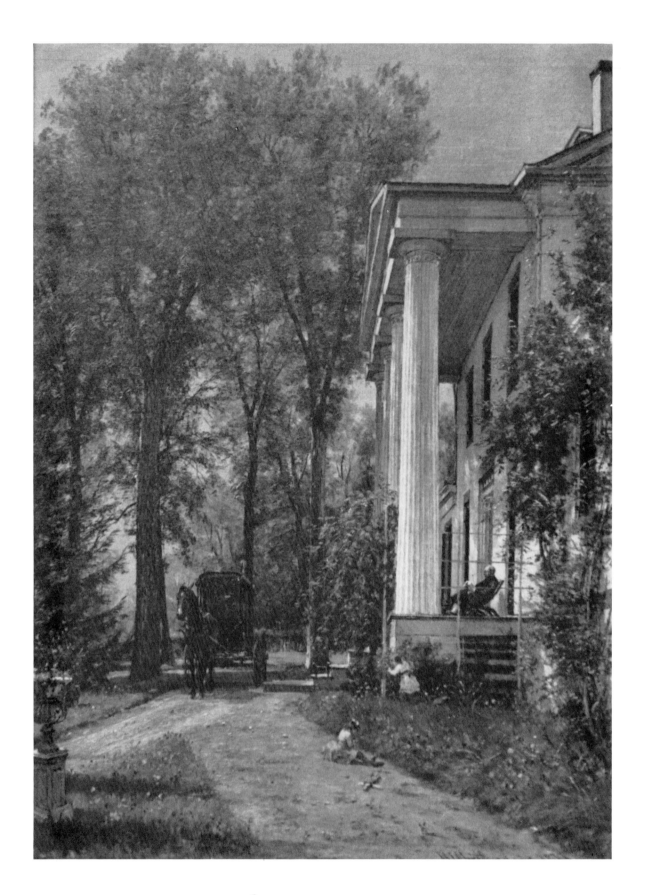

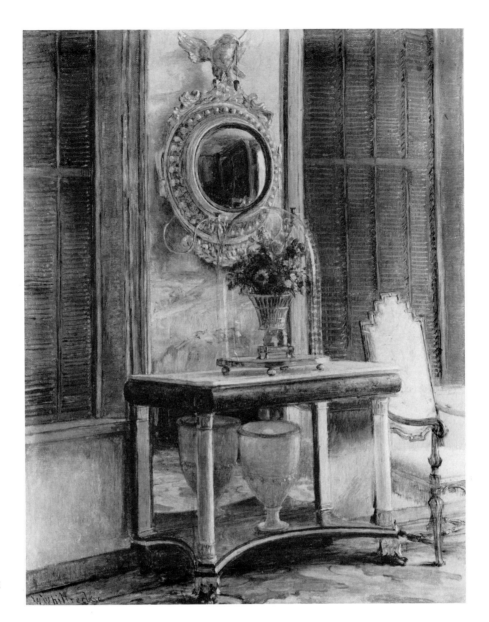

FIGURE 103. Worthington Whittredge. *The Interior of the De Wolfe House*, early 1870s, oil on canvas, 15¼ × 12¼, private collection.

FIGURE 102. Worthington Whittredge. *Geneva House*, 1877, oil on canvas, 23 × 17, private collection.

smaller Third Beach he depicted perhaps once, if at all, and all paintings with that title were later given it incorrectly.

Whittredge never owned any land around Newport. When he was in the area, he stayed in the house of Dr. William Whittredge (1748–1831).

Not far away from Newport though across the Seconnet river in Tiverton had dwelt a great uncle of mine a very eccentric character and for this reason a very interesting relative. He was a physician in early life celebrated as such in the city of New Bedford, which city he abandoned in middle age and

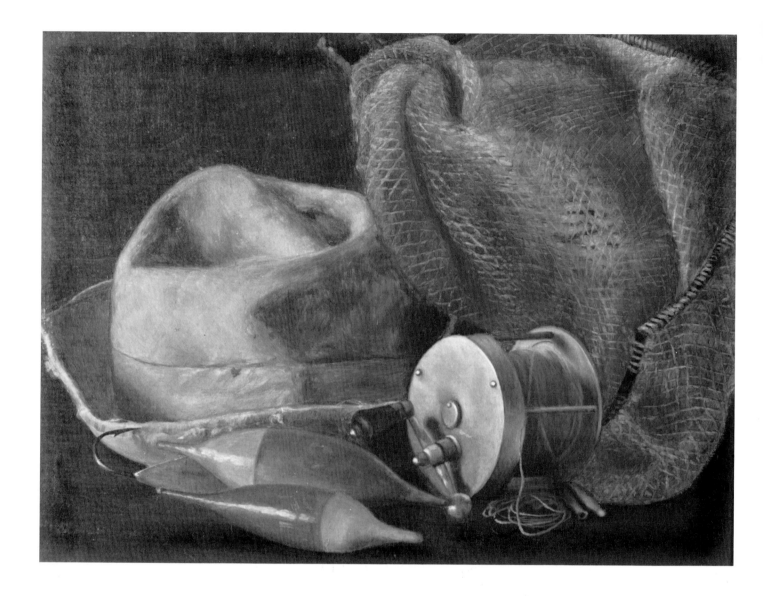

bought a piece of land in a secluded region back of Westport
Harbor where he built a house which still belongs in the
family.[16]

FIGURE 104. Worthington
Whittredge. *The Artist's
Fishing Gear*, 1870s, oil on
canvas, 12 × 16, Mrs.
Theodore Bumiller, Canton,
Ohio.

He relates that the doctor devoted the last forty years of his life to the study
of Greek and Hebrew, and to experiments with a forge that suggest a fasci-
nation with alchemy and the occult.[17] William Whittredge became one of the
largest landowners in the area.[18] The estate, which was never a working farm,
is located at 285 Stone Church Road about 2¼ miles west of Four Corners.
It descended through the family and remained intact until the 1940s, when
the front lots were sold off, but the handsome house still stands.

Because of the distances involved, Whittredge painted most of his Newport

scenes around Tiverton and Little Compton. It is about eighteen miles from the farm to Newport – almost twice the distance to Seconnet Point – which probably represented a good six- or seven-hour round trip by carriage, leaving very little time for sketching. Rarely, if ever, did he stray as far as Point Judith, which lies across Narragansett Bay. It is impossible to identify more than a few specific sites now. Besides "Whitehall," only one of the houses in Whittredge's pictures still stands. The coastline, too, has changed considerably over the past century. It is often hard to tell whether a given scene lies in Tiverton, Little Compton, Cape Ann, or even Gloucester, although the terrain generally provides a clue.

From a letter written on August 11, 1872, to James Pinchot, we know that Sanford Gifford was with Whittredge and Jervis McEntee at Gloucester, where they were joined by Eastman Johnson, before going on to the Catskills.[19] It is likely that Whittredge spent the earlier part of the summer at Tiverton, because that year he painted a pair of important Rhode Island landscapes. These parallel his western scenes in style and expression, and occupy a comparable position in his oeuvre. *A Home by the Seaside* (fig. 105) has the modest rural subject of the earlier *Farm near Newport* (fig. 70), but the painting eschews the luminist sunset, with its philosophical associations, for the pleinairism that

FIGURE 105. Worthington Whittredge. *A Home by the Seaside*, 1872, oil on canvas, 14¼ × 25¼, Los Angeles County Museum of Art. William Randolph Hearst Collection.

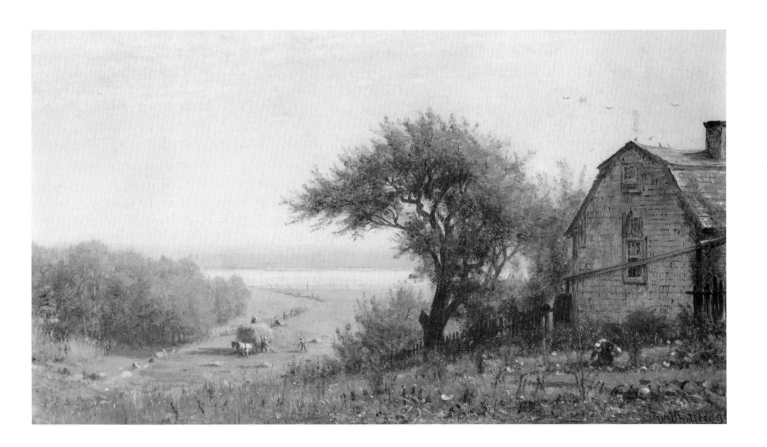

characterizes *On the Plains* from the same year. The painting revives the harvest theme of *Landscape with Hay Wain* from 1861 (fig. 51). The farmers may be understood as pastoral counterparts to the red men living in an idyllic state of harmony with nature in Whittredge's western scenes like *Indian Encampment on the Platte (II)*.

The larger and more important of the two Newport scenes from 1872, *A Home by the Sea* (fig. 106), exists in several replicas, for example one in the Westmoreland County Museum of Art, Greensburg, Pa. (fig. 107). In this landscape, the afternoon light and picturesque setting, with its ramshackle house, evoke Whittredge's deep feelings for the area. The picture is related thematically and compositionally to the artist's European works. The foreground is similar in conception to *Landscape in the Harz Mountains*, whereas the background, which probably shows Warren's Point, is closer in treatment to *Roman Campagna*. Like the German painting, the scene gives every evidence of being a hybrid: A few years later, in *The Old Homestead, Rhode Island* (fig. 108), Whittredge followed the compositional principles he had learned in

FIGURE 106. Worthington Whittredge. *A Home by the Sea*, 1872, oil on canvas, 35½ × 53½, Addison Gallery of American Art, Andover, Mass.

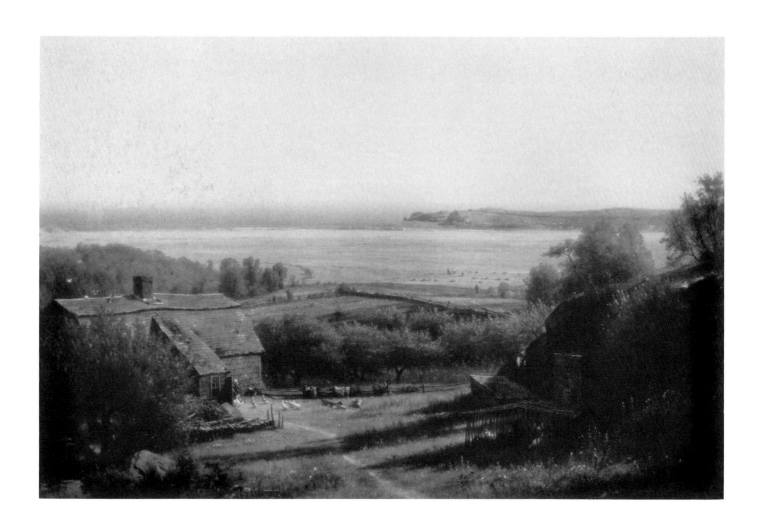

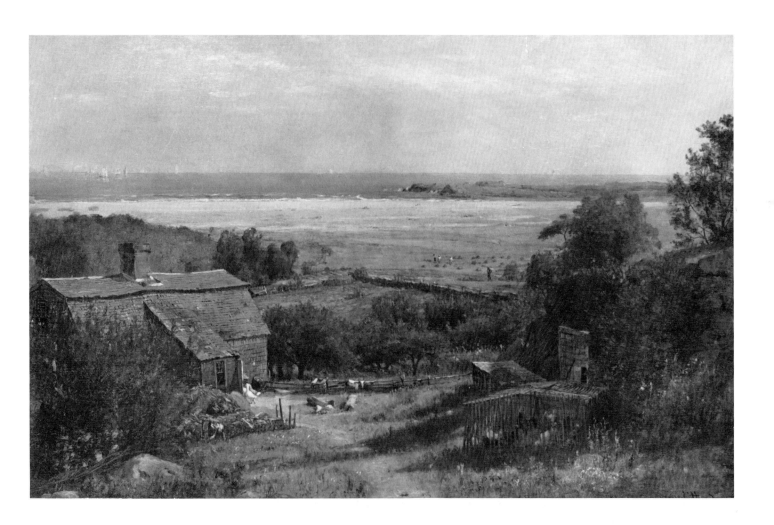

Düsseldorf by using a line of trees as a device to graft the lower half of *Home
by the Sea* onto a new backdrop, possibly Briggs Beach near Warren's Point.

Whittredge painted several other scenes along the New England coast in
the early 1870s. One of them, *Old Time Talk* (fig. 109), dating from 1873, is
of particular interest for reviving the luminist style he had abandoned six
years earlier.[20] The canvas showing a pair of lovers walking the beach at sunset
is unusually romantic for him. At first glance, it appears to be a standard
sentimental Victorian genre scene.[21] Although he was no figure painter, Whit-
tredge did execute a few such pictures in the 1870s, including one of two
young women walking in a garden (formerly Vose Galleries, Boston). *Old Time
Talk*, however, is unique in his oeuvre. The title, inscribed on the back, suggests
a literary source. No work by that title is known, but the inspiration may have
come from William Cullen Bryant's poem "The New Moon":

> Most welcome to the lover's sight
> Glitters that pure, emerging light;

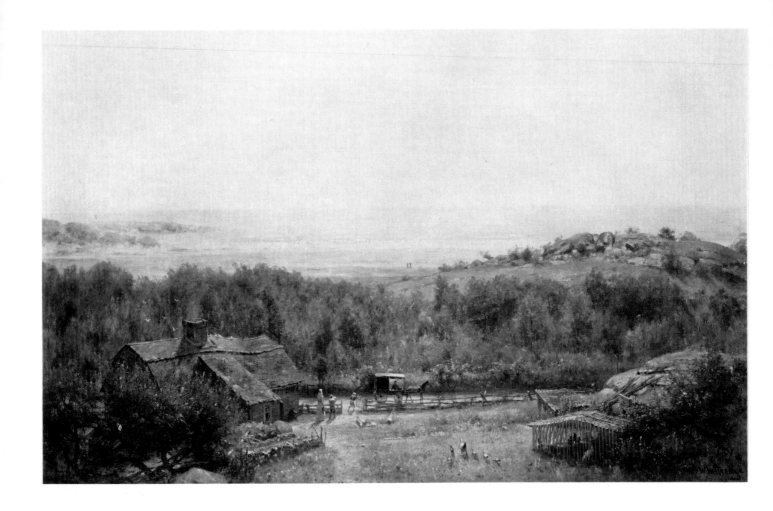

For prattling poets say,
That sweetest is the lovers' walk
And tenderest is their murmured talk,
Beneath its gentle ray.

FIGURE 108. Worthington
Whittredge. *The Old
Homestead, Rhode Island*, c.
1872–5, oil on canvas, 36 ×
56, private collection.

Except that it shows the setting sun, the painting matches the passage very
well in character.

FOREST SCENES

Between 1872 and 1876, Whittredge painted numerous views of the Catskills,
which remained perhaps his favorite locale:

> I have been where I could see the Adirondack Mountains and
> have remained at such places for some time, but I never went
> to them, not from any suspicion that they were less interesting

142

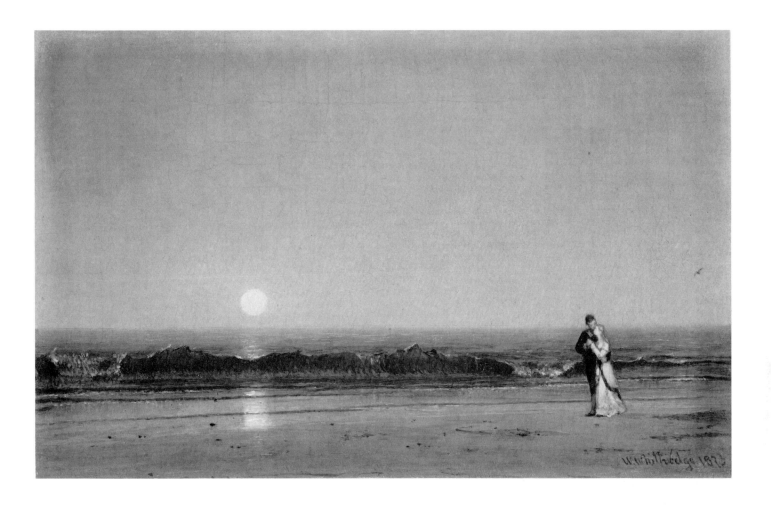

FIGURE 109. Worthington
Whittredge. *Old Time Talk*,
1873, oil on canvas, 9 × 15,
private collection.

than the Catskills, but because I did not wish to burden myself
with studies which I could not use. Short distances in our
Catskill country often bring us to changed landscapes which
display peculiar characteristics not always easy to engraft upon
the scenery of another neighborhood. When my quiver was
full, too full I often thought, I have considered it unwise to
have other arrows lying around loose.[22]

The forest scenes from the early 1870s evince the same preoccupation with
light that defines Whittredge's other paintings of this period. *Forest – Rocks
and Trees* (fig. 110) is a more intimate study of the kind presented in *Pine
Trees, Minerva* (fig. 75). In its choice of view, detailed description, and dappled
coloration the painting draws close to the woodland interiors of Asher B.
Durand and his follower David Johnson.[23] A similar study, *Woodland Interior
with Two Deer* (Henry M. Fuller, New York), suggests, however, that the prox-
imate inspiration was again John Kensett's late works like *Study of Beeches*

FIGURE 110. Worthington Whittredge. *Forest – Rocks and Trees*, early 1870s, oil on canvas, 23 × 15, present whereabouts unknown.

(Metropolitan Museum of Art, New York). The difference is that Whittredge's palette sometimes attains a greater coloristic intensity.[24]

Sunshine on the Brook (plate XIV) shows a direct kinship with Sanford Gifford's *Kauterskill Falls* (1871, Detroit Institute of Arts) in composition and execution. Whittredge creates a similar play of light without adopting Gifford's potent orange-tinted palette. Like Gifford's painting, *Sunshine on the Brook* is certainly an oil sketch from nature. It is similar in execution to *A Catskill Brook* (fig. 111), which was clearly begun outdoors but never finished. *Forest – Rocks and Trees* and *Woodland Interior with Two Deer* must also be studies from nature, for they share the same size and brushwork as *Sunshine on the Brook* and *A*

FIGURE 111. Worthington Whittredge. *A Catskill Brook*, early 1870s, oil on canvas, 21¾ × 15⅜, present whereabouts unknown. Photo courtesy of Hirschl and Adler Gallery, New York.

FIGURE 112. Worthington Whittredge. *The Brook in the Woods*, c. 1875, oil on canvas, 22¾ × 16½, private collection.

Catskill Brook. All of these canvases are so faithful to the experience of nature as to give the inescapable impression of having been painted outdoors.

It is remarkable that Whittredge painted so many oil sketches of the woods that were intended to be complete, self-standing works in themselves. In one instance, such a study served as the basis for a studio painting. Whittredge translated *The Brook in the Woods* (fig. 112) into *A Forest Stream* (fig. 113). The finished canvas was done as a pendant to *White Birches* (fig. 114), which repeats the second version of *The Old Hunting Ground* without the canoe and its associative symbolism. The two paintings form perfect complements to each other.

The Brook in the Woods was painted within fifteen feet of Jervis McEntee's

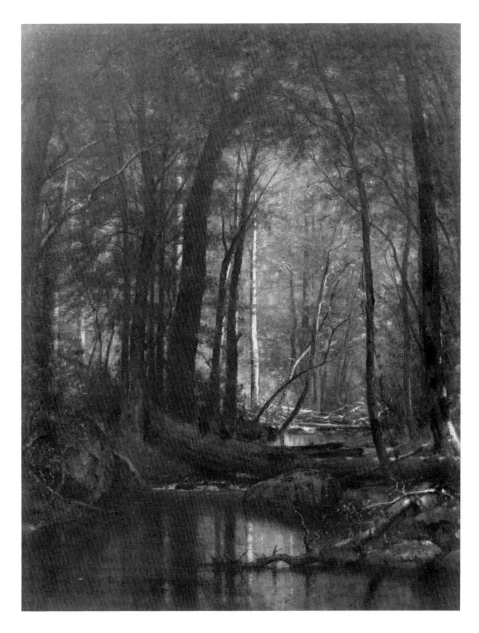

FIGURE 113. Worthington Whittredge. *A Forest Stream,* c. 1875, oil on canvas, 34 × 27, Jerald Fessenden, New York.

sketch *September Morning* (Cleveland Museum of Art). The picture documents a close friendship that endured for many years:

> Jervis McEntee was one of my most intimate friends. Summer after summer we were together in the Catskills. His home had always been near them and he knew every nook and corner of them and every stepping-stone across their brooks. One phase of nature, the melancholy phase, was never better depicted than in his pictures. He often tried the sunny side of

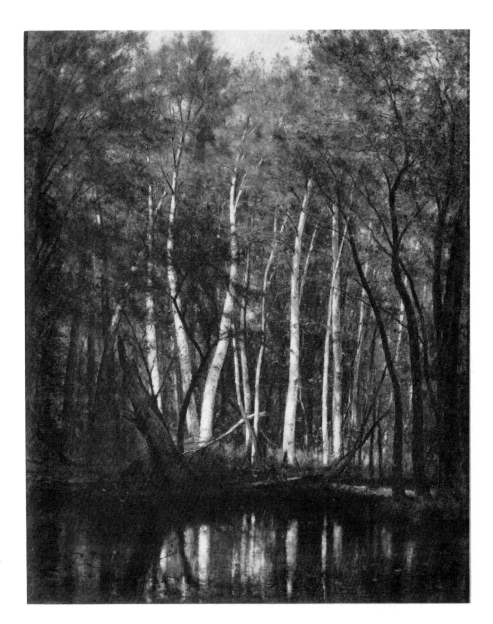

nature, but was never as successful with subjects of this sort as
with those which dealt with the leafless trees and lowering skies
of November.[25]

McEntee was a close friend and follower of Sanford Gifford, whose influence
pervades *September Morning*, but he was also among the first Hudson River
painters to discover Barbizon landscapes as the means of expressing his mel-
ancholy disposition. Beginning in 1872, his diaries record his often fragile

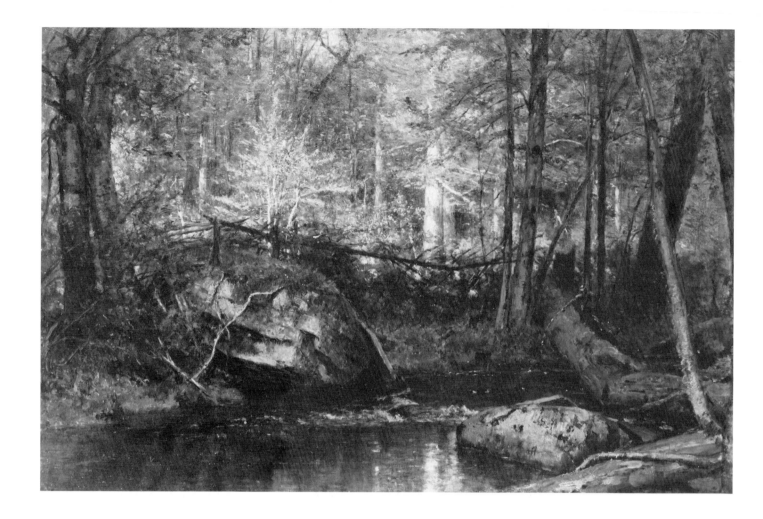

health and frequent depression, which deepened following the deaths of his
wife in 1878 and of Gifford two years later.[26]

View in the Catskills (fig. 115) looks across the same stream as *The Brook in
the Woods*, and was probably painted the same day. Such a view is unprece-
dented for a forest interior by Whittredge before this time, as is the format.[27]
Toward the mid–1870s, though, he began to paint horizontal views of the
woods as part of a larger change in which his forest scenes grow darker in
style and then freer in execution. This departure from his previous practice
is announced in 1874 by *The Camp Meeting* (fig. 116). A precursor of this
multifigured oblong composition can be found in Whittredge's painting of
The Market near Subiaco (fig. 40). The landscape shows a tent revival meeting,
possibly in the Catskills, as the entry for June 1, 1874, in the diary of Jervis
McEntee establishes: "Today I called on Sam. Coykendall, and asked him to
go and see Whittredge's picture of the camp meeting, which he promised to
do. I said all I could in favor of Whittredge's picture and I only hope he will

buy it." The painting was eventually purchased by Matthew Chaloner Borden at the National Academy of Design's Buyer's Day on April 14, 1875.[28] In May of that year *The Camp Meeting* was praised in the *Art Journal* as "Mr. Whittredge at his best." In comparing this well-known painting to the artist's early *View of Cincinnati*, Virgil Barker notes:

> [It] exhales the same feeling of discovery, but the glow is mellower and the mood elegiac. The many tiny figures here are not drawn with the tight insistence of the more commonplace [Hudson River] School mind.... The inescapable, but welcome, inference is that Whittredge possessed an intensity of feeling which was missing in his fellow School-men and which could poetize even the the technique which their example persuaded him to adopt.[29]

The muted palette and delicate impasto surrounds the festive group gathered in the park with a wonderfully evocative, diaphanous atmosphere.

These are the hallmarks as well of Whittredge's most important forest scene of the 1870s, *Trout Brook in the Catskills* (fig. 117), which was purchased directly from the artist by William Corcoran in 1875. *A Catskill Brook* (Thyssen-Bornemisza Collection, Lugano) has recently come to light which differs chiefly in its slightly smaller size but somewhat more inclusive composition; otherwise there is no qualitative difference between them.[30] The landscape has been sensitively analyzed by the critic Frank J. Mather, Jr.:

FIGURE 116. Worthington Whittredge. *The Camp Meeting*, 1874, oil on canvas, 16 × 41, Metropolitan Museum of Art, New York.

> It is obvious that the artist has approached the subject with a kind of reverence, questioning it only so far as he might expect

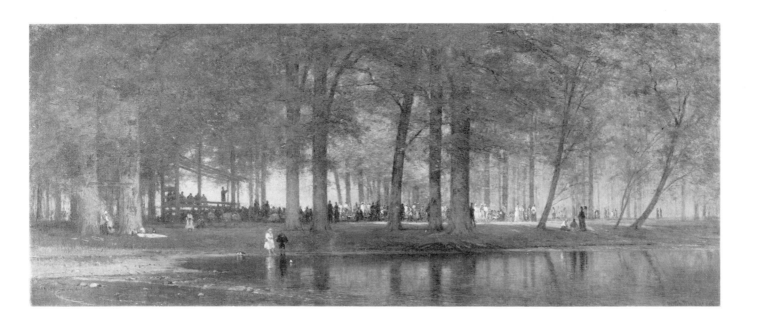

an answer, and never venturing to paint Whittredge between the lines. Yet Whittredge is there all the same, in a certain freshness, and, if one may use the term, amenity – as if the scene stood on good terms with an invisible painter outside of the frame.[31]

Trout Brook in the Catskills and *A Catskill Brook* are classic statements from the height of Whittredge's maturity. They revive the lyrical expression of Whittredge's forest interiors from the mid–1860s, yet are very different in their pictorial construction from any of his previous works. The composition is one of Whittredge's own invention that had not been tried before in Hudson River

FIGURE 117. Worthington Whittredge. *Trout Brook in the Catskills*, 1875, oil on canvas, 35½ × 48⅜, the Corcoran Gallery of Art, Washington, D.C.

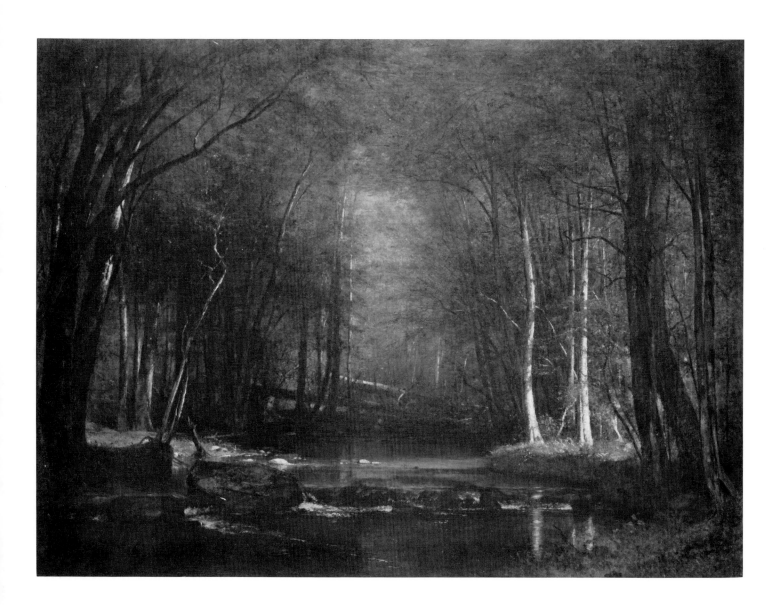

150

painting, though it is found in some English and German landscapes of the Romantic period. It is surprising that this elegantly simple view had not been used in America, since it seems such an obvious solution to the problem of how to represent a forest stream; yet the type never seems to have caught on. One of the rare exceptions is John G. Brown's atmospheric *The Country Gallants* of a year later (Toledo Museum of Art), which was clearly influenced by Whittredge's example. The virtues of this kind of composition are readily apparent, however, in the stability and spaciousness of the scene, which breathes a timeless serenity. Whittredge's total mastery of the brush creates a refined surface that conveys the subtlest nuances of light and texture. The effect is so convincing that one can almost hear the murmur of the brook in the cool shade of the woods!

PRESIDENT OF THE NATIONAL ACADEMY

In 1874-5, Whittredge was elected to two one-year terms as president of the National Academy of Design. He had already been active in New York art politics for several years. In 1872, he served with Jervis McEntee, Sanford Gifford, and William Beard on the Vienna Exposition Committee, which resigned on December 19 over attacks in the press and turned its affairs over to the National Academy of Design.[32] His presidency of the Academy came at the height of a period of turmoil that lasted from 1870 to 1876. Besides Whittredge, three other artists served as president between the extended terms of Daniel Huntington: Henry Peters Gray (1870), William Page (1871-2), and J. Q. A. Ward (1873). Whittredge, who had been vice-president the year before, was first voted into the office at the Academy's annual meeting on May 13, 1874, only after Ward declined it.[33] Eastman Johnson succeeded him as vice-president. Whittredge's presidency proved to be a difficult time that left him deeply troubled and the Hudson River school in disarray.

Many of its members had become disenchanted with the Academy. Jervis McEntee, for example, wrote in his diary on April 4, 1874, "I am sorry I cannot feel the old interest in the academy it is a different thing from what it used to be." The Academy was also under attack from the outside. McEntee attached a news clipping to his entry stating that the Academy's exhibitions were mediocre primarily because the artists reserved their best pictures for private club showings where they would find the likeliest buyers. Buyer's Day at the Academy's spring exhibitions was still important to the artists, but the issue of the private club shows was a highly divisive one, and Sanford Gifford resigned from the Academy over it on April 13, 1875.[34]

The Academy was heavily in debt for its new building, which opened in 1866, and the question of how to raise money without losing its tax-exempt status as a free art school further divided the membership while threatening the institution's very existence. Whittredge was "told to go to work now and pay the debt."[35] At the urging of Parke Goodwin, he organized a loan exhi-

151

bition of foreign art at the Philadelphia Centennial in cooperation with the Metropolitan Museum of Art, which he had helped to found.[36] The proposal may have been an outgrowth of Whittredge's initial idea to upgrade the annual exhibitions at the National Academy by showing the best work of American and European artists available in this country. He discusses such a concept in a letter of February 15, 1874, to the collector James Pinchot and seeks to borrow Alexandre Cabanel's portrait of Mrs. Pinchot and their children. In any event, the $23,000 net share of the profits, along with additional donations, enabled the Academy to liquidate its debt of $31,000. Consequently, when Whittredge "retired from office the members were willing to forget old differences...and vote for Huntington again."[37]

Whittredge missed the Academy's annual meeting in May 1876, when Huntington was voted back into office, because he was in Philadelphia as a member of the exhibition committee of American art at the Centennial, in which he played a vital role. As a result of this activity, he states, "The Centennial year was almost entirely lost from my studio."[38] As president of the Academy, he in effect headed the New York state delegation,[39] and was able to pack the exhibition with the work of his closest associates among the Hudson River school, to the virtual exclusion of American Barbizon paintings. He himself was represented by five major pictures. According to Julian Alden Weir's account in *The Official Report of the American Centennial Exhibition of 1876*:

> Mr. Whittredge contributed his "Rocky Mountains from the Platte River," "A House by the Sea," "A Hundred Years Ago," "Twilight on the Shawungunk Mountains," and "The Old Hunting-Grounds" – the latter are especially admirable examples of his free nervous style, and of his felicitous treatment of wood interiors. Mr. Whittredge's pictures of forest solitudes, with their delicate intricacies of foliage, and the sifting down of feeble rays of light into depths of shade are always executed with rare skill and feeling. His style is well suited to this class of subjects; it is loose, free, sketchy, void of all that is rigid and formed. It evinces a subtle sympathy with the suggestive and evanescent qualities of the landscape. But in his treatment of the open sky this artist is less happy. There is sometimes apparent a slight crudeness in his rendering of this feature of nature that is open to unfavorable criticism. His pictures, however, always express a sincere and true motive.

Whittredge's friends garnered most of the medals for landscape painting, but the triumph was illusory. As Peter Bermingham has rightly observed, "Without question the exposition as a whole did serve to accelerate the pace of American internationalism in the arts."[40]

The Centennial's hanging committee played a fascinating role in this pro-

cess, which is documented by J. D. Smillie's diaries. The committee consisted of Smillie, Whittredge, James Sartain of Philadelphia, and William Perkins of Boston. After preliminary meetings with Whittredge on April 14, 1876, and again with Whittredge and Sartain on the fifteenth, Smillie was appointed acting chairman of the committee on the twenty-seventh, because no one else was willing to head it. The politics must have been intense: The only agreement they reached was to petition General Alfred T. Goshorn, Director-General of the Centennial Commission, to call the selection committee to pass on the pictures at hand. The final selection was made on May 3 and the hanging began. Two days later Smillie, Whittredge, and Perkins nearly resigned because Sartain had put Whittredge and evidently several other representatives of the American school nearly out of Memorial Hall, where the exhibition was being installed. Sartain refused to budge because "it would interefere with his plan," which was surely to give pride of place to European artists. In the early years of the decade Sartain switched from patronizing American painters to collecting European art. At any rate, the three artists on the hanging committee stayed on only at the urging of General Goshorn, who persuaded them to keep working. Finally on May 10, the exhibition opened.

DECLINING FORTUNES

By the time he stepped down as its president, Whittredge had saved the Academy from ruin, but he could not restore its luster. Nor was he able to stem the tide of Barbizon that soon engulfed the Hudson River school and transformed his own work as well. The fundamental cause was the bankruptcy of the school itself, which declined rapidly after 1870. Among the most important developments, Asher B. Durand retired from active painting in 1869; John Kensett, the leading representative of the school, died in 1872; and Frederic Edwin Church was stricken in 1876 with inflammatory rheumatism which left him a virtual cripple ten years later. Sanford Gifford's palette became more idiosyncratic as his inspiration flagged; Jasper Cropsey's colors, too, grew more mannered, and he repeated his compositions with little variation. Whittredge had undergone a slower, more varied growth that led to a belated maturation, but he could not single-handedly infuse the school with the fresh inspiration it so sorely needed.

The reversal of the Hudson River school's fortunes was nevertheless totally unexpected. After the Civil War, artists continued to be the darlings of fashionable society in New York City. J. D. Smillie records having dinner with Whittredge and other painters on April 1, 1868, at the home of Theodore Roosevelt, the father of the future president (who was only ten at the time). Whittredge devotes the better part of two pages in his original manuscript to the social life that he and other Hudson River school artists enjoyed during their heydey. He then adds wistfully that the war, changes in the financial

world, and the accumulation of wealth all conspired to alter the status of American artists.[41]

In retrospect, it is remarkable how quickly the popularity of the Hudson River painters faded. On August 11, 1872, Sanford Gifford wrote to Pinchot that Whittredge was well and happy because "his income last season was sufficient to relieve him of anxiety about ways and means, and his baby is a source of perpetual pleasure." A year and a half later the situation had reversed itself. On February 15, 1874, Whittredge wrote Pinchot from his 142 East 18th Street apartment, "Serious things have operated against us, and in some measure against the sale of works of art of all kinds." Intervening between these two letters was the stock market crash of 1873. The failure of Jay Cooke and Co. precipitated a stock market crash on "Black Friday," September 19, causing an economic panic that proved severe but mercifully brief. This cannot be the whole story, however, as Whittredge's distress had already begun earlier that year. Jervis McEntee's diary contains the following entry for July 23, 1873:

> I received a letter this evening from Whittredge from Shandakan where he and his wife are staying at Samuels hotel. He is not well and his letter is very sad and shows that he is much depressed. He wants us to come out and see him and I am going this afternoon. I was struck with Whittredge's look when I left him in N.Y. and I am anxious about him. He had something of the look which I saw come over Moran's face the winter we met in Rome. I have thought of it many times during return from the Adirondacks Thursday.[42]

On the twenty-fifth, he and his father went took the train from Roundout, where they spent every summer, to see Whittredge, and fortunately "found him much better so that he rather regretted having written so despondingly." McEntee does not specify the cause of Whittredge's malaise, but there can be little doubt that it was his finances, which were a source of constant concern to him, as they were to McEntee himself.

McEntee never enjoyed the success of his friends Gifford and Whittredge. His livelihood, always precarious, seems to have reached a low point in 1872. When a patron declined a painting of Venice for $900 on July 2 of that year, McEntee wrote in his diary that he couldn't finish outfitting his studio in Roundout because:

> I can't bear the debt. The fact is I am very unhappy and very disinclined to do any thing. Every thing looks like a great undertaking even the most trivial affair and I find the summer going away without accomplishing much. Whether it is owing to the fact that I have not entirely regained my health or whether I am gradually losing my energy and hopefulness I

can hardly tell, but I am afraid this constant worry about money affairs is having its effect to discourage me. Every summer it is the same. I am tied fast for the want of a little money. I think I must begin now to lay my plans for another year and if possible go elsewhere I can be at work all the time. There is no way to be happy except to keep occupied and I find I cannot occupy myself here.

Part of his problem was that he was in the midst of what is now called midlife crisis, as his entry for July 14 attests:

I am forty-four years old today, nearer I hope to some of the objects at which I have arrived in life and yet how far from much that one could desire. Sometimes I doubt if an artistic temperament is compatible with the happiest and serenest life, for while the satisfactions are often great how many inexpressible longings there are which will not shape themselves.

The following March his mood was just as bleak:

I am in great worry and anxiety on account of my affairs. The season is rapidly passing away and I do not sell much. How I am to get along this summer I have no idea. My father's affairs are a source of anxiety to me also.[43]

In reality, McEntee's finances had improved. A review of his affairs with his wife on May 25, 1873, revealed that his receipts were greater than the previous year's, so that he managed to pay off some debts. For a change, he felt encouraged and was filled with a new enthusiasm, despite the many times he had been unhappy the past year. However, on April 14, 1874, less than twelve months later, he wrote: "Nobody comes to my studio and I begin to feel the old anxiety about money matters from which I have been free all winter. My pictures in the Academy do not sell. I made a mistake not putting lower prices on them but I always do the wrong thing." Interestingly enough, he rarely mentions his finances after that, not because they were better – they weren't – but because he seems to have absorbed himself in his work and resigned himself to his lot.

The problems faced by Whittredge, McEntee, and the rest of the Hudson River painters resulted from a fundamental shift in taste in favor of European art. The tension between the American and foreign schools can already be felt on the last page of a letter written on September 21, 1871, from Whittredge to James Pinchot in which he admits to an occasional desire to return to Europe, but not to travel for personal pleasure: "For all I care about Europe is its art and artists and what they are doing. I am forced to admire it while I don't like it. I admire their knowledge *but* despise *their* souls if one can speak

so." This is an astonishingly uncharitable remark for such an otherwise genial man to make. The reason is reflected later in his letter of February 15, 1874, to Pinchot:

> Immense numbers of pictures however are imported and seem to find sale, some at enormous prices, while the Bierstadts, the Churches, the Giffords and Johnsons, are not sold or even wanted. Some better disposition must be shown by the public for at least our good artists, or art here and our art institutions must die out. It now became I think a little too much the custom to depreciate everything produced here, and over estimate everything brought from abroad.

These sentiments were echoed even more bitterly in another letter written to Pinchot by Jervis McEntee on June 25, 1876, after the opening of the loan exhibition of paintings at the Philadelphia Centennial. After praising Pinchot for supporting American artists, McEntee states:

> It is perilous for us American artists to say anything now. The tide is against us. The dealers, who largely form the popular judgment have no sympathy or interest in us. The press finds it profitable to keep in the good graces of the dealers, so that it is actually the case now that there is no place in New York where the leading American artists can send their pictures for sale with the hope of finding anything like fair treatment.[44]

On September 20, he complained in his diary that despite favorable notices of his work at the Centennial Exhibition, he wished for more buyers, fearing that financial problems would cause him to cater to popular taste, instead of allowing him to create freely. Matters did not improve for the artist. He didn't have the funds to pay his city or state taxes at the beginning of 1878.

It is a measure of the decline in the Hudson River school's standing that the name itself was coined, like so many others, as a pejorative term for native landscape painting. According to Whittredge, it originated with "the acid-penned critic of the New York Tribune," Clarence Cook, who was in his estimation "a confirmed misanthrope."[45] Cook, who began writing in 1864, actively promoted the younger, foreign-trained artists who formed the Society of American Artists in 1877 in protest against the discriminatory hanging policies of the National Academy of Design, but he is not known to have used the term before 1883.[46] Although the acerbic Homer Martin, who converted to the Barbizon style, is sometimes credited with inventing it, the earliest documented reference to the Hudson River school is a review of 1879 in the first issue of the monthly *Art Amateur* by Earl Shinn under the pseudonym Edward Strahan discussing how older American artists were being "sent to the wall by the new men and their creeds."[47]

After serving out his presidency of the Academy, Whittredge remained active in artistic affairs for several more years. His name appears in 1877 on the resolution establishing a loan committee at the National Academy of Design for an exhibition to aid the recently founded Society of Decorative Art. He continued to nominate new members at the Century Association periodically, such as A. B. Stone on January 23, 1878, and on January 31 of that year, he suggested that H. W. Robbins be put in charge of works going to the Paris Exposition, a proposal that was accepted by the rest of the committee. By this time, however, the Hudson River school had all but lost the battle of American landscape painting, and Whittredge himself had already begun his conversion to the Barbizon school.

7

Barbizon Painting

CONVERSION TO BARBIZON

BEFORE THE CENTENNIAL YEAR WAS OVER Whittredge entered the second major artistic crisis of his career, from which he emerged two years later a convert to Barbizon painting. His metamorphosis began with *Autumn on the Upper Delaware* (fig. 118).[1] Based on a poorly preserved oil sketch (Cincinnati Art Museum),[2] it was the only landscape Whittredge exhibited at the National Academy of Design in 1876. The canvas bore a price of $700, twice what he normally demanded for a comparable picture, which indicates the significance he attached to it.[3] Reflecting the continuing taste for large, ostentatious paintings, the critic for *The Art Journal* wrote that "although it is a creditable specimen of his work, it does not assume importance, owing to its small size," but otherwise reviewed the canvas favorably: "'An Autumn on the Delaware' by Mr. Whittredge is very tenderly painted. The autumn tints are subdued yet forcible in effect, and the work is well kept together. Mr. Whittredge paints the brilliant phases of autumn foliage with charming taste."[4] At first glance, *Autumn on the Upper Delaware* seems typical of Whittredge's mature landscapes, but in fact it marks a significant departure from *Along the Upper Delaware* (fig. 100) of only a few years earlier. The artist's previous delight in technical bravura and crisp highlights has given way to a more painterly approach and subdued tonality, suggesting a new expressive intent. The landscape partakes of George Inness's dreamlike vision and represents Whittredge's first exploration of Barbizon painting in nearly a decade. The russet colors, new to his landscapes, were undoubtedly derived from Jervis McEntee, who adopted the same palette and silvery light as early as the mid–1860s. Whittredge uses it to impose an elusive veil across the flat, abstract composition, evoking a broad range of associations beyond time and place.

This experiment, however tentative, plunged Whittredge into turmoil, which is reflected in *Evening in the Woods* (fig. 119). Painted later in 1876, it was received favorably on the whole in the *Art Journal's* review of the National Academy's annual exhibition a year later:

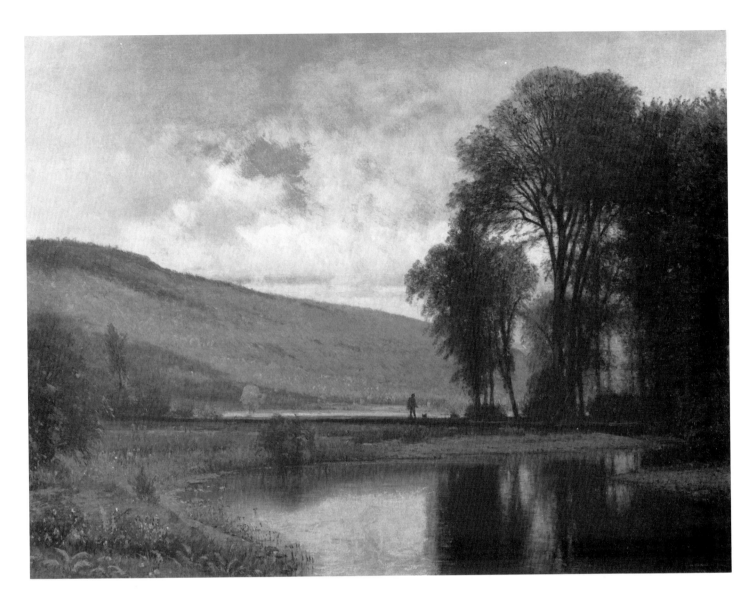

FIGURE 118. Worthington
Whittredge. *Autumn on the
Delaware*, 1876, oil on
canvas, 17 × 23, Santa
Barbara Museum of Art.

Two subjects by Whittredge have great charm. One is called "Morning in the Woods" (186), the other "Evening in the Woods" (391). They are wood interiors of the character this artist so much delights to paint, and in which he appears at his best. "Evening in the Woods" is not so large a painting, and *scarcely so satisfactory*. A group of trees in the foreground, a light in the distant evening sky shining through the trees, and casting, in the brook that flows amid the trees, reflections of those dark-red tints that always seem to give a twilight landscape strange depths of solemn mystery – these features make up the well-painted scene.[5]

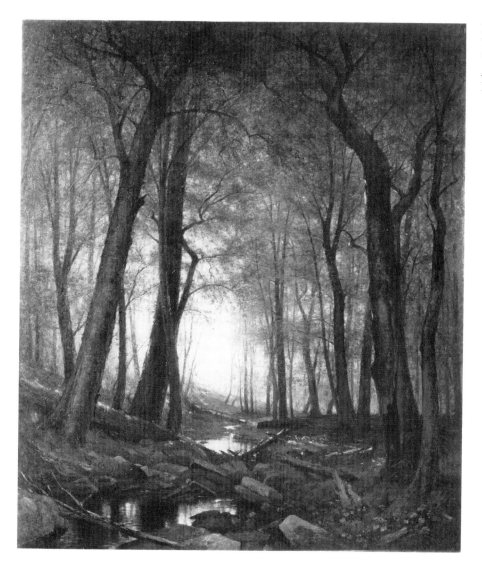

FIGURE 119. Worthington Whittredge. *Evening in the Woods*, 1876, oil on canvas, 42¼ × 36⅛, Metropolitan Museum of Art, New York.

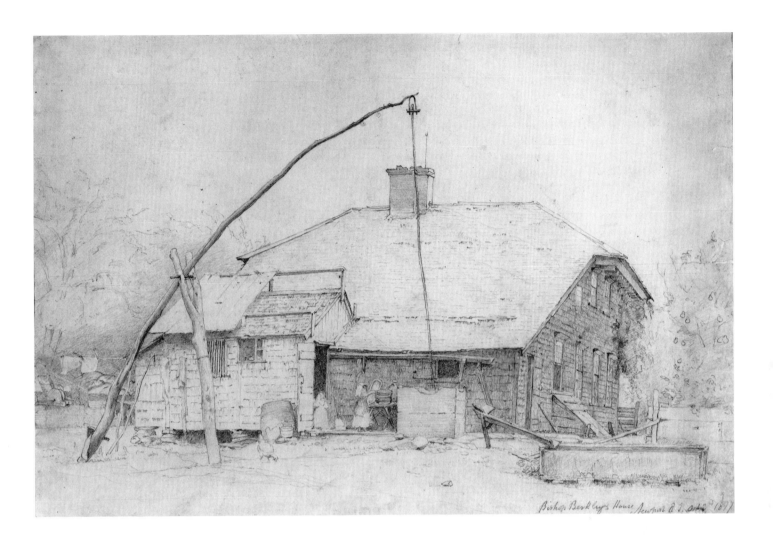

Bishop Berkley's House Newport R.I. Octr 1877

FIGURE 120. Worthington Whittredge. *Bishop Berkeley's House*, 1877, pencil on paper, 15¼ × 22³⁄₁₆, M. and M. Karolik Collection, Museum of Fine Arts, Boston.

The only note of criticism (indicated by the author's italics) is an understatement. *Evening in the Woods* is inferior to any of the artist's earlier forest interiors. It points to a mounting artistic crisis, which emerges fully in the paintings of 1877. *Landscape with Stream and Deer* (formerly Hirschl and Adler Gallery, New York) is an awkward variation of the composition in *Autumn on the Upper Delaware*, while the impasto has become coarse in an unsuccessful attempt to heighten the suggestive ambience. We know that the artist was by now in a state of acute distress. On April 17, 1877, McEntee wrote in his journal: "Poor Whittredge came in very despondent. He has not done well this winter and does not think he can go to the country this summer." In late August, Whittredge did go to Rhode Island where he wrote a pessimistic letter received by McEntee on September 2. A few days later he complained to McEntee that his sketching was going poorly.[6] The oil sketches by Whittredge that can be assigned to this period – *Thatcher's Island* (formerly Bernard Da-

161

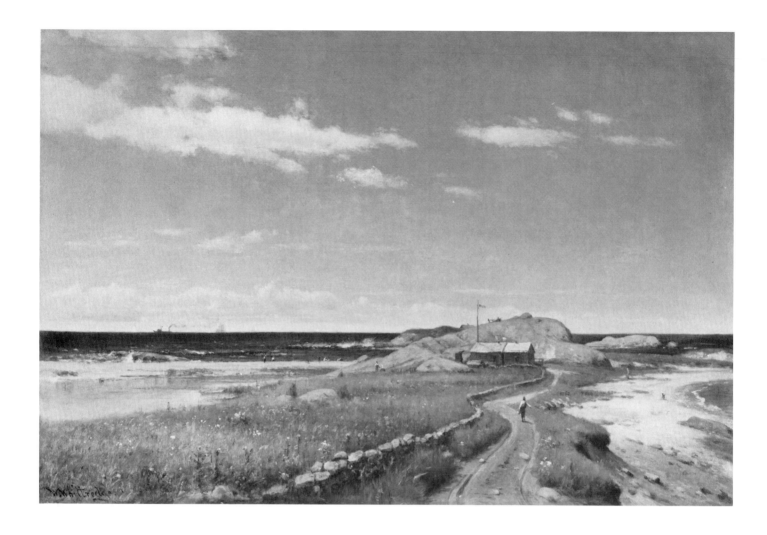

nenberg Galleries, New York) and *Beach at Newport* (Wichita Art Museum, Kans.) – reflect the aimless drift of an artist who has lost his bearings. He nevertheless made two handsome drawings in Newport, the only finished sheets known by his hand after he returned from Europe. *Apple Tree* (private collection) is an airy study that creates the impression of brilliant sunlight by omitting all shading and leaving much of the surrounding paper bare. As a contemporary photograph in the *New York Sketchbook of Architecture* of 1874 attests, *Bishop Berkeley's House* (fig. 120) is a minutely accurate record of the landmark featured in several of the artist's later paintings, except that the chimney was deleted for aesthetic reasons.[7]

At first Whittredge tried to impart a generalized mood to his paintings by imitating Barbizon effects without reevaluating his art. Unlike a decade earlier, however, the Hudson River school no longer carried the authority to absorb other styles. With his European experience, Whittredge seemed uniquely capable among his generation of adapting to Barbizon art.[8]

FIGURE 121. Worthington Whittredge. *Seconnet Point*, c. 1878, oil on canvas, 25 × 38, Amon Carter Museum, Ft. Worth.

162

Nevertheless, as he had discovered in France nearly thirty years before, he was ill-suited by temperament or training to Barbizon painting.[9] Torn between his Hudson River outlook and the Barbizon aesthetic, he now found it difficult to reconcile the contradictions between the two seemingly incompatible schools. Realizing that he had to change his style without renouncing his artistic personality, Whittredge turned to Newport for his subject matter. The familiar coast of Rhode Island held deep personal associations unburdened by Hudson River rhetoric or Barbizon ethos, and it was there that he would achieve a new synthesis, despite his initial difficulties that autumn.

FIGURE 122. Worthington Whittredge. *Seconnet Point*, c. 1880, oil on canvas, 13¾ × 20⅞, National Museum of American Art, Washington, D.C., L. E. Katzenbach Fund.

BARBIZON NATURALISM

Whittredge, however, needed a catalyst, and he found it in the landscapes of Charles-François Daubigny. This forerunner of Impressionism sought to cap-

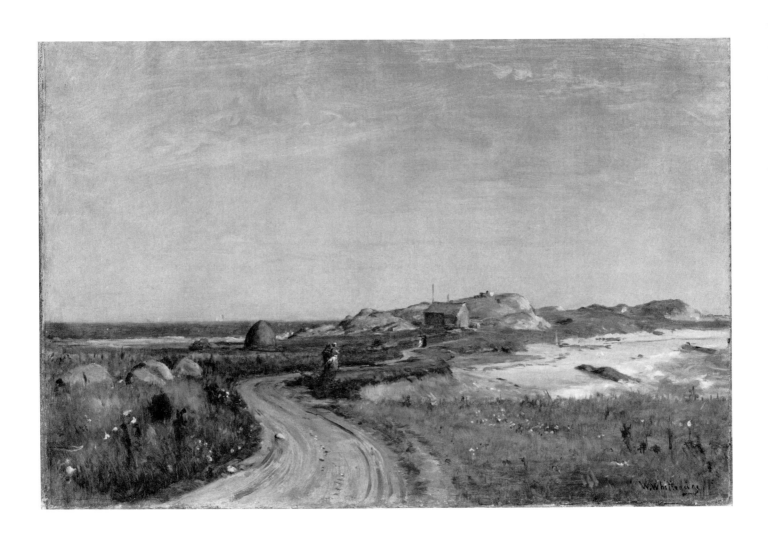

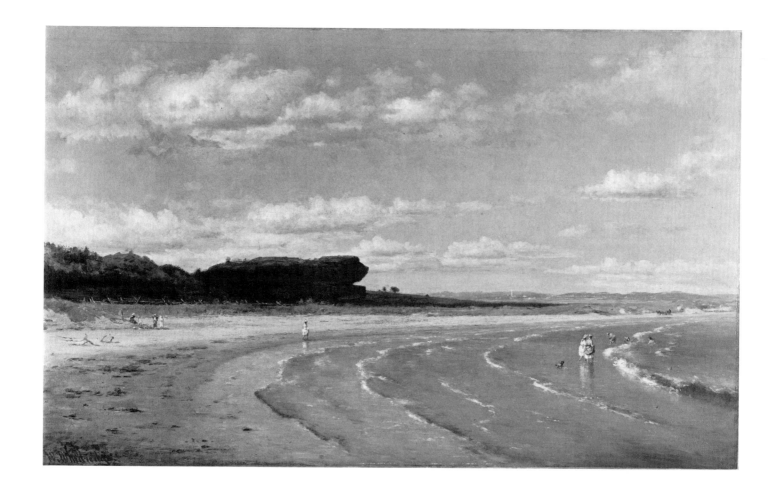

ture the changing face of nature, which he sketched ceaselessly on paper and canvas.[10] Unlike other American Barbizon painters at the time, who were concerned primarily with the landscape of mood, Whittredge discovered in the French artist a naturalism and above all an interest in light that were very much in keeping with his own. Light is the principal subject of two views of Seconnet Point painted around 1880 or a little earlier under Daubigny's influence (figs. 121 and 122).[11] In them Whittredge fully embraces the Frenchman's technique and color to record the breezy, sunlit ambience of Newport.[12] Daubigny's example demonstrated to Whittredge how to suggest landscape forms with a new freedom that conveys the sensation of colored light, although neither artist achieved the saturated palette of the Impressionists. The Washington *Seconnet Point* is an extremely precocious work, and there is nothing else like it in American Barbizon painting before 1890.

The masterpiece among these Newport scenes unquestionably is *Second Beach, Newport* (fig. 123, plate xv). The canvas closely follows a two-page sketch that was most likely made in the summer of 1881.[13] Remarkably, it manages to retain all the directness of a Barbizon oil sketch and, despite its size, the

FIGURE 123. Worthington Whittredge. *Second Beach, Newport*, c. 1880–1, oil on canvas, 30⅛ × 50⅛, private collection.

164

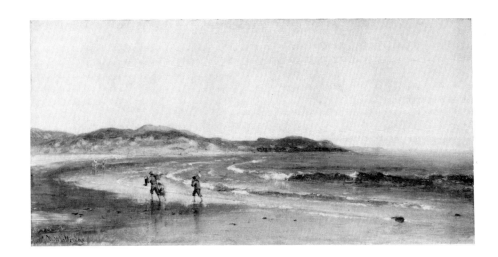

FIGURE 124. Worthington Whittredge. *Scene on Cape Ann*, early 1880s, oil on canvas, 11 × 22, Delbert Gutridge, Cleveland.

FIGURE 125. Worthington Whittredge. *Second Beach*, early 1880s, oil on canvas, 15 × 23, private collection.

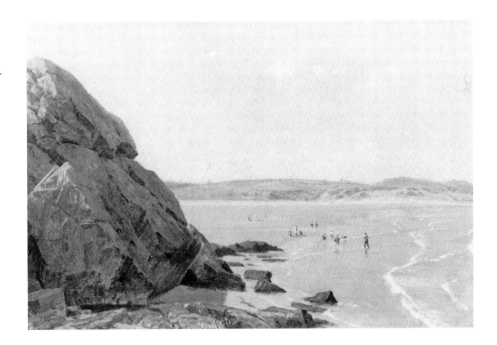

painting is fresher in its observation than Whittredge's Newport scenes of the mid–1860s.[14] Whittredge has captured to perfection the moist, wind-blown atmosphere that sweeps across the great arching expanse of strand.

In effect, Whittredge translated his mature Hudson River style into a Barbizon idiom, using Daubigny's realism as the primary vehicle. This is demonstrated by a pair of beach scenes that must have been executed around the same time. *Scene on Cape Ann* (fig. 124) is painted in essentially the same style as the Washington *Seconnet Point*, yet the results are not significantly different from *Second Beach* (fig. 125), which is among the most Kensettian pictures Whittredge ever painted. Although the technique is not as dry as

FIGURE 126. Worthington Whittredge. *Fields at Tiverton*, early 1880s, oil on canvas, 15 × 22, present whereabouts unknown. Photo courtesy of Kennedy Galleries.

FIGURE 127. Worthington
Whittredge. *Fields near
Newport*, early 1880s, oil on
canvas, 14½ × 22, present
whereabouts unknown.
Photo courtesy of Kennedy
Galleries.

FIGURE 128. View near
Kempton Place at Warren's
Point, Little Compton.

Kensett's, the latter relies on his friend's landscapes of the 1860s, such as *Forty Steps, Newport, Rhode Island* (1860, Jo Ann and Julian Ganz, Jr., Los Angeles). The scene is probably a hybrid. Such a view with rocks dominating the foreground is possible only from atop Purgatory Chasm at the northern tip of Second Beach, but instead of Bishop Berkeley's Seat in the distance, the canvas seems to show part of the vista further to the right.

In the early 1880s, Whittredge executed a half-dozen or so Newport studies from nature in this Barbizon mode. *Fields near Newport* (fig. 127) was painted near Kempton Place at Warren's Point on the other side of Seconnet Point, Little Compton. Its pendant, traditionally identified as a scene near Point Judith (fig. 126), must actually illustrate how the view just to the left looked at the time, as the accompanying composite photograph suggests (fig. 128). In both, Whittredge uses the clear palette to heighten the air of plein air spontaneity. *Peconic Bay* (Mrs. Margaret Mallory, Santa Barbara, Calif.) has been aptly described as "modest in subject matter, direct in handling and full of a mellow charm."[5] Whereas the artist's other Newport oil sketches show the influence of Daubigny, this one seemingly responds to the Barbizon-inspired vistas of Holland by the Hague school that were beginning to be seen in the United States. The closely related painting *Off Seconnet Point, Rhode Island* (fig. 129) has an assurance and freedom that display Whittredge's complete mastery of the Barbizon sketch.

In a concurrent series of studies devoted to houses around Newport, the influence of Barbizon is so completely assimilated that it is no longer dependent on Daubigny's model. These are not the grand mansions whose interiors he had painted in the 1860s and 1870s but the ramshackle, shingle-covered homes built largely during the eighteenth century which were so characteristic of the area. Relatively few have survived. The house in *Landscape with Washerwoman* (fig. 130) is one of only two in Whittredge's pictures that can still be identified. Built in 1878, only a few years before he painted it, the structure is located in the 3,500 block of Main Road in Tiverton, less than three-quarters of a mile north of Four Corners (fig. 131).[16] This is arguably his finest painting of Newport houses. The landscape owes much of its success to the composition, which has been thought out with uncommon care. The space is conceived as a rhythmic arrangement of horizontal layers which are firmly anchored by the vertical accents of the trees, so that the surface geometry echoes the shape of the house. The foliage along the pond in the foreground establishes our precise visual relationship to the scene. The canvas is painted with a deft ease and atmospheric light that faithfully preserve the feel of a summer day. There is some evidence that Jervis McEntee participated in this phase of Whittredge's Barbizon pleinairism. McEntee's small painting *Old House on Long Island* (fig. 132) shares the vigorous brushwork and forceful color of *Farm Scene on Long Island* (formerly Knoedler Gallery, New York) and *Old Newport House* (fig. 133).[17] Both artists imbue their scenes with an affectionate mood and include such felicitous details as the cat on the fence in Whittredge's picture and the chicken in McEntee's.

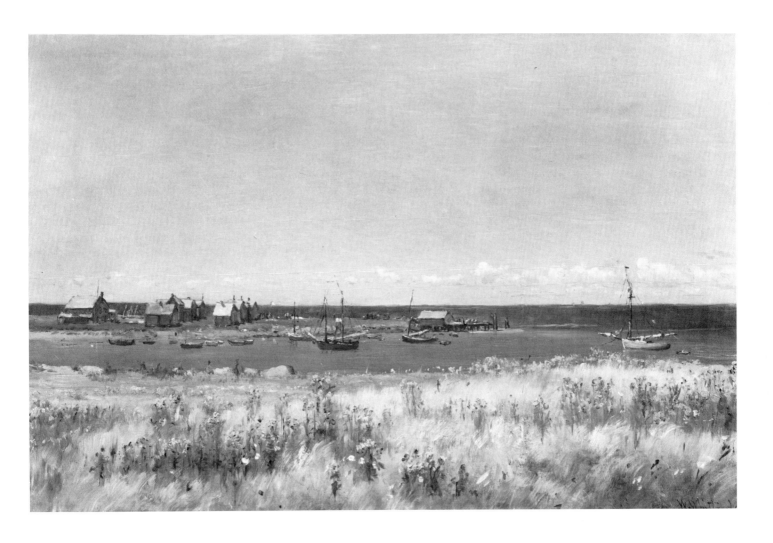

FIGURE 129. Worthington Whittredge. *Off Seconnet Point, Rhode Island,* early 1880s, oil on canvas, 14½ × 22½, the Manoogian Collection.

In 1880, Whittredge built a house, "Hillcrest," in Summit, New Jersey, which he called home for the rest of his life. The move inspired a return to the autumnal subjects traditional to the Hudson River school, which he now treated in a Barbizon style. *View near Millburn* (fig. 134) takes up the copper tones of *Autumn on the Upper Delaware* (fig. 118), while utilizing the painterly brushwork and free play of light in *Old Newport House* (fig. 133) to communicate the artist's pleasure at exploring his new surroundings. *A Grey Day under the Cliff* (fig. 135), in which a startled pheasant rises at the intruder's approach, breathes a similar sense of enchantment. Whittredge's work in this hybrid style culminates in *An Autumn Landscape* (fig. 136). Every passage of the dignified composition is informed by a love of nature so exalted that it achieves a total expressive unity through the refined treatment of the surface and sensitive handling of forms. *An Autumn Landscape* may be regarded as Whittredge's valedictory statement of the theme first expressed nearly forty years earlier in *View of Hawk's Nest* (fig. 7). In both canvases, the artist seeks to

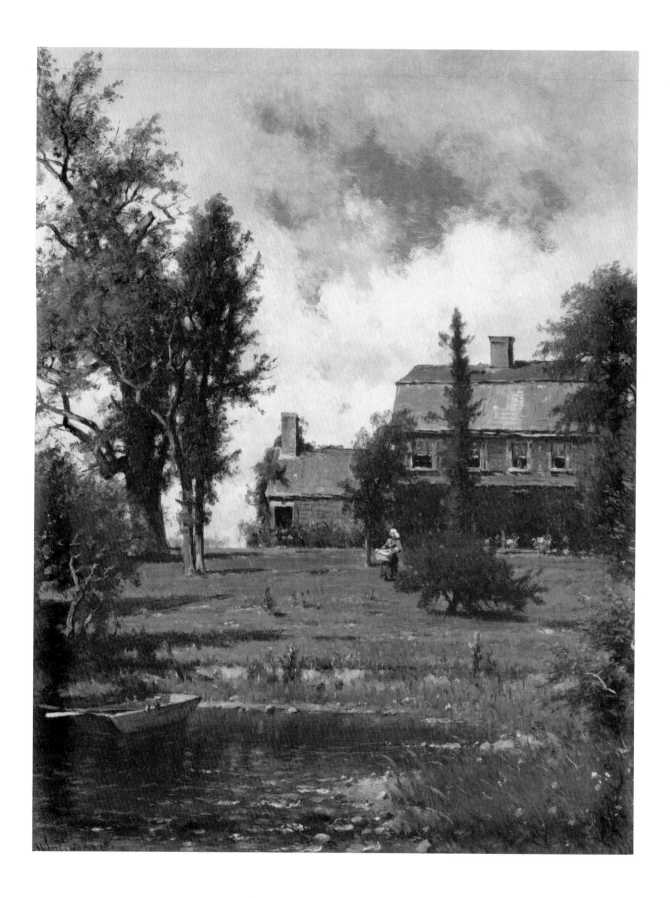

FIGURE 130. Worthington
Whittredge. *Landscape with
Washerwoman*, early 1880s,
oil on canvas, 20¼ × 16,
Saint Petersburg Museum of
Fine Arts.

FIGURE 131. House near
Four Corners, Tiverton.
Photograph courtesy of Dr.
Robert Aaronson.

reveal the inner life of nature, but here the youthful sense of wonder before
nature's vastness has yielded to a lyrical harmony.

BARBIZON PAINTING AND THE
RECONSTRUCTION ERA

The rapid reversal in the school's fortunes reflected in Whittredge's landscapes
after the Centennial is one of the most complex developments in American

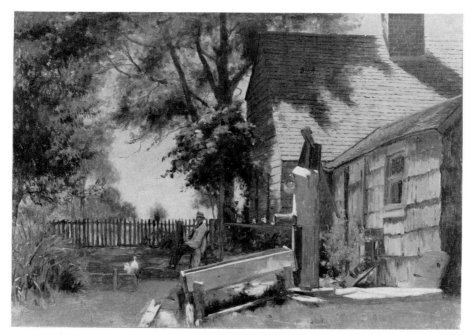

FIGURE 132. Jervis McEntee, *Old House on Long Island*, early 1880s, oil on canvas, 11 × 16¼, Detroit Institute of Arts.

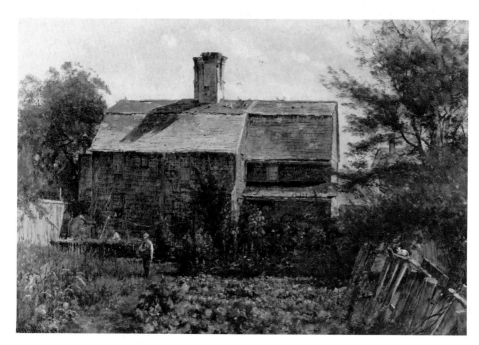

FIGURE 133. Worthington Whittredge. *Old Newport House*, early 1880s, oil on canvas, 14½ × 22, private collection.

FIGURE 134. Worthington Whittredge. *View near Millburn*, early 1880s, oil on canvas, 20½ × 15¼, the Newark Museum. Felix Fund bequest.

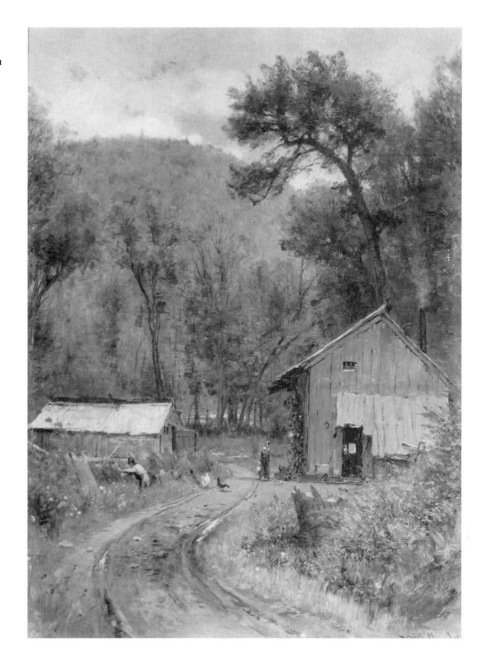

art. As we have already seen, the immediate factor was the bankruptcy of the school itself, which began to stagnate after 1870. Believing they represented the national school, most Hudson River painters were incapable of change. They accepted at face value the Romantic myth of social identity, which took "for granted that a personality, a national one as well as individual, is something pre-existing, within which an invariable and foreseeable pattern of decision reigns."[18] To the extent that it can be said to have constituted a native tradition, its origin in English art notwithstanding, American Romantic art

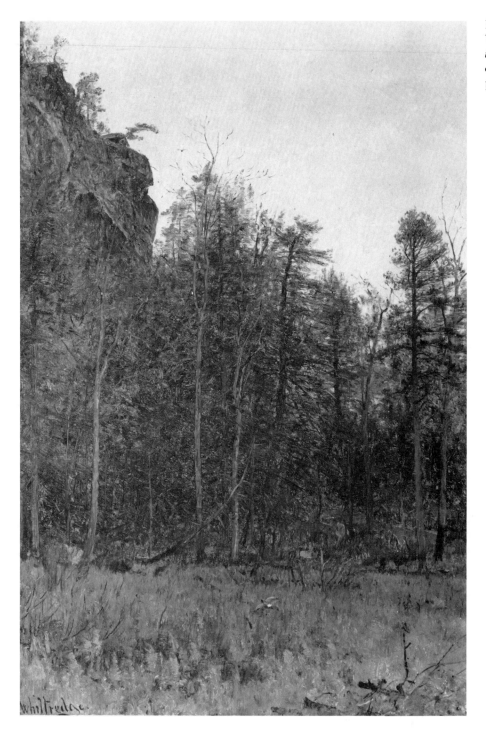

FIGURE 135. Worthington Whittredge. *A Grey Day under the Cliff*, early to mid-1880s, oil on canvas, 16¾ × 11¾, private collection.

FIGURE 136. Worthington Whittredge. *An Autumn Landscape*, early 1880s, oil on canvas, 27¼ × 22¼, Berry-Hill Galleries, New York.

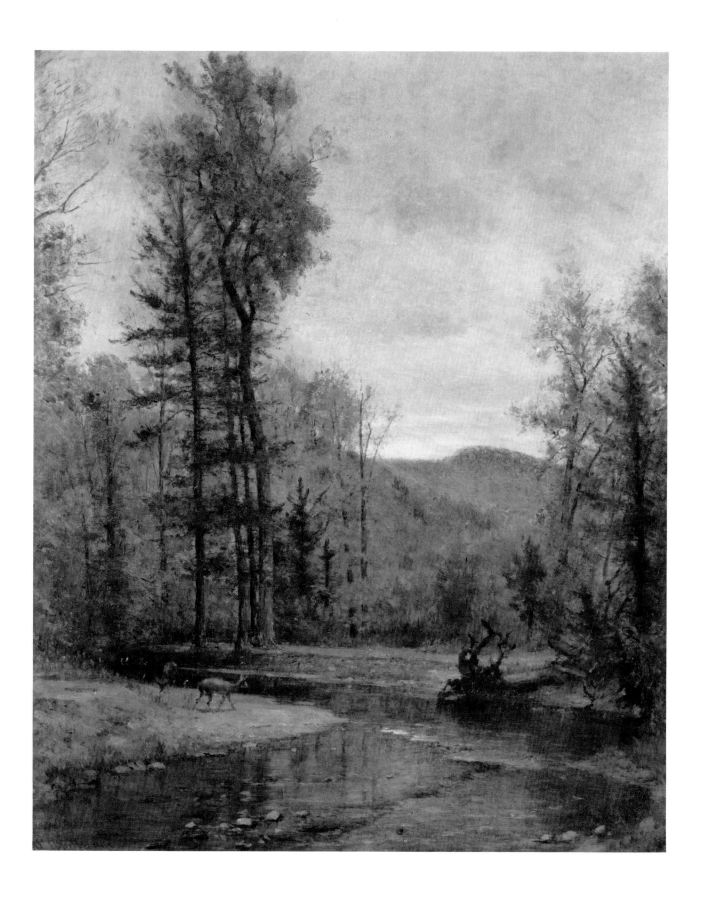

was doomed to a relatively brief efflorescence. Dutch Baroque painting demonstrates compellingly that national schools produced under hothouse historical conditions are too fragile to endure beside the mainstream of Western art.[19]

The underlying cause for the decline of the Hudson River school, however, was the transformation of American civilization after the Civil War. The United States underwent unprecedented industrial growth, immigration, and westward expansion during the Reconstruction era, and these produced not only a new range of social and economic problems, but also a different attitude toward nature.[20] The industrial and cultural transformation of America that followed from the Civil War was an accomplished fact by the end of Reconstruction. The Centennial exhibition effectively signaled the triumph of industry and commerce. The uneasy balance between civilization and nature shifted irrevocably in favor of progress by the end of Grant's presidency.[21] The loss of the twin Romantic visions of the virgin wilderness and a pastoral Eden, which had always existed in tenuous equilibrium, left nature as little more than a sentimental vestige to be preserved in gardens.[22] Even the Far West was, for all practical purposes, won. The Parks Movement symbolized the retreat of the wilderness, which had to be set aside from further encroachment.[23]

The rhetoric of Manifest Destiny, which saw America as a new Eden rising to supplant a decaying Europe, was rendered an outmoded anachronism by the Civil War, which left painful emotional scars in its place that took decades to heal.[24] With it, the epic landscapes of Church and Bierstadt, which had expressed the nation's vision so admirably in the 1860s, came to be considered pretentious and histrionic. In spite of their differences, the Hudson River and Rocky Mountain schools shared much the same philosophy. And because they expressed many of the same beliefs, even the more intimate Hudson River painters like Whittredge suffered as well.

Most damaging of all, perhaps, to the Romantic landscape schools in America, traditional faith in the moral foundation of the universe was seriously undermined by new intellectual currents being imported from Europe. Scottish Realism, which dominated American thought through the Civil War, held that everything which happens in nature has a moral purpose according to God's plan. In addition to overthrowing belief in the creation of Adam and Eve and therefore in original sin, Darwin's theory of evolution posed a natural order that was coldly amoral, if not immoral, in which only the fittest could survive. The similar philosophy of Herbert Spencer subverted the trust in the moral basis of American society and justified the emergence of the new captains of industry. Finally, Hegel's Idealism posited that the universe, and therefore morality, is rational in a metaphysical sense. Broadly speaking, he reconciled the opposition between mind and matter through dialectical thought by synthesizing the Subjective Idea and the Objective Idea into the Absolute Idea, which is pure Thought conscious of itself. Spirit becomes an

almost mystical, homogeneous Infinite, which constitutes Reality as a whole. History is seen as the time-process toward man's more perfect understanding of Spirit in which Christianity implicitly stands for only one developmental stage.[25]

The change in the nation's outlook was accompanied by an equally dramatic shift in taste. As the United States, especially the Northeast, became more like Europe, Americans traveled abroad in growing numbers seeking their cultural models and roots. American painters after 1860 increasingly congregated in art colonies across Europe, especially France. Concurrently, the burgeoning number of art journals in this country employed a younger generation of well-educated writers who were most often Francophiles. The Centennial Exhibition tried, among other things, to demonstrate that progress was compatible with culture by displaying a wide range of art from Europe, America, and the Orient.[26]

This greater cosmopolitanism proved beneficial to American art. Many of the country's greatest painters were active during the final quarter-century after studying in Europe: Thomas Eakins, Winslow Homer, Albert Pinkham Ryder, James McNeill Whistler, John Singer Sargent, William Merritt Chase, Frank Duveneck, and William Harnett, to name only the most important. The country became a kind of artistic melting pot which flourished under a rich diversity of styles that interacted to create an up-to-date American art.

Barbizon was first introduced into this country by Millet's pupil William Morris Hunt and the dealer Seth Vose in Boston. It would probably have remained of little more than local interest had not the tenor of the country changed so radically after the Civil War. When nature ceased to be a teacher of manifest moral truth, the viewer was left only with his reaction to a total impression of nature. Through this resonance, the mystery of nature retained its spiritual significance but required an alternative mode of expression. Barbizon painters answered the need for a new kind of landscape. They responded to the transformation of America by turning inward. The canvases of George Inness, Alexander Wyant, and Homer Martin came to embody the altered mentality of the United States by affording the artist and viewer alike a new creative freedom to evoke a poetic state of mind.[27]

Barbizon was perceived differently on this side of the Atlantic than in France, although it was based directly on the work of Rousseau, Corot, Millet, and their followers. For example, American Barbizon was devoid of the radical social or political implications that were fundamental to its appeal in France.[28] There was, to be sure, an implicit antiindustrial attitude in the work of these artists, but it was allied to the escapism fostered most prominently in this country by the Aesthetic movement and the Pre-Raphaelites. Other than Hunt, Barbizon painters in the United States were by and large no more interested in depicting peasant scenes than the Hudson River school had been in painting industrial landscapes.[29]

What enabled the Barbizon painters to create this new vision? We cannot

point to a generation gap. Most were only a few years younger than the other second-generation members of the Hudson River school to which they initially belonged. George Inness was born in 1825, a year before Frederic Church; Wyant and Martin in 1836, making them exact contemporaries of Alfred Bricher. Coincidentally, all the leading Barbizon painters died within a few years of each other in the 1890s. The distinguishing feature they had in common was the disabilities that helped to shape their art. As Flexner has rightly observed:

> Exuberant health and tramps through the mountains were hallmarks of the Hudson River School. But after the Civil War, there rose to prominence a variant group. Its leader [Inness] was an epileptic. Of his two main followers, one [Martin] had such defective eyesight that he could not draw a vertical line and the other [Wyant] was so crippled that he had to walk sideways.[30]

As a result of their physical disabilities, most members of the Barbizon school in the United States suffered from character disorders that isolated them from the world around them. The most extreme case was Ralph Blakelock, Wyant's junior by ten years, who spent the last two decades of his life confined to a mental hospital with schizophrenia, which includes among its symptoms total absorption in an inner world. Many other American artists after the Centennial – including Winslow Homer and Thomas Eakins – had strange personalities and psychological problems that placed them outside the mainstream of society and caused them to withdraw into the realm of the imagination. Like them, Barbizon school artists were able to capture the state of mind of an altered world precisely because they were misfits. Their private visions provided a significant commentary on Victorian America by revealing the dreams and frustrations that lay behind its prim facade.

The fundamental difference in character between the Hudson River and Barbizon artists and its effect on their work can be seen in the careers of Whittredge and Wyant. Born a half-generation apart, they started out in the Midwest as sign painters. During a visit to Cincinnati in 1857, Wyant became so enthused by the landscapes of George Inness that he undertook a trip to New York to meet him. Inness in turn was sufficiently impressed to help obtain the support of the Cincinnati patron Nicholas Longworth for the young painter. In 1863, Wyant moved to New York, but an exhibition several years later of Düsseldorf paintings inspired him to study in Germany with the Norwegian artist Hans Gude, whose brooding manner he imposed on American landscapes. Like Inness and Martin, he began as a practicing member of the Hudson River school. Wyant might never have developed beyond this point, but for a trip to the West. Undertaken in 1874 to improve his fragile health, it proved so exhausting that he suffered a stroke, rendering his

right arm useless. With much effort he learned to paint successfully with his left hand. Because his subsequent work is no less skillful than his earlier paintings, Wyant certainly did not adopt the broken brushwork of the Barbizon school to disguise the diminution of his powers, as some historians have maintained. Rather, his infirmity led to a profound change in personality, which became increasingly introspective, much as Jervis McEntee's did. Under Inness's influence, his landscapes acquired the character of poetic reveries enveloped in an evocative haze. He finally reduced his compositions to two main types. *An Adirondack Brook* (Cincinnati Art Museum) of the late 1870s treats a typical Hudson River forest interior similar to Whittredge's *A Forest Stream* (fig. 113) but cloaks it in a veiled atmosphere inspired by Corot. *Any Man's Land* (Los Angeles County Museum of Art), painted about 1880, presents his definitive Barbizon style. Here Wyant abandons his previous Hudson River subject matter altogether for a composition derived from Théodore Rousseau showing the silhouette of the woods along the edge of a clearing.

8

Old Age

WANING POWERS

IN 1883, WHITTREDGE'S ART BEGAN TO DECLINE. The change was so gradual as to be barely perceptible at first. Its onset is signaled by a reversion to landscape prototypes from the early 1870s. *Old Homestead by the Sea* (fig. 137) has the picturesque flavor of *A Home by the Seaside* (fig. 105), but now the nostalgia has become self-conscious.[1] As in *Scene on the Upper Delaware, State of New York* (fig. 99), the pointed brushwork equates light and form, while the soft, pastel-like hues imbue the landscape with a pastoral feeling. In comparison to the paintings of a decade earlier, however, the execution has lost some of its deftness and precision. *A Home by the Sea, Newport* of about 1885 (fig. 138) uses broad brushstrokes to suggest a free impressionism of light that compensates for the vagueness of description. The same evolution can be observed in Whittredge's seascapes. The fractured brushwork in *Sunrise at Long Branch* (fig. 139), which won first prize at the National Academy in 1883, creates a forceful play of light and evokes the turbulence of the tide. With its emotive color, the painting looks back to the luminist expression in *Old Time Talk* (fig. 109). Although the figures are omitted here, a second version (Charles F. Maurice, Bayville, N.Y.) includes a group of clam gatherers to elicit a more Romantic state of mind. *Misty Morning on Cape Ann* (fig. 140), which was exhibited the same year at the Artists' Fund Society, introduces a major innovation in the artist's technique. The painting is surprisingly loose in structure and execution, which effectively conveys the feel of damp sea air. Equally atmospheric is the splendid sketch from nature *New England Coast Scene* (fig. 141). The signs of incipient deterioration become more apparent in the slightly later *Seascape* (fig. 142), where the artist divides the painting into three zones of contrasting texture, instead of integrating the surface. Whittredge's forest interiors of the mid–1880s trace a similar course. In *A Trout Brook* (formerly Berry-Hill Galleries, New York), which was shown at The Artists' Fund Society in 1884, and *Autumn – Catskill Mountains in Mist* (fig. 143), the trees are very free in their handling as against the flat treatment of the foreground. Certainly his finest effort in this vein is *Dry Brook, Arkville,*

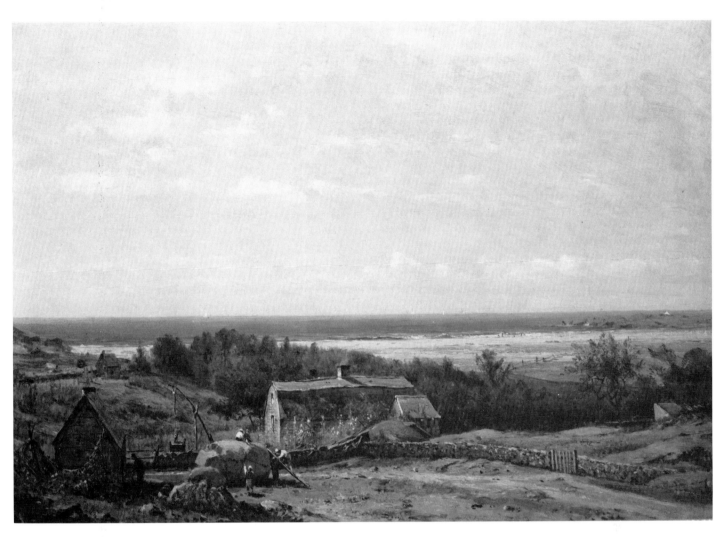

FIGURE 137. Worthington
Whittredge. *Old Homestead by
the Sea*, 1883, oil on canvas,
22 × 32, M. and M. Karolik
Collection, Museum of Fine
Arts, Boston.

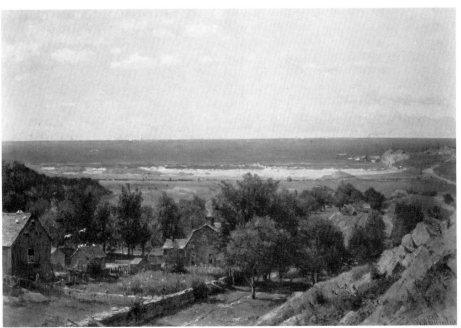

FIGURE 138. Worthington
Whittredge. *A Home by the
Sea, Newport*, c. 1883–5, oil
on canvas, 14¾ × 28¾,
private collection.

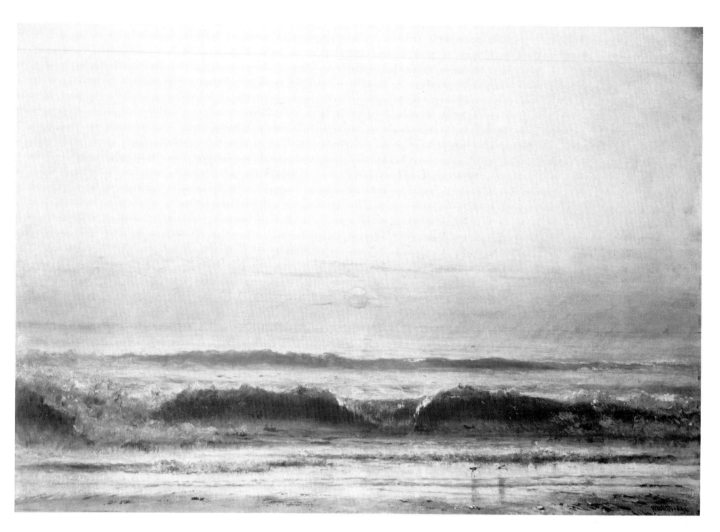

FIGURE 139. Worthington Whittredge. *Sunrise at Long Branch*, 1883, oil on canvas, 22½ × 32, Delbert Gutridge, Cleveland.

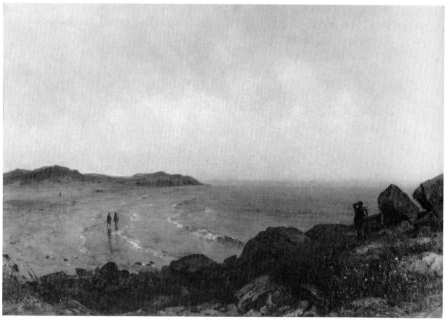

FIGURE 140. Worthington Whittredge. *Misty Morning on Cape Ann*, 1883, oil on canvas, 18 × 26, present whereabouts unknown. Photo courtesy of Kennedy Galleries, New York.

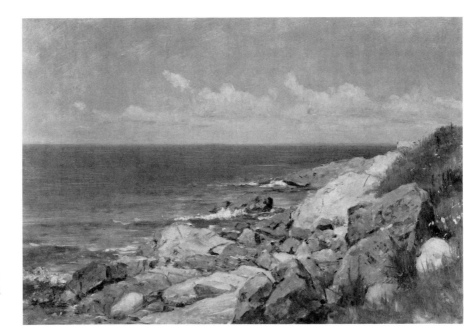

FIGURE 141. Worthington
Whittredge. *New England
Coast Scene*, c. 1885–7, oil on
canvas, 12½ × 18⅞, Hirschl
and Adler Galleries, New
York.

FIGURE 142. Worthington
Whittredge. *Seascape*,
c. 1883–5, oil on canvas,
14⅔ × 20, present
whereabouts unknown.
Photo courtesy of Kennedy
Galleries, New York.

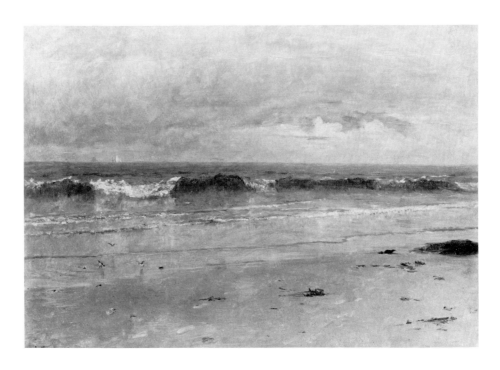

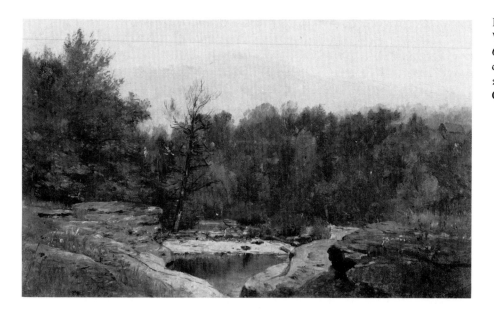

FIGURE 143. Worthington Whittredge. *Autumn – Catskill Mountains in Mist*, c. 1883, oil on canvas, 12 × 20, formerly Kennedy Galleries, New York.

Catskills (fig. 144). The painting nearly equals *Brook in the Woods* (private collection) of a decade earlier, which it resembles in composition.

It should be emphasized that the deterioration in Whittredge's paintings was neither abrupt nor absolute. During the mid–1880s he executed a fine series of paintings devoted to Whitehall and its environs. *Bishop Berkeley's House* (fig. 145), seen from the back, freely rearranges the elements of the drawing from 1877 (fig. 120) on which it is based. The second chimney has again been eliminated, while the forked tree and well-sweep have been transposed to the right and the path redrawn toward the center of the picture. The view itself is fictitious. The house, located well inland, faces a hilly field instead of the ocean, and has a shallow back yard. *Whitehall – Bishop Berkeley's Farm* (fig. 146) repeats the composition but adjusts the pathway to lead the eye more smoothly into the landscape. These liberties lend the scene a spaciousness and balance that are undeniably effective. As Omoto rightly notes, "Whittredge was never a meticulous delineator of details with utmost fidelity to natural appearance. The painting is more satisfactory than the sketch from the compositional point of view."[2] The pasture and orchard seen in these landscapes most likely describe the adjacent properties, which originally belonged to Bishop Berkeley, as they looked a hundred years ago. There can be no question that *The Willows* (fig. 147) depicts the trees lining the road to Whitehall, as a photograph of the site demonstrates (fig. 148). *No Water in the Well* (fig. 149) probably also shows the same locale. Both canvases have the feathery brushwork that sometimes characterizes Whittredge's style at middecade.[3]

In 1884, Whittredge painted his last great Newport scene. *The Old Road to the Sea* (plate XVI) was exhibited that spring at the National Academy of Design with the exceptionally high price of $1,200, and again later that year at the Brooklyn Art Association at only $800 but still failed to find a buyer.

It was finally sold at a major auction of Whittredge's paintings by Ortgies' Art Galleries in New York on March 9, 1887, when it was evidently acquired by Messrs. Pettis and Curtis. The landscape was certainly intended as a major showpiece that would attract a wealthy collector. The size alone announces its importance. This is the largest format he normally worked in, and was reserved for his most prestigious landscapes. Only a handful of works on such a scale are known by him.

The Old Road to the Sea depicts the seaweed harvest at Little Compton, R.I., apparently in the vicinity of Briggs Beach. It is based directly on a small oil (fig. 150) that was probably painted from nature. The study is reminiscent of Rousseau's early Auvergne sketch in the Louvre, and the final landscape retains a strong Barbizon flavor. Whittredge, however, did more than simply enlarge the composition. Although the basic elements remain the same, he has rethought the picture, making something new of it. Whereas the sketch has an appropriate intimacy, the finished canvas possesses extraordinary breadth. Whittredge has elaborated the landscape with an abundance of de-

FIGURE 144. Worthington Whittredge. *Dry Brook, Arkville, Catskills*, c. 1885, oil on canvas, 10¾ × 16½, Currier Gallery, Manchester, N.H. Gift of Mr. and Mrs. Albert Beaudry.

FIGURE 145. Worthington
Whittredge. *Bishop Berkeley's
House*, c. 1885, oil on canvas,
13 × 18¼, from the
Collection of Chateau-sur-
Mer, the Preservation
Society of Newport County,
Newport, Rhode Island.

FIGURE 146. Worthington
Whittredge. *Whitehall –
Bishop Berkeley's Farm*, c.
1885, oil on canvas, 12 ×
18, formerly Titus C.
Geesey, Wilmington, Del.

of the Hudson River school, which is evident in the reluctant acquiescence to
the predominant style of Inness and his followers. *Path along the Stream* (fig.
152) still employs a loose variation on his synthesis of Hudson River outlook
and Barbizon expression from the early part of the decade. *After the Rain* (fig.
153), on the other hand, adopts the manner of Alexander Wyant to transcribe
the liquid atmosphere, rather than evoking an inner vision. *The Bathers* (fig.
154), by way of contrast, reverts to his Hudson River style of the mid–1860s,
but surrounds each form with a suggestive haze as a concession to Barbizon.
There are signs of a total artistic collapse in *Hunters in the Woods* (formerly
Webster, Inc., Chevy Chase, Maryland), which is a lamentable rehash of earlier
compositions like *Pine Cone Gatherers*, and in two New England seascapes

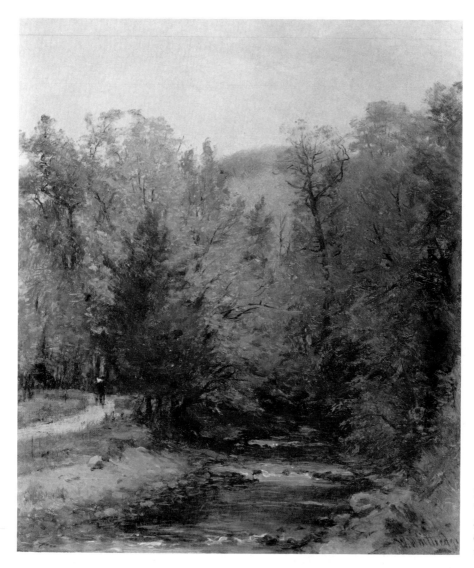

FIGURE 152. Worthington
Whittredge. *Path along the
Stream*, late 1880s, oil on
canvas, 14 × 22, present
whereabouts unknown.

painted toward the end of the decade: the forbidding *Stormy Coast* (Rev.
William N. Bumiller, Dayton, Ohio) and the abstract *Rocky Coast* (formerly
Vose Galleries, Boston).

LATER BARBIZON PAINTING AND AMERICAN IMPRESSIONISM

Around 1890, Whittredge was revitalized by the rise of a new generation of
American Barbizon painters born in the 1850s and trained for the most part
abroad. They were divided between the tonalists, led by Henry Ward Ranger
and Elliott Daingerfield, who continued the landscape of mood;[8] and the
naturalists, under Walter Shurlitt and Bruce Crane, who drew on the Hague

FIGURE 153. Worthington Whittredge. *After the Rain*, mid-1880s, oil on canvas, 12 × 9, private collection.

FIGURE 154. Worthington Whittredge. *The Bathers*, c. 1885, oil on canvas, 25¼ × 38½, Montclair Art Museum, N.J. Gift of William T. Evans, 1915.

FIGURE 155. Worthington Whittredge. *The Old Cart Road*, late 1880s, oil on canvas, 11 × 15½, present whereabouts unknown. Photo courtesy of Kennedy Galleries, New York.

school. Despite their differences, the two camps actually had the same sources in common. Moreover, some of these artists held dual allegiances, alternating between the two modes as the subject demanded; Crane himself later switched to tonalism. Whittredge acknowledged both sides of the dialogue. On the one hand, *The Old Cart Road* (fig. 155) evokes a somber mood by employing a tonalist style and Barbizon motif similar to Sarah Whitman's *The Hayrick* (Worcester Art Museum, Worcester, Mass.). On other hand, *High up on a Hill* (fig. 156), which is probably a study from nature, adopts the vocabulary of Crane's *Country Scene* (private collection), reflecting Willem Maris's fusion of Dupré and Corot. Whittredge was no doubt attracted to Crane's landscapes because he found in them a validation of his own pioneering exploration of Barbizon and Hague school naturalism ten years earlier.

Whittredge's landscapes reflect the state of flux in American painting around 1890.[9] This in turn set the stage for his experiment with Impressionism.[10] The term "impressionism" had been applied earlier by American critics to denote Barbizon landscapes that combined the real and the ideal, emphasizing the imaginative and intellectual sides of painting.[11] By 1890, however, artists who had been exposed to Monet and his circle began returning to the United States. Inness, whom Samuel Benjamin had designated the leader of American Impressionism in 1878, quickly denounced the naturalism of the new school.[12] However, in a passage that can only refer to Monet's followers, not Inness's, Whittredge wrote: "The appearance of impressionism in our midst has never disturbed me in the least. The commotion it has created has kept us alive."[13] He soon became the only Hudson River painter besides Homer Martin to

explore an Impressionist style. *Tree Study* (fig. 157) compares closely in color and brushwork with the landscape elements in *Reverie* (Dr. John J. Mc-Donough) painted only a few years earlier by Robert Reid shortly after arriving home from Europe in 1890.[14] *A Bit of Color* (fig. 158) of around the same time shares the vigorous execution but without the bright palette of *Rock Garden* (Mr. and Mrs. Benjamin F. Williams) by John Leslie Breck, who had just spent several years at Giverny.[15] Nowhere is Whittredge's affinity for the new style more evident than in *An Artist at His Easel* (fig. 159), which has the spontaneity of Sargent's famous sketch *Monet at His Easel* (late 1880s, Tate Gallery, London).

In contrast to France, where it evolved as a logical consequence of Barbizon and Realism, Impressionism in the United States was only one of several styles that arrived fully formed from abroad and were absorbed in rapid succession during the final quarter of the nineteenth century. Removed from their original contexts of time and place, these movements necessarily bore a different relationship to each other than they did in Europe. Like the foreign immigrants who came to these shores, they initially coexisted in mutual isolation and without historical continuity, until they began to interact in the artistic melting pot of America to form a more coherent national expression. In this way, American Impressionism soon acquired a distinctive character different

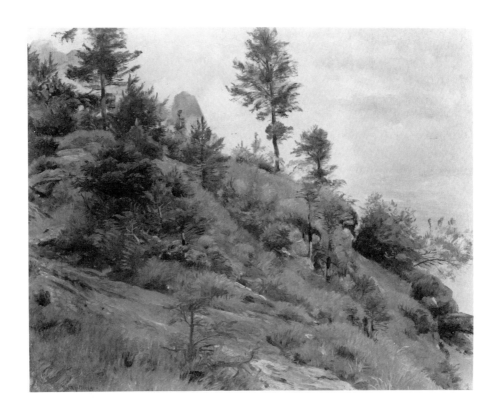

FIGURE 156. Worthington Whittredge. *High Up on a Hill*, late 1880s, oil on canvas, 12¼ × 15¼, Kennedy Galleries, New York.

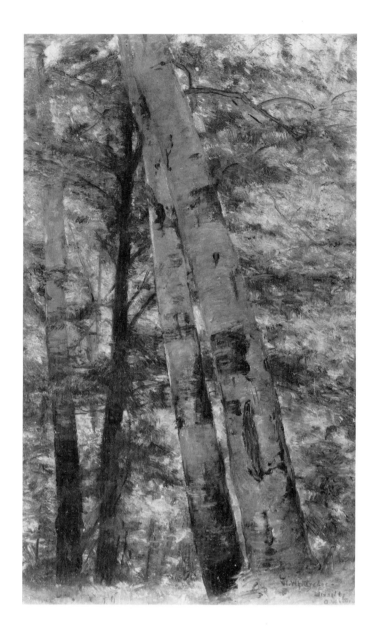

FIGURE 157. Worthington Whittredge. *Tree Study*, early 1890s, oil on canvas, 12¾ × 7¾, present whereabouts unknown. Photo courtesy of Kennedy Galleries, New York.

in complexion and more variable in both style and quality than in France.[16] From the beginning, Impressionism on this side of the Atlantic was characterized by eclecticism, which is a reflection of the broad range of artists who made significant contributions to it: John Singer Sargent, James McNeill Whistler, Frank Duveneck, and William Merritt Chase, to name only the most prominent, as well as Homer Martin, Theodore Robinson and John Twachtman, who always retained Barbizon elements in their styles.[17] The fluidity of Impressionism and Barbizon in the United States permitted Whittredge to move between the two schools with relative ease.

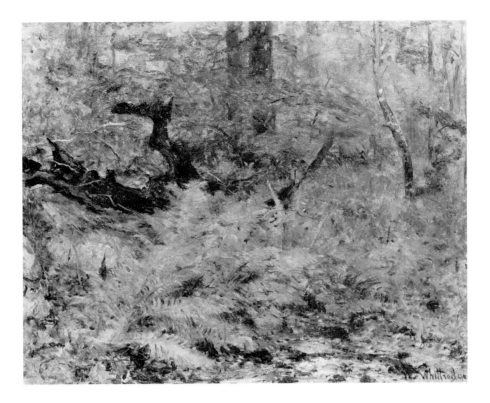

MEXICO

According to his autobiography, Whittredge accompanied Frederic Edwin
Church to Mexico in 1896.[18] However, the drawings from this trip in Whit-
tredge's sketchbook (Archives of American Art, Washington, D.C.) place the
journey three years earlier, during Church's penultimate visit to that country.
Church sought to alleviate the effects of his crippling rheumatism in the warm,
dry climate of Mexico, which he visited almost annually. In December 1892,
he wrote a letter to his sister stating that he had just left for Mexico with an
unnamed friend who can be identified as Whittredge.[19] The inscriptions in
Whittredge's sketchbook show that the two artists toured Mexico City, Acam-
bara, Morelia, Belam, and Lake Cuetzeo between February 21 and 26, 1893.

Whittredge writes that "of all my rambles [it was] the least productive thus
far of anything from my easel."[20] Only four canvases and two watercolors
issued from this trip.[21] *A Mexican Street Corner* (fig. 160) is the best known of
those works. The rapid brushwork and sunlit colors infuse the painting with
a sense of spontaneity that still responds to the artist's experiment with Impres-
sionism of the preceding few years. According to Edward Dwight, the picture
may show a street in Orizaba.[22] There can be no doubt, however, about the
site of the recently rediscovered *A Mexican Fountain, City of Orizaba* (fig. 161).
An inscription on the back of the canvas identifies the locale and confirms
the date of the journey. The painting ranks among the masterpieces of Whit-

197

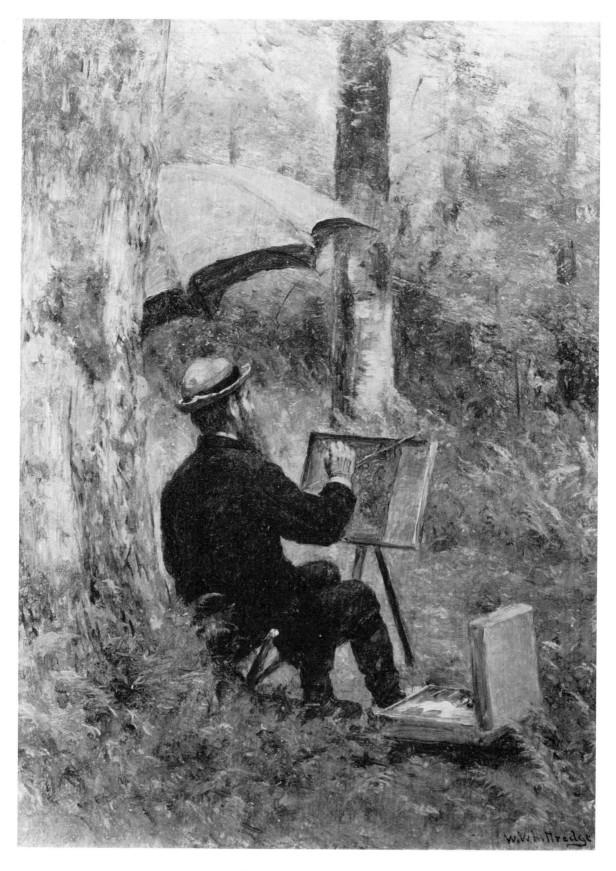

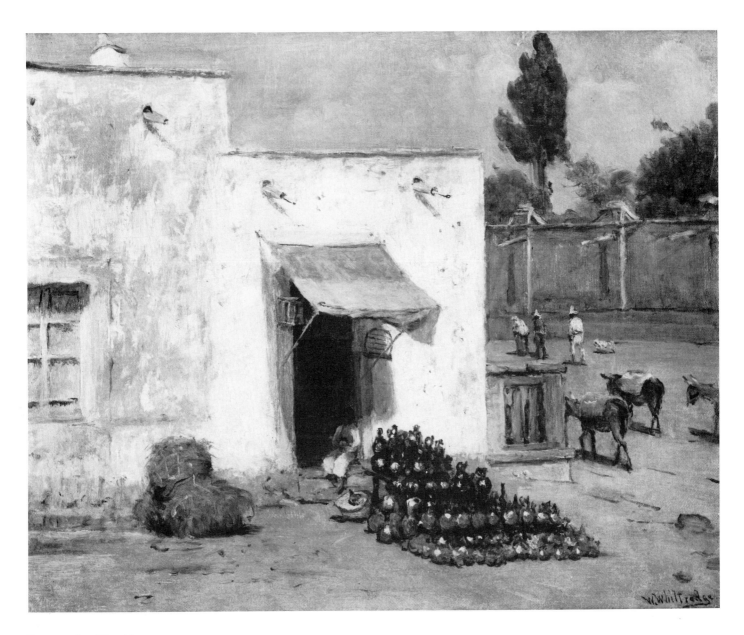

FIGURE 160. Worthington Whittredge. *A Mexican Street Corner*, c. 1893, oil on canvas, 11½ × 14½, Munson-Williams-Proctor Institute, Utica, N.Y.

FIGURE 159. Worthington Whittredge. *An Artist at His Easel*, early 1890s, oil on paper mounted on panel, 11⅜ × 8¼, Collection of Irwin Goldstein, M.D.

tredge's old age. Although the artist was seventy-three years old when he painted it, one would hardly guess it. Unlike much of his late work, which is highly erratic in quality, here there is no hesitation, no infirmity in the brush-work. The keen observation shows an almost youthful relish, testifying to the artist's undiminished enthusiasm for painting. The pigments are thinly brushed on, almost like a watercolor. In fact, Whittredge repeated the com-position in a watercolor version, *Fountain in a Park* (fig. 162), which has a watermark from 1894, indicating that it was painted later.[23] The other wa-tercolor that resulted from this tour, *Francisco Street, City of Mexico* (fig. 163),[24]

must also have been executed after his return, as it is drawn with greater care than similar studies in his sketchbook.

WATERCOLORS

Whittredge's investigation of watercolors was one of several experiments he conducted late in his career. He is known to have used them only once before, and then merely as a compositional aid. He now decided to explore the medium more fully. He made a study of three boats (Mr. and Mrs. L. Emery Katzenbach, New Canaan, Conn.), which is similar to a wash drawing (M. and M. Karolik Collection, Museum of Fine Arts, Boston) done in Switzerland in 1856. He also painted a fine still life, *Laurel Blossoms in a Blue Vase* (formerly Mr. and Mrs. Edward Kessler, Philadelphia), which shows an awareness of

FIGURE 161. Worthington Whittredge. *A Mexican Fountain, City of Orizaba*, c. 1893-5, oil on canvas, 18 × 26¼, Ira Spanierman Gallery, New York.

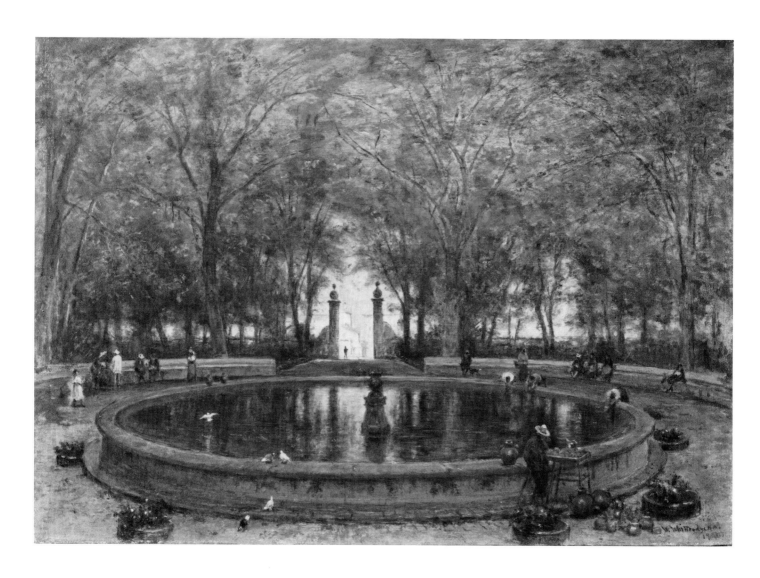

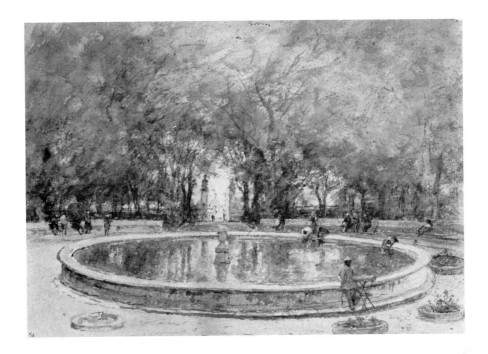

the intensely observed late watercolors of flowers by John LaFarge. Watercolors
were not a natural medium for Whittredge, however, and he soon abandoned
them altogether.

FINAL WORKS

Peach Tree Bough (fig. 164) must have been done around the same time as
Laurel Blossoms in a Blue Vase, which is similar to it in execution, despite the
difference in medium. Like his earlier still lifes, this is a bough picture. Edward
Dwight thought he could discern the date 1894 on the painting, but though
this has not been verified, the canvas can be placed in the mid–1890s on other
grounds. The surface actually bears two signatures: The one at the lower left
is by the artist himself, and is typical for those years; the other, running
vertically up the tree trunk in the lower center of the picture, was added by
his daughter Olive, who inscribed many of his later works, even when they
already bore his signature. The style accords well with works by Whittredge
from the middle years of the decade. The execution has a characteristic loose-
ness, especially in the background, but the draftsmanship remains firm. Still
intact, too, is Whittredge's distinctive palette, which retains all its freshness.

Unlike Asher B. Durand, who quit painting at the age of seventy-five,
Whittredge remained active as an artist for several more years. A great many
of the lesser landscapes and oil sketches by him on the art market were done
during the last years of his career. Most look back to the 1860s and 1870s,

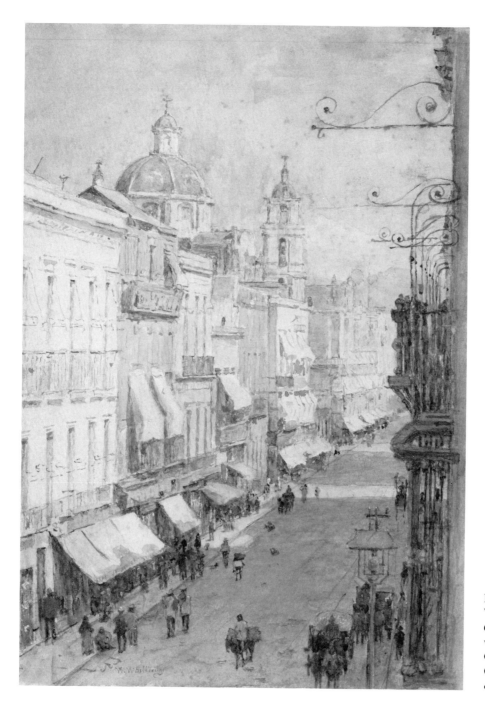

FIGURE 163. Worthington Whittredge. *Francisco Street, City of Mexico*, c. 1894, watercolor, 14½ × 10½, Oliver Shaler Swan Collection, the Art Institute of Chicago.

when his Hudson River style was at its height. The majority are admittedly weak productions, though the best ones can sometimes pass for much earlier works.

In the years 1898–1900, Whittredge painted a group of Newport scenes that are repetitions and variations of previous works. *Along the Sands* (fig. 165),

inscribed 1899, resurrects one of the artist's most important compositions and the one that is the quintessential expression of his attachment to Newport. The fact that this is only his second dated canvas in over fifteen years is a clear indication of the importance he attached to it. The twilight glow endows the landscape with a nostalgic reverie that further suggests it held a special significance for him. A similar composition of *Second Beach* (fig. 166) is closer in style and mood to the great painting of that title from nearly two decades earlier (fig. 123). *Down by the Docks* (fig. 167) further revives the artist's plein-airism of the early 1880s.

These landscapes have a fragile technique that Whittredge was able to overcome in one final masterpiece. *Noon in the Orchard* (1900, fig. 168) is an extraordinary accomplishment for an eighty-year-old man.[25] The landscape, which most likely depicts a scene on Rhode Island,[26] was painted in reaction to a new generation of Barbizon artists. The balanced composition, harmo-

FIGURE 164. Worthington Whittredge. *Peach Tree Bough*, c. 1895, oil on canvas, 15½ × 22¼, Munson-Williams-Proctor Institute, Utica, N.Y.

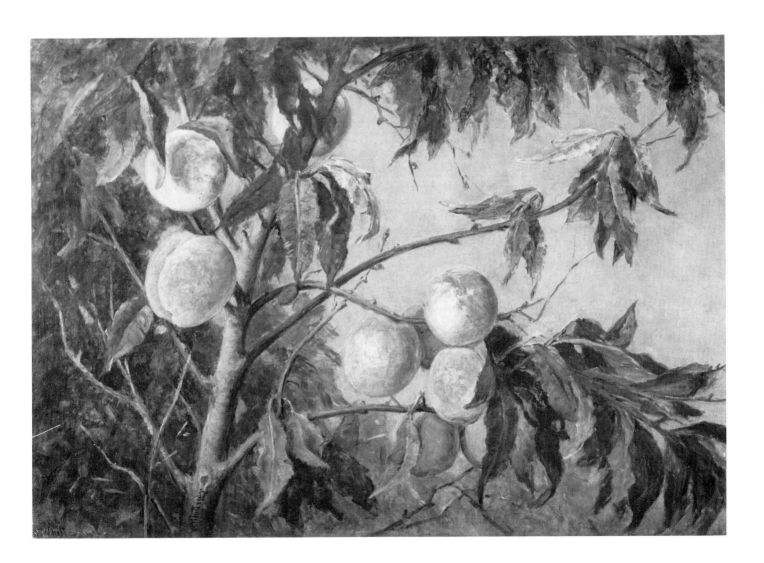

nious palette, and painterly brushwork presume contact with young painters like Anna Brewster.[27] Shortly after 1900, Whittredge tried his hand at the Barbizon–Impressionist manner of Theodore Robinson, but by now he could no longer compensate for the effects of old age, and his works in this vein are decidedly feeble. His last painting is signed and dated 1903. Whittredge knew that his career had finally drawn to an end: It was probably in that year that he penned most of his autobiography.

Whittredge's uncommon willingness to investigate the styles of a succession of other painters toward the end of his career is explained with typical candor in that remarkable document: "It has been one of the greatest pleasures of my life to study their work, not so much for any dexterity that might be displayed as to ascertain what they were thinking of that was new and original and which they desired to express." This exploration reflects a larger desire to come to terms with the fundamental changes in American art at the turn of the century. "The marked influence of their work on the art of our present

FIGURE 165. Worthington Whittredge. *Along the Sands*, 1899, oil on canvas, 17¼ × 26¼, present whereabouts unknown. Photo courtesy of Hirschl and Adler Gallery, New York.

day and on our country has been great and has served to keep alive a flame kindled by the timely appearance of the Hudson River Artists."[28] Whittredge's quest was motivated by traditional nationalism:

> I have hoped to see the great artist, the strong man, overtop-
> ping in strength the artists of any country, an American by
> birth. I have been so anxious to see him that I have strained
> my eyes and wondered if that were not he in the distance. Or
> I have feared that he may have come and passed like a ship
> in the night.[29]

He muses whether he will find this artist among such international painters as James McNeill Whistler and John Singer Sargent or closer to home in the figure of Winslow Homer. Ironically, he omits the strongest of them all, Thomas Eakins.

Whittredge's goal was the emergence of a national school, a process he understood would be necessarily slow:

> Schools of art are not born like mushrooms in a night. They are the result of the slow accumulation of work done by many men without any organization as teachers, but who, in the aggregate, stamp the work of their period with a national or local character different from all other schools.[30]

He adds, "We are looking and hoping for something distinctive in the art of our country, something which shall receive a new tinge...to distinguish it

FIGURE 167. Worthington Whittredge. *Down by the Docks*, c. 1900, oil on canvas, 12¾ × 16¼, present whereabouts unknown. Photo courtesy of Sotheby Park Bernet, New York.

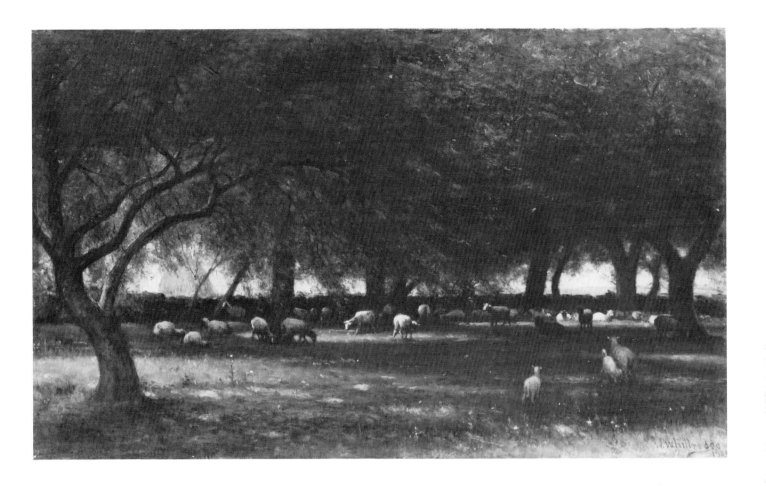

FIGURE 168. Worthington
Whittredge. *Noon in the
Orchard*, 1900, oil on canvas,
18¼ × 31¼, National
Museum of American Art,
Washington, D.C.

from the art of other countries."[31] Whittredge echoes the contemporary belief
that American painting might stem from "our peculiar form of Government,
from our position on the globe, or something peculiar to our people," but
adds that it is the artist's "faith in the heritage of his own country" that provides
the basis for the development of a national art.[32] He locates the uniqueness
of American art not in a fictitious national character or nonexistent unity of
style, but in a diverse and changing expression that reflects the variety and flux
of American society itself. Foreign study is denounced to the extent that it
impedes the development of a national art. Whittredge was nevertheless ex-
ceptionally liberal in his attitude. He acknowledges the importance of a cos-
mopolitan approach: "If art in America is ever to receive any distinctive
character so that we can speak of an American School of Art, it must come
from . . . the close intermingling of the people of the earth."[33]

Whittredge spent the last ten years of his life at his home "Hillcrest" in
Summit, N.J. In addition to a major retrospective exhibition accorded him
by the Century Association in 1904, dinners were given in his honor by his

neighbors on December 22, 1899 and May 1, 1908.[34] The artist's health precluded anything more than a small home reception on his birthday a year later.[35] He died peacefully in Summit on February 25, 1910, barely three months before his ninetieth birthday.

Notes

CHAPTER 1

1. For an excellent overview of early American landscapes, see E. J. Nygren, "From View to Vision," in idem, *Views and Vision – American Landscape before 1830*, Corcoran Gallery of Art, Washington, D.C., 1986.

2. See B. Robertson, "Venit, Vidit, Depinxit," in Nygren, *Views*.

3. Ibid.

4. For a fuller history of the term "picturesque," see E. W. Manwaring, *Italian Landscape in Eighteenth Century England*, New York, 1965, chap. 7.

5. L. Herrmann, *British Landscape Painting of the Eighteenth Century*, London, 1973, p. 110.

6. Price believed that, in contrast to the sublime, the picturesque had nothing to do with dimension and therefore with awe. He made a distinct break with Edmund Burke (*Inquiry into the Origin of our Ideas of the Sublime and the Beautiful*, London, 1756) by emphasizing qualities inherent in the object, not the beholder's state of mind.

7. Herrmann, *British Landscape*, chap. 4.

8. For the contribution of eighteenth-century attitudes to early English Romantic attitudes toward landscape, see A. Holcomb, "The Bridge in the Middle Distance: Symbolic Elements in Romantic Landcape," *Art Quarterly*, 37:1, Spring 1974, esp. pp. 32–3.

9. For a general survey, see W. G. Constable, *Art Collecting in the United States of America*, London, 1958, esp. chaps. 7 and 9.

10. Ibid.

11. M. Friedlaender, *Landscape, Portrait, Still-Life*, trans. R. F. C. Hull, New York, 1963, pp. 112–14.

12. On the role of nature in the national mythology of the nineteenth century, see D. C. Huntington, *The Landscapes of Frederic Edwin Church*, New York, 1966, pp. x–xi, 17–18, and P. Miller, *Nature's Nation*, Cambridge, Mass., 1967, pp. 10–12, 150–8, 196–207.

13. W. P. Hudson, "Archibald Alison and William Cullen Bryant," *American Literature*, 12:1, March 1940, pp. 59–68.

14. On religion and the arts, see N. Harris, *The Artist in American Society*, New York, 1966, pp. 134–5.

15. In general, see Miller, *Nature's Nation*. See also Hudson, "Alison"; D. Ringe, "Painting as Poem in the Hudson River Aesthetic," *American Quarterly*, 12:1, Spring 1960, pp. 71–83; C. L. Sanford, "The Concept of the Sublime in the Works of Thomas Cole and William Cullen Bryant," *American Literature*, 28:4, May 1957, pp. 434–48.

16. On Bryant's religiosity, see C. H. Brown, *William Cullen Bryant, A Biography*, New York, 1971, pp. 397–8. See also P. Miller, *The Transcendentalists*, Cambridge, Mass., 1967, esp. pp. 3–15, 164, 339, 429–30.

17. Miller, *Nature's Nation*.

18. W. H. Gerdts, "American Landscape Painting: Critical Judgments, 1730–1845," *American Art Journal*, 17:1, Winter 1985, pp. 39–40.

19. The only serious study of this artist published to date remains F. Goodyear, Jr., *Thomas Doughty 1793–1856*, Pennsylvania Academy of the Fine Arts, Philadelphia, 1973.

20. It is unclear how Doughty could have known Cozens's painting, which seems not to have been exhibited or reproduced. See K. Sloan, *Alexander and John Robert Cozens, The Poetry of Landscape*, New Haven, 1986, pp. 37, 170, n. 13.

21. On Cole, see E. I. Seaver, *Thomas Cole, 1800–1848, One Hundred Years Later*, Wadsworth Atheneum, Hartford, 1948; H. S. Merritt, *Thomas Cole*, Memorial Art Gallery, University of Rochester, Rochester, N.Y., 1969; J. T. Flexner, *That Wilder Image, The Painting of America's Native School from Thomas Cole to Winslow Homer*, 2nd ed., New York, 1970, chaps. 1–3; M. Baigell; *Thomas Cole*, New York, 1981.

22. Seaver, *Cole*, p. 2. See E. P. Richardson, "Allen Smith, Collector and Benefactor," *American Art Journal*, 1:2, Fall 1969.

23. Cf. E. C. Parry III, "Cole's Early Career: 1818–1829," in Nygren, *Views*.

24. W. Dunlap, *History of the Rise and Progress of the Arts of Design in the United States*, ed. R. Weiss, 3 vols., New York, 1969, p. 360. A variation is recorded that upon meeting Cole, Trumbull exclaimed, "You have already done what I, with all my years and experience, am yet unable to do." See Rev. L. Noble, *The Life and Works of Thomas Cole*, ed. E. S. Vesell, Cambridge, Mass., 1964, p. 32.

25. I have relied throughout this account on Rev. C. F. Goss, *Cincinnati: The Queen City 1788–1912*, 4 vols., Cincinnati, 1912. On Cincinnati as an art center, see L. B. Miller, *Patrons and Patriotism*, Chicago, 1966, pp. 188–200.

26. See M. Cunliffe, "Frances Trollope 1780–1864," *Abroad in America: Visitors to the New Nation 1776–1914*, ed. M. Pachter and F. Wein, Washington, D.C., 1976, pp. 32–42.

27. See E. Clark, *History of the National Academy of Design, 1825–1953*, New York, 1954; H. W. Henderson, *The Pennsylvania Academy of the Fine Arts*, Boston, 1911.

28. Flexner, *Wilder Image*, pp. 149–50. For art instruction in European academies, see N. Pevsner, *Academies of Art, Past and Present*, Cambridge, 1940; A. Boime, *The Academy and French Painting in the Nineteenth Century*, London, 1971, esp. chap. 2; W. Becker, *Paris und die deutsche Malerei, 1750–1840*, Munich, 1971, esp. pp. 12–18.

29. Formal instruction was most readily available to young women at genteel schools like the Columbia Academy run by Archibald Robertson in Philadelphia around the turn of the century.

30. On English manuals, see E. M. Bloch, *George Caleb Bingham*, Berkeley, and Los Angeles, 1967, pp. 41–3.

31. W. Craven, *Sculpture in America*, New York, 1968, pp. 111f., 180–7.

32. See W. Whittredge, original manuscript, Archives of American Art, Washington, D.C., pp. 31–7, which are devoted to Longworth.

33. This section is based on a talk given by the author at the Cincinnati Art Museum in October 1980, portions of which appeared as "The Cincinnati Landscape Tradition," *Celebrate Cincinnati Art*, ed. K. R. Trapp, Cincinnati, 1982. I am indebted to discussions with Elizabeth G. Holt, and to a lecture by Marc Pachter at the Indianapolis Museum of Art in 1980.

34. On Frankenstein, see K. Trapp in D. Carter, *The Golden Age: Cincinnati Painters of the Nineteenth Century Represented in the Cincinnati Art Museum*, Cincinnati, 1979, pp. 73–4; also J. E. Arrington, "Godfrey N. Frankenstein's Moving Panorama of Niagara Falls," *New York History*, 1968, pp. 169–99.

35. See Chapter 2.

36. See N. Moure, *William Louis Sonntag*, Los Angeles, 1980; C. A. Sarnoff, *William Louis Sonntag – A Biographical Sketch*, unpublished manuscript, 1974.

37. On the phenomenon of panoramas in American art, see W. Born, *American Landscape Painting, An Interpretation*, New Haven, 1948, p. 12.

38. Sarnoff, *Sonntag*, p. 17.

39. Ibid., p. 19 and n. 30.

40. Ibid., pp. 19–20 and n. 52.

41. Joseph Kentner's monograph in preparation for the Cambridge series will shed some much-needed light on Duncanson. In the interim, see J. Porter, "Robert S. Duncanson, Midwestern Romantic Realist," *Art in America*, October 1951; G. McElroy, *Robert S. Duncanson*, Cincinnati Art Museum, 1972; and Edward H. Dwight's pioneering publications, listed in

McElroy's bibliography, pp. 16–17. The most recent literature is J. O. Horton and L. R. Hartigan, *Sharing Traditions, Five Black Artists in Nineteenth-Century America*, National Museum of American Art, Washington, D.C., 1985, esp. pp. 51–68.

42. McElroy, *Duncanson*, p. 11.

CHAPTER 2

1. Pp. 165–6. My thanks to Arthur Lesser for providing this material to me. Additional information was supplied by James Whitridge Twyford of Newburgh, Ind. The Whittredge papers in the Archives of American art in Washington, D.C. include a typed copy of the genealogy given in the family bible owned by the artist's father. Whittredge himself includes a brief discussion of his heritage on p. 5 of the original manuscript of his autobiography in the same collection. There are only minor discrepancies between these various sources.

2. On p. 5 of his original manuscript, however, the artist states, "In 1637 one Nathaniel Whittredge from whom I am descended settled in Glouchester, Massachussetts." He paid £ 17s. 6d taxes from which it would seem he was a land owner. He came from County Kent England on the ship Elizabeth and was probably at first a fisherman.

3. Whittredge, ibid., adds that the name Worthington "frequently appears in the early history of Connecticut. Governor Worthington, one of the early governors of Ohio, was her cousin. Her father was a minister and her mother was a woman of more than ordinary education and of great loveliness of character."

4. Our knowledge of Whittredge's youth is confined to his autobiography. See W. Whittredge, *The Autobiography of Worthington Whittredge*, ed. J. Baur, Brooklyn Museum of Art, 1942.

5. Ibid., p. 9.

6. Ibid., p. 7.

7. Ibid., p. 9.

8. Ibid.

9. Ibid.

10. Ibid.

11. Ibid.

12. Whittredge, original manuscript, p. 17.

13. Ibid., pp. 17–18.

14. This information kindly provided by Frances R. Martindale of the Cincinnati Art Museum.

15. Whittredge, *Autobiography*, p. 17.

16. Ibid., p. 10.

17. Ibid.

18. Ibid., p. 11.

19. Whittredge, original manuscript, p. 20.

20. C. A. Sarnoff, *William Louis Sonntag – A Biographical Sketch*, unpublished manuscript, 1974, p. 7.

21. A somewhat later bucolic landscape in the Cincinnati Art Museum shows little evolution in style.

22. Whittredge, *Autobiography*, p. 17.

23. Ibid.

24. Ibid., pp. 12–13.

25. W. D. Peat, *Pioneer Painters of Indiana*, Indianapolis, 1954, p. 159.

26. Ibid. Beecher had actually moved there from Cincinnati in 1839.

27. Whittredge, original manuscript, p. 20.

28. See E. T. Wheatley, *Kentucky Ante-Bellum Portraiture*, Lexington, Ky., 1956. According to Whittredge's original manuscript, p. 26, Jenks, who hailed from New Orleans, wintered over in the South and spent his summers in the White Sulphur Springs area of Virginia, which was intended as their final destination after getting whatever business they could in Charleston, West Virginia.

29. See E. P. Richardson, *Painting in America: The Story of 450 Years*, New York, 1956, pp. 154–5.

30. Whittredge, *Autobiography*, pp. 13–14. The account is confirmed by the entry for May 26, 1898 in James D. Smillie's diary (Archives of American Art, Washington, D.C.), which records that "a married woman almost succeeded in seducing" Whittredge. I am indebted to Dr. Brucia Witthoft for pointing this out to me.

31. Whittredge, *Autobiography*, p. 16.

32. J. T. Flexner, *That Wilder Image, The Painting of America's Native School from Thomas Cole to Winslow Homer*, 2nd ed., New York, 1970, pp. 94–100.

33. Compare Doughty's *The Lucky Fisherman* (1836, New York State Historical Association, Cooperstown), which uses a similar double-wing composition in the left half of the picture.

34. Compare *View of the Susquehanna River* (late 1820s, Pennsylvania Academy of the Fine Arts, Philadelphia) and *Landscape* (1829, Delaware Art Museum, Wilmington).

35. Whittredge, original manuscript, p. 39.

36. G. C. Groce and D. H. Wallace, *The New-York Historical Society's Dictionary of Artists in America, 1564–1860*, New Haven, 1957, p. 411.

37. The poem relies on the second and sixth stanzas of Bryant's "A Walk at Sunset," published three years earlier.

38. N. Moure, *William Louis Sonntag*, Los Angeles, 1980, p. 44.

39. E. Dwight, *Worthington Whittredge*, Munson-Williams-Proctor Institute, Utica, N.Y., 1965, p. 25.

40. The painting is inscribed by the artist View from Dayton Cemetery by T. W. Whitridge.

41. I am grateful to Nancy R. Horlacher, reference librarian at the Dayton and Montgomery County Public Library, for providing information on the painting, whose present whereabouts is unknown.

42. Flexner, *Wilder Image*, pp. 56–65. For a more recent, thorough survey, see also T. E. Stebbins, Jr., *Close Observations: Selected Oil Sketches by Frederic E. Church*, Washington, D.C., 1978.

43. Whittredge, *Autobiography*, p. 15.

44. *Hunters of Kentucky*, Western Art-Union, 1847, no. 22.

45. The title is inscribed by the artist on the back.

46. *Scene on the Juniata*, 39 × 27, was no. 6 distributed by the American Art-Union in 1849:

> A raft or flat boat is transporting cattle across a broad stream. At the landing on the left a man with a horse and dog are waiting to pass over. In the distance are hills, and a little way above the landing on the other side is a forge, the smoke of which is seen. To J. Colburn, Leominster, Mass.

See M. B. Cowdrey, *American Academy of Fine Arts and American Art Union, Exhibition Record, 1816–1852*, New York, 1953, p. 397.

47. Flexner, *Wilder Image*, pp. 149–50.

48. F. Goodyear, Jr., *Thomas Doughty 1793–1856*, Pennsylvania Academy of the Fine Arts, Philadelphia, 1973, p. 18.

49. D. Lawall, *A. B. Durand 1796–1886*, Montclair, N.J., 1971, p. 26.

50. Whittredge, *Autobiography*, p. 18.

51. The dates are given in his passport and account books, which are preserved in the Archives of American Art, Washington, D.C.

CHAPTER 3

1. Whittredge, original manuscript, Archives of American Art, Washington, D.C., pp. 39–41.

2. Whittredge's activies and their approximate dates can be determined from his passport and autobiography.

3. W. Whittredge, *The Autobiography of Worthington Whittredge*, ed. J. Baur, Brooklyn Museum of Art, 1942.

4. Ibid. pp. 20–1. The artist also states erroneously, "my friend Frederick

[sic] Church" was studying in Paris when, in fact, he did not go to Europe until 1867.

5. Whittredge, *Autobiography*, p. 21. American artists had been regularly admonished for twenty years not to be seduced from their native vision.

6. Ibid.

7. Ibid.

8. Other leading practitioners of the classical landscape were Eugène Buttura, Felix Lanoue, and Achille Benouville. See A. Boime, *The Academy and French Painting in the Nineteenth Century*, London, 1971, p. 147.

9. R. L. Herbert, *Barbizon Revisited*, Museum of Fine Arts, Boston, 1962, pp. 38, 64–5.

10. Whittredge, *Autobiography*, p. 21.

11. Ibid. His passport was visaed on October 9, 1849.

12. Ibid.

13. Whittredge, original manuscript, p. 34.

14. R. L. Stehle, *The Life and Works of Emmanuel Leutze*, unpublished manuscript, 1972, pp. 13–14.

15. Cf. B. S. Groseclose, *Emmanuel Leutze, 1816–1868: Freedom is the Only King*, National Collection of Fine Arts, Washington, D.C., 1976, pp. 51–2. Although p. 23 of Whittredge's *Autobiography* indicates that he did not see the Düsseldorf Gallery in New York City before leaving for Europe, the discussion on pp. 54–5 and 61 of the original manuscript about the fact that Boker was the first to exhibit paintings at night by gaslight suggests that he had probably heard of it.

16. W. Becker, *Paris und die deutsche Malerei, 1750–1840*, Munich, 1971, p. 91, also List 2, esp. p. 449.

17. W. von Kalnein, "The Düsseldorf Academy," *The Düsseldorf Academy and the Americans*, High Museum of Art, Atlanta, 1973. Genre painting was headed by Johann Hasenclever. Johann Preyer was the leader of the still life painters.

18. N. Pevsner, *Academies of Art, Past and Present*, Cambridge, 1940, pp. 215–8.

19. Whittredge, *Autobiography*, p. 24.

20. R. L. Stehle, *The Life and Works of Emmanuel Leutze*, unpublished manuscript, 1972, p. 20.

21. Whittredge, *Autobiography*, pp. 22–3. The original painting was lost in a fire. The version now in the Metropolitan Museum is a duplicate executed by Leutze and Eastman Johnson. See Stehle, *Leutze*, chap. 3.

22. Whittredge, *Autobiography*, p. 23; and idem., original manuscript, p. 34.

23. Whittredge, *Autobiography*, pp. 24–5.

24. Ibid. p. 25; and idem., original manuscript, p. 45.

25. Compare the painting to Lessing's *Siege of a Castle* and *Arnheim Cloister* (both Kunstmuseum, Düsseldorf).

26. Noted in Whittredge's account book.

27. Rolandseck is a ruined castle one mile south of Drachenfels on the opposite side of the Rhine below Bonn. Compare the execution to Achenbach's *Norwegian Coast* (1834, Muzeum Narodowe, Poznan), for example. The landscape is based on a two-page sketch in his European sketchbook (Archives of American Art, Washington, D.C.).

28. Whittredge, *Autobiography*, p. 20. It is unclear whether he is referring to Henri or Louis Robbe, though the latter is perhaps the more likely candidate.

29. See P. de Mont, *De Schilderkunst in Belgie van 1830 tot 1921*, s'Gravenhage, 1921, chap. 9, esp. p. 153; also G. Vanzype, *L'Art Belge du XIXe Siècle*, Brussels, 1923, chap. 9. Whittredge's landscape bears an obvious resemblance to *The Gylieu Pond near Optevoz* (Cincinnati Art Museum) painted three years earlier by Charles-François Daubigny. M. Fidell-Beaufort kindly informs me that similar illustrations appeared during the 1840s in such journals as *Magazin Pittoresque* and presumably acted as the common source for these canvases.

30. Stehle, *Leutze*, p. 14.

31. Whittredge, *Autobiography*, p. 25.

32. Whittredge, original manuscript, pp. 63–4.

33. Whittredge, *Autobiography*, p. 26, and idem., original manuscript, p. 48.

34. Compare the topography with Lessing's drawing of Regenstein (Cincinnati Art Museum).

35. F. Schaarschmidt, *Zur Geschichte der Düsseldorfer Malerei*, Düsseldorf, 1902, chap. 10.

36. Because they both intensely disliked teaching, neither Achenbach nor Lessing was a member of the Academy.

37. Schaarschmidt, *Düsseldorfer Malerei*, chap. 10.

38. Whittredge, *Autobiography*, p. 26.

39. Becker, *Paris und die deutsche Malerei*, pp. 371, 452, 453. On p. 457, he lists third-class medals awarded to Lessing, Schirmer, and Achenbach at Paris Salons between 1837 and 1839, among the numerous honors accorded German artists by the French. The interaction of German landscape painting with French art corresponds with a major shift in German history painting as well. Ibid., p. 91, notes that after 1840 there was hardly a German history painter who did not work without close ties to French art, because the Nazarenes left no viable heritage.

40. It is generally assumed that Schirmer's landscapes in the Karlsruhe Kunsthalle were executed after he moved there. See J. Lauts and W. Zimmerman, *Katalog Neuere Meister, 19 und 20. Jahrhundert*, Staatliche Kunsthalle, Karlsruhe, 1972. However, Dr. R. Thielmann of the museum is inclined

to date many of them considerably earlier. On the basis of the artist's dated paintings, *Waldteich* and *Am Bach* should probably be reassigned to the early 1850s, before he left Düsseldorf.

41. I. Markowitz, *Die Düsseldorfer Malerschule*, II, Kunstmuseum, Düsseldorf, 1969, pp. 44–6.

42. Ibid., p. 298.

43. Compare the German attitude to the French outlook, discussed in Boime, *French Academy*, esp. chap. 9.

44. H. Curjel, *Landschaftstudien*, Düsseldorf, n.d., pp. 10–13.

45. Whittredge, *Autobiography*, p. 56.

46. The now badly damaged drawing is inscribed The Oaks at Dessau and dated 1852, but the passport proves the journey took place in 1855, not 1852. The signature and inscription were added around 1906, when the sheet was among thirty-one drawings presented to the Century Association by its members to decorate the private dining room. The artist states that he made the trip with Lessing, though this cannot be proved. He adds that the drawings he made at Dessau proved of little use to him, but this is clearly wrong.

47. For a balanced assessment of Friedrich, see F. Novotny, *Painting and Sculpture in Europe, 1780–1880*, 2nd ed., Baltimore, 1971, p. 95ff. It is preferable to the simplified iconographic interpretations advanced, among others, by W. Vaughn and H. Börsch-Supan, *Caspar David Friedrich*, London, 1972.

48. Whittredge, *Autobiography*, p. 63.

49. Ibid. pp. 19, 28. Baur, who did not have access to Whittredge's passport, gave the departure date as 1854, which has been repeated by most subsequent scholars. However, visas were issued by the U.S. consulate in Frankfurt on July 19, 1856; by the Swiss and Italian consulates in Germany on July 25, 1856; and by the American consuls in Switzerland and Genoa on August 1 and September 24, 1856. The later date is confirmed by the autobiography. Whittredge states on p. 31 that he departed with William Stanley Haseltine, who arrived in Düsseldorf in the autumn of 1855.

50. Whittredge, *Autobiography*, pp. 29–30.

51. Ibid., pp. 30–31.

52. Piloty, who combined Dutch influences with French academic tendencies, may be considered an abler and more up-to-date artist than the history painters remaining in Düsseldorf. Unfortunately, very little has been published on him to date.

53. Whittredge, original manuscript, p. 96.

54. Compare Troyon's *Landscape near Paris* (Museum of Fine Arts, Boston).

55. Becker, *Paris und die deutsche Malerei*, pp. 35, 100, 419. R. Causa, *Pitloo*, Naples, 1956. Joseph Rebell painted a view of Mount Vesuvius (Kunst-

halle, Karlsruhe) as early as 1813–15 in this manner, which continued well past midcentury. See also Albert Bierstadt's similar sketch of Vesuvius (formerly Hirschl and Adler Galleries, New York). On Valenciennes, see Boime, *French Academy*, pp. 162–3; also L. Venturi, "Pierre Henri de Valenciennes," *Art Quarterly*, 4:2. Corot's sketch remained in his collection until his death. See C. Sterling and H. Adhémar, *Peintures Ecole Française, XIXe Siècle*, Louvre, Paris, 1958, 1:26. Achenbach certainly need not have known this particular work to have assimilated the French sketching technique.

56. Markowitz, *Düsseldorfer Malerschule*, p. 19.

57. A similar sketch by Achenbach of Stromboli, dating from two years later, is also in the Düsseldorf museum.

58. On September 3, 1856, Haseltine wrote to his mother from Meyringen, "We go to the north of Italy for six weeks." See D. Plowden, *William Stanley Haseltine*, London, 1947, p. 33.

59. G. Hendricks, *Albert Bierstadt*, New York, 1974, p. 53, is incorrect in stating that they stayed together in northern Italy as late as October, since Whittredge arrived in Rome on September 24.

60. Whittredge, *Autobiography*, pp. 33–4. The artist states that he met only the former Cincinnati sculptor Hiram Powers in Florence.

61. Flexner, *Wilder Image*, p. 40.

62. See E. C., Parry III, "Thomas Cole and the Problem of Figure Painting," *American Art Journal*, 4:1, May 1972.

63. J. T. Flexner, *That Wilder Image, The Painting of America's Native School from Thomas Cole to Winslow Homer*, 2nd ed., New York, 1970, p. 40.

64. Whittredge, original manuscript, p. 89.

65. Whittredge, *Autobiography*, p. 36.

66. Plowden, *Haseltine*, p. 33.

67. Whittredge, *Autobiography*, pp. 26–7.

68. Hendricks, *Bierstadt*, p. 35.

69. Whittredge, *Autobiography*, p. 39.

70. N. Cikovsky, *Sanford Robinson Gifford*, University of Texas, Austin, 1970, p. 9.

71. Plowden, *Haseltine*, p. 54. A drawing of Civita del Vecchio in Whittredge's European sketchbook (Archives of American Art, Washington, D.C.) documents his presence there on June 12, 1857.

72. The disparity between the actual and recorded size is not unusual in the artist's account book, and the notation is clearly meant as no more than a general measurement. The painting was exhibited at the Pennsylvania Academy of Fine Arts in 1858 as no. 63, "*Scene near Brunnen on Lake Lucerne* (Switzerland), Owner S. B. Fales." See A. Rutledge, *Cumulative Record of Exhibition Catalogues, The Pennsylvania Academy of Fine Arts, 1807–*

1870, The Society of Artists, 1800–1814, The Artists' Fund Society, 1805–1845, Philadelphia, 1955. Henry Tuckerman (*Book of the Artists, American Artist Life,* New York, 1867, p. 516) records: " 'The Schutzenfest,' a large Swiss landscape with numerous figures, was purchased by Mr. Samuel B. Fales, a well-known connoisseur of Philadelphia." By 1865 it was in the possession of Marshall O. Roberts of New York, and was included in an exhibition at his home in 1877 to benefit the Society of Decorative Art, of which Whittredge was also a member. The canvas, which was owned around 1896 by Samuel P. Avery, was acquired in 1910 from the estate of John Miller by Henry D. G. Rohlfs and descended through his family until it entered the art market in 1988. I am grateful to David Henry of Spanierman Gallery for supplying the later provenance of the picture.

73. The figures are recorded in a running tally as part of Whittredge's European account book.

74. Whittredge, *Autobiography,* p. 37.

75. Whittredge, original manuscript, pp. 97–8. See also Plowden, *Haseltine,* p. 46. Cf. Diday's *Mont Blanc at the Sallanches* (Musée d'art et d'histoire, Geneva).

76. F. Zelger, "Alexandre Calame," *Palette,* 40, p. 5.

77. On Read (whose name is sometimes spelled "Reed"), see L. B. Miller, *Patrons and Patriotism,* Chicago, 1966, p. 194. See also G. C. Groce and D. H. Wallace, *The New-York Historical Society's Dictionary of Artists in America, 1564–1860,* New Haven, 1957, p. 527.

78. Whittredge, *Autobiography,* pp. 38–9.

79. But compare the drawing cited above of Civita del Vecchio, dated June 12, 1857, in his sketchbook (Archives of American Art, Washington, D.C.).

80. Compare Franz Horny's drawing of Olevano in the Fogg Art Museum, Cambridge, Mass. A second sheet of a Sabine hill town by Whittredge (Hirschl and Adler Galleries, New York) may also represent Olevano. Plowden, *Haseltine,* p. 68, cites a letter from Whittredge dating the visit to June 1858. The Saint Louis drawing, however, corresponds so closely to the view in Bierstadt's painting in the same museum that it is possible Whittredge accompanied Bierstadt and Gifford to the Sabines before their trip to Capri the year before.

81. Another version is in a private collection.

82. Whittredge, *Autobiography,* p. 38.

83. Ibid. p. 41; also, p. 61, where the title is given as *Evening on the Campagna.*

84. Cole's painting is in the Wadsworth Atheneum, Hartford, Conn. An earlier picture by Cole, no longer traceable, was illustrated in *The Token* in 1837. Tilton's painting, dated 1862, is in the Museum of Fine Arts, Boston. Gifford's study from 1859 is in the Vassar College Art Gallery, Poughkeepsie, N.Y.

85. G. S. Hillard, *Six Months in Italy,* Boston, 1853, I:311, quoted in C. E.

Eldredge, *The Arcadian Landscape*, Spencer Museum of Art, Lawrence, Kans., 1972, no. 39.

86. Whittredge, *Autobiography*, p. 32.

87. The painting is signed and dated 1860, but like *Morning on Lake Maggiore*, it must have been executed in Italy.

88. The canvas is signed and dated 1860, but as discussed in Chapter 4, the circumstances surrounding its exhibition at the National Academy of Design make it certain that the landscape could not have been painted in New York.

89. Whittredge, *Autobiography*, p. 40.

90. See Chapter 4.

91. Whittredge, *Autobiography*, p. 40; and his passport.

Chapter 4

1. This is how the titles are shown on p. 130 of the W. Whittredge, original manuscript, *Archives of American Art*, Washington, D.C.

2. Whittredge, *The Autobiography of Worthington Whittredge*, ed. J. Baur, Brooklyn Museum of Art, 1942.

3. A. F. Janson, "Two Early Landscapes by Worthington Whittredge," *Detroit Institute of Arts Bulletin*, Winter 1977, and H. S. Merritt, *Thomas Cole*, Memorial Art Gallery, University of Rochester, 1969, p. 35.

4. Whittredge, *Autobiography*, p. 41. It is interesting to note that Whittredge's friend Eastman Johnson had also stayed in Cincinnati for several months after returning from Europe before he decided to settle in New York in April 1858.

5. Whittredge, original manuscript, pp. 112–13.

6. Whittredge, *Autobiography*, p. 41.

7. Ibid.

8. Whittredge, original manuscript, p. 134 states that he exhibited one small painting and *Aqueducts of the Campagna* at the National Academy of Design.

9. See M. B. Cowdrey, *National Academy of Design Exhibition Record, 1826–1860*, New York, 1943, 2, p. 207. The first three paintings, but not *The Amphitheater at Tusculum*, are recorded among the contents of Whittredge's Roman studio in his European account book, Archives of American Art, Washington, D.C.

10. Whittredge, original manuscript, p. 180.

11. Whittredge, *Autobiography*, p. 42.

12. Ibid., pp. 30–40. Cf. N. Cikovsky, Jr., *Sanford Robinson Gifford*, University of Texas, Austin, 1970, p. 15.

13. On Durand's attitude toward nature, see D. Lawall, *A. B. Durand*, Mont-

clair Art Museum, 1971, pp. 19–21; cf. L. Marx, *The Machine in the Garden: Technology and the Pastoral Ideal in America*, New York, 1964, p. 245.

14. B. Novak, *American Painting of the Nineteenth Century*, New York, 1969, p. 245.

15. Durand's letters parallel in significance and attitude Gustav Carus's *Nine Letters on Landscape Painting*, published in 1831.

16. P. Miller, *Nature's Nation*, Cambridge, Mass., 1967, p. 180.

17. M. Friedlaender, *Landscape, Portrait, Still-Life*, tr. R. F. C. Hull, New York, 1963, p. 113.

18. See D. B. Lawall, *Asher Brown Durand*, New York, 1977; and J. P. Driscoll and J. K. Howat, *John Frederick Kensett, An American Master*, Worcester Art Museum, Worcester, Mass., 1985.

19. See J. Wilmerding, *Fitz Hugh Lane, 1804–1865, American Marine Painter*, Salem, Mass., 1964; idem, *A History of American Marine Painting*, Boston, 1968, esp. chap. 10; T. E. Stebbins, Jr., *Martin Johnson Heade*, University of Maryland Art Gallery, College Park, 1969; R. G. McIntyre, *Martin Johnson Heade, 1819–1904*, New York, 1948.

20. D. C. Huntington, *The Landscapes of Frederic Edwin Church*, New York, 1966.

21. G. Hendricks, *Albert Bierstadt*, New York, 1974. Bierstadt and Church are generally excluded from the Hudson River school, despite their obvious affinities in style and outlook with Kensett and Durand.

22. See R. B. Stein, *John Ruskin and Aesthetic Thought in America, 1840–1900*, Cambridge, Mass., 1967.

23. The back of the canvas is inscribed, This study which was painted entirely [in one afternoon?] was varnished with thick Copal varnish 3 months after being painted. W. Whittredge Nov. 1860.

24. *View of West Point* (1861, M. and M. Karolik Collection, Museum of Fine Arts, Boston) closely follows the sketch, reducing only the most intrusive tree to a stump. In a final attempt to resolve the landscape, Whittredge cleared the view even further and added a twilight atmosphere to *Cauldwell's Landing*, which was submitted as his initiation fee to the Century Association in 1862.

25. Whittredge, *Autobiography*, p. 42.

26. H. Tuckerman, *Book of the Artists, American Artist Life*, New York, 1867, p. 515.

27. Because they are not recorded in his European account book, which is by no means complete, it can be surmised that all three canvases were in the second crate of paintings Whittredge sent hastily from Rome. Whittredge often postdated his European work, and although they are signed and dated 1860, the style of *Morning on Lake Maggiore* and *The Amphitheater at Tusculum* makes it certain that they were executed in Rome during 1859.

28. Cf. P. Hills, *The Painter's America, Rural and Urban Life, 1810–1910*, Whitney Museum of American Art, New York, 1974, p. 5.

29. The hay harvest was a common symbol of America's fruitfulness. See Otis Bullard's *Loading Hay* (1846, Newhouse Galleries, New York), Jerome B. Thompson's *The Haymakers, Mount Mansfield, Vermont* (1859, private collection, formerly Hirschl and Adler Galleries, New York), and George Inness's *Peace and Plenty* (1865, Metropolitan Museum of Art, New York). See also L. Marx, *The Machine in the Garden. Technology and the Pastoral Ideal in America*, New York, 1964.

30. Whittredge, *Autobiography*, p. 42. Elections were apparently held in 1861, but the results were not announced until later.

31. Ibid., p. 43.

32. Whittredge, original manuscript, pp. 174–5.

33. When fifteen members resigned in 1862, the club decided to accept paintings in lieu of the $50 initiation fee. See A. H. Mayor and M. Davis, *American Art at the Century*, New York, 1977, p. xxvii. Other artists who were invited to join that year included Eastman Johnson.

34. Whittredge, *Autobiography*, p. 62.

35. Whittredge later added to his European account book a considerable number of moral and inspirational passages from unidentified sources that seem embarrassingly trite today.

36. Compare, for example, *The Blodgett Family* (1864, Mr. and Mrs. Stephen Blodgett Collection).

37. L. Eitner, "The Open Window and the Storm-Tossed Boat: An Essay on the Iconography of Romanticism," *Art Bulletin*, 37:4, December 1955, p. 286.

38. Their activities are documented in the diaries of Jervis McEntee, preserved in the Archives of American Art, Washington, D.C.

39. Whittredge evidently held on to *Sunday Morning*. It is probably the same picture that was sold as *An Old Room, Rhode Island, Sunday Morning* at an auction of Whittredge's paintings by Ortgies' Art Galleries, New York, March 9, 1887, along with *An Old New England Kitchen*. The painting was soon exhibited at the Brooklyn Art Association as #152 in April 1887, when the owner was given as George Seney. See C. S. Marlor, *A History of the Brooklyn Art Association with an Index of Exhibitions*, New York, 1970, p. 376.

40. Whittredge had painted *Interior of a Westphalian Cottage* (National Museum of American Art, Washington, D.C.) in 1852.

41. The painting was exhibited at the Pennsylvania Academy of the Fine Arts in 1862, as no. 64 for sale. See A. Rutledge, *Cumulative Record of Exhibition Catalogues, The Pennsylvania Academy of Fine Arts, 1807–1870, The Society of Artists, 1800–1814, The Artists' Fund Society, 1805–1845*, Philadelphia, 1955.

42. Pinchot's son, Gifford, named in the artist's honor, went on to have an

illustrious career as a forestry expert and as an early leader of the conservation movement, serving in a variety of important government posts before being elected governor of Pennsylvania. My thanks to Jean Pablo, curator at Grey Towers, Pinchot's home near Baltimore, for providing this information. According to her the elder Pinchot bought other works by Whittredge, but the collection was sold by the U.S. Parks Department, and the paintings are no longer traceable. I am further indebted to Mary Nason of the Simsbury Historical Society.

43. Tuckerman, *Artist Life*, p. 518.

44. B. Lassiter, *Reynolda House, American Paintings*, Winston-Salem, N.C., 1970, p. 28.

45. See Eitner, "Storm-Tossed Boat"; also R. Stein, *Seascape and the American Imagination*, Whitney Museum of American Art, New York, 1975, p. 84ff.

46. On the red man as symbol in Bryant's poetry, see D. A. Ringe, "Kindred Spirits: Bryant and Cole." *American Quarterly*, 6:3, Fall 1954.

47. Whittredge, original manuscript, pp. 155–7, recounts a visit to Bryant at his home in Roslyn, Long Island, N.Y.

48. Ibid. p. 155, claims to have known Bryant quite well, in spite of the poet's general taciturnity.

49. Cf. D. A. Ringe, "Painting as Poem in the Hudson River Aesthetic," *American Quarterly*, 12:1, 1960; Lawall, *Durand*, esp. pp. 19–21. It seems possible as well that Durand was acquainted with Phillip Otto Runge's writings about landscape.

50. In addition to Ringe's articles cited above, see W. P. Hudson, "Archibald Alison and William Cullen Bryant," *American Literature*, 12:1, March 1940, pp. 59–68; Miller, *Nature's Nation*, pp. 10–12, 152; C. H. Brown, *William Cullen Bryant, A Biography*, New York, 1971, pp. 83, 145–6; A. F. McLean, Jr., *William Cullen Bryant*, New York, 1964, p. 58.

51. Whittredge, *Autobiography*, pp. 34–5; Hendricks, *Bierstadt*, p. 37; Jervis McEntee, "Diaries," Archives of American Art, Washington, D.C. Bierstadt and Church joined the group less often, particularly after they built their large estates in 1866 and 1872, respectively. See also A. Blaugrund, "The Tenth Street Studio Building: A Roster, 1857–1895," *American Art Journal*, 14:2, Spring 1982, pp. 64–71.

52. Whittredge, *Autobiography*, pp. 55–60.

53. The picture appears to show another view of a site found in a drawing in one of Whittredge's sketchbooks that corresponds to frame 287 on the Whittredge microfilm, Archives of American Art, Washington, D.C.

54. Whittredge, *Autobiography*, p. 55.

55. Tuckerman, *Artist Life*, pp. 514–15.

56. Frame 263 on the Whittredge microfilm, Archives of American Art, Washington, D.C.

57. See Whittredge's eulogy in the Gifford Memorial Catalogue, Century Association, 1880, p. 43.

58. For a thorough history, see R. van Zandt, *The Catskill Mountain House*, New Brunswick, N.J., 1966.

59. On March 28, 1865, John Smillie had a "private view" of the painting at Whittredge's studio.

60. Abigail Gerdts kindly informs me that the dedication of the building was delayed to April 27 because of Lincoln's assassination.

61. Tuckerman, *Artist Life*, p. 518.

62. D. K. Keyes, catalogue entry in T. E. Stebbins, *A New World: Masterpieces of American Painting 1760–1910*, Museum of Fine Arts, Boston, 1983, p. 243. On the iconography of *Twilight in the Wilderness*, see Huntington, *Church*, pp. 80–3.

63. See J. K. Howat, *American Paradise, The World of the Hudson River School*, Metropolitan Museum of Art, N.Y., 1987, pp. 229–31. A similar study (now in a private collection) by Jervis McEntee, a close friend of both Whittredge and Gifford, suggests the possibility that the three artists may have worked together at Hunter Mountain.

64. See Cikovsky, *Gifford*, pp. 26, 58.

65. Tuckerman, *Artist Life*, p. 517. It was exhibited at the Paris Exposition of 1867 and the Philadelphia Centennial. The site is also known as Hangman's Rock. See S. Omoto, "Berkeley and Whittredge at Newport," *Art Quarterly*, 27:1, Spring 1964.

66. J. Baur, "American Luminism," *Perspectives*, 9.

67. Flexner, *Wilder Image*, p. 230.

68. Novak, *American Painting*, esp. chap. 5.

69. J. Wilmerding, *American Light, The Luminist Movement 1850–1875*, National Gallery of Art, Washington, D.C., 1980.

70. See Wilmerding, *American Marine Painting*, chap. 8; idem, *Robert Salmon, Painter of Ship and Shore*, Boston, 1968. See also D. Cordingly, *English Marine Painting, 1700–1900*, London, 1974. Salmon spent most of his early career in Liverpool and Scotland, where a "proto-luminist" style arose in the early 1800s based on the eighteenth-century topographical tradition stemming from Canaletto. Compare, for example, Salmon's *Steamboat at the Custom House, Greenock* (1820, Corporation of Greenock, Scotland) to Edward Dayes' *Greenwich Hospital* (1799, watercolor, Whitworth Art Gallery, Manchester, England).

71. B. Novak, *American Painting*, p. 110.

72. See T. E. Stebbins, Jr., "Luminism in Context: A New View," in Wilmerding, *American Light*. Interestingly enough, G. Vanzype, *L'Art Belge du XIXe Siècle à l'Exposition de Paris en 1923*, Brussels and Paris, 1924, also claims Luminism as a native Belgian tendency!

73. Stebbins, "Luminism in Context," p. 215.

74. B. Novak, "Some American Words: Basic Aesthetic Guidelines, 1825–1870," *American Art Journal*, 1:1, Spring 1969.

75. In addition to Baur, "American Luminism"; and Novak, *American Painting*; see W. S. Talbot, "Landscape and Light," *Cleveland Museum of Art Bulletin*, 60:1, January 1973; Friedlaender, *Landscape, Portrait, Still-Life*, esp. p. 113; Miller, *Nature's Nation*, pp. 152–3; Brown, *Bryant*, pp. 397–8; McLean, *Bryant*, p. 58; C. L. Sanford, "The Concept of the Sublime in the Works of Thomas Cole and William Cullen Bryant," *American Literature*, 28:4, May 1857, pp. 434–8. Cf. R. Rosenblum, *Modern Painting and the Northern Romantic Tradition, Friedrich to Rothko*, New York, 1975, chap. 1.

76. Flexner, *Wilder Image*, p. 226.

77. Whittredge had painted a similar composition, *Landscape with Ducks* (formerly Kennedy Galleries, New York) in 1861, but in a Düsseldorf style.

78. P. Bermingham, *American Art in the Barbizon Mood*, National Collection of Fine Arts, Washington, D.C., 1975, chaps. 2 and 3.

79. At this point in his career, Inness had not yet become interested in Swedenborgism. Several luminists also dabbled in spiritualism, but only late in their careers when it exercised at best a limited influence on their art, certainly much less than Novak, *American Painting* (pp. 122, 147, 164–5), implies. See G. E. McCormick, "Fitz Hugh Lane, Gloucester Artist, 1804–1865," *Art Quarterly*, 15:4 1952; B. Cowdrey and H. W. Williams, Jr., *William Sidney Mount, 1807–1868: An American Painter*, New York, 1944, pp. 8–9; A. Christ-Janer, *George Caleb Bingham of Missouri*, New York, 1942, p. 118.

80. Dwight, *Whittredge*, p. 68. According to George Worthington's genealogy (see Chapter 1), they had four daughters: Jeannie (1871–3), Effie (b. 1874), Olive (b. 1875), and Mary (b. 1879).

81. See W. H. Gerdts and R. Burke, *American Still-Life Painting*, New York, 1971, chap. 7.

82. Ibid., p. 101.

83. Unlike trompe l'oeil still lifes, bough pictures are not intended to deceive the eye. Compare the illusionistic clusters of grapes painted by Samuel M. Brookes, for example. See A. Frankenstein, *After the Hunt*, 2nd ed., Berkeley and Los Angeles, 1965; idem, *The Reality of Appearance, The Trompe l'Oeil Tradition in American Painting*, University Art Museum, Berkeley, 1970.

84. Gerdts and Burke, *American Still-Life Painting*, p. 163. Also W. H. Gerdts, *Painters of the Humble Truth, Masterpieces of American Still Life 1801–1939*, Philbrook Art Center and University of Missouri, Columbia, 1981, p. 108.

85. Minerva is a resort village in Essex County, New York.

86. See Mayor and Davis, *Century*, p. 32.

87. Compare John G. Brown's *Country Gallants* (1875, Toledo Museum of Art).

88. Cf. Marx, *Machine*, p. 252.

89. Twain's classic, published in 1884, is set in the 1840s. See Marx, "The

Machine in the Garden," p. 325. For a recent study, see S. Burns, "Barefoot Boys and Other Country Children: Sentiment and Ideology in Nineteenth-Century American Art," *The American Art Journal*, 20:1, 1988, pp. 24–50.

90. Miller, *Nature's Nation*, p. 197.

91. Marx, "The Machine in the Garden," p. 285. For a standard overview of industrial expansion during Reconstruction, see S. E. Morison and H. S. Commager, *The Growth of the American Republic*, 5th ed., New York, 1962, 2, chap. 3.

92. Although it is but one of the religious, intellectual, and social factors that have motivated landscape painting in the West, the desire to escape the city for the countryside has played an important role in man's response to nature since antiquity. See K. Clark, *Landscape into Art*, 2nd ed., Boston, 1961, p. 7.

93. See also the related versions of 1851 in Lyman Allyn Museum and 1855 in the M. and M. Karolik Collection, Museum of Fine Arts, Boston; compare also *The Falls and Bridge*, 1858, Century Association, New York.

94. Driscoll and Howat, *Kensett*, p. 79. The motif comes from English art. See A. Holcomb, "The Bridge in the Middle Distance: Symbolic Elements in Romantic Landscape," *Art Quarterly*, 37:1, Spring 1974.

95. For a further discussion of this painting, see N. Spassky, *American Paintings in the Metropolitan Museum of Art*, New York, 1985, 2:136–8.

CHAPTER 5

1. W. Whittredge, *The Autobiography of Worthington Whittredge*, J. Baur, Brooklyn Museum of Art, 1942.

2. W. Whittredge, original manuscript, Archives of American Art, Washington, D.C.

3. N. Moure, "Three Artists Out West," *The American Art Journal*, 4, 1974, p. 2. See also R. Taft, *Artists and Illustrators of the Old West, 1850–1900*, New York, 1953, esp. p. 295.

4. H. Tuckerman, *Book of the Artists, American Artist Life*, New York, 1867, p. 517.

5. Whittredge, *Autobiography*, pp. 45–6.

6. Ibid. p. 45.

7. G. S. Hillard, *Six Months in Italy*, Boston, 1853, 1, p. 311, quoted in C. E. Eldredge, *The Arcadian Landscape*, Spencer Museum of Art, Lawrence, 1972, no. 39.

8. Cf. Whittredge, *Autobiography*, p. 51, and Pope's letter to General Sherman in *Annual Report of the Secretary of War*, House Executive Documents, no. 1, 39th Congress, Second Session, vol. 3, 1866, pp. 29–30.

9. Cf. N. Cikovsky, Jr., *Sanford Robinson Gifford*, University of Texas, Austin, 1970, pp. 16–17.

10. H. James, "Hawthorne," *The Shock of Recognition*, ed. E. Wilson, New York, rev. ed., 1955, p. 536.

11. Whittredge, *Autobiography*, p. 53.

12. Tuckerman, *Artist Life*, p. 517.

13. Whittredge, *Autobiography*, p. 64.

14. Ibid. p. 35.

15. J. T. Flexner, *That Wilder Image, The Painting of America's Native School from Thomas Cole to Winslow Homer*, 2nd ed., New York, 1970, pp. 225–6.

16. Whittredge, *Autobiography*, p. 60; Moure, "Three Artists"; J. K. Howat, *John Frederick Kensett, 1816–1872*, American Federation of the Arts, New York, 1968, Introduction and entry 43. There is no evidence that Whittredge did much wandering south of Denver in 1870, contrary to the assertion by B. P. Draper, "Worthington Whittredge in the West," *Antiques*, 55, 1949. Whittredge's statement (*Autobiography*, p. 60) that Gifford rejoined the group near Denver after a month is probably incorrect. Instead, Gifford seems to have returned to New York via Fort Bridger, Wyoming, and Salt Lake City. I. S. Weiss, *Sanford Robinson 1823–1880*, New York, 1977, p. 331.

17. Whittredge, *Autobiography*, p. 64. The date has also been given incorrectly as 1877 by Dwight, *Worthington Whittredge*, Munson-Williams-Proctor Institute, Utica, 1965, p. 68.

18. My thanks to Brucia Witthof for drawing this to my attention. See also R. Schneider, "The Career of James David Smillie (1833–1909) As Revealed in His Diaries," *American Art Journal*, 16:1, Winter 1984, pp. 4–33.

19. Although *Buffalo on the Platte River* is on panel, which he used for sketching during his 1870 trip west, the style makes it likely that the landscape was executed toward the middle of the decade. Moreover, it cannot be from nature, as a pencil sketch is in the Archives of American Art, Washington, D.C.

20. Regarding the correct title, see A. F. Janson, "The Western Landscapes of Worthington Whittredge," *American Art Review*, Winter 1976, n. 31, and ibid., "Worthington Whittredge: The Development of a Hudson River Painter, 1860–1868," *The American Art Journal*, April 1979, n. 33.

CHAPTER 6

1. W. Whittredge, *original manuscript, Archives of American Art*, Washington, D.C.

2. Cf. G. Reynolds, *Constable, The Natural Painter*, New York, 1969, pp. 19, 65.

3. See the newspaper account in McEntee, "Diary," *Archives of American Art*, Washington, D.C.

4. See O. Rodriguez Roque, "The Last Summer's Work," in J. P. Driscoll

and J. K. Howat, *John Fredrick Kensett, An American Master*, Worcester Art Museum, Worcester, Mass., 1985.

5. Cf. F. Novotny, *Painting and Sculpture in Europe, 1780–1880*, 2nd ed., Baltimore, 1971, pp. 183–4.

6. Cf. *Autumn on the Hudson* to Linnell's *Landscape with Harvesters* (1855, Victoria and Albert Museum, London), for example. Cropsey's first mature painting, *Autumn on the Hudson* (1860, National Gallery of Art, Washington, D.C.) shows a strong debt to Linnell's work, such as *Southampton from the River near Netley Abbey* (1825, Lawrence Gowing, London).

7. Whittredge, original manuscript, p. 184, says that "the brooks at Milford Pennsylvania, the early home of my friend James W. Pinchot were equally interesting to me."

8. In the early to mid-1880s, he painted another landscape at Simsbury (formerly Corbin and Brown Fine Arts, Boston).

9. I am grateful to Mr. Lesser for sharing his research with me. The cemetery was first noticed by Susan C. Riford of Auburn, N.Y., who also provided information about the history of stage coaches in the region.

10. E. Dwight, *Worthington Whittredge*, Munson-Williams-Proctor Institute, Utica, 1965, no. 24.

11. See, for example, E. L. Henry's *Portrait of Mrs. Lydig and Her Daughter* (1887–91, watercolor, Hirschl and Adler Galleries, New York).

12. Another interior of the De Wolf house from 1860 is listed as no. 92 among the paintings by Whittredge exhibited at the Century Association March 12–31, 1904.

13. Ibid., no. 44.

14. Whittredge, original manuscript, p. 182.

15. It is also called "Hangman's Rock." See S. Omoto, "Berkeley and Whittredge at Newport," *Art Quarterly*, XXVII, 1, Jan.-March 1964.

16. Whittredge, original manuscript, pp. 182–3.

17. Ibid.

18. It is unclear when the estate was put together, but he was involved in six transactions in Tiverton around 1825 that are perhaps related to it.

19. On July 28th, Jervis McEntee wrote in his "Diaries" (Archives of American Art, Washington, D.C.) that he will go next day with Whittredge and Gifford for a trip to the coast of Massachusetts in the vicinity of Cape Ann. His entry of August 26 confirms that he had joined them at Hudson and that they had then all gone to Gloucester, where Johnson met them. He adds on October 20 that Whittredge and his wife went with Gifford to the mountains from mid-September to mid-October.

20. This is the correct reading of the title, according to the owner.

21. Compare Winslow Homer's *An Evening Promenade* (Museum of Fine Arts, Springfield, Mass.) of 1880.

22. Whittredge, original manuscript, p. 182.

23. Cf. Durand's *A Sycamore Tree, Plaaterkill Clove,* c. 1858, Yale University Art Gallery, New Haven, Conn.

24. Cf. *Sunlit Glade in Early Autumn,* early 1870s, formerly Hirschl and Adler Galleries, New York.

25. Whittredge, *Autobiography,* p. 60.

26. A note in the margin of the entry for September 16, 1877, in McEntee, "Diaries," by his nephew, Col. Girard McEntee, states that the artist had all the symptoms of diabetes.

27. Similar views are very rare in American art, though not in European nineteenth-century painting. Among the few examples is a large canvas of the mid–1870s by Alexander Wyant that was once handled by Dee Wigmore Fine Arts, New York.

28. See the entry in McEntee, "Diaries," for April 7, 1875.

29. V. Barker, *American Painting: History and Interpretation,* New York, 1950, p. 403.

30. A small study (13 × 16) was sold from the Robert M. Olyphant collection in 1919; another version (15 × 22) was formerly in the collection of Leeds A. Wheeler, Wellesley Hills, Mass. Another variant is in the Yale University Art Gallery, New Haven.

31. F. Mather, Jr., in the *Outlook,* July 2, 1904, quoted in Dwight, *Whittredge,* no. 18. For another excellent analysis, see M. W. Brown, *One Hundred Masterpieces of American Painting from Public Collections in Washington, D.C.,*Washington, D.C., 1983, p. 70.

32. See the entry of December 12, 1872 in Jervis McEntee, "Diaries."

33. See Whittredge, *Autobiography,* pp. 43–4, and Jervis McEntee, "Diaries," for May 14, 1874.

34. Entry in McEntee, "Diaries," for that date. He adds ruefully, "We ought to have rescinded that rule about the clubs."

35. Whittredge, *Autobiography,* p. 44.

36. Ibid., p. 69.

37. Ibid., p. 42. See also E. Clark, *History of the National Academy of Design, 1825–1853,* New York, 1954, p. 89, on the problems Whittredge encountered during his presidency. Huntington remained in office until 1890.

38. Ibid., p. 44.

39. Ibid.

40. P. Bermingham, *American Art in the Barbizon Mood,* National Collection of Fine Arts, Washington, D.C., 1975, p. 69.

41. Whittredge, original manuscript, pp. 86–7.

42. This and the following entry are from Jervis McEntee, "Diaries," Archives of American Art, Washington, D.C.

43. McEntee's father was often strapped for money and borrowed regularly from him.

44. Both letters are preserved in the Gifford Pinchot Papers, Library of Congress, Washington, D.C.

45. Whittredge, original manuscript, pp. 66–7.

46. Whittredge was naturally opposed to the Society of American Artists. See R. Pisano, *A Leading Spirit in American Art, William Merritt Chase, 1849–1916*, Henry Art Gallery, Seattle, 1983, p. 40.

47. See K. J. Avery, "A Historiography of the Hudson River School," in J. K. Howat, Jr., *American Paradise, The World of the Hudson River School*, Metropolitan Museum of Art, New York, 1987.

CHAPTER 7

1. See also my discussion of this painting in K. H. Mead, ed., *The Preston Morton Collection of American Art*, Santa Barbara, 1981, pp. 100–3.

2. The sketch bears an old label on the back: An artist's sketch from nature by Worthington Whittredge (my grand uncle) and given to my father by him in July 1876. Bert L. Baldwin.

3. See M. Naylor, *National Academy of Design Exhibition Record, 1861–1900*, New York, 1973, 2, p. 1025.

4. *The Art Journal*, 1876, p. 190.

5. *The Art Journal*, 1877, p. 158.

6. Jervis McEntee, "Diaries," Archives of American Art, Washington, D.C., September 2 and 5, 1877.

7. S. Omoto, "Berkeley and Whittredge at Newport," *Art Quarterly*, 27:1, January–March 1964, p. 46.

8. Homer Martin and David Johnson were the only other Hudson River painters to convert fully to Barbizon.

9. See Chapter 3.

10. J. Rewald, *The History of Impressionism*, New York, 1946, p. 90.

11. It is tempting to identify one of these paintings with *The New England Shore*. See Naylor, *National Academy of Design 1880 Exhibition Record*, p. 1026.

12. Compare *The Harvest* by Daubigny in the Louvre, Paris.

13. The drawing is one of several Newport scenes in the same sketchbook, one of which is dated 1881. For more on the painting, see S. Omoto, "Berkeley and Whittredge at Newport," *Art Quarterly*, 27:1, January–March 1964, and ibid., "The Sketchbooks of Worthington Whittredge," *Art Journal*, 24:4, Summer 1964.

14. Cf., for example, Constant Troyon's *The Beach at Tréport* (early 1860s, John G. Johnson Collection, Philadelphia).

15. E. Dwight, *Worthington Whittredge*, Munson-Williams-Proctor Institute, Utica, 1965, p. 54. On the Hague school in America, see J. de Gruyter, *Meesters van de Haagse School*, The Hague, 1965.

16. Dr. Robert Aaronson kindly pointed out the house to me.

17. It is probable that all three of these works show sites around Newport, not Long Island.

18. P. Miller, *Nature's Nation*, Cambridge, Mass., 1967, p. 12.

19. Cf. J. H. Huizinga, *Dutch Civilization in the Seventeenth Century*, New York, 1968, pp. 102–3; S. Slive, J. Rosenberg, and E. H. ter Kuile, *Dutch Art and Architecture*, Baltimore, 1966, pp. 123, 126, 157–8, 202.

20. E. Morison and H. S. Commager, *The Growth of the American Republic*, 5th ed., New York, 1962, 2, chaps. 5–11.

21. See Miller, *Nature's Nation*, p. 197.

22. B. Novak, "The Double-Edged Axe"; and J. E. Cantor, "The New England Landscape of Change," and D. Kuspit, "19th-Century Landscape: Poetry and Property"; *Art in America*, 64:1, January–February 1976.

23. On the Parks Movement, see A. Fein, *Frederick Law Olmstead and the American Environmental Tradition*, New York, 1972.

24. Cf. D. C. Huntington, *The Landscapes of Frederic Edwin Church*, New York, 1966, pp. 106–7; J. T. Flexner, *That Wilder Image, The Painting of America's Native School from Thomas Cole to Winslow Homer*, 2nd ed., New York, 1970, p. 248; H. James, "Hawthorne," *The Shock of Recognition*, ed. E. Wilson, rev. ed., New York, 1955, p. 536.

25. Cf. Miller, *Nature's Nation*, pp. 196–207; idem, *American Thought, Civil War to World War I*, New York, 1954, p. ix.

26. P. Bermingham, *American Art in the Barbizon Mood*, National Collection of Fine Arts, Washington, D.C., 1975, p. 69.

27. Ibid., especially pp. 17, 95–6.

28. J. Taylor's introduction in ibid., 1975, pp. 9–10.

29. The only exceptions are Hunt's peasant scenes which are, however, far more sentimental than those of Millet that inspired them. See M. A. S. Shannon, *Boston Days of William Morris Hunt*, Boston, 1923.

30. Flexner, *That Wilder Image*, p. 313. I have argued this case in detail in my paper "The Death of The Hudson River School and The Changing Personality of The American Artist," presented at the symposium on late nineteenth-century American landscape painting held in conjunction with the exhibition *In Nature's Ways* at the Norton Gallery of Art, West Palm Beach, Fla., March 1987.

CHAPTER 8

1. Although the scene is probably Newport, it should be noted that a second version, owned by Louis A. Hoornbeck of Glen Ellyn Ill., is titled *A Scene of Gloucester, Massachusetts.*

2. S. Omoto, "Berkeley and Whittredge at Newport," *Art Quarterly*, 27:1, January–March 1964, pp. 54–6.

3. However, a later date is not beyond question for these and similar pictures, which are sometimes difficult to locate precisely in the artist's oeuvre. In the early 1890s, Whittredge reverted to Barbizon naturalism for a while; see pages 192–5 for a discussion of this revival.

4. My thanks to Annette Blaugrund, who is reconstructing the American pictures at the exposition for an exhibition to be held at the Pennsylvania Academy of the Fine Arts in 1989–90.

5. E. M. Clark, *Ohio Art and Artists*, Richmond, 1932, p. 501.

6. Trinity College, Hartford, has on permanant deposit a replica of c. 1889–90 bearing the curious title *I Come from Haunts of Coot and Hern* from "The Brook" by Alfred Lord Tennyson. The title was probably added much later, since the artist rarely gave his works literary titles.

7. A much smaller replica in a Massachusetts private collection has the looseness characteristic of Whittredge's work at the end of the decade.

8. See W. H. Gerdts, "American Tonalism: An Artistic Overview," and D. Sweet, "American Tonalism: An explanation of Its Ideas Through the Work and Literature of Four Major Artists," *Tonalism, An American Experience*, New York, 1982.

9. For an excellent overview, see B. Weber and W. H. Gerdts, *In Nature's Ways: American Landscape Painting of the Late Nineteenth Century*, Norton Gallery of Art, Palm Beach, 1986.

10. The best survey remains R. J. Boyle, *American Impressionism*, Boston, 1974. See also W. H. Gerdts, *American Impressionism*, New York, 1984; and M. Domit, *American Impressionist Painting*, National Gallery of Art, Washington, D.C., 1973.

11. P. Bermingham, *American Art in the Barbizon Mood*, National Collection of Fine Arts, Washington, D.C., 1975, p. 70.

12. Ibid.; J. T. Flexner, *That Wilder Image, The Painting of America's Native School from Thomas Cole to Winslow Homer*, 2nd ed., New York, 1970, pp. 265–6; N. Cikovsky, Jr., *George Inness*, New York, 1971, pp. 44–5, 62–3.

13. W. Whittredge, original manuscript, Archives of American Art, Washington, D.C. p. 123.

14. The painting may also be compared to Duveneck's *Beechwoods at Polling* (c. 1876, Cincinnati Art Museum).

15. M. Domit, *American Impressionist Painting*, 21.

16. Ibid., pp. 11, 15, discusses the differences between Impressionism in Europe and America and stresses the need to judge each according to different standards.

17. See Boyle, *American Impressionism*, chaps. 5, 9–11.

18. W. Whittredge, *The Autobiography, of Worthington Whittredge*, ed. J. Baur, Brooklyn Museum of Art, 1942, p. 42.

19. Joel Sweinler, the curator of Olana, Church's home overlooking the Hudson River, kindly brought the letter to my attention. He informs me that the archives contain other correspondence indicating that Church's journey in 1896 was undertaken with his son, Louis.

20. Whittredge, *Autobiography*, p. 42.

21. Besides the two shown here, the other paintings are *A Mexican Village Square* (Mrs. Nicholas Niles, Jr., Fairfield, Conn.) and *A Mountain Valley* (formerly Kennedy Galleries, New York), which probably shows a view along the Sierra Madre Oriental.

22. E. Dwight, *Worthington Whittredge*, Munson-Williams-Proctor Institute, Utica, 1965, p. 65.

23. Ibid. p. 64, initially thought it to be a view in Mexico City, but later correctly identified the site as Orizaba.

24. Illustrated in Ibid. no. 39.

25. A similar painting, *Apple Orchard*, was owned by W. W. Katzenbach, New Canaan, Conn.

26. In 1897, Whittredge exhibited another landscape with the title *The Old Orchard – Rhode Island* at the National Academy of Design.

27. Compare her small canvas *Newport, R.I.* (formerly Kennedy Galleries, New York).

28. Whittredge, *Autobiography*, p. 61.

29. Ibid.

30. Ibid., p. 54.

31. Ibid., p. 40.

32. Ibid.

33. Ibid., p. 54.

34. Reported in the *Summit Record*, December 2, 1899, and *The Summit Herald*, May 2, 1908. According to E. M. Clark, *Ohio Art and Artists*, Richmond, Va., 1932, p. 501, Whittredge was awarded silver medals at the Pan-American Exposition in Buffalo of 1901 and the Saint Louis Exposition of 1904.

35. Whittredge, *Autobiography*, p. 66, n. 1.

The American Frontier, Images and Myths, Whitney Museum of American Art, New York, 1973.

The Painter's America, Rural and Urban Life, 1810–1910, Whitney Museum of American Art, New York, 1974.

Holcomb, A., "The Bridge in the Middle Distance: Symbolic Elements in Romantic Landscape," *Art Quarterly*, 37:1, Spring 1974.

Honour, H., *The European Vision of America*, Cleveland Museum of Art, 1975.

Hoopes, D., *American Narrative Painting*, Los Angeles County Museum of Art, 1974.

Horton, J. O., and Hartigan, L. R., *Sharing Traditions, Five Black Artists in Nineteenth-Century America*, National Museum of American Art, Washington, D.C., 1985.

Howat, J. K., *John Frederick Kensett, 1816–1872*, American Federation of the Arts, New York, 1968.

The Hudson River and Its Painters, New York, 1972.

American Paradise, The World of the Hudson River School, Metropolitan Museum of Art, New York, 1987.

Hudson, W. P., "Archibald Alison and William Cullen Bryant," *American Literature*, 12:1, March 1940, pp. 59–68.

Huizinga, J. H., *Dutch Civilization in the Seventeenth Century*, New York, 1968.

Huntington, D. C., *The Landscapes of Frederic Edwin Church*, New York, 1966.

Ireland, L., *The Works of George Inness*, Austin, 1865.

Isham, S., *A History of American Painting*, 2nd ed. with additions by R. Cortissoz, New York, 1927.

James, H., "Hawthorne," *The Shock of Recognition*, ed. E. Wilson, New York, rev. ed., 1955.

Janson, A. F., "The Western Landscapes of Worthington Whittredge," *American Art Review*, Winter 1976.

"Two Early Landscapes by Worthington Whittredge," *Detroit Institute of Arts Bulletin*, Winter 1977.

"Worthington Whittredge: The Development of a Hudson River Painter, 1860–1868," *The American Art Journal*, April 1979.

"Worthington Whittredge's An Autumn on the Upper Delaware," in K. Mead, *Catalogue of the Robert Preston Morton Collection*, Santa Barbara Museum of Art, 1981.

"The Cincinnati Landscape Tradition," *Celebrate Cincinnati Art*, ed. K. R. Trapp, Cincinnati, 1982.

Jones, A. H., *The Hudson River School*, Exhibition Gallery of the Fine Arts Center, State University of New York, Geneseo, 1968.

Kuspit, D., "19th-Century Landscape: Poetry and Property," *Art in America*, 64:1, January-February 1976.

Landgren, M. E., *American Pupils of Thomas Couture*, University of Maryland Art Gallery, College Park, 1970.

Landgaard, J. H., *J. C. Dahl's Verk*, Oslo, 1937.

Lassiter, B., *Reynolda House, American Paintings*, Winston-Salem, N.C., 1970.

Lauts, J., and Zimmerman, W., *Katalog Neuere Meister, 19. und 20. Jahrhundert*, Staatliche Kunsthalle, Karlsruhe, 1972.

Lawall, D., *A. B. Durand 1796–1886*, Montclair Art Museum, N.J., 1971. *Asher Brown Durand*, New York, 1977.

Lawrence, E., *1800–1874, European and American Landscape, To Look on Nature*, Brown University and Rhode Island School of Design, Providence, 1972.

Lessing, W., *Johann Georg von Dillis*, Munich, 1971.

Leuschmer, V. *Drawings by Carl Friedrich Lessing, 1808–1880, in the Collection of the Cincinnati Art Museum*, Cincinnati, 1972.

Lindsay, K. C., *The Works of John Vanderlyn, From Tammany to the Capitol*, University Art Gallery, Binghamton, N.Y., 1970.

Lipman, J., *American Primitive Painting*, 2nd ed., New York, 1969.

Little, N. F., *American Decorative Wall Painting, 1700–1850*, rev. ed., New York, 1972.

McCormick, G. E., "Fitz Hugh Lane, Gloucester Artist, 1804–1865," *Art Quarterly*, 15:4, 1952.

McCoubrey, J., *The American Tradition in Painting*, New York, 1963.

McElroy, G., *Robert S. Duncanson*, Cincinnati Art Museum, 1972.

McEntee, J., "Diaries," *Archives of American Artists*, Washington, D.C.

McIntyre, R. G., *Martin Johnson Heade, 1819–1904*, New York, 1948.

McLanathan, J., *The American Tradition in the Arts*, New York, 1968.

McLean, A. F., Jr., *William Cullen Bryant*, New York, 1964.

Manwaring, E. W., *Italian Landscape in Eighteenth Century England*, New York, 1965.

Markowitz, I., *Die Düsseldorfer Malerschule*, Kunstmuseum, Düsseldorf, 1969.

Marx, L., *The Machine in the Garden: Technology and the Pastoral Ideal in America*, New York, 1964.

Mather, F. J., Jr., "Worthington Whittredge, Landscape Painter," *The Outlook*, 77:9, July 1904. *Homer Martin, Poet in Landscape*, New York, 1919.

Mayor, A. H., and Davis, M., *American Art at the Century*, New York, 1977.

Mead, K. H., ed., *The Preston Morton Collection of American Art*, Santa Barbara, 1981.

Merritt, H. S., *Thomas Cole*, Memorial Art Gallery, University of Rochester, Rochester, N.Y., 1969.

Miller, L. B., *Patrons and Patriotism*, Chicago, 1966.

Miller, P., *American Thought, Civil War to World War I*, New York, 1954.
 Nature's Nation, Cambridge, Mass., 1967.
 The Transcendentalists, Cambridge, Mass., 1967.

Mitnick, B. J., *Worthington Whittredge: Artist of the Hudson River School*, Morris
 Museum of Arts and Sciences, N.J., 1982.

Morison, E., and Commager, H. S., *The Growth of the American Republic*, 5th
 ed., New York, 1962.

Moure, N., "Three Artists Out West," *The American Art Journal*, 4, 1974.
 William Louis Sonntag, Los Angeles, 1980.

Mumford, L., *The Brown Decades: A Study of the Arts in America, 1865–1895*,
 2nd rev. ed., New York, 1955.

Naylor, M., *National Academy of Design Exhibition Record, 1861–1900*, New York,
 1973.

Noble, L., Rev. *The Life and Works of Thomas Cole*, ed. E. S. Vesell, Cambridge,
 Mass., 1964.

Novak, B., *American Painting of the Nineteenth Century*, New York, 1969.
 "Some American Words: Basic Aesthetic Guidelines, 1825–1870," *American
 Art Journal*, 1:1, Spring 1969.
 "The Double-Edged Axe," *Art in America*, 64:1, January-February 1976.

Novotny, F., *Painting and Sculpture in Europe, 1780–1880*, 2nd ed., Baltimore,
 1971.

Nygren, E. J., *Views and Vision – American Landscape before 1830*, Corcoran
 Gallery of Art, Washington, D.C., 1986.

Omoto, S., "The Sketchbooks of Worthington Whittredge," *Art Journal*, 24:4,
 Summer 1964.
 "Berkeley and Whittredge at Newport," *Art Quarterly*, 27:1, January-March
 1964.

Parry, E. C., III, "Thomas Cole and the Problem of Figure Painting," *American
 Art Journal*, 4:1, May 1972.
 The Image of the Indian and the Black Man in American Art, 1590–1900, New
 York, 1974.

Peat, W., *Pioneer Painters of Indiana*, Indianapolis, 1954.

Pevsner, N., *Academies of Art, Past and Present*, Cambridge, 1940.

Pinto, H. J., *William Cullen Bryant and the Hudson River School of Landscape
 Painting*, Nassau County Museum of Fine Art, Roslyn, 1981.

Pisano, R., *A Leading Spirit in American Art, William Merritt Chase, 1849–1916*,
 Henry Art Gallery, Seattle, 1983.

Plowden, D., *William Stanley Haseltine*, London, 1947.

Porter, J., "Robert S. Duncanson, Midwestern Romantic Realist," *Art in Amer-
 ica*, October 1951.

Rathbone, P. T., *American Paintings in the Museum of Fine Arts*, Boston, 1969.

Rave, P. O., *Karl Blechen, Leben, Würdigungen, Werk*, Berlin, 1940.

Reid, N., Parris, L., and Shields, C., *Landscape in Britain, c. 1750–1850*, Royal Academy of Art, London, 1973.

Rewald, J., *The History of Impressionism*, New York, 1946.

Reynolds, G., *Constable, The Natural Painter*, New York, 1969.
Turner, New York, 1969.

Richardson, E. P., *Travellers in Arcadia*, Detroit Institute of Arts, 1951.
Painting in America: The Story of 450 Years, New York, 1956.
"Allen Smith, Collector and Benefactor," *American Art Journal*, 1:2, Fall 1969.

Ringe, D., "Painting as Poem in the Hudson River Aesthetic," *American Quarterly*, 12:1, Spring 1960.

Rosenblum, R., *Modern Painting and the Northern Romantic Tradition, Friedrich to Rothko*, New York, 1975.

Rutledge, A. W., *Cumulative Record of Exhibition Catalogues, The Pennsylvania Academy of Fine Arts, 1807–1870, The Society of Artists, 1800–1814, The Artists' Fund Society, 1805–1845*, Philadelphia, 1955.

Sanford, C. L., "The Concept of the Sublime in the Works of Thomas Cole and William Cullen Bryant," *American Literature*, 28:4, May 1957, pp. 434–48.

Sarnoff, C. A., *William Louis Sonntag – A Biographical Sketch*, unpublished manuscript, 1974.

Schaarschmidt, F., *Zur Geschichte der Düsseldorfer Malerei*, Düsseldorf, 1902.

Schneider, R., "The Career of James David Smillie (1833–1909) As Revealed in His Diaries," *American Art Journal*, 14:1, Winter 1984, pp. 4–33.

Sears, C. E., *Highlights among the Hudson River Artists*, Boston, 1947.

Seaver, E. I., *Thomas Cole, 1800–1848, One Hundred Years Later*, Wadsworth Atheneum, Hartford, Conn., 1948.

Shannon, M. A. S., *Boston Days of William Morris Hunt*, Boston, 1923.

Slive, S., Rosenberg, J., and ter Kuile, E. H., *Dutch Art and Architecture*, Baltimore, 1966.

Sloan, K., *Alexander and John Robert Cozens, The Poetry of Landscape*, New Haven, 1986.

Spassky, N., *American Paintings in the Metropolitan Museum of Art*, II, New York, 1985.

Stebbins, T. E., Jr., *Martin Johnson Heade*, University of Maryland Art Gallery, College Park, 1969.
Close Observations: Selected Oil Sketches by Frederic E. Church, Washington, D.C., 1978.
A New World: Masterpieces of American Painting 1760–1910, Museum of Fine Arts, Boston, 1983.

Stebbins, T. E., and Gorokhoff, G., *A Checklist of American Paintings at Yale University*, New Haven, 1982.

Stechow, W., *Dutch Landscape Painting of the Seventeenth Century*, London, 1966.

Stehle, R. L., *The Life and Works of Emmanuel Leutze*, unpublished manuscript, 1972.

Stein, R. B., *John Ruskin and Aesthetic Thought in America, 1840–1900*, Cambridge, Mass., 1967.
Seascape and the American Imagination, Whitney Museum of American Art, New York, 1975.

Sterling, C., and Adhémar, H., *Peintures Ecole Française, XIXe Siècle*, Louvre, Paris, 1958.

Sweet, F., *The Hudson River School and the Early American Landscape Tradition*, Art Institute of Chicago, 1945.

Taft, R., *Artists and Illustrators of the Old West, 1850–1900*, New York, 1953.

Talbot, W. S., *Jasper F. Cropsey, 1823–1900*, National Collection of Fine Arts, Washington, D.C., 1970.
"Landscape and Light," *Cleveland Museum of Art Bulletin*, 60:1 January 1973.

Tuckerman, H., *Book of the Artists, American Artist Life*, New York, 1867.

Turner, A. R., *The Vision of Landscape in Italy*, Princeton, N.J., 1966.

van Zandt, R., *The Catskill Mountain House*, New Brunswick, N.J., 1966.

Vanzype, G., *L'Art Belge du XIXe Siècle à l'Exposition de Paris en 1923*, Brussels, 1924.

Vaughn, W., and Börsch-Supan, H., *Caspar David Friedrich*, London, 1972.

Venturi, L., "Pierre Henri de Valenciennes," *Art Quarterly*, 4:2, Spring 1941.

von Kalnein, W., and Hoopes, D., *The Düsseldorf Academy and the Americans*, High Museum of Art, Atlanta, 1973.

von Saldren, A., *Triumph of Realism*, Brooklyn Museum of Art, 1967.

Warner, H. W., Jr., *Mirror to the American Past*, Greenwich, Conn., 1973.

Weber, B., and Gerdts, W. H., *In Nature's Ways: American Landscape Painting of the Late Nineteenth Century*, Norton Gallery of Art, Palm Beach, 1986.

Weiss, I. S., *Sanford Robinson Gifford, 1823–1880*, New York, 1977.

Whitley, E. T., *Kentucky Ante-Bellum Portraiture*, Lexington, Ky., 1956.

Whittredge, W., *The Autobiography of Worthington Whittredge*, ed. J. Baur, Brooklyn Museum of Art, 1942.

Whittredge, W., original manuscript, Archives of American Art, Washington, D.C.

Wichmann, S., *Wilhelm von Kobell*, Munich, 1972.

Wilmerding, J., *Fitz Hugh Lane, 1804–1865, American Marine Painter*, Salem, Mass. 1964.
A History of American Marine Painting, Boston, 1968.
Robert Salmon, Painter of Ship and Shore, Boston, 1968.

American Light, The Luminist Movement 1850–1875, National Gallery of Art, Washington, D.C., 1980.

Wolf, G. J., *Leibl und sein Kreis*, Munich, 1923.

Wunderlich, R., *The Hudson River School*, Shreveport, La., 1974.

Zelger, F., "Alexandre Calame," *Palette*, 40.

Index